Praise for *The Brutish Museums*

'A real game-changer.'
The Economist

'If you care about museums and the world, read this book.'
New York Times 'Best Art Books' 2020

'Hicks's urgent, lucid, and brilliantly enraged book feels like a long-awaited
treatise on justice.'
Coco Fusco, *New York Review of Books*

'Unsparing ... especially timely ... his book invites readers to help break the
impasse by joining the movement for restitution.'
CNN

'The book is a vital call to action: part historical investigation, part manifesto,
demanding the reader do away with the existing "brutish museums" of
the title and find a new way for them to exist.'
Charlotte Lydia Riley, *Guardian*

'A startling act of conscience. An important book which could overturn what
people have felt about British history, empire, civilisation, Africa, and African
art. It is with books like this that cultures are saved, by beginning truthfully to
face the suppressed and brutal past. It has fired a powerful shot into the debate
about cultural restitution. You will never see many European museums in the
same way again. Books like this give one hope that a new future is possible.'
Ben Okri, poet and writer

'An epiphanic book for many generations to come.'
Victor Ehikhamenor, visual artist and writer

'Unflinching, elegantly written and passionately argued, this is a call to action.'
Bénédicte Savoy, Professor of Art History, Technische University Berlin

'In his passionate, personal, and, yes, political account, Dan Hicks transforms
our understanding of the looting of Benin. This book shows why being against
violence now more than ever means repatriating stolen royal and sacred objects
and restoring stolen memories.'
Nicholas Mirzoeff, Professor in the Department of Media,
Culture and Communication, New York University

'Destined to become an essential text.'
Bryan Appleyard, *Sunday Times*

'Dan, your words brought tears to my eyes. I salute you.'
MC Hammer

'A masterful condemnation and inspiring call to action.'
Los Angeles Review of Books

'Timely.'
Nature

'Shows that colonial violence is unfinished, and as it persists in the present, it cannot be relativized.'
Ana Lucia Araujo, *Public Books*

'Leaves no stone unturned.'
Financial Times

'Argues, persuasively, that the corporate-militaristic pillage behind Europe's encyclopedic collections is not a simple matter of possession, but a systematic extension of warfare across time.'
The Baffler

'A bombshell book.'
Los Angeles Times

'After this book, there can be no more false justifications for holding Benin Bronzes in museums outside of Africa.'
Africa is a Country

The Brutish Museums

The Benin Bronzes, Colonial Violence and Cultural Restitution

Dan Hicks

First published 2020; paperback edition first published 2021 by Pluto Press
New Wing, Somerset House, Strand, London WC2R 1LA

www.plutobooks.com

British Library Cataloguing in Publication Data
A catalogue record for this book is available from the British Library

ISBN 978 0 7453 4176 7 Hardback
ISBN 978 0 7453 4622 9 Paperback
ISBN 978 1 7868 0683 3 PDF eBook
ISBN 978 1 7868 0684 0 EPUB eBook

This book is printed on paper suitable for recycling and made from fully
managed and sustained forest sources. Logging, pulping and manufacturing
processes are expected to conform to the environmental standards of the
country of origin.

Typeset by Stanford DTP Services, Northampton, England

Simultaneously printed in the United Kingdom and United States of America

For Judy and Jack

Contents

List of Plates

The methods by which this Continent has been stolen have been contemptible and dishonest beyond expression. Lying treaties, rivers of rum, murder, assassination, mutilation, rape, and torture have marked the progress of Englishman, German, Frenchman, and Belgian on the dark continent. The only way in which the world has been able to endure the horrible tale is by deliberately stopping its ears and changing the subject of conversation while the deviltry went on.

W.E.B. Du Bois, 'The African Roots of War', 1915

And what of the museums, of which Europe is so proud? It would have been better, all things considered, if it had never been necessary to open them. Better if the Europeans had allowed the civilisations beyond the Continent of Europe to live alongside them, dynamic and prosperous, whole and unmutilated. Better if they had let those civilisations develop and flourish rather than offering up scattered limbs, these dead limbs, duly labelled, for us to admire. After all, by itself the museum is nothing. It means nothing. It can say nothing. Here in the museum, the rapture of self-gratification rots our eyes. Here, a secret contempt of others dries up our hearts. Here racism, no matter if it is declared or undeclared, drains all empathy away. No, in the scales of knowledge the mass of all the museums in the world could never outweigh a lone spark of human empathy.

Aimé Césaire, *Discours sur le colonialisme*, 1955 (my translation)

Preface

In his manifesto for the 'Dig Where You Stand' movement, Sven Lindqvist wrote, typed out in all-caps:

FACTORY HISTORY COULD AND SHOULD BE WRITTEN FROM A FRESH POINT OF VIEW.
BY WORKERS INVESTIGATING THEIR OWN WORKPLACES.

In their workplaces, Lindqvist explained, people have 'competence and know their jobs'; 'their working experience is a platform' from which they can see what is being done, and what is not being done.[1] The example that Lindqvist gave was the Swedish concrete industry, and this book too is about the building and anchoring of foundations, about composite and liquid forms, and about how such forms are reinforced and harden over time – but also about the degradation and fatigue of institutional constructions, their structural weaknesses and collapse, the dismantling and demolition of brutal façades – and how among the rubble a prone edifice might be repurposed as some kind of bridge.

My own workplace, which is the subject of this book, is the University of Oxford's Museum of Anthropology and World Archaeology, where I am curator of 'world archaeology'. In what follows, I have sought to follow Lindqvist's invocations: to do research 'on the job', to dig into what we know, to use our specialist and sometimes esoteric technical knowledge to excavate new pasts and presents, perhaps even to seek to carve out better futures too. In the case of the Pitt Rivers Museum, this knowledge begins with what might be reasonably called a form of 'Euro-pessimism', by which I mean that the knowledge that Europeans can make with African objects in the anthropology

museum will be coterminous with knowledge of European colonialism, wholly dependent upon anti-black violence and dispossession, until such a time as these enduring processes are adequately revealed, studied, understood, and until the work of restitution – by which I mean the physical dismantling of the white infrastructure of every anthropology and 'world culture' museum – is begun.

It is thus a book written from Oxford, a self-consciously 'anglocentric' account,[2] written to address how 'British imperial historiography has catered to British interests', especially in the case of Benin,[3] with the conviction that European voices have a service to fulfil in the process of restitution: one of sharing knowledge of the process of cultural dispossession, and of facing up to the colonial ultraviolence, democide, and cultural destructions that characterised the British Empire in Africa during the three decades between the Berlin Conference of 1884 and the outbreak of the First World War in 1914, an episode that I reframe here as 'World War Zero'. One of my main aims in addressing this past is to help to catalyse a new acknowledgement of the scale and horror of British corporate-militarist colonialism, as has begun to happen in the sense of the colonial past in some other European nations, including Germany and Belgium. Anthropology museums represent crucial public spaces in which to undertake this social and political process, which is a necessary first step towards any prospect of the 'decolonisation' of knowledge in these collections. But this cannot be short-circuited by the mere re-writing of labels or shuffling around of stolen objects in new displays that re-tell the history of empire, no matter how 'critically' or self-consciously.

In light of the sheer brutishness of their continued displays of violently-taken loot, British museums need urgently to move beyond the dominant mode of 'reflexivity' and self-awareness in museum thinking, which often amounts to little more than a kind of self-regard, turning the focus back upon the anthropologist, curator, or museum as both object and subject of enquiry, performing dialogue with certain 'source communities'. We need to open up and excavate our institutions, dig up our ongoing pasts, with all the archaeological tools that can be brought to hand, sometimes a teaspoon and toothbrush, other

times a pick-axe or a jack-hammer. Any museum object has a double historicity, of course – its existence before and after the act of accession. But in the case of what loot became under the intellectual regime of 'race science' in the late 19th century and early 20th century, in the museum, the second, most recent of these two layers is dominant. Far from any normal history of collecting or 'provenance', which could co-exist alongside studies of the lives of these objects before that act of taking, under the ultraviolent conditions of military looting through the sheer intensity of the violence witnessed under corporate colonialism, which took the form of an incendiary shattering of the bombs scattering loot from the event of 18 February 1897 to hundreds of museums across the western world – the damage is renewed every day that the museum doors are unlocked and these trophies are displayed to the public. The ongoing British/brutish histories of 'acquisition' must be reconciled before African pasts, presents and futures can be meaningfully understood from the standpoint of any Euro-American museum collection. The primary task for anthropology museums must therefore be, I suggest here, to invert the familiar model of the life-history of an object as it moves between social contexts, new layers of meaning and significance added with each new phase of its biography, sovereignty, of the attempted destruction of cultural significance, to write action-oriented 'necrographies' – death-histories, histories of loss – of the 'primitive accumulation' of museums, in order to inform the ongoing, urgent task of African cultural restitution, intervening through new kinds of co-operation and partnership between Europe and Africa, in which the museum will variously dismantle, repurpose, disperse, return, re-imagine, and rebuild itself. Excavating the knowledge of where Benin loot is located, and urging each of the hundreds of institutions, individuals, and families that hold it today – universities, museums, charitable trusts, local government, nation states, descendants of the soldiers who did the looting, private collectors – to take meaningful action towards cultural restitution, informed by the understanding that the violence is not some past act, to be judged by the supposed standards of the past, but an ongoing event, is a big task. At the end of this book is a first provisional attempt to list where the

Benin loot taken in 1897 is today – please help to correct and expand this knowledge, so that in a revised edition of this book we can update the list, and can start to count up the returns.

I am indebted to the generosity and friendship of many people who have helped me in writing this book. A seed of this book began two decades ago in conversations with David Van Reybrouck, whose key work *Congo: the epic history of a people* (2014) has been an ongoing inspiration, renewed in Berlin in summer 2017. Through my participation on behalf of the Pitt Rivers Museum in the Benin Dialogue Group, it has been an immense privilege to meet colleagues from Nigeria, Germany, and the UK who are so knowledgeable about Benin art and history, and who come together in such mutually respectful ways to discuss what some call 'difficult' histories, and others, myself included, see as quite straightforward, enduring pasts. Within the Group, special thanks are due to Enotie Ogbebor, Barbara Plankensteiner, Jonathan Fine, Henrietta Lidchi, and Lissant Bolton.

The arguments in this book were developed during lectures and public dialogues at a range of venues, including the Berlin International Literature Festival, CARMAH at Humboldt University Berlin, the Hunterian Museum in Glasgow, MARKK Museum am Rothenbaum in Hamburg, the Edinburgh Centre for Global History, the Anthropology Department of the University of St Andrews, the University of Nanterre, Free University Amsterdam, Tübingen University, and the musée du quai Branly.

I have also learned an immense amount from an amazing community of scholars, activists and thinkers over Twitter, not least in the #BeninDisplays thread in June–July 2019, without which the analysis in Chapter 16 would have been impossible. Thank you to everyone who has helped me form the ideas for this book through that platform, especially members of @MuseumDetox, @KimAWagner, @SFKassim, @littlegaudy, @waji35, @CirajRassool, @NatHistGirl, @JuergenZimmerer, and colleagues at other British non-national museums, including Manchester, Liverpool, the Horniman, Brighton, Cambridge, Bristol, Exeter, and beyond.

Many of the ideas developed here were first explored in a series of lectures given during my Visiting Professorship at the musée du quai Branly in 2017–18, and I am grateful to the students, researchers and colleagues from whom I learned so much during that year. The opportunity of sharing platforms with Clémentine Deliss at Humboldt University in Berlin, with Hamady Bocoum and Marie-Cécile Zinsou at the Collège de France in Paris, with Kokunre Agbontaen Eghafona at Technische University in Berlin, and with Ghislaine Glasson Deschaumes at the Victoria and Albert Museum in London, have all represented important opportunities to shape the ideas presented here, and I am grateful to all those who made these events possible, including Felwine Sarr and Bénédicte Savoy.

Special thanks must go to the leading scholars of Benin 1897, Felicity Bodenstein in Paris and Staffan Lundén in Stockholm, for their help and encouragement. Special thanks are also due to Nana Oforiatta Ayim, Michael Barrett, Ines de Castro, Philippe Charlier, Victor Ehikhamenor, Mark Elliott, Sandra Ferracutti, Monica Hanna, Frédéric Keck, Anne Luther, Sharon Macdonald, Sarah Mallet, Nick Mirzoeff, Wayne Modest, Chris Morton, Ciraj Rassool, Anthony Richter, Mike Rowlands, Bénédicte Savoy, Olivia Smith, Adrenele Sonariwo, Carole Souter, Jonas Tinius, Laura Van Broekhoven, Onyekachi Wambu and William Whyte, and very many more who have helped to shape this book in different ways.

The opportunity to contribute to the Symposium on Art, Law and Politics at King's College, Cambridge in March 2019, at the kind invitation of Sarah Rabinowe, Mary-Ann Middelkoop, Luise Scheidt, Honor May, and Freya Sackville-West, was also an important milestone in the development of the book.

The research for this book was supported by an Art Fund Headley Fellowship.

* * *

A note on the black-and-white photographs interspersed in this text is necessary. They are from the album-diary of Captain Herbert Sutherland Walker (1864–1932) of the Cameronians (Scottish Rifles),

who was a Special Service Officer in the Benin Expedition. A recent accession to the Pitt Rivers Museum in Oxford, these photographs are offered without captions and copyright-free, as a reminder of the commonalities between two mnemonic regimes of taking and visuality: the taking of objects and the putting of some of these on display in museums, and the taking of photographs. This book seeks to intervene with these modes of appearance, in which taking is turned from a moment in time into an ongoing duration. The aim is to bring British colonial violence and present into view and into focus, so that we can begin the process of cultural restitution. By digging where we stand.

Preface to the Paperback Edition

I guess the pushback against *The Brutish Museums* was to be expected from right-wing pundits. Expected or not, with all the dreary tedium that would accompany any gang of pub bores, each reminiscing with deep and lengthy regret about a time that never was, their lacklustre attack-pieces and rambling hit-jobs duly arrived. From Melanie Phillips' Substack (non-paywalled content) to Michael Mosbacher's hot take in *The Spectator,* and to David Aaronovitch's column in *The Times*, the book has been criticised, more often more for its tone than for its message, by the usual suspects.[1] Yes, as each such piece is published, in the small hours a chaotic mob of egg-avatar-name-bunch-of-numbers fascist accounts predictably use the reply function to squirt their bile towards my Twitter profile for a day or two. But mainly the recurring thought has been: *Who knew when the fake 'culture war' came it would be so badly written?*

(There have been tons of incredibly generous, thoughtful and positive reviews of course, and I am not about to reference them here but I am immensely and eternally grateful to all those who have written, shared, and commented in long or short form to support my putting my neck very slightly on the line in publishing this book – you know who you are.)

But what I don't think I was really prepared for was some of the really negative stuff coming from so very close to home. Writing in the *Observer*, Tristram Hunt, the Director of the Victoria and Albert Museum, claimed *The Brutish Museums* is a work of histrionic activism.[2] In *The Art Newspaper* Nick Thomas – Director of the Museum of Archaeology and Anthropology at Cambridge University and currently a trustee of the Pitt Rivers Museum where I am a curator – denounced the book for 'trash-talking museums', arguing that 'the Hicks-style monologue learns nothing from, and contributes nothing to, an art of listening that curators have cultivated for decades'.[3]

And my Oxford University colleague the Reverend Canon Nigel Biggar CBE, who is Regius Professor of Moral Philosophy and runs a personal project called 'Ethics and Empire', has claimed that the book represents 'an object lesson in how political zeal can abuse data in the cause of manufacturing an expedient narrative'.

Thomas claims his silence is listening; Hunt claims his inaction is leadership. *The Brutish Museums* takes them both to task for the counter-insurgency of their position on colonial history, but nonetheless their comments have stung as they were intended to, since after all I have written this book as part of doing my job. I'm not an activist, I'm a curator. I'm not attacking museums, I'm trying to play my part in making the one I work in fit for the twenty-first century. In their mutual attempt to dismiss the book as some kind of militant attack on museums, rather than a step forward in the development of new ethical and curatorial standards, Thomas and Hunt indulge in the same simplistic binarism for which Biggar's pro-empire project was so clearly critiqued in an open letter from Oxford academics back in 2017: 'Good and evil may be meaningful terms of analysis for theologians. They are useless to historians.'[4]

There is good news though. Beyond the outgoing generation of Oxbridge professors (and, yes, the occasional aging 'young fogey' national museum director), the call to return the Benin Bronzes has gone mainstream. *The Brutish Museums* has added in a small way to the momentum built up over decades by Nigerian colleagues and campaigners. Crucially the book sought to break down the longstanding pretence by the press officers of some of the richest and most powerful Euro-American museums that the question of African cultural restitution is a stand-off between claimants and curators.

For the truth about some of these recent histories, we now have my dear colleague Bénédicte Savoy's crucial book *Afrikas Kampf um seine Kunst* ('Africa's Struggle for her Art') (2021), an English translation of which may, I believe, already be in the works. But in considering this most recent period of landmark moments for this cause, let me foreground one. In March 2021 when after Aberdeen University announced their intention to return a looted bronze currently in their care, *The Times* reversed its editorial position and came out in favour of

returns, writing that: 'Where it can be shown – such as in the case of this Benin bronze – that the removal of a piece was a criminal act, then repatriation should be the primary objective.'[5]

In the subsequent weeks and months, further commitments to return Benin material have been made by the National Museum of Ireland, the Fowler Museum at UCLA, the Metropolitan Museum in New York City, and by all of the federal state museums of Germany. Speaking in April 2021, German Foreign Minister Heiko Maas has called the agreement to make returns 'a turning point in our approach to colonial history'.[6] This turning point has been driven by the tenacity of Nigerian-led claims, as they have been maintained and restated since the 1930s. Taking stock of this fast-moving field, as plans for a new museum for Benin City gain momentum and the work of the newly-formed Legacy Restoration Trust develops, it is striking how the urgent reckoning with the form and nature of late-nineteenth-century British corporate-militarist-colonial-ism is being led by the German government, by Nigerian scholars and curators, by Irish museum directors, by American campaigners – rather than by the British national museums. And how the old strategies of 'white projection' – pretending that restitution is somehow an attack on museums – are falling apart.

The relationship between formerly colonised nations and formerly colonising nations is only one part of the restitution process, and much of the progress on returns is being made by non-state actors, both in terms of claimants and Euro-American museums. Perhaps half of the perhaps two thousand objects looted in 1897 that are currently in British collections are outside of the national museums. But the position of Britain's national museums matters, and London is looking increasingly isolated and left behind by the day.

The Brutish Museums concludes with a vision of the 2020s as a decade of returns. Early into that decade, there is some cause to be hopeful. Cultural restitution does not happen overnight, but equally endless dialogue that continually defers action is no longer feasible. Attempts by some to draw museums into the 'culture war' that has been declared by British government on supposedly 'woke' institutions or curators are increasingly incoherent. And the wider processes of truth, of what *The Brutish Museums* calls the physical dismantling of the white infra-

structure of Euro-American 'world culture' museums, of the struggle for reconciliation, repair, justice, and the repayment of outstanding debts, are gathering pace. A key part of this is the recognition that returning stolen goods on a case-by-case basis is a wholly necessary, but insufficient, part of cultural restitution. Returns are a *sine qua non*, but acts of dismantling the racist core of our museums must also involve a wider set of anti-colonial, anti-racist actions – from positive action initiatives to diversify these incredibly white organisations to new forms of equitable co-production with African colleagues and institutions, and to new forms of remembrance of the colonial past.

What is clear is that the old argument that restitution is a distraction from the 'real work' of anti-racism is past its sell-by date. Art matters. Culture matters. The destruction of sovereignty, the attack on traditional belief, attempts at wholesale cultural dispossession – all these military tactics engaged by Europeans in Africa recognised the importance of art and culture.

As progress is made with the return of the Benin Bronzes, attention will move to the many smaller, less well documented, but nonetheless crucially important, acts of taking that occurred throughout World War Zero across the continent of Africa. A far wider set of unfinished acts of ultraviolence, extractivism, the ideology of cultural supremacy is unfolding, is coming into view. Stolen art, stolen culture, stolen land, stolen climate, stolen past and stolen future. Loss that is rekindled every day that a Euro-American museum opens its doors and puts stolen goods on display.

We're still in the middle of this period of profound change. It's a time of great hope tempered with an awareness that the opportunity for substantive change could yet be lost.

* * *

In the months since *The Brutish Museums* was first published, in these strange times of lockdown and zoom calls, I have been privileged to join many international colleagues in conversations about the book, from whom I have learned so very much. My sincere thanks to all those with whom I have been in public dialogue in a range of video, radio and podcast formats, including Ana Lucia Araujo, Ariella Azoulay, Aaron

Bastani, Sandeep Bakshi, Natasha Becker, Marla Berns, Alixe Bovey, Leyla Bumbra, Shadreck Chirikure, Adenike Cosgrove, Julie Crooks, Subhadra Das, Souleymane Bachir Diagne, Victor Ehikhamenor, Inua Ellams, Ndubuisi C. Ezeluomba, Errol Francis, Chris Garrard, Paul Gilroy, Andreas Görgen, Diya Gupta, Monica Hanna, Afua Hirsch, Candice Hopkins, Phillip Ihenacho, Ruba Kana'an, Bryan Knight, Christine Mullen Kreamer, Lauren Kroiz, Chaédria LaBouvier, Peju Layiwola, Wim Manuhutu, Wayne Modest, Nina Möntmann, Mai Musié, Terri Ochiagha, Ken Olende, Alice Procter, Ciraj Rassool, Seph Rodney, Felwine Sarr, Bénédicte Savoy, Olga Symeonoglou, Nanette Snoep, Chardine Taylor-Stone, Onyekachi Wambu, Esmé Ward, Anne Wetsi Mpoma and Gary Younge. Thank you all. And thank you also to all those who joined in the audience and the growing online community. Do keep reaching out through @BrutishMuseums and @ProfDanHicks. And a very special thanks also to MC Hammer for hosting the epic four-and-a-half-hour-long Clubhouse event for *The Brutish Museums* on 5 March 2021 – a night that will forever stay with me and many who participated or tuned in.

Finally, before you read this book you might just now skip ahead and take a look at *Appendix 5*. Ask yourself how near you are right this minute from a looted Benin Bronze. And then consider what else is in the storerooms of the museum, how and why. What is not even on the database? What is still languishing in a box unopened for a century? The theory that informs this book begins with the premise that an old photograph or an archaeological artefact or a historical object is not a fragment of time, but an endurance. *Archaeology is not the study of the remnants of the past: it's the science of human duration* is one of the book's guiding principles.

So, as you read what follows, do try to keep in mind a sense of how much harm that stolen culture might still be doing – from inside each locked room or ziplocked bag – as you turn the pages. Yes, the Benin theft is ten thousand unfinished events. But yes, there are also millions more items of stolen African material culture in Euro-American collections, further unfinished events, endurances in their millions. We still don't know how this ends.

Dan Hicks
August 2021

1

The Gun That Shoots Twice

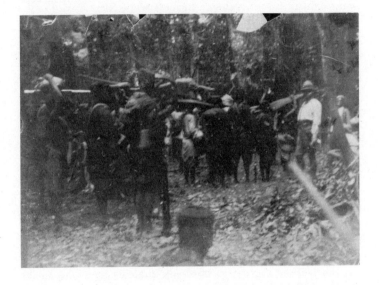

The seven-pounders are most excellent guns, as they are made to stand any amount of knocking about, and also to be mounted and dismounted in a very short space of time. They are much disliked by the natives of the country, who call them 'them gun that shoot twice' – referring to the explosion of the shells, which they consider distinctly unfair, taking place as it does so far away from the gun, and mostly unpleasantly close to themselves, when they are, as they fondly imagine, out of range.

Captain Alan Boisragon, Commandant
of Niger Coast Protectorate Force (1897)[1]

Along the Niger River since 1894 Alan Boisragon had seen scores of military 'punitive expeditions' in the bush, with warships, Maxim machine guns, rocket launchers and Martini-Henry rifles. In the passage above, he is describing the rifled muzzle-loading mounted carriage field gun, known as a 'seven-pounder' because of the weight of the shell that it fired (about 3.2 kilograms), in his popular account of the military attack on Ubini[2] (Benin City) by Niger Coast Protectorate and Admiralty forces in February 1897. Boisragon does not record the number of casualties from the shelling of the city, of scores of surrounding towns and villages, of incessant firing of machine guns and rockets into the bush, during this 18-day attack. He does not take stock of the numbers of killed and wounded soldiers and displaced people in the many, many previous 'expeditions' and attacks, or reflect on the extent of death and injury in the many as yet unplanned expeditions of the coming months and years, as yet unnamed: Opobo, Qua, Aro, Cross River, Niger Rivers, Patani, Kano, 'opening up new territories', 'journeying into the interior', 'pacifications', exacting punishment for supposed offences against civilisation.

Undetained by any question of African deaths, this description in fact came from an autobiographical adventure story, in which Alan Boisragon told of his own escape in the face of attack, one of just two survivors of the earlier supposedly peaceful expedition to the City in January 1897, during which perhaps seven (or perhaps five) Englishmen were killed, and how he and his comrade had to walk through the jungle for five days before finally returning to safety and civilisation – ready to exact a brutal revenge on his 'barbaric' attackers and the heart of their 'uncivilised' power – the so-called city of blood.[3]

The *Daily Mail* and *The Times* led the newspaper coverage of this *Boys' Own* yarn of 'massacre' and heroism and to which the February 'punitive expedition' was the necessary response. A year later, the War Office was issuing medals commending soldiers described as members of 'the squadron sent to punish the King of Benin for the massacre of the political expedition'.

This is a book about that violent sacking by British troops of the City of Benin in February 1897. It rethinks the enduring effects of this destruction in Britain today, taking stock of its place in a wider military campaign of regime change, underscoring its status as the pivotal moment in the formation of Nigeria as a British protectorate and British colony, exposing how the many 'punitive expeditions' were never acts of retaliation, and trying to perceive the meaning and enduring effects of the public display of royal artworks and other sacred objects looted by marines and soldiers from the Royal Court now dispersed across more than 150 known museums and galleries, plus perhaps half as many again unknown public and private collections globally – from the Met in New York to the British Museum, from Toronto to Glasgow, from Berlin to Moscow, Los Angeles, Abu Dhabi, Lagos, Adelaide, Bristol and beyond. Some of these objects have a truly immense monetary value on the open market today, selling for millions of dollars.

Objects looted from the City of Benin are on display in an estimated 161 museums and galleries in Europe and North America. Let us begin with this question: *What does it mean that, in scores of museums across the western world, a specially written museum interpretation board tells the visitor the story of the Benin Punitive Expedition?*

One of the largest of these collections of violently stolen objects, trophies of this colonial victory, is the University of Oxford's Pitt Rivers Museum – where I am Curator of World Archaeology. Are museums like the Pitt Rivers just neutral containers, custodians of a universal heritage, displaying a common global cultural patrimony to an international public of millions each year, celebrations of African creativity that radically lift up African art alongside European sculpture and painting as a universal heritage? The point of departure for this book is the idea that, for as long as they continue to display sacred and royal objects looted during colonial massacres, they will remain the very inverse of all this: hundreds of monuments to the violent propaganda of western superiority above African civilisations erected in the name of 'race science', littered across Europe and North America like war memorials to gain rather than to loss, devices for the construction

of the Global South as backward, institutions complicit in a prolongation of extreme violence and cultural destruction, indexes of mass atrocity and iconoclasm and ongoing degradation, legacies of when the ideology of cultural evolution, which was an ideology of white supremacy, used the museum as a tool for the production of alterity: tools still operating, hiding in plain sight.

And so this is a book about sovereignty and violence, about how museums were co-opted into the nascent project of proto-fascism through the looting of African sovereignty, and about how museums can resist that racist legacy today. It is at the same time a kind of defence of the importance of anthropology museums, as places that decentre European culture, world-views and prejudices – but only if such museums transform themselves by facing up to the enduring presence of empire, including through acts of cultural restitution and reparations, and for the transformation of a central part of the purpose of these spaces into sites of conscience. It is therefore a book about a wider British reckoning with the brutishness of our Victorian colonial history, to which museums represent a unique index, and important spaces in which to make those pasts visible.

The Pitt Rivers Museum is not a national museum, but it is a brutish museum. Along with other anthropology museums, it allowed itself to become a vehicle for a militarist vision of white supremacy through the display of the loot of so-called 'small wars' in Africa. The purpose of this book is to change the course of these brutish museums, to redefine them as public spaces, sites of conscience, in which to face up to the ultraviolence of Britain's colonial past in Africa, and its enduring nature, and in which to begin practical steps towards African cultural restitution.

* * *

Stand in the Court of the Pitt Rivers Museum and go up to the Lower Gallery. Walk with me to the east wall and stop in the still, dark space; the vast silent expanse of the museum is behind us and before us is a cabinet of sacred and royal objects, dimly lit, returning our gaze. Let

us step before the glass 'in order to soak up the fugitive breath that this event has left behind'.[4]

Hold your phone up against the plate glass of the triple vitrine. The silence and stillness are not natural conditions for the displaced objects on display here. They are the effect of a stilling, as when detention interrupts transit, and of a fracturing, as when a shrapnel shell explodes at its target, and of a silencing, as when a gun is silenced.

The Victorian wooden case is nine feet high. There are more than a hundred objects contained within: bronze and wooden heads, brass plaques, ceremonial swords, armlets and headgear, boxes and carved ivory tusks, one burned in the fire of the sacking. The title reads: 'Court Art of Benin', and then an interpretation panel states:

> Benin is a kingdom in Nigeria, West Africa. It has been ruled by a succession of kings known as Obas since the fourteenth century. Benin is famous for its rich artistic traditions, especially in brass-casting. In January 1897 a small party of British officials and traders on its way to Benin was ambushed. In retaliation a British military force attacked the city and the Oba was exiled. Members of the expedition brought thousands of objects back to Britain. The Oba returned to the throne in 1914 and court life began again. The artists of Benin continue to make objects for the Oba and the court, and rituals and ceremonies are still performed. The objects displayed here were made between the fifteenth and nineteenth centuries.

How little has changed over the decades since February 1899 when Charles Hercules Read and Ormonde Maddock Dalton, the Keeper and Senior Assistant respectively in the Department of British and Medieval Antiquities and Ethnography at the British Museum introduced their catalogue *Antiquities from the City of Benin* by telling the same story of ambush and retaliation – 'objects obtained by the recent successful expedition sent to Benin to punish the natives of that city for a treacherous massacre of a peaceful English mission'[5] – with the following note of explanation:

Captain Gallwey, of the East Lancashire Regiment, [was] sent on a political mission in 1892. Four years later a larger mission, under Consul Phillips, was attacked on its way up from the coast, and the majority of the party were massacred. This outrage led to the despatch of a military expedition, which destroyed Benin City, and made accessible to students of ethnography the interesting works of native art that form the subject of the following pages.[6]

The museum may operate to stabilize and reproduce certain narratives, and to repress and diminish others – but only ever provisionally. Insofar as the museum is not just a device for slowing down time, but also a weapon in its own right, then to what extent are its interventions with time like the brute force of field guns manned by Captain Boisragon's African forces, carried through the jungle by men selected for their physical strength, a projection across time and space, where some kind of explosion is yet contained in each brass object within this vitrine, unfinished events from which the curator might feel safely out of range, having taken place so far away across time and space: another continent, another millennium? By intervening with time, decelerating memory, displaying loot, what kind of ordnance has the museum brought within its glass cases, caught between one shot and another, between the projection and the return? What do we see when a light is shone into these most hesitant, uncertain of spaces, unresolved and raw? What connections will be made when human time and space re-align and the thing is still here? Each stolen object is an unfinished event, its event-density grows with each passing hour. The Victorian soldiers and museum curators said these were 'ju-ju' fetishes whose power needed to be broken. Spend time in front of this case and the solid and the visible seem to soften, as when brass is cast, to blend with memory and with knowledge, at a tipping point. A new conjunction is coming about for museums and empire. What is this moment? How does loss come into view?

*　*　*

Objects from Benin's Royal Court, burnt to the ground by British troops, are displayed in the 'court' and galleries of this Oxford museum. What kind of archive is this replica, this stagey performance in a windowless space today curated to enchant, a century and a half ago built to shape knowledge, to redraw the world? Anthropologists have a word for it: myth. And myths are temporal devices. Myth serves, as does music, as Claude Lévi-Strauss famously argued, to 'immobilize the passage of time', so 'overcoming the antinomy of historical and elapsed time'. The technologies of the museum and the archive – the museum label, the zip-lock bag, the conservation lab – are analogous interventions. They are forms of notation: *dal segno* ('go back to the mark'). Among the outcomes of these technologies are provisional and contingent stoppages in time, rendering fragments as objects, which are wrought as cadences. A form of secondary deposition emerges in the museum, like curtain calls.[7] In 2017, Edward Weisband[8] observed that various spectacular or dramaturgical political and symbolic forms, which he calls 'the macabresque', tended to accompany mass violence during the 20th century – a kind of sadistic, performative self-creation that emerges hand-in-hand with the inflicting of loss, the myth of the 'primitive' in violence extended across time: the weaponization of time itself.

Benin City lies on a high sandy plain to the north of the Niger Delta in Edo State, Nigeria, in an area of former tropical forest. Today, it is a city of 1.5 million people and the centre of a major precolonial kingdom of the Niger Delta, which once controlled the land and river systems that connected the African interior with the maritime world of the Bight of Benin and the Atlantic Ocean. The city first emerged during a period of urbanisation and state formation along the tropical belt of West Africa, some one thousand years ago, which saw the emergence of the great centres of Edo, Yoruba, and Akan pre-colonial states: Benin, Ife, Ilesa, Oyo, Kumasi, Begho – with Aja and Fon states and urban polities such as Dahomey emerging later, from the 16th century. The Kingdom of Benin has been ruled by an unbroken line of Obas (Kings) that began with Ewuare I who reigned from 1440 CE – a century before Queen Elizabeth I came to the English

throne – and had its origins in the late Iron Age urban societies of the 10th or 11th century CE onwards: when he was crowned in 2016, the current Oba, Ewuare II, became the fortieth Oba in an unbroken line across eight centuries. The Kingdom grew in power and scope during its involvement in European and transatlantic trade from the 16th century, at first with Portuguese traders, and later British and French – central among which was the slave trade. By the 19th century, Benin City was a sacred monumental landscape of courthouses, compounds, and mausoleums, the centre of royal and religious power encompassed in an ancient network of ditched and banked earthwork enclosures, and with central repositories of thousands of unique artefacts that bore witness to the kingdom's past – a kind of unseen city, a centre for changing forms of religious observance and royal power over centuries. The sacking of this city, more than twelve decades ago, involved the looting of more than ten thousand royal and sacred objects.

In the artificial, darkened secondary landscapes of this museum, let us understand this place not as some dazzling gathering of the flotsam and jetsam of the colonial past, but, following the lead of Laurent Olivier,[9] understand these fragments of cultural history as forms of human memory. As the visionary archaeologist Jacquetta Hawkes once put it, archaeologists are 'instruments of consciousness who are engaged in reawakening the memory of the world'.[10] The memory here which must be recalled to allow other pasts to re-emerge, to be no longer silenced, is a memory of loss through extraction, where the bronze plaques and other royal and sacred objects looted from Benin City were no more side effects of empire than palm oil or rubber were side effects of empire; in fact, they form an enduring part of the ecology of militarist colonialism.

The immense loss involved in the British cultural atrocity at Benin City is coming into view for white museum staff in Europe and North America in the 2020s, but in truth it has always been hypervisible for some museum visitors, and for so many more unable or unwilling ever to step their foot inside an anthropological, 'ethnological', 'ethnographic', '*Völkerkunde*', or newly rebranded 'world culture' museum.

The new awareness among curators, refracted through a new enthusiasm for 'decolonisation', in word if not in deed, comes not through some sudden enlightenment to the intertwined history of anthropology and empire, or to the processes of institutional racism, on the part of either the bureaucrats or the connoisseurs of these red-bricked, steel-girdered railway-station-like edifices. This new scramble for decolonisation throws up new dangers: of obfuscation, of tokenism, of the co-option of activists, of the appropriation of the labour of 'source', descendant and diasporic African communities, of the cancellation of outstanding debt, of a hundred varieties of side-step that allow violence to persist. But there the loss can be seen in a new way, nonetheless. Why is this, why now?

* * *

Since one of the principal arguments of this book will be that ethnological museums should be seen as a kind of device, an implement or weapon just like those displayed in the traditional cabinets of so-called 'primitive technology', but forged for a new Anglo-German ideology of imperialism made in the final third of the 19th century, then an analogy might be drawn with one of the main lessons of the anthropology of science and technology. We became familiar in the 1980s with the idea that our knowledge of the world is shaped by society – 'socially constructed', as the theorists used to say. Back then, the study of science and technology gradually introduced material things into those accounts of knowledge production – the social agents including objects as well as humans: in Bruno Latour's business school theory of 'actor-networks' in which 'technology is society made durable',[11] and in the techno-feminism of Donna Haraway, where the overarching figure of the cyborg rose up in answer to the question of the day: *'the social construction of what?'*.[12] Those debates in material culture studies, those rhetorical switching of position between subject and object to suggest the agency of things in human life, or the making of our bodies and worlds through doing rather than just saying, are long behind us.[13] But a lesson from the early days of that phase of academic study may yet be pertinent here. Before academics generalised their

idea of 'object agency' to all spheres of the material world, a primary body of work – known at the time as 'the weak programme of science and technology studies' – showed how visibility is produced when things fail.

Perhaps the most famous example was Ruth Cowan's study of the relative efficiency of gas and electric domestic cooling: 'How the Refrigerator Got its Hum'.[14] The influence of factors other than pure rationality, Cowan argued, can be seen when a more efficient technology like the gas fridge loses out to the less efficient electric fridge. So too, Mike Schiffer showed, for the story of how the electric car lost out to the internal combustion engine.[15] We might express these observations – where the failure of a technology causes it to emerge as an object for anthropological study – in less convoluted ways today, by simply observing that most technology is taken for granted most of the time, it goes unnoticed and so remains effectively unseen, even when we're looking straight at it – until it fails. A key snaps in the door lock. Your shopping bag splits when you're only halfway home. The car won't start and it is suddenly visible in a way that it wasn't only five minutes before. A tanker spills oil into the ocean and its contents are suddenly, shockingly, revealed. Burning ancient fossil fuels sets the Global South alight. The gasket blows and the train grinds to a halt. Technological failures are, at whatever human or global scale, primarily visual moments; the thing is suddenly seen, flashing up in the moment and demanding our attention because action is required. It can happen very quickly. In such moments, we see the device, as if for the first time. Those anticipatory periods of time before such moments, sensed but not seen, operate at a very different pace, like a museum vault that is filled with all the darkness of a coal mine. Often with the first possible signs of failure come new gestures of anxiety, or of denial of course, as the driver kicks the tyres to check the pressure of thin air contained in rubber.

The colonial museum has failed. This failure is why it can be seen by white curators now, myself included, with a new clarity and intensity, an event horizon of colonial ultraviolence is illuminated at once suddenly and yet unfolding over decades and centuries – like the

impact and human after-effects of cartridges shot from a machine gun, like an oil slick, like some Victorian smog leaching in through the cast-iron air-vents of the museum. This failure of the ethnological museum is a breakdown in its temporal and visual regimes, which use displays to make it seem like the moment of military victory against 'primitive' people is timeless and unending. The perspective of contemporary archaeology might trace this, working as it does between place and memory in the material remains of the recent past and the near present: exploring its 'photology', which is to say knowledge made by the casting of light,[16] but also needing to find a new language for the knowledge of loss.

The invention of ethnological displays was surely as significant a technology in the history of Victorian colonialism as the Maxim machine gun: Hiram Maxim's invention of 1884 (the same year as the opening of both the Pitt Rivers Museum and the Berlin Conference) was adopted by the British Army in 1889 and by the Navy in 1892, was the first recoil-operated machine gun. Known variously as the 'Pom Pom', or 'piss-gun', due to its use of water as a coolant and its ability to spray bullets from its barrel, this weapon could fire ten bullets per second, six hundred per minute.[17] The Maxim transformed jungle warfare, at first when mounted to gunboats on rivers and creeks, and then increasingly when carried for miles by teams of carriers through the bush. Procedures of looting too became a new dysfunctional kind of artillery weapon, making a bang but still *en route* to some further distant target, a double explosion, its aim to denigrate and to shame the enemy beyond the present moment, while also making some memoir in the name of the idea of superiority and victory in the face of the sheer immensity of loss wrought through machine guns and rockets against bows and arrows and muskets. There was never any coherent or scholarly strategy to this de facto policy of cultural under-development, by which culture was not just throttled but decimated, wilfully; therein lies the truly unquantifiable horror that came to overwhelm the whole.

* * *

The troops took royal and sacred objects, dividing them amongst themselves, and the administrators took photographs, developing multiple copies for inclusion in soldiers' diaries and albums, just as the artefacts were negatives for future histories. These parallel acts of taking began a dislocation of time as well as place. In the spring of 1897 in press reports of the attack, earlier photographs of the Palace of Benin, taken by trader Cyril Punch on his visit to the city in 1891,[18] and by Liverpool trader John Swainson of Pinnocks when he joined a visit to Benin City in March 1892, were circulated to the press and widely used in the press coverage, presented as if they were new images.[19] Six or seven cameras were present at the Phillips incident in January 1897; Alan Boisragon recorded how when they arrived at Gwato: 'some of our demon photographers – I believe there were six or seven cameras amongst our party of nine – began taking photos of everything they could get within range of. Amongst our photographers was a Mr. Baddoo, a man from Accra, on the Gold Coast, the Consul-General's chief clerk.'[20]

Perhaps there were a dozen cameras when the city was sacked, perhaps more. The photographic archives are scattered across museums, archives, and private collections, just like the objects, and are poorly documented at present.[21] The photographers almost certainly included two Protectorate staff: Dr Robert Allman, aged 42, Principal Medical Officer and Reginald Kerr Granville, District Officer for the Warri Division.[22] Through a camera, through a museum display, through a gun that shoots twice, an event, through violence, can encompass a kind of fragmentation that means it can't quite end.

Surely taking trophies from the battlefield is a universal and timeless human practice in times of war? No, there was a new dimension to these acts of taking, far more than just moving something from a to b. This is a story of documentary interventions in the fabric of time itself, to create a timeless past in the present as a weapon that generates alterity – appropriations in form not so much as property as unspecified rights, interests, privileges and claims, including the rights of mimesis and parody. This taking was no side effect of how the violence grew, mere mementoes or keepsakes for scrapbooks and cabinets,

but 'relics' through which the violence, as both an idea and a reality, would be continually surfaced and made to last. The photographs are here in this book to remind us of how the museum operates as a camera: objects, images, time, knowledge drawn out into the future. Acts of collecting slowed the pace of a violence wrought to turn the enemy into the past – but never quite to a standstill. In the public museum and in the private collection, artworks themselves became weapons – but they are also much more.

One contribution of archaeological thinking – and one major theme of this book – is to understand artefacts such as photographs not as frozen moments of time, but ongoing durations. There were a dozen or more cameras, in addition to those of the *Illustrated London News*, present during the Punitive Expedition. In image after image, bronzes, ivories and figures are laid out, sometimes in front of soldiers in pith helmets, sometimes just stacked against the walls of palace buildings. The soldiers and administrators took objects and they took photographs, and there is a temporal affinity between these two types of taking. As a technology, archaeology emerged hand-in-hand with both photography and 19th-century European colonialism. All three operated as devices for the marking of time. The very rawness of the image and the thing means that the forms of knowledge and memory that they constitute are open-ended, unresolved exposures. As in the mimetic practices of the museum vitrine, so with the visual multiplications from negatives, images, objects and human lives were taken hand-in-hand as modes of appropriation, dispossession and warfare. The photographs that are reproduced in this book, from the archives of the Pitt Rivers Museum, are not stills, just as the objects have not reached their endpoint in the dark rooms of the museum: not stills, but extensions of colonial violence. In this light, we might reflect on Lucien Lévy-Bruhl's account, in his 1922 book on what he termed 'primitive mentality', of photography and the parting of body and soul among Tsonga people in South Africa in the early 1890s:

Almost everywhere photographic equipment appeared especially dangerous. 'Ignorant natives', says [Henri-Alexandre] Junod, 'instinctively object to being photographed. They say: "These white people want to rob us and take us with them, far into lands which we do not know, and we shall remain only an incomplete being." When shown the magic lantern you hear them pitying the men shown on the pictures and saying: "This is the way they are ill-treating us when they take our photographs!"' Before the 1894 war broke out, I had gone to show the magic lantern in remote heathen villages. People blamed me for causing this misfortune by bringing back to life men who had died long ago.[23]

In January 1898, the 24-year-old Lieutenant George Abadie of the West Africa Frontier Force recorded in a letter home to Jersey a trip to the royal palace at Ilorin, the first visit of white men since the attack by the Royal Niger Company eleven months previously – an attack that will be discussed later. Abadie explained how his attempt to buy horses from the Emir was unsuccessful, as he complained that the Company had 'burnt the greater part of his town last year and had taken most of his horses' – but he made a gift of five horses to Abadie's group nevertheless. The King also agreed to Abadie photographing him – 'but his chiefs would not, as they were afraid the camera was a sort of gun.'[24] Discussing this incident a century later, the historian Lawrence James interpreted the chiefs' actions as their mistaking the brass and wood of the tripod for the mounting for a Maxim machine gun, so that as the soldier began to set up his photographic equipment, his attendants fled, recalling the violence of the sacking of Ilorin less than a year before.[25] But another interpretation is possible, in which there was a clear understanding of taking photographs as a form of dispossession that operates by making a duration – just as the taking of loot and its display in a museum creates a blurring – the weapons employed by troops in destroying a city, the cameras employed as a weapon of administration and governance, the object as a weapon; the gun sights folding into the sextant, the camera lens and the glass vitrine; the delay built into the cylinder of the bombshell and the

aperture of the camera measuring out the period of exposure, and the vast dark room of the museum – this blurring is ongoing today in the colonial museum as a persistent regime of visuality and violence.

The photographs that punctuate this book are just such incendiary projectiles, held in the archives of the Pitt Rivers Museum, a few metres away from the looted objects in the gallery case. The passage of time can be neither turned back nor halted, but the illusion of a stoppage, even that made through the legerdemain of the museum curator, is always in truth a duration. Museums are devices for extending events across time: in this case extending, repeating and intensifying the violence. But endurance must also always open up a space for something new to happen because each object, each photograph, each memory, each fact, each thought or thing in the case of Benin 1897, is a live event, behind the glass of the cabinets. Every sheet of glass holds within it the certainty of a thousand future shards. What soldiers and anthropologists and the brutish museums of Europe and America saw as relics or curios are of course forms of cultural endurance unfolding over centuries, which will outlast this wooden case, these steel mounts in which they are held, but for which colonial histories need to be not so much reversed as somehow dug into.

* * *

The purpose of this book is to take stock of the use of the anthropology museum during the 1890s as a weapon, a method and a device for the ideology of white supremacy to legitimise, extend and naturalise new extremes of violence within corporate colonialism – in order to reclaim the vital function of these institutions in the future, to transform their purpose, to put an end to their function as the warehouses of disaster capitalist-colonialism: dismantle, repurpose, restitute, recognise their status as sites of conscience. The book aims to break three dominant narratives about key aspects of the sacking of Benin City. First, to expand the story of the punitive expedition to become a wider history of colonial violence in the 19th century. Second, to expose the truth about the supposed official nature of the looting and sale of the Benin Bronzes, and thus to trace how the sheer force with which a

cultural centre was destroyed still fractures and splinters across time and space throughout the 20th century and into the 21st. Third, to reveal the intimate links of the narrative of the so-called 'universal museum' with enduring processes of militarist-corporate colonialism in 21st-century global capitalism. In each case, this is about stepping back from a focus on nation states, understanding the intertwined nature of German and British traders on the Niger River and museum curators from Berlin to Oxford, and seeing African cultural restitution today as about more than just nation-to-nation, especially where the European nation is often limited to the former colonial power: the global geographies of the Benin Bronzes holds lessons for many other cases.

In dialogue with Achille Mbembe's account of 'necropolitics' – the politics of who lives and who dies[26] – this discussion of the human cost of pillaged objects, displaced and displayed in western museums as some kind of global treasure, introduces and experiments with a series of analytical tools and lenses: an anthropological theory of taking (Chapter 2), the longer-term histories of World War Zero (Chapter 4), the 'necrography' of loot, a kind of 'necrological' rather than eth-nological knowledge (Chapter 12), the 'chronopolitics' through which museums were weaponised in the name of 'race science' (Chapter 14), in order to try to clear the ground for new kinds of global dialogue and – crucially – action around cultural restitution. Along the way, the three main forms of violence enacted in Benin 1897 – democide, the destruction of cultural sites, and looting – are outlined, in the context of their being outlawed under the Hague Convention of just two years later (Chapters 8–11). A reassessment of the history of mil-itarist-corporate colonialism in Africa is also called for, widening out our awareness of the building momentum and scale of British ultra-violence during 'World War Zero' as it was conducted in the three decades between 1884 and 1914 – where the British atrocities and body count should be considered alongside how we think of German and Belgian atrocities in Western and Southern Africa at exactly the same time. Running throughout, I want to question the agency and complicity of the anthropology museum – as a project put to work

in the name of brutal colonial and racial violence. These are legacies that our museums need to reject and to address – not defend. A major conclusion of the book is that Britain needs to come to terms with its Victorian colonial-militarist past in a totally new way – and that anthropology museums offer spaces for doing this, sites of conscience, and of restitution, reparation and reconciliation. In this respect, I want this book to be read as a kind of defence of the unfinished project of the anthropological museum – as long as we are happy to invert, reverse, flip, repurpose and dismantle most of it.

The book has been written with this motto in mind: *as the border is to the nation state so the museum is to empire.* Like the border uses space to classify, making distinctions between different kinds of human, so the museum uses time. Like the telegraph, the camera and the disciplines of archaeology and anthropology themselves, the museum seeks to annihilate time and space, to weaponise distance. Like the camera, the museum does not freeze time but controls exposure, measures out duration. A time of taking is giving way to a time of returns, like the gun that shoots twice, a second moment is coming. From the outset, therefore, we need *a theory of taking*.

2

A Theory of Taking

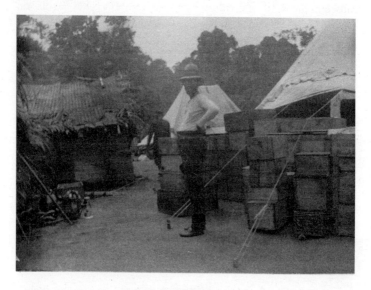

We can no longer afford to take that which was good in the past and simply call it our heritage, to discard the bad and simply think of it as a dead load which by itself time will bury in oblivion. The subterranean stream of Western history has finally come to the surface and usurped the dignity of our tradition. This is the reality in which we live. And this is why all efforts to escape from the grimness of the past into nostalgia for a still intact past, or into the anticipated oblivion of a better future, are vain.

Hannah Arendt, Preface to *The Origins of Totalitarianism*, 1950

The present moment in which anthropology and archaeology collections find themselves – whether re-branded as 'world culture' museums,

or still retaining the old language of 'ethnology' – is the same moment as that in which anthropology as a discipline is stuck. This moment in time demands anthropological, rather than more narrowly historical, thinking, because these museums are spaces of knowledge rather than just narrative; they constitute standpoints rather than merely a perspective, existing in the present rather than just the past. These museums are filled with cultural heritage from Africa and across the Global South and American First Nations, taken under the conditions of duress that were ever-present under colonialism. There are new dialogues with colleagues, communities and institutions in Africa. A major risk in those dialogues (apart from the wilful conflations and whataboutisms of press officers seeking always to reduce the debate to the question of the Classical Greek Elgin/Parthenon Marbles) is that the contemporary rhetoric of 'decolonising' museums is an attempt at the cancellation of debts that arise from the colonial past. As Sumaya Kassim has observed in the context of the landmark *The Past Is Now* exhibition at Birmingham City Museum and Art Gallery:

> Decolonising is deeper than just being represented. When projects and institutions proclaim a commitment to 'diversity', 'inclusion' or 'decoloniality' we need to attend to these claims with a critical eye. Decoloniality is a complex set of ideas – it requires complex processes, space, money, and time, otherwise it runs the risk of becoming another buzzword, like 'diversity'. As interest in decolonial thought grows, we must beware of museums' and other institutions' propensity to collect and exhibit because there is a danger (some may argue an inevitability) that the museum will exhibit decoloniality in much the same way they display/ed black and brown bodies as part of Empire's 'collection'. I do not want to see decolonisation become part of Britain's national narrative as a pretty curio with no substance – or, worse, for decoloniality to be claimed as yet another great British accomplishment: *the railways, two world wars, one world cup, and decolonisation.*[1]

With no hint of irony, in the first week of class each year, we anthro-
pologists and museum curators introduce our students to the field
of material culture studies through the foundational concept of 'the
gift'. Through the continued influence of Marcel Mauss's *Essay on the
Gift: the form and reason of exchange in archaic societies*, published in
1925, the notions of debt, the obligation to receive and the law of
reciprocity, and the desire of the gift itself to make a return, are at
the heart of our anthropological reflections on material things. The
sustained image, which runs across the anthropology of objects, is one
of gift-giving as central to the creation of bonds of sociality, and thus
also one of objects as central to the constitution of subjects in human
cultures.[2] The passage and interchange of objects between people or
communities creates lasting relationships, the very fabric of social life,
we explain to our students.

As Jane Guyer has pointed out in her new English translation of
Mauss's essay, an immense and nuanced vocabulary emerges, a typology
of objects and the social relationships they create: *dons* (gifts), *cadeaux*
(presents), *présents* (presentations), *prestations, donations* (donations),
échange-dons (exchange gifts), *salaire-dons* (payment), *contre-dons*
(counter-gifts), *les donateurs et les donataires* (donors and recipients),
les données (data).[3]

And yet those institutions that anthropology has built for material
culture research are filled with objects that have not been given, but
taken. Compared with giving, we have no such fine nuance in the
vague vocabularies of booty, desolation, wasting, ravaging, depre-
dation, plunder, pillage, confiscations, desecration, trophy-taking,
spoliation, enslavement, loot, *elginisme*, relics of war.

The facts of the matter in the anthropological museum emerge
through process rather than being handed down from the past in a
one-way street with no diversion, they emerge as 'givens' – that is to
say, those things that are taken for granted, and for which there exists
the second obligation described by Mauss: a debt. In the museum,
each fact – any knowledge that might be made in this place – holds
within it constant ties that bind, an obligation or promise, a kind
of yearning even, that must be understood, emerging as 'a mixture

of things, values, contacts, people'.[4] The obligation in these objects is temporal. It is a deferral, a hesitation, and so a duration. As for the whole museum, so for each thing contained within it, each obligation constituted in material form, the knowledge involved is a kind of memory, a re-collection. To our collective disciplinary and professional shame, no anthropological theory of looting, plunder, dispossession has been written.

This paradox of anthropology's focus on gifts despite its history of thefts is surely not unrelated to the paradoxical place of direct violent dispossession in global capitalism and corporate extractive colonialism, famously described by Karl Marx, in the concluding sections of the first volume of *Capital* in 1867, as 'primitive accumulation', the 'brute force' of British colonialism that compressed time and space in the tropics, 'to hasten, hot-house fashion, the process of transformation into the capitalist mode':

> The discovery of lands of gold and silver in America, the extermination, enslavement and entombment in mines of Indigenous people, conquest and plunder of the East Indies, the transformation of Africa into an enclosure for the commercial hunting of black skins, mark the rosy dawn of the era of capitalist production. These idyllic proceedings are the main elements of primitive accumulation. Hard on their heels comes the commercial war of European nations, with the whole planet as its arena.[5]

Rosa Luxemburg offered an important corrective to Marx's formulation of primitive accumulation, providing a key definition for understanding extractive corporate colonialism today. In her 1913 study of *The Accumulation of Capital*, Luxemburg underlined the role of militarism as not just originary, but ongoing, under colonialism:

> Chapter XXIV of *Capital* Volume I is devoted to the origin of the English proletariat, of the capitalistic agricultural tenant class and of industrial capital, with particular emphasis on the looting of colonial countries by European capital. Yet all this is treated solely

with a view to so-called primitive accumulation. For Marx, these processes are incidental, illustrating merely the genesis of capital, its first appearance in the world; they are, as it were, travails by which the capitalist mode of production emerges from a feudal society. As soon as he comes to analyse the capitalist process of production and circulation, he reaffirms the universal and exclusive domination of capitalist production. Yet, as we have seen, capitalism in its full maturity also depends in all respects on non-capitalist strata and social organisations existing side by side with it. It is not merely a question of a market for the additional product. The interrelations of accumulating capital and non-capitalist forms of production extend over values as well as over material conditions. *The non-capitalist mode of production is the given historical setting for this process.*[6]

Rosa Luxemburg's account of extractive colonialism has been debated and expanded over the past century by a range of other thinkers, not least David Harvey's description of 'accumulation by dispossession'.[7] But her argument, in italics above, about capitalism's need to create and maintain a kind of contemporary past in the Global South has been drowned out over the past century by the sustained geographical focus of theories of development and underdevelopment, from world systems to identity politics. Did global capitalism hold back, allowing non-capitalist economies to persist, or did the West create new distant pasts into which to slot our contemporaries in the Global South, since 'primitive conditions allow of a greater drive and of far more ruthless measures than could be tolerated under purely capitalist social conditions.'[8] Writing from 1913, Luxemburg's words challenge us here and now to consider how Africa was not left as non-capitalist, but performed as 'pre-capitalist'. What do temporal exclusions, prejudices and dispossessions look like? Archaeology and anthropology as academic disciplines emerged hand-in-hand with this process. Welcome to the 'world culture' museum. These are inherently temporal devices, dark rooms crammed with unfulfilled obligations from across the British Empire and beyond, tools in Europe's fashioning of imperial worlds, in achieving this ongoingness, the persistent violence of the (post)

colonial world in material form. The things on display are not melancholy traces but durations in a condition, as Ann Laura Stoler has put it, of '*duress*' – a term that evokes not 'haunting' but a coercive and relentless hardness, a severity and cruelty, compulsion and perhaps punishment even. As Stoler argues for empire as a whole, so quite precisely for the world culture museum, endurance is not mere remnants or leftovers but generative persistence and 'violating absences'.[9]

Anthropology has offered no theory of the 'permanent' exhibition in museums of inalienable culture – things that could never be given; no theory of the curation of what has been stolen. As Mauss wrote: 'To refuse to give, to neglect to invite, just like refusing to receive what is offered, is tantamount to declaring war; it is refusing covenant and communion.'[10] What then of the refusal to give back?

* * *

A contemplative period of anthropological theory in material culture studies is coming to an end. The predicament of African museum collections in particular, whether from Nigeria, from Egypt, from Ethiopia, or across the Continent, is reaching breaking point. Anthropology and archaeology need to take the looting of Africa seriously – not as a side effect of empire, but as a central technology of extractive and militarist colonialism and indirect rule, in which 'world culture' museums were complicit in brutality, and still are to this day. Our notion of dispossession needs to break apart the old distinction, drawn ultimately from Roman law, between portable objects or chattels on the one hand and the 'inalienability' of land on the other. We are accustomed, in the contexts of settler colonialism, to dialogues around land rights and Indigenous source communities. But dialogue about sacred, royal, or otherwise powerful objects, which are equally inalienable in that they could never be given away, takes place in a different register. The pillaging of objects was far from just an opportunistic side effect of what the Victorians called their 'small wars' or 'little wars' of colonial expansion in Africa. Loot and pillage were of central importance to extractive and militarist colonialism, just as land was to settler colonialism, but dominance of settler colo-

nialism as a model for anglophone academic discourse in and about European imperialism has narrowed our conception of dispossession and its place in the ideology of race, in stark contrast with the genealogies of *Raubkunst* – the act of taking supposedly degenerate art from those who are defined as inferior – traced by Aimé Césaire, Sven Lindqvist and others from Africa in the 1890s to the soils of Europe in the 1930s.

'There are two possible courses to affluence,' the anthropologist Marshall Sahlins once wrote, sketching out alternatives to market economies: 'Wants may be easily satisfied either by producing much or desiring little.'[11] Sadly there is also a third: that of violent theft. What kind of a mode of production is theft? Clearly it involves objects, but also images. The act of putting pen to paper, whether drawing a map, filling out an accession register, or writing this book, can represent an act of taking. Clearly, if it is in any way generative, it is a mode of cultural production in that it is predatory, beginning with the most extreme and dangerous forms of what we today call 'cultural appropriation'. A theory of taking requires us to talk not just about the life histories of objects, but also about killing: of people, of objects, of culture: the 'death histories' of objects.

3

Necrography

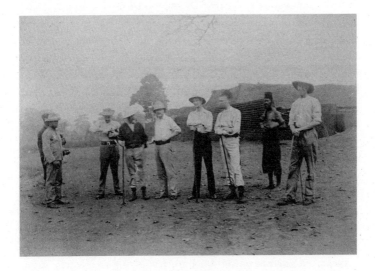

Since the 1990s, two dominant abstract and conservative theories in material culture and museum studies have stifled any adequate engagement with colonial violence or cultural restitution. The first of these comes into view with the case of the so-called 'Elgin Marbles' – the group of Classical Greek marble sculptures made in the 5th century BCE and brought to the British Museum by Thomas Bruce, 7th Earl of Elgin in the year 1812 – which is the usual first point of reference for British conversations about cultural restitution. In January 2019, Hartwig Fischer, the director of the British Museum, announced that in his view 'When you move cultural heritage into a museum, you move it out of context. However, this shift is also a creative act.'[1]

In '*the cultural biography of objects*', such an argument runs, each new event is an accumulation, so an accession into a museum, like any gift

exchanged across cultures or between friends, represents another layer added to the life course of a thing; it creates new values, coherences, social links and cultural meanings.[2] A generation ago, this use of the idea of 'the social life of things'[3] became an important analytical tool for the study of material culture. But it has come, through sustained use by curators,[4] over time to be used by the press officers of Britain's national museums to distract our attention from, to relativise and thus to diminish, claims for the restitution of objects collected during European colonialism, and to encourage us in the fallacy that we might ever reasonably think ourselves back to some past 'regime of value' in which wrongful actions might have been okay, in order to justify ongoing and unresolved injustices. The proliferation of 'object biographies, their ubiquity in teaching art history, anthropology and museum studies – with little discernible change to how, sixty years ago, a classic British school essay topic was "the life story of a penny"'[5] – has brought a new confidence to the old object-oriented museum histories, overstating the stability and coherence of things as they move between contexts: as if there were multiple contexts but only singular things, multiculturalism but static objecthood, fluid meanings but solid things, as if focusing on things gave us bedrock, concreteness, 'materiality'. But in truth, it is surely only from the privileged position of the museum executive or out-of-touch trustee, relying on the dark arts of conservation and curation, that these objects can evoke fixity. The only thing that is sure about the sustained popularity of object-oriented life-histories, and the accompanying misplaced concreteness, is that it has deepened persistent colonial inequalities – repeated and exacerbated dehumanisations, reproduced and extended dispossessions.

Just as the first idea, that of *cultural biography*, has served to stifle any discussion of enduring colonial violence over time, so a second idea has served to hold back dialogue and action on cultural restitution in the present: the idea of *entanglement*. A key text here was Alfred Gell's influential, densely written, neo-functionalist 1998 book *Art and Agency: an anthropological theory*. Gell rejected the anthropological study of art in symbolic or aesthetic terms, instead adopting what he called a 'methodological philistinism', to frame the study of art as

one of social relations not aesthetics, where the focus was on the intention of the artist in extending their agency through objects as a kind of material prosthetic. Examples of museum objects from across the Pacific, Africa and the Americas were discussed in the book, but the location of these objects in western collections was never questioned. The theory of 'distributed personhood' was presented as if such scatterings were never inflicted but always willingly undertaken. The artist was presented as empowered through the movement of objects away from him or her, through a heady mix of the traditional functionalist approach of LSE economic anthropology with the so-called 'Actor-Network Theory' (ANT) that emerged from 1980s Schools of Management[6] and suggesting a kind of ultra-materialistic 'symmetrical' approach to treating people and objects as if they were entirely commensurable agents. Gell's nuancing of ANT – so objects themselves were not agentive, but were conduits or 'indices' of the artist's will – drew much of its politics, which is to say its *lack* of politics, from the idea of 'entanglement', as developed by Nick Thomas. Thomas's work allowed Gell to distinguish between the 'reception' of 'ethnographic art' and 'a genuinely anthropological theory of art', with all of the inconvenient politics of power left out. How did Thomas's influential 1991 account of *Entangled Objects* give Gell the intellectual resources with which to pull this off? It began with Thomas re-reading Mauss on gift exchange in order to question the boundaries between gifts and commodities, and to foreground the 'creative recontextualization' of material culture on both sides of colonial histories in the Pacific Ocean, so as to highlight Indigenous agency and 'the continuing dynamism of local societies'.[7] Thomas's book was a major critique, from the position of anthropological theory, of any assumption in postcolonial theory of 'the imposition of the West upon the rest',[8] and of any analytical dichotomy between 'the Western' and 'the non-Western'. Thomas argued for giving equal weight to 'the Indigenous appropriation of European things' and 'the European appropriation of Indigenous things', as if western 'constructions' of nonwestern objects were always equally met with the opposite, and mapped a theory of cultural hybridity onto descriptions of the 'mutual entanglements of

objects and people' and 'the dialectic of international inequalities and local appropriations'.[9] As objects and people are entangled, Thomas argued, so the categories of 'native' and European are too. In his preface to Gell's book, Nick Thomas welcomed its application as an anthropological theory for 'the workings of all art', from that which Gell called 'primitive' and Thomas described as 'canonical tribal art forms' as opposed to 'high Oriental' and 'western'.[10]

Developing his theory of colonial 'entanglement' into a model of 'the museum as method', Thomas has expanded his primary critique of scholars who 'employ critical discourse' and postcolonial theory, to those who 'interrogate primitivist representations in display, and otherwise explore the politics of institutions and exhibits'.[11] But all along the model of 'entanglement', the method of swapping analytical focus back and forth between the 'agency' of people and things, of 'Indigenous' and 'Western' people and communities, actively omits those moments where a relationship is constituted by separations not entanglements. In invoking Gell's abstract, playful, Duchampian notion of the object as a 'stoppage' of a network of agency,[12] Thomas erases the events to which museums bear witness when worlds fragment, networks are cut, paths are blocked, movements are forced, when instability is not just in words and ideas but in physical form: when people are killed in their thousands and tens of thousands, when palaces, temples and villages are bombarded, when cultural treasures are looted and sold. Nick Thomas imagines the potential of 'the museum as method'. Let us instead acknowledge the ongoing status of the museum as a weapon.

These two ideas, more tropes than theories – '*object biographies*' and '*relational entanglements*' – have stood, as if mapping onto older anthropological theories of descent and alliance, as the dominant modes of thinking for western museums since the 1990s.[13] It is time for that to change. Let me offer some examples of how this dominant school of thought has served to divert and hold back anthropology museums from thinking about colonial violence or taking action on cultural restitution. The examples are drawn from the Pitt Rivers, my own institution, but parallel examples could doubtless be found in

any western anthropology museum, not to mention many academic museum studies and so-called 'critical heritage' departments across Europe, North America and Australia.

When I arrived at the Pitt Rivers in 2007, quite a lot of institutional effort had recently gone in to re-describing the museum of 'Anthropology and World Archaeology' as 'an ethnographic museum' containing 'ethnographic objects'. This definition reduced the many diverse routes through which objects came to be in this place to the provenance history of just one subset of material: that collected during 20th-century participant observation. With its intellectual associations with key thinkers in the discipline, questions of acquisition became neutralised, or watered down at least, in a wider set of questions about the ethics of anthropological fieldwork in the past. In my own work, I sought to develop a model of collections-based research that understood the museum as a kind of archaeological site, where the excavation of the archives would 're-shape them, just as excavation constantly re-shapes the archaeological record'.[14] But in seeing archaeology as an intervention, rather than an ethnographic act of observant participation, I have, as I think so very many others working in anthropology museums also have, been made to feel out of step with my field and its traditions. Against that background – and today with a degree of white male privilege and institutional position that means there is really a duty to try to get some of this down on paper and out into the world – this book is a first sustained attempt to challenge the equivocations, and apologisms, and obscurantism, and gate-keeping, and the conceit that turns the anthropological museum in upon itself, as a disciplinary venue for hagiography of dead white colonialists and thus for self-regard, even when, as Tim Ingold has very sensibly observed, the very idea of 'museum ethnography, where there are only curated objects, is simply oxymoronic'.[15] The aim is to take the process of excavation further, layer by layer, object by object, and with a decent-sized trowel rather than a mere toothpick: to reveal what is present in the collections visible to the world, which is to *make* it present,[16] and to share this knowledge, to move from an

inward-looking, object-oriented to an outward-looking, action-oriented approach to curation.

I first encountered the erasure of Victorian acts of violence in the 'relational museum' project, which ran at the Pitt Rivers between 2004 and 2007, just before I arrived. Drawing together *object biographies* and *relational entanglements*, the project was a kind of hybrid of James Clifford's project in his book *Routes* (1997) to expand the language of the North American model of 'culture contact studies' to re-describe anthropology museums as 'contact zones' on the one hand, and Bruno Latour's Actor-Network Theory on the other. Ideas of 'object agency' were used in the project to make the quite abstract assertions that 'objects hold people together', that collections 'enable reasonably stable structures that allow people to interact productively', that 'the Museum is a dynamic entity, made up of a shifting mass of people and things', that 'objects collect people' and so past networks of human relationships 'sparking chains of connection' can be studied to understand the creation of anthropological knowledge, charting 'the full set of forces – intellectual, institutional, colonial, and biographical – which needs to be taken into account when understanding tangled histories'.[17] Just as Jonathan Friedman observed about Clifford's *Routes* – that it thought it was moving away from 'roots' but in reality was obscuring histories of violent 'routing'[18] – so the Relational Museum project, published as the 2007 book *Knowing Things* – in the very same year as the Pitt Rivers had loaned material to the largest ever display of Benin Court Art[19] – did not once mention the many instances of colonial violence and looting, or address live questions of cultural restitution, but instead invited the reader and visitor on 'an anthropological adventure':

The site of our fieldwork starts at the Pitt Rivers Museum, but then moves out to many parts of the world from which objects came … You could start in the Museum with an object, a whole display case, or a person, and follow a chain of connections that would eventually lead you almost anywhere in the world, past or present. You need have no idea at the outset of paths along which you would

travel and when or where weariness would lead you to stop. Some routes would be shaped by your prior interests, but many different paths would present themselves, testing your ability to step outside your existing intellectual or cultural framework ... Knowing the Museum, like knowing the world, is something of an anthropological adventure.[20]

Such work was in keeping with the long-standing assertion by collections staff in the Pitt Rivers that the museum is not an unchanging Victorian space, a 'museum of museums', but a dynamic and contemporary multicultural place: assertions that sometimes gave way to a 'growing feeling of frustration at the repeated stereotyping of the Museum as a colonial institution full of Victorian evolutionary (if not racist) displays'.[21] A museum research project on General Pitt-Rivers, founder of the collection, explicitly sought to 'see him as a man of his times', 'deliberately uninterested in Pitt-Rivers' legacy'.[22] And a 'provocation' that 'the ethnographic museum is dead', produced as part of a major international conference on 'the future of the ethnographic museum' in fact concluded that 'Ethnographic museums can be places for discovery and dreaming, for memories and meetings: sites where the freedom to wonder at the variety and ingenuity of man-made things is not yet dead.'[23] Important pioneering work on the restitution of First Nations ancestral remains was done in this period, led by Laura Peers and her colleagues,[24] and on the 'digital repatriation' of photographs led by Chris Morton.[25] Nevertheless, through the twin theories of *object biographies* and *relational entanglement*, the Durkheimian emphasis of both theories upon the role of objects in the construction and maintenance of social relationships (rather than, for example, even Weber's account of booty capitalism, or Marx's description of primitive accumulation – not to mention the many other possible non-European intellectual points of reference) conditioned and facilitated ongoing silences about colonial violence and questions of cultural restitution, while allowing for the persistence of increasingly ingrained historical narratives.

Let us clearly refute both Hartwig Fischer's position on the Parthenon Marbles and also the object-biographical-relationally-entangled body of anthro-historical and sociological theory that enables it. *The theft of an object by a European museum is a negative act.* It requires us not to trot out some upbeat, or dispassionate, or supposedly neutral life-history or to reduce the museum to the venue for some 'power-charged set of exchanges, of push and pull',[26] but to find a way of telling and untelling the past losses and deaths that are the primary layer, the very foundations, the deepest part of these institutions (not to mention the many other forms of taking in later episodes during the 20th century). How to gather up and offer an account of the scale of the damage that has been done? Not to undo it, but to seek to make some kind of reparation and return, to shine a light, so that violence, dispossession and loss can be not erased but cancelled out, so the thing itself can come back into view outside both the lens and the shadow of the museum as thief.

Take for example the account of human life that informs Foucault's account of 'biopolitics'.[27] Foucault described a transformation that took place during the 19th century, through which the sovereign's power to 'take life or let live' came to be joined by the emergent power of the state to 'make live and let die'; it was 'the emergence of something that is no longer an anatomo-politics of the human body, but … a "biopolitics" of the human race'.[28] The potential of a Foucauldian biopolitical approach, especially as it was developed by Giorgio Agamben through his accounts of 'bare life',[29] has been explored in many different ways in the study of the violent displacement of people under extractive, militarist colonialism.[30] How might it apply to the parallel case of the violent displacement of objects? Achille Mbembe's account of 'necropolitics' has provided a powerful corrective to the eurocentrism of Foucault's account of the biopolitical, and the general absence of the contexts of enduring legacies of empire from the uses of Agamben's account of 'bare life' in African Studies and beyond. Crucially, Mbembe underlines the role of colonial histories and their continued after-effects, and in doing so he expands the persistent Foucauldian focus on the living body: in Mbembe's view, it is the use of

the bulldozer for the continual destruction of the lived environment, as much as the fighter jet used for precision strikes targeting individuals, that are central to the practice of neocolonialism in Palestine – an 'infrastructural warfare':[31] 'We learn from Mbembe that necropolitical conditions can be made through attacks upon the nonhuman environment as well as just the human body.'[32]

Now, Foucault wrote very little about museums (and presumably cared even less); he was interested more in words than things – although you'd be hard pushed to tell given how much of the renaissance of 'museum studies', as it has fashioned itself since the mid 1980s, has defined its interests in para-Foucauldian terms: foregrounding order, control, genealogy, discipline, power, and so on, in that familiarly crypto-normative negativity, offering critique in a purely contemplative mode, standing firmly outside whichever institution it is that is at stake. And the present book, written from within the cabinets and galleries of the institution and its discipline, is certainly no Foucauldian study, far from it. Nevertheless we might think back to some of what he wrote about the dead body and, specifically, the autopsy, if we are to make a break from the world-view of those museum directors who write with such unforgivably wilful ignorance about curiosity and human creativity, about universal values and visitor numbers, while the violence of their institutions is repeated every day that restitution and reparations do not move ahead. Perhaps this is precisely the kind of forensic death-writing that the colonial museum, not yet dead, requires of us – an exercise in contemporary archaeology (the excavation of the recent past and the near-present) – forensic because this is about understanding the truth at the scene of a crime: *a necrography*.

Let us begin this necrography by turning the theorists' timeless model of *entangled biographies* on its head by making a simple historical observation. That most violent and purposeful of category mistakes, the mixing-up of humanity and things, had come to West Africa with the slave trade – the commoditisation of people on an industrial scale, the treatment of the body as if it is property. This blurring was achieved, as Igor Kopytoff has shown, through social transformations that changed the status of people by removing identity

and reducing personhood, which do not simply end in the relatively short period between capture and sale but involve being 're-individualised by acquiring new statuses' in different situations while always remaining a 'potential commodity' with the ever-present potential to have an exchange-value realised by re-sale.[33] In the case of objects, however, the notion of the biography serves to fix the boundaries of the object too firmly, reducing it to context as it moves between what Kopytoff called 'regimes of value'. Other things live on in material form, the thing constituting an event more than a life-history.[34] This is most clear where sacred and royal objects, in some cases constituting rather than just representing the ancestors, were turned into cargo, when things that could never be given, inalienable items, were taken, broken up, melted down, violently scattered, reduced to dust, in this case as with human subjects under slavery, so these stolen things underwent some form of what Orlando Patterson famously called the 'social death' of enslaved Africans, taken into a universe of racial ideology and a violent regime of mere objecthood, being made into an 'intrusive' presence to whites, 'symbolic of the defeated enemy'.[35] The control of the property of another, rights over their living or dying, total control over the environment itself, is the relationship of the master to the slave, and so it was in West Africa with the desecration of ancestral heritage – the saleability of what is royal or sacred, the supposed right to destroy and despoil, to make profit – a specific form of property that holds much in common with slave owning,[36] as if the ancestral past and the human present itself could become merged as what Paul Gilroy has called 'third things' –'human bodies more easily imprisoned and destroyed than others':

> The native, the enemy, the prisoner and all the other shadowy 'third things' lodged between animal and human can only be held accountable under special emergency rules and fierce martial laws. Their lowly status underscores the fact that they cannot be reciprocally endowed with the same vital humanity enjoyed by their well-heeled captors, conquerors, judges, executioners and other racial betters.[37]

Introducing his image of the 'anti-museum', Achille Mbembe considers the example of the presentation of transatlantic slavery in museums, in which 'the slave appears, at best, as the appendix to another history, a citation at the bottom of a page devoted to someone else, to other places, to other things. For that matter, were the figure of the slave really to enter the museum, such as it exists nowadays, the museum would automatically cease to be.'[38]

With this in mind, the urgent twin task for European anthropology museums is to use their status as unique public spaces and indexes of enduring colonial histories to change the stories that we tell ourselves about the British Empire, while taking action in support of communities across the Global South in building museums on a totally new kind of model. To do so, to seek to study the necrology (knowledge made through death and loss) of the ethnological museum, is to resist the position of entanglement and biography through which the logic of Nick Thomas's position leads naturally to his complaint about how 'cross-cultural curiosity has been disparaged and stigmatized', and about 'the much-rehashed issue of repatriation':[39]

Repatriation is, to borrow the language of consumer electronics, 'pre-loaded' with potent assumptions about cultural property, identity, collectivity and belonging ... Restitution appears, in the world of public politics, to be a zero-sum contest, but engagement over time, in the oddly intimate settings of museum stores and workrooms, has tended to result in an interest in sustaining relationships. Certain forms of curatorial authority, or comprehensive sets of digital images, may be 'repatriated'; a language of 'custodianship' may be adopted; objects are shared on long-term loan; metropolitan museums may fund training, internships or other programmes for members of the indigenous communities in question, otherwise seek to build skills and be seen to ...

Forgive me for cutting Nick Thomas off there. You get the picture. It's clear by now what is at stake. The options are drawn up pretty firmly between interminable academic talk about dialogues about training

and loans, or meaningful anti-racist action for change, dismantling and repurposing.

Archaeology is not the study of remnants of the past: it's the science of human duration. This necrography of Benin 1897 is a forensic excavation not an anthrohistorical exercise, seeking not just to call out the crimes, to count up the dead, to think ourselves back into the past like the historian – but to take action in the present.

Our purpose must be to redefine the purpose of the anthropological museum. I propose thinking about this as a move away from being a space of representation and towards what Hannah Arendt called a 'space of appearance'[40] – in which curatorial authority is actively diminished and decentred while their expert knowledge of collections is invested in and opened up to the world. To begin this necrography, this writing of loss, we need to start with one significant pathology of Victorian 'race science': *white projection*.

4

White Projection

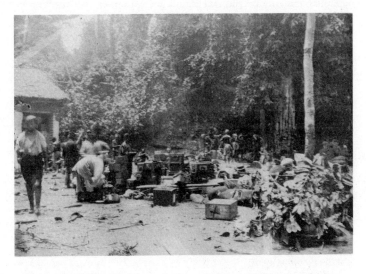

Generally, it's difficult to acquire an object without employing at least some violence. I reckon that half the objects in your museum were stolen.

<div align="right">

Richard Kandt to Felix von Luschan, Deputy Director of
the Ethnologisches Museum Berlin, 1897[1]

</div>

How is it possible for the keen awareness of Herr Kandt of the violence of colonial collecting, expressed to the Berlin museum curator von Luschan a few weeks after the sacking of the City of Benin, to be contentious among some British museum professionals today?

Part of this ethical lag begins with a more general failure by the British to come to terms with our colonial past. Twelve decades on, there is still ongoing power in the telegraphic spin of Britain's imperial

forces during Queen Victoria's Diamond Jubilee year of 1897, and specifically during the period between 23 September 1896 when she surpassed George III as the nation's longest-reigning monarch, and the celebrations held back until June 1897, and billed by Joseph Chamberlain as *A Festival of the British Empire*.[2] There is no record of the precise role that the 77-year-old Queen – newly prescribed eyedrops of a cocaine and belladonna solution to aid her reading the small print of state papers – played in the formulation of the plan for Benin 1897.[3]

Not long after the sacking of Benin City in 1897, in a speech to the Royal Geographical Society, George Goldie reminded his audience that 'it was largely due to the Prince Consort that Parliament took up the question' of West Africa.[4] This was a reference to Albert's famous speech at Exeter Hall in London on 1 June 1840 as President of Thomas Fowell Buxton's Society for the Extinction of the Slave Trade and for the Civilization of Africa, delivered during the gradual enactment of emancipation from 1838 under the Slavery Abolition Act of 1833 and the ongoing pressure of the Aborigines' Protection Society (founded 1837). Albert's speech had led to government backing for the disastrous 'African Colonization Expedition' or 'Niger Expedition' of 1841, an attempt mounted by British missionary and activist groups to 'open up' the Niger River to Thomas Buxton and David Livingstone's 'three Cs' (civilisation, Christianity, commerce) by signing treaties with local chiefs. Three government-supplied steamers travelled around the West African coastline and up the Niger River to Lokoja – which would half a century later be the military headquarters of the Royal Niger Company, but which now was the intended site of a mission and a 'model farm', until one-third of the party died, and more than half of the remainder became ill with malaria, and the enterprise was abandoned to widespread public ridicule.[5] But as a joint government-sponsored treaty-signing venture of the Church Missionary Society, scientists of the African Civilisation Society, and traders of the Agricultural Association who wished to establish African plantations on a Caribbean model, undertaken in the name of humanitarianism and Christian values, the expedition was not just unprecedented but

anticipated the events and rhetoric of the 1890s. For Victoria, the events of February 1897 were perhaps a final push to achieve what the dead Prince Consort had desired, just two years before Victoria laid the foundation stone, on 17 May 1899, to re-name the South Kensington Museum the Victoria and Albert Museum.

And yet any description of the events of February 1897 is preempted by a series of accounts published in this atmosphere at the time by men who were involved at the sacking of the City of Benin. As Prince Edun Akenzua observed on the centenary of the attack in February 1997, 'the history that has been written of the events all along was done by those who perpetrated the act' (Eyo 2007: 34)[6] – accounts of men who held to the conviction expressed in Rudyard Kipling's poem *If*, written in 1895: 'Yours is the earth and everything that's in it.'

Through Reginald Bacon's *City of Blood*, Alan Maxwell Boisragon's *The Benin Massacre*, Henry Ling Roth's semi-anthropological account of *Great Benin: its customs, art and horrors* and the increasingly sensationalist rolling coverage in the *London Illustrated News*, whose special war correspondent Henry Charles Seppings Wright was on the spot, the event was being framed and narrated even as it unfolded. It began with the supposed 'massacre' of nine British officials and traders led by Deputy Commissioner James Phillips in an unarmed party seeking to meet with the Oba of Benin to ask him to comply with the terms of a trading treaty. It continued from this 'massacre' to images of 'ferocious cruelty', 'evil customs', 'superstitious idolatry and barbarity', 'the wanton sacrifice of life', crucifixion trees, decapitated bodies, cannibalism, 'ju-ju altars' doused with human blood, a 'city of skulls', the stench of decomposing corpses slaughtered for 'a cult to the devil', 'fiendish torture', 'the demon's fetish' kissed as the 'death signal' for the executioner. Each new story of the Oba's barbarity sought to outdo the last, to take the hyperbolic yarn spun by Richard Burton, penned a few years before his ethnological foray into vampire fiction,[7] after a visit to Benin City in 1862 when he was British Consul at Fernando Pó, to new levels of gothic schlock-horror – all the more so, no doubt, after the publication of Bram Stoker's *Dracula* in May 1897.[8] Here in the

metropole of accelerationist colonialism, where a diamond anniversary could suddenly be counted in 60 rather than 75 years, through a 'telegraphic realism' the figure of the vampire stood for an 'encabled' fear of empire.[9] Like the story of Dracula, so the 'modernizing of Gothic' in the narration of Benin 1897 played on Victorian anxieties about the morality of imperialism and fears about the precarity of western civilisation, the presence of dangerous alterity within Europe.[10]

The framing of Benin 1897 begins with a silencing of the scale of the British violence, of the loss of life of Bini and iJekri people, and the idea of punishment. Western museum curators have played a central role in maintaining this framing, as if these misrepresentations were themselves a sacred and delicate artefact demanding our conservation.

For example, in 1981 William Fagg, for many years Deputy Keeper of Ethnography at the British Museum and a dominant figure in the 20th-century history of the Benin Bronzes, took the opportunity of an invitation to contribute a short piece to Flora Kaplan's 1981 book *Images of Power: Art of the Royal Court of Benin*, which accompanied an exhibition of Benin art at the Grey Art Gallery, New York University. Titled *Benin: The Sack That Never Was*, to repeat the rhetoric of the Victorian soldiers to the letter: the attack was provoked by an outrageous 'massacre', 'it sought to suppress the practice of human sacrifice', 'there was no indiscriminate slaughter', the troops did not 'set out to destroy' the city, the burning of the city was an accident, there was no evidence of 'significant looting' beyond the 'custom of war in the nineteenth century' and 'official' war booty.[11]

More recently, Barbara Plankensteiner has described 'a chain of fatal misunderstandings' and explains the expedition as 'retribution for the murder of members of the British mission'.[12] But since the 1960s, historians have increasingly understood the expedition to depose Oba Ovonramwen Nogbaisi (Overami) who had acceded to the throne in 1888, not as a retaliation, but to have been dictated by policy for a long time.[13]

The purpose of this cultural necrography of objects, this death-history of Benin 1897 at the Pitt Rivers Museum, is to contribute to the ongoing task of breaking this untruthful framing, 12 decades

on from its fabrication by those who participated in the atrocity. Numerous attempts have been made by historians, notably Philip Igbafe's 'The Fall of Benin: a reassessment' (1970) and Robert Home's *City of Blood Revisited* (1982), and hopefully more will come in the near future. This contribution, written from my position as a museum curator, anthropologist and archaeologist, aims to push this process beyond just making a break with the dominant narrative, to write against the grain, which in this case risks just adding another layer of interpretation, albeit at right angles, to generate further discourse, like so many accumulated strata, the mass of which the storerooms and vitrines of the museum are built to absorb with the gravitational pull of a black hole, each new text panel another event horizon from which nothing can return. The approach is not contemplative, but curatorial and therefore interventionist – to break not with discourse but with ellipses and legerdemain – to excavate the making of silences, the phases of death through which ethnological knowledge is still passing, not like stages of the cross in the secular, high church architecture of Britain's Victorian museums, but as phases in the decomposition of ten thousand acts of killing. The purpose then must be a gesture of transtextuality, reading between words and loss as different registers of knowledge of the past. To make such a break requires the archaeological technique of turning back, which I would like to associate with that form of narration outlined by Eberhard Lämmert as an alternative to the omniscient narrator on the one hand, or just the first person on the other: the more physical, spatio-temporal time-shifts of *Rückschritt, Rückgriff* and *Rückblick*: stepping back, pulling back, looking back.[14] In the case of Benin 1897, the task is to catalyse an institutional flashback, a punctum of the post-traumatic 'dual awareness' of the material presence of ultraviolence.

The framing is one of, for want of a better term, white projection – both across time, as it endures in the narratives of museum texts, such as the current one at the Pitt Rivers with which this book began, and also in the Freudian, psychological sense: a process of transference in which thoughts and actions that cannot be accepted as one's own are effaced from the self and attributed to others, a psychopathological

mechanism of defence, a kind of unconscious and distorting transposition caused by the will to adapt to trauma or violence.

Through this displacement onto the object of that hostility, even the dead can come to seem to be a malignant enemy. In *Totem and Taboo*, Freud went so far as to describe the 'projection of their own evil impulses into demons', in the form of 'animism' and the fetish, as part of the *Weltanschauung* of so-called 'primitive' people[15] – surely the ur-moment of colonial projection. But it is the vernacular projections of militarist colonialism that must detain us here: the narcissism of the British ideology of militarist, mercantile imperialism, with its new adoption of intelligence, military propaganda and media spin, and companies like Reuter's and newspapers forming a key part of the global flows of the new corporate colonialism[16] made use of one principal strategy – a continual switching of positions between the powerful and the weak to create the image of white victims through mediatised violence. This pathology is what lies behind the idea of the 'punitive expedition', a trick that led to so much of the violence freely distributed for commercial interests against Africa in the late Victorian and Edwardian periods – and to so much of the looting that fills British museums today. The logic is quite straightforward: an alleged slight or offence is recorded in order to justify an open season on brutality by the supposed victim, who is in reality the aggressor. Charles Callwell, in his guide to *Small Wars*, first published in 1896, was quite direct about the purpose of 'campaigns to punish and wipe out an insult or avenge a wrong', 'to chastise a people who have inflicted some injury' such as the British at Maqdala in 1868 or against the Kingdom of Asante in 1874, or the French at Dahomey in 1892, are generally undertaken 'for some ulterior political purpose, or to establish order in some foreign land – wars of expediency, in fact'.[17]

Reporting the Phillips incident used to justify the Benin Expedition, here is the *The Graphic* on 16 January 1897:

TRULY may Africa be called 'the White Man's Grave.' Before the echoes of fatal fighting have died away in East and South, the disaster on the West Coast opens a fresh chapter of native treachery

and loss of life. A peaceful British mission from the Niger Coast Protectorate, travelling up country to negotiate with the King of Benin, have been treacherously attacked, and, so far as known at present, massacred to a man.

In his 1897 account of the sacking of Benin, Alan Boisragon captured a similar feeling by repeating the supposed words of an anonymous British fighter:

The loss which the British nation has sustained during the last sixty years, through the deaths of so many brave soldiers, bluejackets, and civilians in the glorious work of rescuing the native races in West Africa from the horrors of human sacrifice, cannibalism, and the tortures of fetish worship, must ever be a matter of deep regret and sadness to all.[18]

In the title of his book, hastily published in the immediate aftermath of the British attack, Commander Bacon, Intelligence Officer for the Expedition, popularised the name of Benin first used by Burton, now the ultimate reversal – *The City of Blood*.[19] The same source was given by Dr Henry Ogg Forbes of the Free Public Museum of Liverpool, who wrote in 1898 that the Benin Bronzes themselves 'may, as Commander Bacon suggests to me, have been the spoils of some campaign, kept as fetishes'.[20] This translated directly into the justification presented to government and the public for action: 'Apart from commercial benefits, the removal of such a fetish ruler is to be desired, putting a stop, as it certainly would, to the wholesale slaughter which is yearly taking place by his order.'[21]

Through a host of reversals, spun across British newspapers by Bacon, Flora Shaw and others, the ideology of militarist colonialism blames the enemy for the crimes of the imperialist. A key factor here was the abolition of the slave trade in 1807, and the intensification of a crisis for whiteness in the aftermath of the emancipation of slaves in the Caribbean colonies in 1838. In Africa, by the later 19th century, both in Crown colonies like Lagos and Protectorates like Niger River,

there was widespread pressure to end the institution of slavery; indeed the fact of slavery and slave raiding existing within a British Protectorate was a major factor in the successful lobbying for the sacking of Benin City in 1897 – offering freedom for enslaved people was used as a means of creating a new social order after military operation.[22] But as the status of black Africans as chattel to be raided, sold and displaced shifted, so a new ideology of race was needed to justify the project of European colonialism in Africa.

It is in this context that the accusations began, primary among which was the blaming of slavery on Africans. Putting out of mind the Europeans' transformation of the scale, nature and horror of West African institutions of slavery over three centuries, through the triangular trade and the plantation economy, through which 12½ million enslaved people were shipped to the New World, anti-slavery became evidence of the moral degeneracy of Africans. Now that Britain opposed it, the naval operations of the so-called 'Humanitarian Squadron' for the suppression of the slave trade went through a significant degree of what is perhaps best described as 'mission creep'.

Gunboats suppressing slavers came to have a military role in commerce, at first in protecting traders engaged in the 'legitimate commerce' that was replacing the slave trade, bartering gin, arms, tobacco and Manchester goods for ivory and palm oil and then, after 1885, both the Protectorate and the Company imposing of new regimes of duties and tariffs. An example of the resolution of a trading dispute on the Benin River in the 1860s was given by W.F. Bray, a trader:

> the native towns are all situated on shallow creeks inaccessible to boats, and the river banks present an unbroken wall of mangrove-trees. So these people, who had never seen a war vessel, fancied they had only to retire to their dwellings to be out of reach of all harm. But the exact problem of each village was well known to the traders, and one of them was promptly shelled and destroyed by the gunboats firing over the top of the trees. This brought them to terms.[23]

By the 1890s, the ideology of projection had moved much further, becoming more than just propaganda – a belief system for a new kind of white supremacy. Whereas they had previously just used public anti-slavery sentiment to their own ends, now neo-imperialists accused kings and chiefs of imperialism. Those who were sacking royal palaces and sacred sites claimed that what they were taking had already been looted by the Africans, that ancestral skulls were the war trophies of head-hunters, further memorialised in bronze heads. Brutal naval officers bombarded native villages in the name of ending barbarism. The destruction of sacred spaces and buildings was carried out in the name of civilisation as a universal value. Sentiments of anti-slavery and missionary Christianity were actively used to justify violence, along with new academic disciplines. The claim – to which archaeologists and anthropologists were called as witness, as judge and as jury – was of scientific proof that there could be no civilisation outside of white Euro-America. Through such strategic reversals – a tactic of inversion – a bifurcation opened up, like an alternating current that runs through the ongoing mimetic history of colonial violence in the exhibitionary complex of the Victorian ethnological museum.

Through military violence 'the country was pacified',[24] so that the Royal Niger Company, in close partnership with the Church Missionary Society, oversaw what they described as 'the substitution of a considerable degree of peace for incessant intertribal wars, and the gradual suppression of slavery'.[25] The authors of massacres claimed that their actions were to stop 'holocausts of victims sacrificed to appease the deity'[26] – to 'inspire a wholesome fear in the natives', as Henry Johnson, Archdeacon of the Upper Niger from 1878 to 1891, put it.[27] British lives were given up, in this supposed graveyard of Europeans, in the name of 'the glorious work of rescuing the native races in West Africa from the horrors of human sacrifice, cannibalism, and the tortures of fetish worship'.[28]

The men who reneged on treaties and fabricated their accounts of the Benin atrocity claimed that 'An average n█████ of low type lies without compunction if there is the slightest thing to be gained by

it, and often, when nothing can be gained one way or the other, out of absolute indifference to telling a lie or the truth.' (Reginald Bacon, 1897)[29]

To this day, my academic disciplines – anthropology and archaeology – and my institutional workplace – the anthropology museum – are implicated in this history of racism, the degenerate display of supposedly 'savage' culture reduced to material form. Brute force, brutish displays.

'Everyone knew that the object of that expedition was not to put a stop to these cruelties but to open up trade,' MP for Mayo East John Dillon told the House of Commons on 2 April 1897.[30] White projection became the racial ideology of militarist colonialism. In the case of Benin City 1897, it begins with the pretext, the idea, of *casus belli* at the heart of the punitive expedition: the supposed hurt, the trope of white fragility. Quite probably the Oba made human sacrifices of enslaved people or prisoners, and quite possibly killed hostages he had taken when the Royal City came under rocket attack. But the sacking of Benin City was quite another thing. Part of the temporal dimension of this projection, in which museums were directly implicated, was to make the violence endure. Another part was to create the illusion of timelessness. The academic denial of Africa's history remains today, although it is a prejudice rarely expressed quite so honestly as in the famous shameful lines with which the Tory racist and Oxford historian Hugh Trevor-Roper opened his popular book, *The Rise of Christian Europe*:

It is fashionable to speak today as if European history were devalued: as if historians, in the past, have paid too much attention to it; and if, nowadays, we should pay less. Undergraduates, seduced, as always, by the changing breath of journalistic fashion, demand that they should be taught the history of black Africa. Perhaps in the future, there will be some African history to teach. But at present there is none, or very little: there is only the history of the Europeans in Africa. The rest is largely darkness, like the study of pre-European pre-Columbian America. And darkness is not a subject for history.

Please do not misunderstand me. I do not deny that men existed even in dark countries and dark centuries, nor that they had political life and culture, interesting to sociologists and anthropologists; but history, I believe, is essentially a form of movement, and purposive movement too. It is not a mere phantasmagoria of changing shapes and costumes, of battles and conquests, dynasties and usurpations, social forms and social disintegration. If all history is equal, as some now believe, there is no reason why we should study one section of it rather than another; for certainly we cannot study it all. Then indeed we may neglect our own history and amuse ourselves with the unrewarding gyrations of barbarous tribes in picturesque but irrelevant corners of the globe: tribes whose chief function in history, in my opinion, is to show to the present an image of the past from which, by history, it has escaped; or shall I seek to avoid the indignation of medievalists by saying, from which it has changed?[31]

But the ongoing denial of African history involved from the outset the most recent colonial past as well as its precolonial history. The ideology of projection, which begins with the idea of incident and punishment, gave, gives, may well continue to give, a timeless sheen to each military action of the unfinished experiment that was, and continues to be, corporate colonialism.

To question the framing of an event is to question what is out of proportion: what is trivialised and what is magnified, what themes are not just commensurable but have, perhaps, measured out their own durations by keeping in step. The hushed silences of museum galleries displaying stolen culture and the unspoken ideology of white supremacy is the example that this book is using to try to think that through.

To break the frame might bring us to cross-mend the fragments, as archaeologists do with smashed pottery, to make form visible. Archaeology begins with making visible the transformation of form. In the case of the 'world culture' museum, those transformations, to the shame of every one of us curators, came through cycles of violence – long-term, unfinished cycles of 'white fragility and white projection'.[32]

The pretext was at first the suppression of the slave trade, as most famously with the Reduction of Lagos in 1851, where a naval bombardment of the Royal Palace by the West Africa Squadron was used to remove Oba Kosoko from office, installing the former Oba Akitoye, and bringing in a period of 'consular' rule which led, a decade later in 1861–62, to the annexation of Lagos as a British Colony and Protectorate. But as the century proceeded, further pretexts were found. 'The white man is bringing war,' Oba Ovonramwen reportedly told his chiefs after news of Phillips's approach reached him.[33] A license to commit mass atrocity, cruelty and cultural democide emerged through the idea of white projection. Such processes do not happen in a single incident or attack – they are implemented over years. Benin City 1897 was part of a much bigger event; we could call it World War Zero.

5

World War Zero

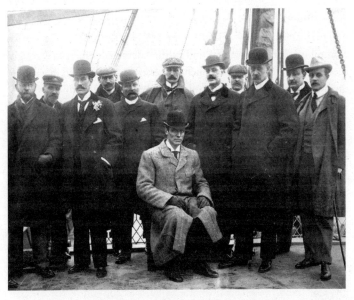

Whenever a regular army finds itself engaged upon hostilities against irregular forces, or forces which in their armament, their organization, and their discipline are palpably inferior to it, [so] the conditions of the campaign become distinct from the conditions of modern regular warfare.

Major-General Charles Callwell,
Small Wars: Their Principles and Practice, 1896[1]

Military History may be the largest section of many British book-shops, but serious histories of what Victorians like General Callwell called their 'Small Wars' – including dozens of 'punitive expeditions'

where machine guns were pitted against bows and arrows – are absent. Callwell, the historian of 'small wars', explained how this category was defined in the extract above.

The word 'expedition' holds within it, over and above the knowingly playful evocation of some *Boys' Own* field trip, a sense of purposeful haste, of the prompt execution of the task in hand. When compounded with the word 'punitive', this sense of pace takes on a more brutal character: to dispatch, to get out of the way, to avenge a perceived wrongdoing, to expedite a king. The idea of the 'punitive expedition' simultaneously evokes *crisis* – declared for the imposition of a state of emergency – and *white fragility*, deployed to justify the suspension of any normal moral codes until some supposed brutish slight is avenged. I want to begin this chapter by suggesting that its logic was a central building-block in the transition from the late 18th-century ideology of racial slavery to the early 20th-century militarist practice of state racism. By the outbreak of World War I, the sheer scale of slaughter across three decades of punitive expeditions had been given an afterlife in the form of exhibitions in every anthropological museum in Europe – an afterlife to the particular form of violent race thinking that accompanied the nascent global capitalism.

The neglect of the histories of 'small wars' or 'little wars', overshadowed by the horrors of 20th-century global industrial warfare, perhaps also derives from the sense that the stories were told once before, at the time, and those narratives are so hard to get past, since colonial soldiers involved in these missions so often wrote self-aggrandising and partisan memoirs documenting their triumphs.

On Wednesday 23 September 1896, Queen Victoria's reign became the longest in English history. 'The Victorian Age has been one of peace,' wrote the *Western Gazette*:

> but scarcely a twelvemonth has passed during her Majesty's reign without finding our country at war in some part of the world. The following is a list of them:- Afghan war 1838-40, first Chinese war 1841, Sikh war 1845-46, K███ war 1846, second war with China, second Afghan war, 1849, second Sikh war 1848-9, Burmese war

1850, second K▓▓▓ war 1851-52, second Burmese war 1852-53, Crimea 1854, third war with China 1856-58, Indian Mutiny 1857, Maori war 1860-61, more wars with China 1860 and 1862, second Maori war 1863-65, Ashantee war 1864, war in Bhootan 1864, Abyssinian war 1867-8, war with the Bazotees 1868, third Maori war 1868-9, war with the Looshais 1871, second Ashantee war 1873-4, third K▓▓▓ war 1877, Zulu war 1878-79, third Afghan war 1878-80, war in Basutoland 1879-81, Transvaal war, 1879-81, Egyptian war 1882, Soudan 1885-85-89, third Burma war 1885-92, Zanzibar 1890, India 1890, Matabele wars 1894 and 1896, Chitral campaign 1895, third Ashantee campaign 1895, second Soudan campaign 1896.[2]

In reality, Victorian Britain was at war in every year of Victoria's reign (1837–1901), and every one of those conflicts, apart from the Crimean War, was a 'small war' according to Callwell's definition.

* * *

Attending to these British small wars and punitive expeditions in Africa and beyond, which were in reality far from small, reminds us that, in the institution of the museum, discipline and punishment operates at a very different scale from any Foucauldian notion of material constraint, imposing not just order but also destruction, which involved the shelling of undefended towns and villages, the ransacking of palaces, the torching of libraries, the desecration of religious spaces. Where discipline does come into things is where the academic fields of anthropology and archaeology repress the knowledge of the brutality of 'acquisition' in the form of loot, knowledge that, when we see it, shatters our image of the museum, forces us to question ourselves, to question what the curation of 'world culture collections' today actually means.

The details of punitive expeditions may remain largely unwritten through the relentless eurocentrism of history faculties, but material culture represents one form of forensic evidence of the scale of these supposedly 'small wars', both looted objects and spoils of war, but also

a more official form of memorial: medals and clasps. The history of African campaign medals sketches a geography of sustained violence on a continental scale, from the Abyssinian War Medal (1867–68), the Egypt Medal (1882–89), the Ashantee Star for the action against King Prempeh in December 1895–February 1896, the Queen's Sudan Medal (1896–98), the Central Africa Medal (1891–98) and the British South Africa Company Medal (1890–97).

The British East and West Africa Campaign Medal was established in 1892. Twenty-one clasps were issued to naval officers, the West India Regiment, and British Protectorate and other local forces for more than thirty military interventions that took place between 1887 and 1900. About one-third of these took place in what is today Nigeria, the rest across Sierra Leone, Ghana, Kenya, Gambia, Malawi and Somalia. An Egypt Medal was issued separately for actions in Egypt and Sudan, bearing an image of the Sphinx. The design for the East and West Africa Campaign Medal, shared with the Central Africa and Ashantee medals, had been commissioned from Sir Edward Poynter in 1874 to commemorate General Garnet Wolseley's recent deposition of Kofi Karikari, tenth *asantehene* of the Kingdom of Asante, at Kumasi (Plate I). The obverse shows the head of Victoria, diademed and veiled, while the reverse depicts a fight at close quarters between British uniformed soldiers and semi-naked Asante fighters in thick bush.[3] An Asante man with a hatchet in his belt aims a musket, while another reaches in with a spear. Two further Asante men have fallen, a knife has dropped to the floor, while two more are on their knees facing away from the British line, one grasping a tree trunk with one hand while with the other he pushes against his comrade with the rifle, grabbing his belt, as if to encourage his surrender. Against these six African figures, three British soldiers attack with Martini-Henry carbines with sword bayonets, while a fourth is wounded. Warwick Wroth of the British Museum's Department of Coins and Medals praised the modernity of the depiction of 'real negroes, and real English soldiers in their helmets'.[4]

The material culture of clothing and weaponry in this design tells a story of white supremacy, a theme to which we will return later in

this book, but for now let us learn two things from these medals and clasps. First, we must shift how we describe this period, and refer no longer to separate expeditions but to a sustained East and West Africa Campaign that ran between 1887 and 1900. As Henk Wesseling has argued in the case of the Maji-Maji wars in German East Africa, so for British colonial militarism up and down the Niger River, there were scores of individual actions across years of sustained warfare, which are broken up as 'disturbances', 'troubles', or 'uprisings' rather than being understood as larger campaigns.[5] As Wesseling concludes: 'The conquest and pacification of Africa by Britain and Germany was a continual process. Not a year passed without a war; in fact, not a month passed without some kind of violent incident or act of repression.'[6]

Taken together with French, German, Belgian and other European activity in Africa and across the Global South in this period, this was a foreshadowing of the horrors of the 20th century, a kind of World War Zero, running across the three decades after the carving-up of African territories between European powers at the Berlin Conference of 1884, during which the East and West Africa Campaign was a crucial theatre of war. The purpose of this decades-long British 'infinity war' came to be to establish systems of governance on a new 'indirect' model, involving the periodic removal of kings, armies and indeed whole human landscapes of towns and villages. The ideology of militarist humanitarianism, begun with the abolition of the slave trade, morphed as it moved inland, facilitated by the new technology of the Maxim gun.

Second, the role of joint stock companies, alongside the British government, during the 'Scramble for Africa', needs explanation. Just one clasp was issued for the Royal Niger Company's Medal, reading 'NIGERIA 1886–1897', and memorialising a host of actions of militarist, corporate colonialism. The story of the anomalous position of this corporate interest began when George Dashwood Taubman Goldie – an atheist Manxman who had trained at the Royal Military Academy, Woolwich, and had held a commission in the Royal Engineers for two years – first visited Niger River, aged 30, in 1876. In 1875, Goldie had purchased interests in Holland Jacques, a small Niger trading

company, following an appeal by Joseph Grove-Ross, secretary of the company and the father-in-law of Goldie's eldest brother, for financial assistance from the family. In 1876, Goldie incorporated a new venture, the British Central Africa Trading Company, and in 1878, founded the United Africa Company Limited (re-named the National African Company in 1881), developed through mergers of more than a dozen British and French companies operating on the Lower Niger.[7] At this time, trade was carried out through hulks moored on rivers and creeks as warehouses and trading stations, and then gradually the building of factories on shore. The British consulate moved from Fernando Pó to Old Calabar in 1880 – 'a barn-like wooden consulate was built on a hill two hundred feet above the riverside' – and then a consulate was built at Sapele – a hulk, the merchant ship *Hindustan*, purchased at Bristol, with a barracks for sixty men made from corrugated iron.[8]

By 1884, the scale of Goldie's operation was critical in negotiations over the Niger Delta at the Berlin Conference, at which he was present. Frederick Lugard, the first Governor-General of Nigeria, later recalled that Goldie 'succeeded in securing the disappearance of all foreign flags just in time to announce at Berlin that the Union Jack alone flew on the Lower Niger, and thus to secure to Great Britain the sole custodianship of its navigable waters'.[9]

The Berlin Conference marked a shift in history of European colonialism in Africa, towards struggles over territorial possession as well as just maritime strength. Unlike in Australia or North America, in West Africa this would not be a 'settler-colonial' model. On the coast, on 10 September, 1884, a Treaty of Protection was signed with the king and chiefs of Old Calabar (Akwa Akpa). Inland the Royal Niger Company expanded its activities, signing, improvising, or even perhaps forging treaties, to the extent that over 230, granting exclusive rights and privileges to the Company, were signed by 1887.[10]

Since the 1950s, economic historians have underlined the significance of alternative forms of empire to African colonial history, how European scrambling involved much more than 'the mere pegging out of claims in African jungles and bush'. But the conventional

terminology to express the importance of such 'informal empire' and 'the imperialism of free trade'[11] fails adequately to capture the militarist, extractive, virulent corporate colonialism that came in the wake of Berlin. The corrective offered by Cain and Hopkins, highlighting how closely aligned commercial and governmental interests were in the late 19th century, involved the coining of a perhaps equally unhelpful term, 'gentlemanly capitalism'.[12] And subsequent accounts of Victorian 'territorial expansion', through the diverse work of settlers, traders, missionaries, administrators and others,[13] has continued the trend of not just finding it hard to describe these forms of colonialism, but of neglecting the crucial questions of the scale of violence, of environmental destruction, and of race thinking – not to mention the looting of cultural property and its display in European museums. As Ann Laura Stoler has argued, '"indirect rule" and "informal empire" are unhelpful euphemisms, not working concepts.'[14] Indeed, these practices perhaps form a kind of regime that is the signature of what Sarah Mallet and I have described elsewhere not as 'informal empire', 'gentlemanly capitalism', 'indirect rule', or 'native administration', as if this were some kind of genuine devolved agency or local governance – but 'militarist colonialism'.[15]

The following sections will chart the growing violence in the development in the Niger Delta of a new form of British capitalist colonialism of 1885–95 into the full-blown corporate-militarist colonialism, which marked one significant step towards what Naomi Klein has called the 'disaster capitalism' of the 21st century.[16]

The clearest evidence that perceived slights were nothing but thin pretexts is the sheer number of times they were used. Protectorate Vice-Consul Henry Galway (who changed his name from Gallwey later in life) described how he was often away, 'chasing some murderers with a small military force',[17] while Lugard, the first Governor-General of Nigeria, recalled 'the many minor operations brought about by murders and outrages, which the Government was compelled to suppress by force of arms' in the 1890s.[18] Galway later explained that 'punitive expeditions used to be annual affairs' in the 1890s:[19]

Every year expeditions were organised, and by degrees the many centres of cannibalism and human sacrifices were cleared, native courts established where fetish rule had previously existed, and, as civilisation advanced, so trade developed, and peace, contentment and justice were secured for regions where hitherto from time immemorial anarchy and misrule had reigned.[20]

There was thus a grim seasonality to these jungle expeditions, carried out during the dry season in December to March – open season for the Protectorate and Company troops. Flora Shaw put it with her familiar chilling candour in an editorial for *The Times* on 8 January 1897, 'in countries where the fighting season is short, action follows swift upon decision.'[21] The ecology of the ultraviolence of World War Zero, 1884–1914, was driven principally by the re-introduction of a dangerous new element to the famous 'three Cs' of Thomas Buxton and David Livingstone. As Philip Stern has put it: to the Holy Trinity of commerce, Christianity, civilisation, was added a fourth: *the corporation*.[22] As the arena of corporate colonialism grew, it became a central terrain for Anglo-German co-operation that laid foundations for the abortive possibilities of more formal political alliance between Germany and Britain,[23] but also for the ethnological museums who continued to interact during the early 20th century, in which ideas of race science were explored through the military spoils of extractive colonialism. Taking stock of this corporate-militarist form of colonialism, as we shall do in the following chapter, is a crucial part of understanding the wider context of the sacking of Benin City.

6

Corporate-Militarist Colonialism

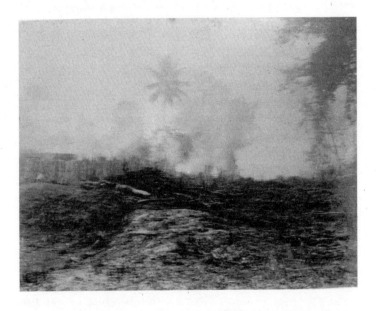

The Secretary of State for War might be officially informed that the Royal Niger Company is doing imperial work in Western Africa and that its official position is carefully emphasised in its Charter under the head of 'General Provision'.

<div align="right">

George Goldie, Governor of the Royal Niger
Company to Lord Salisbury, August 1896[1]

</div>

How should we understand George Goldie's message to the Prime Minister? Chartered joint stock companies had developed in Europe's initial imperial expansion during the 16th and 17th centuries, through the Muscovy Company (1553–1746), the East India

Company (1600–1858), the Dutch East India Company (1602–1799), the Hudson's Bay Company (1670–present), and the Royal African Company (1672–1712), conducting trade at a multinational scale.[2] Then, in the late 19th-century British Empire, a new burst of these entities was led by the British North Borneo Company (chartered 1881), and followed by Goldie's Royal Niger Company (1886), William Mackinnon's Imperial British East Africa Company (1888) and Cecil Rhodes's British South Africa Company (1889).

Britain established four crown colonies in Africa: Gambia (1765), Sierra Leone (1808), Gold Coast (1821), and Lagos (1861). Protectorates were later declared in adjacent areas: Gold Coast (1874), Oil Rivers/Niger Coast (1884/1893), Gambia (1894), Sierra Leone (1896) and Ashanti (1902). But the precise nature of British government 'protectorates', especially when compared with the roles of joint stock companies like Goldie's, was vague. In March 1899, Goldie set out his views on how best to envision an alternative to settler colonialism:

> I do not use the word 'protectorate', as 'protectorate' has for some generations now been used to cover administrations in which European ideas are being carried out by European officials. I very much like myself the phrase 'sphere of influence'. I think it exactly expresses the idea of European rule over Africa, namely, each colonising nation should have its own sphere within which no other civilised nation should interfere, but that colonising nations shall not be bound or inclined to exercise in their sphere more than the general influence which is necessary for the gradual progress of civilisation.[3]

The General Act of the Berlin Conference 'indirectly acknowledged a British protectorate as already existing on the Niger',[4] where no such entity yet existed. In June 1885, a British Protectorate was declared across the 'Niger Districts' between Lagos in the west and Cameroon – newly annexed by Germany – in the east, and across territories along both banks of the Niger River. But from the start, there was ambiguity about what a 'Protectorate' meant, whether its role was to respect

local sovereignty or to transition towards the status of a Crown colony, and the extent to which the British government was accountable for the rule of law in these areas. The National African Company argued for a distinction between the 'Oil Rivers' seaboard regions of the Niger Delta, and 'the essentially Central African territory generally known as "Niger Benué", the trade of which is carried on in large and densely populated countries, hundreds of miles up rivers and creeks' where 'local administration', as compared with 'such as exists in Cyprus or the Gold Coast Colony' would be 'impracticable for some years'. In the view of the company, the model set by Germany in Cameroon, which 'with her usual practical ability had at once recognised that Central Africa could only be developed, in the first instance, by Companies combining administrative authority with commercial influence', and had 'immediately given the necessary powers to the East African Company', was one that the British government should follow.[5]

The following year, under the short-lived third Gladstone administration of 1886, amidst fears of losing territory to France or Germany, the Company was granted a charter on 25 June 1886, with a capital of £1 million, divided into 100,000 shares sold at £10 each.[6] It was renamed the Royal Niger Company (RNC) on 13 July 1886. Under the provisions of the charter, Oil Rivers Protectorate comprised the coastal regions from the Colony of Lagos to the mouth of the Rio del Rey, while a 100-mile section of the Niger Delta, between the Forcados and Brass Rivers, and fanning out to the north of the Niger-Benue river system, from Ilorin to Sokoto, and from Lokoja and Bida to Kano, would be 'subject to the government' of the RNC.[7]

The confusion over the status of Oil Rivers Protectorate (administered through the Colonial Office) and the Company (chartered by the Foreign Office) was controversial,[8] bringing about a kind of 'dual mandate' where there were Company territories and Protectorate territories, and each was governed to different standards of the rule of law.[9] Within its territories, the RNC held an effective monopoly, and the beginning of a shift towards what R. Palme Dutt called 'super-

profit' in the shift from an era of industrial capital to an era of colonial finance capital, in which companies would

> utilize state machinery to establish political dominion or control, direct or indirect, over the backward country; including with the use of armed force, in order to establish for itself as far as possible a monopoly hold on the particular country as a market, a source of raw materials and a sphere of investment, and so to insure a special favoured position for the extraction of maximum super-profit.[10]

There were reports of unrest and violence right from the RNC's implementation of their monopoly in November 1886, with the *Liverpool Courier* reporting on New Year's Day 1887 that it was

> provoking a 'little war' by interfering with both African and European trading arrangements that had been in place since the abolition of the slave trade – imposing and collecting duties, requiring the purchase of annual licenses, and penalising smuggling, so that from the Protectorate perspective 'this dual control was the very Devil'.[11]

The following decade, William Hall observed in his *Treatise on the Foreign Powers and Jurisdiction of the British Crown* how there were significant differences between how Germany and France defined 'Protectorates' and the practice of Great Britain, the latter understanding 'protected states as retaining their independence' which, being 'of insufficient power to protect it themselves', 'placed their foreign relations under the tutelage of a country strong enough to provide for their security; but they retained, or at least were in law supposed to retain, their complete rights of internal sovereignty.'[12] The analogy for the Oil Rivers Protectorate were thus cases such as the 1861 French treaty with Monaco as a protected state where the monarchy was recognised, or the former British 'amical protectorate' of the United States of the Ionian Islands, which ran from the Congress of Vienna in 1815 until 1864 – or indeed the 1888 Agreement with Sultan Hashim Jalilul

Alam Aqamaddin of Brunei, under which 'the state is to continue to be governed and administered by the Sultan and his successors as an independent state, under the protection of Great Britain'[13] – a Protectorate that continued until 1984.

The principal driver of Britain's nascent global capitalism in the Niger Delta was the growing need for two products. In the 17th and 18th centuries, the transatlantic slave trade had been intimately linked with what Sidney Mintz called the 'drug foods' of sugar, tobacco and coffee in the new agricultural regimes of the New World and the markets for consumption in Europe.[14] In the late 19th century, the riverside 'factories' of Liverpool and Glasgow traders who had been improvising various forms of 'legitimate' commerce after the abolition of the slave trade, had been joined by new waves of Christian influence in the form of the evangelical Church Missionary Society, through whose agency the ideology of commerce came to grow hand-in-hand with that of Christian civilisation; these all found themselves at the heart of a new phase of extractive colonialism. The first steamship company trading with West Africa was formed in 1852, and the journey from Britain to West Africa was cut from 35 days to 21 days or fewer, and 'the tonnage of British shipping to West Africa more than doubled every decade between 1854 and 1904.'[15] This new phase of economic imperialism was based not on slavery but on two principal products – at first palm oil and palm kernels, and then increasingly rubber. Alongside these two main products, ivory, mahogany, ebony, various resins and gums, and smaller quantities of chilli peppers, coffee, cocoa, gutta percha, cassava flour, balsam, capsicums, castor oil seed, bark, patchouli, piassava, indigo, hides, nuts and raffia were also significant exports during this period.[16]

Palm oil exported from the Niger Delta lubricated many of the wheels of Victorian industry, and palm kernel oil was used for soap, candles and lamp oil, as well as culinary uses. Between 1863 and 1869, exports from Lagos had increased tenfold to 20,394 tons per annum.[17] The beginning of the petroleum industry brought competition for the use of palm oil, but any decrease in demand was offset by the growing export value of palm kernels after Francis Loder's deodorising process

was patented in 1887, making its use in the commercial manufacture of vegetable margarine possible.[18] As for rubber, at the time of the Berlin Conference, wild rubber was harvested by local producers across the Niger Delta, and traded through middlemen along the river, in an economic geography that echoed the earlier patterns of slave trading. This pattern was to change radically in the first decade of the 20th century, with the creation of large rubber plantations organised by the colonial Forest Department; nearly one thousand such estates had been established around Benin City by 1910.[19] To the north, shea butter and ivory were of importance for the RNC, mainly bartered for gin and firearms.[20]

A series of changes took place in the first decade after the Berlin Conference. From the outset, the RNC oversaw a major disruption of both other British and also African trading interests on the Niger, as they developed during the decades since abolition. The Charter gave the RNC 'exclusive trading and sovereign rights ... to levy duties to defray the costs of administration'.[21] The Company sought to remove 'middle-men' and trade directly with 'producers' of palm oil, rubber and other products – while English and Scottish companies, the largest of which were the Glasgow-based Alexander Miller, Brother and Company, and Liverpool-based James Pinnock's, were keen to see the RNC's charter revoked. In 1888–89, the RNC failed in an attempt to take over the Oil Rivers Protectorate;[22] nine of the companies competing with them then formed the Liverpool-Hamburg alliance named the African Association,[23] although eventually, ongoing disputes with Liverpool traders ended in 1893 when the RNC bought them out. Then, in a re-arrangement of bureaucratic provision, in 1891–93 an Imperial Administrator and Consul-General, Sir Claude MacDonald, was appointed to administer the Protectorate, which was renamed 'Niger Coast Protectorate', and to place some limits on the power and monopoly of the RNC, with vice consuls on each river – at New Benin, Brass, New Calabar, Kwa Ibo, Opobo and Old Calabar – in all, six vice consulates, including one on Benin River where Henry Galway was based. In the early 1890s, a Protectorate building purchased at New Benin from the African Association was expanded, to

accommodate six Europeans, and a Consular Court, Customs Offices, Surgery, boat-house and pier were provided, and a hulk purchased at Bristol was used to establish a trading station at Sapele, with a customs office, consular court, treasury, barracks and prison, occupied by a detachment of Protectorate troops.[24]

The Brussels Anti-Slavery Conference of November 1889–July 1890 marked a new threshold in the suppression of the slave trade, shifting public opinion about the continued existence of slavery in Africa. Ratified in August 1892, from 1893 it catalysed a new phase in the use of military force justified as anti-slavery measures in British West Africa, giving a new impetus to military operations in both the Protectorate and Company territories. Focusing on land routes and river systems rather than coastal routes, the Brussels Act on 'the Convention Relative to the Slave Trade and Importation into Africa of Firearms, Ammunition, and Spiritous Liquors' led to 'the establishment of strongly-occupied stations, fortified posts on navigable waterways, expeditions and flying columns for repressive action' along the Niger River,[25] as well as introducing significant restrictions on the gin and firearms trade to restrict non-European military power, including a ban on the sale of all firearms apart from 'flintlock guns with unrifled barrels, and common gunpowder, known as trade powder'.[26]

The RNC became increasingly direct in their use of force, and increasingly coerced the Protectorate into military engagements. Goldie's language was of 'opening up', 'breaking into' Africa.[27] Both the Company and the Protectorate developed their own Constabulary – 'or a military force, to give it its proper name'.[28] It was an important task, Galway explained, 'to raise a force of coloured troops, officered by white officers, as it was very patent we could not attempt to open up the country by means of smiles and white umbrellas for any length of time.'[29] In 1891, a new Regulation, on the pretext of suppressing the 'intolerable evil' of slave trading, considerably expanded power and authority of the Company by allowing it to increase its military force, which was 'hitherto – numerically insufficient'. Humanitarian sentiment was leveraged in the RNC's commercial interests, with

descriptions of ever-advancing raids of slave hunters, which, 'if unchecked, entirely [would] destroy the newly-created commerce of those fertile regions'.[30] In August 1892, an official report stated that the Protectorate's 'Oil Rivers Irregulars' comprised a force of two officers, ten staff (including five tailors and one 'Priest Mahomedan'), and 153 Hausa soldiers, recruited from the Gold Coast and Lagos colonies, including a band of six drummers and buglers, armed with Snider carbines, and with seven 3-barrel Nordenfelt machine guns for both 'bush' and 'naval' work, and a 6-pounder, plus new supplies of a Maxim, two 7-pounder field guns, and rocket apparatus.[31] Two years later, the Protectorate Constabulary (under the Niger Coast Constabulary Ordinance 1894) commanded by Alan Boisragon, had grown to 15 European Officers, four African Officers, and 450 rank-and-file 'Mohammedan Yoruba' troops in four companies of a hundred each, and fifty band and regimental staff, armed with Martini-Henry carbines with sword bayonets and two Maxim guns, and a battery of four 7-pounders, which in 1896 'did very heavy and important expeditionary work'.[32] There were barracks at Old Calabar, Degba on the New Calabar River and Sapele on the Benin River.[33] Protectorate officials reported on the violence, 'bloodshed' and 'irksome' actions 'contrary to all principles of free trade' and against arrangements provided to iJekri traders and others by the British government to traders long-established since abolition.[34]

Relationships with local chiefs were central to the NCP's mode of operation, and they signed 342 treaties between 1884 and 1892.[35] The threat of military attack for any refusal to co-operate with increasingly bold British demands was ever-present, from both the Company and the Protectorate. Harry Johnston, appointed Vice Consul of the Cameroons and Oil Rivers Protectorate in 1886, later recalled that 'When [I] arrived at the Niger Delta in 1885 and took stock of the situation I decided there were two powerful native states with whom one had to deal carefully: the Kingdom of Benin on the west, with its important coast vice-royalty under the chief Nana; and Opobo, under Jaja, to the east of the main river.'[36]

The Protectorate's removal of King Jaja of Opobo in 1887, led by Johnston (promoted as 'Acting Consul' in the same year, aged 29), was one sign of the shape of things to come. An alumnus of King's College London, Johnston had gone on to study painting at the Royal Academy for four years, and led an 1884 Royal Geographical Society Expedition to Mount Kilimanjaro, later publishing a book-length account of his views on 'the colonisation of Africa by superior races'.[37] Meanwhile Jubo Jubogha, known as King Jaja in his transactions with whites, had been born in 1821 in Igboland, at Amaigbo. Taken as a slave to Bonny aged 12, he went on to become an immensely powerful and wealthy merchant, founding the city-state of Opobo in 1869, aged 48. Jaja had visited England in 1885, arriving at Liverpool on the steamer *Tenerife* on 31 July,[38] and developed a powerful network of palm oil trading houses along the Niger River, even shipping palm oil directly to Liverpool independently of British companies. During a trade dispute in 1887, the Protectorate tricked him by arranging a meeting and taking him as a prisoner or hostage. He was tried and convicted for various crimes at Accra, brought to London for an audience with Queen Victoria, and then exiled to São Vicente, Cape Verde. Henry Galway later described how his first journey from Plymouth to Bonny in July 1891, to take up the position of Deputy Commissioner and Vice Consul of the Niger Coast Protectorate became entangled with the repatriation to Opobo of the human remains of Jaja, who had died at Tenerife – perhaps, as the British later claimed, while en route home from Cape Verde after being allowed to return home.[39]

Meanwhile, a series of attempts by the Protectorate to sign a treaty with the Oba of Benin were made. The first had been made a generation earlier, with Richard Burton's visit to Oba Adolo in 1862, from which Burton came away with no treaty.[40] In June 1885, Benin Vice Consul David Blair and a group of traders and 50 Hausa soldiers reported that they had failed to meet with the Oba, having come to a location 25 miles from the city, and after three days of waiting they departed.[41] Several visits were made in subsequent years, notably by Cyril Punch in December 1889[42] and in 1891,[43] two in 1890 by T.B. Auchterlonie,[44] and another by Consul G.F.N.B. Annesley. Audiences

were given with the Oba, and gifts exchanged, but no treaties were signed.

The prospect of the removal of the Oba was discussed throughout this period. Geographical knowledge was key to British interests, and in January 1892, Galway reported on his mapping of the interior creeks between Lagos and Benin.[45] Finally, in March 1892, Galway came to Gwato on the Benin River and, having exchanged messages with the King and receiving an invitation, travelled with three other white men and 40 carriers (Plate IIa). His visit coincided with a commemoration of the previous Oba. Some 5,000 people were present for the meeting, and when an audience was granted, the Oba 'was dressed in a rigid suit of coral, only his eyes, nose, finger-tips and toes being visible, an immense umbrella held above him'.[46]

A Treaty of Protection was signed 26 March, witnessed by Galway's consular agent H. Haly Hutton, NCP medical officer Dr Hanley, and John Swainson from Pinnock's of Liverpool.[47] Like earlier visitors, Galway was kept waiting for three days during ceremonial preparations. In a standard treaty text, 'Her Majesty the Queen of Great Britain and Ireland, Empress of India' 'undertook to extend to the King of Benin, and to the territory under his authority and Jurisdiction, Her gracious favour and protection', in return for a number of provisions, central among which was Article VI: 'The subjects and citizens of all countries may freely carry on trade in every part of the territories of the King, party hereto, and may have houses and factories therein.'[48]

While it was unclear how the addition of a cross to the paper was understood and interpreted by the Oba, after signing, Galway 'informed the King that as long as he kept to the terms of the Treaty, that the Queen of England would always be his friend', and the King reportedly removed a 'Fetish' from Gum Copal, meaning that it could be freely traded, and gave orders for it to be collected.[49] However, it is unclear whether any trade restrictions were ever actually imposed by the Royal Court.[50]

In the months after the signing of this treaty, Protectorate officials openly wrote and spoke about their desire to remove the Oba from

power, when the time was right. Sending a 'signed' copy of the treaty, with the 'X' of Oba Ovonramwen Nogbaisi to the Prime Minister, the Marquess of Salisbury, on 16 May 1892 Consul General MacDonald noted ongoing problems in what he claimed to perceive as restrictions on trade imposed by the Oba:

> There is no doubt that the Benin Territory is a very rich and most important one. Minerals, Gum Copal, Gum Arabic, Palm Oil Kernels, &c are to be found in large quantities. Trade, commerce and civilisation however are paralysed by the form of Fetish Government which unfortunately prevails throughout the Kingdom; the present Ruler it appears from all the information I can gather would be willing to put an end to the present state of affairs but he is overawed by the priesthood. I hope before long to be able to put a stop to this state of affairs, and I look upon the Treaty, so ably effected by Captain Galway, as the first step towards carrying out this much to be desired end. I shall be surprised however if these barbarous practices which have been the custom of the country for centuries will be abandoned by the Priesthood without a severe struggle, and a display, and probable use of force on the part of the Government of the Oil Rivers Protectorate which however I should only recommend as a last extremity.[51]

Vice Consul Galway's *Report on Benin District of Oil Rivers Protectorate for the year ending 31 July 1892* complained that 'Palm oil and palm kernels are the only commodities traded in to any extent at present. Small quantities of rubber and ivory are occasionally exported. There is plenty of rubber in the country, but the natives have a great disinclination to start working a new commodity.'[52]

Galway's *Report* clearly indicated that the Protectorate was already considering a 'punitive expedition' at this point, four and a half years before the sacking of the City of Benin in February 1897, but was concerned about the potential impact such an act might have on their profits:

Nearly all trade products are reserved for the King's benefit. This is done by placing a 'ju ju' on the products in question. Any Jakri man who wishes to trade in the Benin country must first pay a very heavy tax to the King. As a rule, this has to be paid every year. The King also has a knack of very often demanding a further payment of such tax, and if his wish is not gratified he not only stops trade, but very often makes a raid on the offenders. Owing to the fetish rule several very valuable trade products cannot be touched. Amongst these is the palm kernel. However, since the signing of the Treaty between Her Majesty and the King in March last, the King has expressed his readiness to open up trade in several of these hitherto forbidden commodities, the most noticeable being gum copal, in which the country abounds, and palm kernel. Trade is continually being stopped by order of the King, it generally being impossible to ascertain why. The King struck me as being very ready to listen to reason, but he is tied down by fetish customs, and until the power of the fetish priests is done away with, the trade of the Benin country will continue to be a very doubtful source of profit to any great extent. *The breaking down of this fetish theocracy must take time, and can only be effected by degrees. Anything in the shape of a punitory expedition, though it may eventually prove advisable, would paralyze trade for a very long period.*[53]

Commissioner and Vice Consul MacDonald made similar comments in the months after the 1892 treaty was signed. On 2 November 1892, Liverpool Chamber of Commerce hosted him at the Adelphi Hotel, in the presence of Vice Consuls, MPs and the mayors of Liverpool, Bootle and Birkenhead, and in his speech:

he alluded to human sacrifice, cannibalism, the slaughter of twins, and slave-raiding, with all its attendant horrors. *To do away with these without setting the country in a blaze would require time, immense patience, and an intimate knowledge of the native character.* Above all things with the African natives, they should be just: they should say what they were going to do and do it. They should be

gentle, but just and firm, and, above all, let the native feel that if he did wrong there was an iron hand of justice, backed by the law and power of England, but tempered by its mercy, from which, in the long run, there was no escape.[54]

The following year, in May 1893, MacDonald repeated this sentiment: 'Time and much patience will be required however before the resources of this district can be in any measure developed, the great stumbling-block to any immediate advance being the fetish reign of terror which exists throughout the Kingdom of Benin, and will require severe measures in the future before it can be stopped.'[55]

As is clear from this review of the speeches and correspondence of Claude Maxwell MacDonald and Vice Consul Galway, the desirability and, indeed, the practicalities of a punitive expedition against the Kingdom of Benin were already being discussed, in, as it were, an anticipatory mode, in the months after the signing of the 1892 Treaty. The temporal juggling of this form of pre-emptive punishment went to the heart of how the sacking of Benin City would unfold. The ongoing context of the Brussels Act was key: it meant that the British government and those pressuring them could seek to justify their taking action against any region where slavery existed, on humanitarian grounds, but gradually such arguments morphed, as the ambiguities of the status of 'Protectorates' became the focus of arguments about whether proactive action needed to be taken where slavery existed within British colonial possessions.

But as well as this context it is necessary, before describing the events of February 1897, to outline two principal preconditions, operating across the same time period but at two geographical scales, for the sacking of Benin, in the following two sections. The first is the growing violence, in the form of punitive expeditions, of the Niger Coast Protectorate and Royal Niger Company in facilitating British commercial operations on the Niger Delta. The second is the growing momentum and pace for 'regime change' across British colonial interests in Africa, the central role of the Admiralty, and the growing

alignment of the interests of the Royal Niger Company with the Niger
Coast Protectorate.

* * *

The kidnapping and deposition of Jaja set in train the sequence of
events indicated above, involving the uncertain circumstances of
his death and the eventual return of his remains, through which the
29-year-old Vice Consul Harry Johnston felt that he 'had drawn
one thorn' of three. By his description, two more thorns remained,
in the form of Chief Nana Olomu and the Oba of Benin for future
administrators.[56] Both, and much more, were to be 'plucked', as the
Company put increasing pressure on the Protectorate to take military
action. As early as March 1888, a question was asked in the House of
Commons about a Company 'exploring mission' led by a Swiss man
Josua Zweifel with a force of 160 Sierra Leonean troops, which led
to the shooting of 'practically unarmed' men due to 'a difference as
to the terms of engagement', with seven killed and others injured.[57]
But over the next decade, the sheer scale of the growing violence used
by the Protectorate and Company forces, and its sustained, demo-
cidal character using the repeated pretext of the punitive expedition,
supported by the Admiralty, and the routine attacks upon towns and
villages, even from the colonial reports that consistently decline to list
or describe African casualties, is shocking. As Michelle Gordon has
shown for two British colonial 'small wars' in 1898 – the 'Hut Tax'
War in Sierra Leone and the Anglo-Egyptian War of Reconquest in
the Sudan – extreme violence led by 'men on the spot' was hidden in
colonial reports back to Whitehall.[58]

A key player here was Ralph Denham Rayment Moor, who in
March 1891 joined the Protectorate, after a decade from the Royal
Irish Constabulary, as Commandant of the growing NCP Constabu-
lary. In July 1892, he was appointed as Vice Consul to the Protectorate,
following Galway's promotion to Deputy Commissioner, and took on
the job of Acting Consul General during periods when Galway was
absent, eventually succeeding MacDonald as Imperial Administrator
and Consul General on 1 February 1896 when MacDonald took up

the role of British Minister at Peking. Moor's gradual rise during the 1890s, facilitated by Galway and MacDonald, was one factor in the stepping-up of military operations.

A key first development under Moor's Acting Consulship, during one of the periods of Galway's absence, was the Protectorate's 'Brohemie Expedition' or 'Benin River Expedition' against Chief Nana Olomu, in July–September 1894. Since the days of John Beecroft's consulship at Fernando Pó – the predecessor to Richard Burton – an Itsekiri (iJekri) Chief had been officially appointed as Governor of Benin River. In 1884, Nana was ceremonially proclaimed as the fourth such Governor by Vice Consul Blair, and signed a treaty.[59] Known as the 'Viceroy' of the Oba of Benin, he played a key diplomatic and governance role. Colonial administrators admired the architectural quality of his town of Brohemie (Ebrohimi)[60] on a creek of the Niger, with its corrugated iron roofs and European-style buildings, as well as his wealth, the quality of his food and hospitality, and his vast linguistic ability in the many languages and dialects of the Niger Delta, as well as in English, was admiringly documented by Protectorate administrators.[61] *The Times* reported: 'the creek has on either side a thick belt of mangrove trees and salt bush. This salt bush is of considerable value owing to the potash that can be extracted from the ashes after burning the wood and leaves. Nana is said to have realised £2,000 a year by his trade in this product; he certainly had large stores of it in his town.'[62]

In 1892, a trade dispute, in which Nana objected to take the price offered for palm oil and kernels, led to his prohibition of trade, and the situation swiftly escalated.[63] In November 1892, Vice Consul Galway complained of three limitations to trade in the Benin District. Chief among these, alongside 'the fetish rule of the King of Benin' and 'the inability of the natives to understand the varying price of products in the home markets', was 'the predominating influence of the great middleman chief Nana, who had had for many years a monopoly of the trade, and who is jealous of any interference'.[64] In 1894, MacDonald reported that Nana 'has been accustomed for many years past to rule the river by terrorism':

He has a large force of some 3,000 or 4,000 men, and innumerable canoes, some of them capable of holding forty or fifty paddlers; they can be mounted with guns. He has also a large number of rifles, and usually moves about with a body-guard of thirty or forty men armed with Winchesters. His own canoe is a very beautiful one, and was made in England. Some few years ago, for some slight, real or fancied, on the part of the commercial community, he closed the entire trade of the river for several months. Many of the smaller Chiefs are willing and anxious to break through this rule of terror, and trade freely with the Europeans.[65]

In July 1894, in his capacity as Acting Consul, while MacDonald and Galway were on leave,[66] Moor announced a ban on war canoes on public waterways which, he alleged, were establishing 'a state of terrorism in the Benin, Sapele and Warri districts'.[67] In retaliation for a claimed kidnapping of 12 people on 1 August 1894, Moor sent HMS *Alecto* on an expedition to raze to the ground an Idzo village of 35 houses, while rockets fired into the bush to deter attacks, 'exercising a form of *lex talionis* as punishment'. Then on 7 August at Efferonu, a settlement of 3,000–4,000 people, a failed palaver by an unarmed delegation over a disturbance with native traders during July was used as a pretext for a rocket attack and an armed raid in which 'the greater part of the town was fired and burnt.'[68] The official report recorded how then on 19 August, a force including the *Alecto*, led by Lieutenant Commander Heugh 'in a steam cutter armed with a rocket tube and a two-barrelled Nordenfelt gun', continually and indiscriminately fired rockets, machine guns and volleys into the bush during a journey of two hours towards 'the large town of Oteghélé', understood to be supportive of Nana. The town was shelled, charged and 'completely destroyed by fire', using rockets and mines, and a series of other villages were destroyed along the way.[69] Separately, Commander Heugh was later court-martialled for excessive alcohol consumption which caused him hallucinations, while back in Yorkshire.[70]

In the face of increasing unrest, on the same day Ralph Moor telegrammed the Admiralty to request the presence of HMS *Phoebe*.

A week later, the *Alecto* destroyed three villages at the entrance to Brohemie Creek; during the operations a specially armour-plated steam pinnace was attacked, two crew mortally wounded, and others hurt, including Major Copland Crawford, who was Vice Consul.[71] In retaliation, on 27 August 1894, HMS *Phoebe* and HMS *Alecto* began shelling Brohemie, *Phoebe* firing 1,100 shells while rockets were launched from a rocket tube on the foretopmast head of the *Alecto*.[72] Following the bombardment, on 28–29 August Brohemie was stormed by a combined force of 400 Protectorate troops and bluejackets from the *Alecto* and *Phoebe*, supported by teams of Kroo carriers and cutters working through the bush with machetes, their way being cleared by the NCP troops raking the bush with two Maxim machine guns on field carriages. Advancing inland from the river, large guns, Maxims and rocket launchers were passed across an improvised bridge, and the bombardment of the town of Brohemie commenced. There was widespread unrest across the Protectorate, and Moor sent 'strong detachments' of marines and Protectorate troops to Warri and Sapele during the first weeks of September, while canoes and warships patrolled the river, in a campaign of counter-insurgency against chiefs and villages supporting Nana.[73] The sacking of Brohemie continued into late September, reinforced by HMS *Philomel* and HMS *Widgeon*.

By the end of September, the town had been razed to the ground, thatched houses burned, sacred religious spaces desecrated, the houses of Chiefs Nana and Allura converted into barracks, and warehouses looted.[74] Nearby villages, including Eddo, were 'cleared by the machine-gun and destroyed by burning'.[75] Later that autumn, *The Times* reported that

> Brohemie was reduced to a level plain, covered with burnt and charred frameworks of houses … Nana's trade must have been very extensive; his warehouses, arranged in a rectangular manner, covered about one and a half acres, containing Manchester goods, glass and china ware, guns and edged weapons. The stores of gin were immense, 8,000 cases of a dozen each, and 14 tons of powder.[76]

Nana's escape was prevented, and an empty canoe seized with 'personal valuables, £324 in English money, his private correspondence, and … six quarts of champagne'.[77] Nana was captured, found guilty of 'horrible acts' including crucifixions, was sentenced at Old Calabar to life imprisonment, and exiled to the Gold Coast.[78]

In the aftermath, official reports indicated that thousands of 'refugees, very many of them in a most miserable condition from starvation, [who] had evidently been living in their canoes in the bush for a considerable time' came out of hiding as the warships departed, and Moor 'made arrangements for the future of about 2,500' of them.[79] Press reports repeated the Protectorate spin of these human consequences of the expedition as the freeing of enslaved people, and the end of a reign of terror. The *Glasgow Herald* reported that Nana, reflecting on the attack, underlined the decisive role of the rockets and the Maxim machine guns, saying 'I no be fit fight English with dem ole big gun, but suppose I have new gun like English I no be beat. Plenty man fight for Nana and no let English come up, but me no fit for meet dem big gun with dem big bom boms and dem other gun with plenty shoots.'[80]

After the Brohemie Expedition of 1894, the Protectorate's ultra-violence, made possible by the Maxims and rockets, especially when used against non-military targets, continued in other expeditions. In 1894, 1895 and 1896, an ongoing series of smaller actions took place including on the Kwa Ibo, Opobo, Cross and Calabar Rivers,[81] some of which were supported by Naval Brigades under Admiral Frederick Bedford.[82]

Another major punitive expedition, the Brass Expedition, was launched by a combined force of Protectorate troops, Niger Company troops, and Admiralty bluejackets and marines, and took place between 17 February and 26 March 1895, this time to depose King Koko from his fortified town of Nembe. In their continued attempt to establish a monopoly on the Niger above Akassa, the RNC had begun treating traders from Brass seeking to operate in their traditional markets as foreigners, because Brass was in Protectorate rather than Company territory. They were subjected to new regimes of duty,

imposed with violence, and accused of smuggling when duties were evaded.[83] Matters came to a head on 29 January 1895, when 1,000 Nembe soldiers in 50 war canoes attacked the Company headquarters at Akassa, destroying workshops, stores, machinery and the engines of steamers.[84] The canoes were each fitted with a 'blunderbuss fixed on the gunwales – which fired bullets of various sizes, nails, bolts, and pieces of metal – and muzzle-loading cannon mounted in the bow and stern'.[85] The Nembe soldiers were accused of killing two dozen company soldiers, sacrificing prisoners, taking the heads of the deceased, and engaging in cannibalism, as well as plundering trade goods. Bishop Tugwell described the Akassa attack as 'a long cherished plan'.[86]

Because the attack was made from Protectorate territory, the Company were paid £20,000 in compensation for the raid by the Niger Coast Protectorate.[87] Led by Galway, the Punitive Expedition brought together Protectorate forces with HMS *Thrush* and *Widgeon*, the Niger Company's warships SS *Nupé* and SS *Yakoha*, to a combined strength of more than 300 troops, with three 7-pounder RML guns and a Maxim, under Galway, was launched on 20 February 1895.[88] Some 1,750 Nembe soldiers were engaged, and after a white flag of surrender was shown, the attack reportedly proceeded: shelling and burning the towns of Nimbe and Allagoa.[89] Sir John Kirk's *Enquiry into Outrage Committed on Brass People by Royal Niger Company* was highly critical of the actions of the NCP.[90] 'The pools of blood along the line of retreat were sufficient evidence that the retreating army had taken their killed and wounded with them', wrote one correspondent seeking to assess the casualties.[91] Mr G.A. Moore, of the Liverpool-based Oil Rivers Trading and Expedition Company, described the Company's conduct as 'a system of legalised murder'.[92] As another commentator put it:

> For showing discontent and causing trouble, in ways perhaps not unnatural to 'sniped', starved and defrauded savages, the Brass people were mowed down by Maxim guns and other 'resources of civilization' with inhumanity at least equal to theirs, the greater

offence of which was in proportion to the difference between these persecuted barbarians and their 'enlightened' persecutors.[93]

Kirk travelled to Niger Coast Protectorate in June 1894 to undertake investigations for his report. This valuable document, which contains the testimony of Chiefs as well as Protectorate and Company officials, gives a picture of the regimes of different forms of violence, including rape and torture, enacted by the British at this time. Kirk's report described how RNC officials 'have been in the constant habit of firing upon their canoes, without cause, whenever seen on the Niger, and seizing both boats and canoes', how people were regularly killed with no cause, and how those who traded or paid debts to Brass 'would be severely punished, and their villages burnt' by the Company, and that towns including 'Kiama, lower portion of Sabagreia, Tombia and Permoberi' had been destroyed, and that people were displaced in large numbers. The 'ill-treating of women' is attested to, as well as 'the wounding of people' by the Company.[94] In their letter to Kirk, dated 14 February 1895, the Chiefs of Brass vividly described the actions of the Company:

Including the Niger district down to us the people killed by the Niger Company annually without cause are over 100 men. This action they kept secret from your knowledge. But we have explained all these to you before. Even the innocent women were caught, stripped naked, and painted with coal tar all over the body, and driven away. We have before informed you of the cruel oppressions done us by the Niger Company. You are fully acquainted with same. Through all these actions and their saying that they will oppress us to such an extent that we Brass men shall eat dust; so, instead of living in the country and die of starvation, we were obliged to die in their hands. You said in your letter that we kill innocent people. In the war the agents of the Niger Company caught two of our boys, put them in irons, and afterwards cut off their heads and cut their bodies to pieces and thrown in the water. If we are said to

kill innocent people, the Niger Company first kill innocent people from us.[95]

Kirk's report also included harrowing fragments of first-hand descriptions of sexual violence, including the rape of a pregnant Ijo woman, who was the wife of the Chief of Ekpetyama, who later miscarried, and a woman taken into a store and stripped and tarred by the beach-master at Akassa, Captain Christian, with another white man.[96]

The momentum of violence gained further pace in the Protectorate's Ediba Punitive Expedition in February–April 1896. Here, the Protectorate returned to Ediba, where the town had been burned in October 1895, but where the inhabitants were allegedly 'continuing their evil practices', justifying a punitive action. Operations concluded when a Chief was hung on Ediba beach, a new treaty was signed, and a detachment of an officer with 25 NCP troops were permanently stationed at Ediba, but not before the force of 150 men burned at least 11 villages, and hunted down those who fled: 'The people of Esubndon and the other towns and villages that we had burnt were scattered and living in the bush. In order to drive them out we divided into three parties, and spent some days in scouring the country. It was now twelve days since we commenced punishing these people.'[97]

Further attacks, including the Agbor and Cross River Punitive Expeditions, were made over the course of 1896. In the case of the latter, in August a Protectorate force of 200 men with two 7-pounders and a Maxim travelled up the Cross River in a steamship 'to visit certain towns some 160 miles up the Cross River, to palaver with them, and if necessary, to punish them for their having constantly stopped trade on the Cross River'. On 22 August 1896, they shelled and burnt the town of Ediba after its Chief refused to meet with them. Having travelled to various other towns, including a palaver at Nsi Atam to discuss the disposal of hunted ivory, they shelled and burnt the town of Obudura, and continued to patrol the river at Unwana for two months.[98] Also in 1896, the Protectorate seized Bakisuku (Amayanabo of Okrika), of the town of Oporo, and destroyed religious sites and buildings, an official report stating that 'The Ju-ju houses lined with the skins of

human victims were all destroyed, and the natives promised to give up cannibalism.'[99]

Throughout these operations, official reports repeatedly stated that 'It is impossible to form any idea of the number of natives killed' due to the mode of operations in the jungle with rockets and machine guns.[100] Working through this history of violence, it is clear that the many expeditions were part of an ongoing campaign – one that extended not just beyond individual events, across the 1890s, but also geographically across British interests in Africa – a self-styled War on Terror.

7

War on Terror

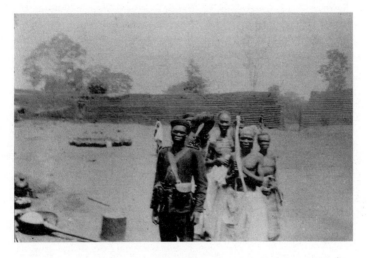

My career as Secretary of State for the Colonies is yet to be made; but I will say that no one has ever been wafted into office with more favourable gales. I will venture to claim two qualifications for the great office which I hold, and which, to my mind, without making invidious distinctions, is one of the most important that can be held by any Englishman. These qualifications are that, in the first place, I believe in the British Empire and, in second place, I believe that the British race is the greatest of governing races that the world has ever seen. I say that not merely as an idle boast, but as proved and evidenced by the success which we have had in administering the vast dominions which are connected with these small islands, and I believe accordingly that there are no limits to its future.

<div align="right">

Joseph Chamberlain, Secretary of State for the Colonies,
November 1895[1]

</div>

We get a sense of Chamberlain's ambition and world-view from these words, given at a banquet at the Imperial Institute on 11 November 1895. In the longer-term processes of growing consular power, gunboat politics, and the frontier of militarist-capitalist colonial rule in a new phase of British imperialism, from which the sacking of Benin City in 1897 emerged, the new catalyst of a *fin-de-siécle* 'rogue-empire' phase of this Tory–Liberal coalition must not be understated. The coming to power on 25 June 1895 of the Unionist coalition government which returned Robert Gascoyne-Cecil, 3rd Marquess of Salisbury, to his third term of office as Prime Minister with Chamberlain as Secretary of State for the Colonies, in the final years of Victoria (1895–1901), brought new extremes in militarist-corporate colonialism to Africa. This was the administration that took the British Empire in Africa careering towards the Second Boer War (from 1899), using it to win a landslide second term in 1900.[2]

The changing colonial strategies of France, Belgium and Germany witnessed the emergence of a new phase in the scramble for Africa, based on the new military possibilities brought by the Maxim machine gun, and brought British interests new competition for territorial sovereignty in West Africa over the course of the 1890s: from French Sudan to the north and French trans-Saharan expansion towards control of the Upper Niger, French Dahomey to the west, German Kamerun to the east, and King Leopold's Congo Free State beyond. In 1892, a dispute with France over the incursion of the 'Soudan Expedition' of Lieutenant Antoine Mizon into RNC territory had increased pressure on Britain over control of the northern areas above the Niger-Benue rivers. Meanwhile George Goldie's becoming Governor of the Royal Niger Company in 1895 after Lord Aberdare's death gave a new energy to the corporate-militarist colonialism on the Niger River. The increasingly confident Goldie used 'informality' as a way of achieving violence with carte blanche; as he put it in a letter to the Foreign Office in August 1896, lobbying for the promotion of Lieutenant Arnold who was Commandant of the Company's military force and would lead the Niger-Soudan expedition the following year: 'The whole idea of Chartered Companies is illogical from the point of view

of the constitutionally "doctrinaire". It is a rough and ready way of extending the empire and commerce of Great Britain and demands measures as irregular as itself. We are doing ~~good~~ your work at our risk' (strike-through in original).[3]

The term 'militarist colonialism', which I have offered as an alternative to the euphemisms 'informal empire' or 'gentlemanly capitalism', might also present a foil here to Joseph Chamberlain's preferred phrase, 'constructive imperialism' – a concept that went hand-in-hand with his idea of empire as a blank landscape of outlying estates, neglected by their absentee owners,[4] a metaphor that he associated, in his famous speech in the House of Commons, a few weeks after taking office in 1895 as Secretary of State for the Colonies, with applying different rules to 'savage countries': 'I regard many of our colonies as being in the condition of undeveloped estates, and estates which can never be developed without Imperial assistance. It appears to me to be absurd to apply to savage countries the same rules which we apply to civilised portions of the United Kingdom.'[5]

The first years of the new coalition administration brought a wholly new phase of colonial violence, in the form of the active removal of long-standing powerful kings – in each case based on accusations of illegal acts and barbaric practices, a favourite amongst which was slavery – defining each ruler as overseeing failed regimes of terror, which needed to be ended through war.

The French sacking of the palaces of Abomey in Dahomey (today the Republic of Benin) in 1892 – during which royal art and brass plaques were looted, King Béhanzin exiled to Martinique, and Dahomey made a French colony – had been in significant contrast with the 1892 treaty with the Kingdom of Benin. A key figure in the new regime was Admiral Harry Holdsworth Rawson, who was appointed Commander-in-Chief at the Cape of Good Hope on 4 May 1895. Rawson had 'a lifelong friendship with Queen Victoria', having served on the royal steam yacht HMY *Victoria and Albert II*.[6] Rawson brought the fire power of his squadron of 15 warships to support a series of these new 'small wars' to unseat powerful political, spiritual and royal figures.

In East Africa, the establishment of the Protectorate of Uganda in 1894 and East Africa Protectorate in 1895, and the rationalisation of the position of the Imperial British East Africa Company, bore similarities with the processes on the Niger River. The strategic control of the Indian Ocean coastline and connections was a priority. During a dispute over the sheikhdom of Takaungu (today on the Kenyan coast), where a replacement had been selected by the Company, which was actively resisted by the rightful claimant, Sheikh Mbarak bin Rashid al-Mazru'i, large-scale military action was taken to support the newly appointed Commissioner of the Protectorate Arthur Henry Hardinge, in defending the interests of the Company. Hardinge had been Secretary to Lord Salisbury in his role as Foreign Minister from 1885 and Consul General in Cairo, before becoming Consul General in Zanzibar and taking up the Commissionership of the East Africa Protectorate in July 1895. Like Rawson, Hardinge was close to the Queen, having been Page of Honour to Her Majesty between 1870 and 1876, aged 11 to 16. (Later in life, Hardinge was British Ambassador to Spain and in 1923 a founding member of the Grand Council of Rotha Lintorn-Orman's blueshirts, the British Fascisti.) During July–August 1895, Rawson oversaw a series of naval actions along the coastline and inland, including the burning of Gongoro to the ground and the Mweli Expedition, marching inland from Mombasa for five days, which culminated in the storming of the stronghold of bin Rashid at Mweli, and its destruction.[7]

The following summer, on 27 August 1896, Rawson oversaw the bombardment of the Sultan's palace and harem at Zanzibar by HMS *Sparrow*, *Thrush* and *Racoon*, feted by the Victorians as 'the shortest war in history', lasting 38 minutes. Again, this began with a dispute over succession, after the death of Sultan Hamad bin Thuwaini on 25 August. The title was expected to be passed to Sultan Khalid bin Barghash, rather than the British preference of Hamud bin Muhammed, and he entered the palace with several thousand supporters, including the sultanate force of some 1,200 men.[8] Using the justification of a treaty signed in 1886, which included a clause stipulating that accession to the sultanate was contingent on securing the

approval of the British Consul General, the British expected him to stand down, but only a matter of hours later the attack took place, citing 'open defiance' as a just cause for the use of violence, and the palace was burned to the ground and raided, with an estimated 500 troops and an unknown number of civilians killed. The Sultan fled and Hamud bin Muhammed was installed later that day, just 48 hours after the death of the previous Sultan, issuing a decree abolishing slavery on 6 April 1897.

Between these two summer 'expeditions', Rawson brought the squadron to the Gold Coast of West Africa in December 1895–January 1896, to support the removal of the Asante King Prempeh I at Kumasi, during the so-called 'Second Ashantee Expedition', or Fourth Ashanti War. Unlike the East African expeditions, the Ashantee Expeditionary Force was a British Army operation, led by Colonel Francis Scott. Following the earlier Ashantee Expedition of 1873–74, the Gold Coast Protectorate had been established in July 1874, stretching from the Gold Coast Colony along the coastal region inland to the Asante Kingdom. After 14 years of periodic conflict under the British, Asantehene (King) Prempeh I had gained accession to the throne in March 1888 with the support of the colonial administration, but various disputes over the conditions of trade arose between the Palace and the British, and a claim for 50,000 ounces of gold was issued to Prempeh, the British claiming license under the treaty signed in 1874. Claiming a lack of response by the King, they launched a punitive military attack. Special service officers from across the UK arrived alongside soldiers from the West India Regiment, and Gold Coast and Lagos Hausa troops. Roadways were cut through the bush, and some 13,000 carriers and scouts were involved. A surrender was issued by the King, and he was exiled with the Queen Mother and Chief. Sacred buildings at Bantama were burned, and there was widespread looting of gold and royal and sacred objects. The King was replaced by a Resident at Kumasi, Captain Donald Stewart, and a fort was built. A major bloody conflict ensued, culminating in the War of the Golden Stool in 1900 – sparked after the Resident sat on the Stool, a highly provocative act that led to the deaths of thousands.

In these wars on supposed terror, a kind of temporal violence was enacted in the form of reciprocity. What I mean by this is that just as the theory of 'militarist colonialism' in practice justified theft as a kind of repayment, so the same mental process took place in the justification of war. In both cases, the operation involved a shuffling in time frames. African retaliations to violence were presented as having been premeditated for years in advance, while long-planned British attacks were claimed as purely reactive – against slave-raiding in Company territories to the north, and against human sacrifice in Protectorate territories to the south. These temporal projections – part time-warp, part head-trip – marked the ideology of militarist colonialism and signalled the beginning of militarist humanitarianism: the use of a 'human rightist' justification for unprovoked regime change.

* * *

In this longer-term context, it is no longer acceptable for museums, not least the Pitt Rivers, to continue to repeat the story of the so-called 'Phillips massacre' of January 1897, which was nothing but a pretext for the real massacre. The fact is that an attack on Benin City had been planned for years, and the momentum gained significant pace under the new Coalition Government after the summer of 1895. The economic motivation and the pure sham of the humanitarian justification for the expedition have been clear to historians for decades.[9] Numerous official reports stated clearly that 'an expedition was preparing in December by the protectorate forces against Benin City', before the Phillips incident,[10] and it is clear in terms of simple logistics that an operation of this scale could not have been planned and delivered between mid-January and mid-February 1897.

Although the Colonial Office had refused a request by the Protectorate to grant approval for an attack on Benin City in spring 1895, by autumn 1896, preparations for an attack in February 1897 were clearly already well under way. In January 1897, the *Scotsman* claimed that planning for the Punitive Expedition had involved 'an elaborate survey of the rivers and waterways leading into Benin territory made by the Niger Coast Protectorate over a year ago'.[11] Military officers

participating in an expected Royal Niger Company expedition, against an unknown target, had already arrived on the Niger River in November 1896.[12] Aware of the growing threat, a war camp of up to 10,000 soldiers was established at Obadan, to the north-east of Benin City, and a royal order was sent out to every town and village in the Benin Kingdom to send soldiers.[13] Rumours circulated that the Oba might make a pre-emptive attack on the coastal trading post of New Benin.[14]

Reporting of the high-profile events of the Ashanti Expedition of 1896 had immediately catalysed new calls from Liverpool traders, evangelical missionaries and others for an equivalent mission against Benin City. The case was made on the basis of broken terms of a treaty, and for a familiar host of other complaints, from slavery to non-Christian religious practices – including the assertion, as with the Brass Expedition, that the site of these offences lay within Protectorate territory. Given the imprecise nature of the boundaries, the question of whether Benin City came under Company or Protectorate jurisdiction had been previously challenged – but it had been resolved. In 1894, a dispute had arisen when W. MacTaggart of the Royal Niger Company had taken a military force of 40 soldiers with a large team of carriers to Benin City. This was quickly condemned by the Protectorate as an act of trespass, undertaken 'without any credentials beyond an armed party'.[15] Two years on, pressure could now be exerted on the Protectorate to suppress slavery, barbarism and the breaking of written treaties, within its territory – as it had done in the case of the Brass Expedition.

At a meeting of the African Trade Section of the Liverpool Chamber of Commerce on 31 January 1896, letters from Messrs Elder, Dempster and Co. and Mr J. Pinnock were read, complaining that 'this tyrant would not allow his own people to crack palm kernels, sell gum, or collect rubber.' After the usual points about barbarity and trade potential, 'it was decided that a letter should be written to the Foreign Office, asking for Government intervention, Benin lying within or on the border of the Niger Coast Protectorate.'[16] On 15 February 1896, the *Edinburgh Evening News* ran the following opinion piece, captur-

ing the mood in which the Liverpool Chamber of Commerce were calling for such an expedition:

> Whatever our colonial policy has been in the past, humbug has certainly not been its predominating note. It has been reserved for our own days to go to and fro on the earth seeking whom we may devour, under the guise of apostles of civilisation. Colonial expansion is carried on under Pecksniffian auspices. We strike to elevate the poor native's untutored mind by means of tracts, but we take good care that each bundle of tracts includes an unsigned mining concession for our own benefit. We send out an expedition to put an end to atrocities in Ashantee, and then quietly congratulate ourselves that the country is worth exploiting. Ashantee has proved an attractive example. Yesterday the Liverpool Chamber of Commerce resolved to appeal to the government to put a stop to the atrocities in Benin. Details are given of barbarities practised by the native monarch. Then it is added that the Benin country is rich in palm oil, gum and rubber but it is impossible to develop the resources of the district because of the obstructive tactics of the potentate. One may well admire the fine morality of this proposal. The government is in effect asked to ship out men and Maxims, mow down as need be a few hundreds, or a few thousands, of the natives, all for their ultimate good, of course, and by way of introducing them to the grandeur of civilisation. After the mowing down process is completed the palm oil, the gum and the rubber of the Benin country will be peaceably exploited by European traders. Probably the natives in return will make an acquaintance with the European civilisation in the form of rum ... At all events, Liverpool Chamber of Commerce considers that an admirable case has been presented for the intervention of the British Government. After Ashantee, Benin should be next in the Colonial Secretary's line.[17]

A central figure in making these calls from Liverpool was the long-standing Niger River trader James Pinnock, who poured out the

following breathless letter to a number of British newspapers in early February 1896:

> I have recently addressed a letter to the Secretary of the African Section of the Liverpool Chamber of Commerce soliciting that important body to urge on Her Majesty's Government the great necessity of sending a force to the city of Benin on the West Coast of Africa, with a view of compelling the blood-thirsty sable potentate ruling over those dominions to cease the appalling human sacrifices almost daily committed by his orders, and to force him to permit his people to trade with Europeans in the valuable productions of their country. The remedy for this awful state of affairs must be enforced some time soon, and the sooner the better. The City of Benin is within a hundred miles of the important British colony of Lagos on the one side, and thirty miles off the British flag on the other, in the Niger Coast Protectorate. Not the slightest improvement in trade has taken place as any history carries us, and the horrible native sacrificial customs are as terrible as ever. Once free the people from such barbaric rule, and the country could vie with the very flourishing adjacent colony of Lagos in its commerce, both export and import: and by its great consumption of English manufactured cottons and other goods would give more employment to the working peoples of this country. Apart from all consideration of commerce on both sides, the depopulation of the country by human sacrifices would be a sufficient reason for Her Majesty's Government stepping in to suppress horrors more atrocious than anything depicted in history; and this in a country which is practically British territory. The voice of a Wilberforce is wanted in defence of the subjects of the monster at present ruling at Benin City. A force of black troops (Africans) is all that would be necessary and would not prove one-hundredth part as costly and troublesome as the recent Coomassie Expedition.[18]

At the next meeting of the Liverpool Chamber of Commerce African Trade Section, on Friday, 6 March 1896, a letter from the African

Association suggested that Galway's evidence from 1892, presented to Parliament in September 1893, had 'reported Drunami [Ovonramwen], King of Benin, to be on a par with the late King of Dahomey: the country is described as wealthy and the customs as cruel and barbarous'. A reply from the Foreign Office was read out, acknowledging receipt of the Section's letter 'calling Lord Salisbury's attention to the condition of matters in the kingdom of Benin'. It included a copy of the 1892 treaty and stated that 'Her Majesty's Commissioner and Consul-General had been instructed in November last [1895] to reopen communication with King Drunami, and that the question of the proper opportunity for enforcing the provisions of the treaty would receive due consideration.'[19]

After McTaggart's attempted RNC visit to the City of Benin in 1894, further audiences with the Oba were sought by the NCP, unsuccessfully. Three attempts were made by Protectorate officials to visit Benin City between September 1895 and mid-1896: by Major P. Copland-Crawford, Vice Consul of the Benin District, then by Locke, Vice Consul Assistant, and then by Captain Arthur Maling, the Commandant of the Niger Coast Protectorate Force detachment based in Sapele.[20] On 19 February 1896, the *Liverpool Mercury* reported:

> On 18th ult. Dr Fagan of the Niger Coast Protectorate arrived in the Forcados River in the mail steamer Cabenda from Old Calabar, for the purpose of going to Sapele in the Benin River to join Acting-Consul Major Crawford in an expedition to the Benin country. Major Crawford, who is the NP consul at Waree, had left that place for Sapele. The expedition was to be of a friendly nature, to try and induce the King of Benin to remove the restrictions on trade and to allow his country to be opened up in accordance with the treaty the British have with him. This will be the second attempt that Major Crawford has made to visit Benin City. On the previous occasion he had to return by order of the King. There are a force of black troops, nearly 100 strong, at Sapele, but it is understood that only a few of these would be taken.[21]

Then, on Monday 16 November 1896, Acting Consul of the Niger Coast Protectorate, James Phillips[22] made his intentions clear when he wrote to Prime Minister Salisbury:

The King of Benin has continued to do everything in his power to stop the people from trading and prevent the Government from opening up the country. By means of his Fetish he has succeeded to a marked degree. He has permanently placed a Juju on (Palm) Kernels, the most profitable product of the country, and the penalty for trading in this produce is death. He has closed the markets and has only occasionally consented to open them in certain places on receipt of presents from the Jakri chiefs. Only however to close them again when he desires more blackmail ... I feel so convinced that every means has been successfully tried that I have advised the Jakri chiefs to discontinue their presents ... To sum up, the situation is this: – the King of Benin whose country is within a British Protectorate and whose City lies within fifty miles of a Protectorate Customs Station and who has signed a treaty with Her Majesty's representative, has deliberately stopped all trade and effectually blocked the way to all progress in that part of the Protectorate. The Jakri traders, a most important and most loyal tribe whose prosperity depends to a very large extent upon the produce they can get from the Benin Country, have appealed to this Government to give them such assistance as will enable them to pursue their lawful trade. The whole of the English traders represented on the River have petitioned the Government for aid to enable them to keep their Factories open, and last but not perhaps least the Revenues of the Protectorate are suffering. I am certain that there is only one remedy, that is to depose the King of Benin from his Stool. I am convinced from information, which leaves no room for doubt, as well as from experience of native character, that pacific measures are now quite useless, and that the time has come to remove their obstruction. I therefore ask for his Lordship's permission to visit Benin City in February next, to depose and remove the King of Benin and to establish a native council in his place and to take such

further steps for the opening up of the country as the occasion may require. I do not anticipate any serious resistance from the people of the country – there is every reason to believe that they would be glad to get rid of their King – but in order to obviate any danger I wish to take up a sufficient armed Force, consisting of 250 troops, two seven-pounder guns, 1 Maxim gun and 1 Rocket apparatus of the Niger Coast Protectorate Force (NCPF) and a detachment of Lagos Hausas 150 strong, if his Lordship and the Secretary of State for the Colonies will sanction the use of the Colonial Forces to this extent. I would add that I have reason to hope that sufficient ivory may be found in the King's house to pay the expenses incurred in removing the King from his Stool.[23]

It is clear that preparations were being put in place during the month after the receipt at the Foreign Office of Phillips's letter pressing for the removal of the Oba, while both Goldie and Moor were in London: not least because of War Office correspondence dated 24 December 1896 confirming the agreement and arrangement of the expedition with the Colonial Office, and the Foreign Office's advanced discussions over the details with Ralph Moor between 26 and 29 December.[24] Indeed, Phillips's plan was clearly expressed in a report from 6 January 1897 in the *Daily Mail*, based on the testimony of passengers who had arrived at Liverpool that day on the steamer *Bathhurst*, having left Forcados on 10 December:

At that time [10 December] preparations were being made for an expedition up to Benin City by the Niger Coast Protectorate. The Acting Consul General [Phillips] was to accompany the expedition, which was at first to be a pacific one to ask the King of Benin to remove the obstacles he places in the way of trade. Seeing that the King is a 'Ju-Ju' follower and that his city is, so to speak, full of the remains of human sacrifices, it was not expected that he would agree to the protectorate officials' request, and in such an event it is intended to get the sanction of the Foreign Office for an armed expedition to proceed against this monarch, who recently threat-

ened death to the next white man who attempted to visit him. Benin City is within the British territory of the Niger Coast Protectorate and it is the only place within the sphere where human sacrifices take place.[25]

Running the same story, the *Liverpool Mercury* reported further clear evidence that the Phillips visit was a prelude to a planned military attack: 'It was fully believed that force would have been resorted to [in order] to stop the great slaughter of human life at Benin City, and also to remove the present trade obstacles imposed by the King.'[26]

The same day, the *Pall Mall Gazette* amplified the message of the Liverpool traders, with the headline 'Human Sacrifices on British Territory', and reported that it was a Niger Company expedition, rather than a purely Protectorate venture, that was imminently expected to depose the Oba of Benin.[27] Meanwhile, on 6 January 1897, the mail steamer *Calabar* also arrived at Liverpool from New Calabar, and brought news that the previous year's operations against the Okrika Kingdom had led to the escape of the King and failed operations to recapture him, and *The Times* reported, in the usual hyperbole of Flora Shaw, that traders at Bahana, near Okrika town, took reports of intentions to 'chop the white agents' as threats of invasion and cannibalism – despite her knowing that the term 'chop' meant to meet and do business.[28]

It is in this context that James Phillips – aged 32, son of the Archdeacon of Furness, a lawyer and alumnus of Trinity College Cambridge, 'Sheriff and Overseer of Prisons' on the Gold Coast since 1891, promoted to Acting Queen's Advocate of the Gold Coast in 1896, Acting Consul General in the absence of Ralph Moor, newly arrived in the Niger Coast Protectorate on 24 October 1896 – set out from Gwato towards Benin City, with a party of eight other white men, each with their servants. With them were Herbert Clarke, an 'interpreter and political agent', a second interpreter named Towny, Mr Baddoo who was chief clerk in the Consul General's Office in the Gold Coast, a cook from the same office also named Baddoo who was possibly the clerk's wife, a steward and Sapele shopkeeper named Owoo, and 215

iJekri and Kroo carriers.[29] The party reportedly took no firearms apart from revolvers.[30] What should we make of the familiar story of the 'massacre' of this expedition?

Gwato was the traditional and routine starting-point for whites wishing to visit the City of Benin, where a royal official would oversee exchanges with the Oba,[31] and here Phillips received the direct warning via Chief Dore Numa, the royal agent on the Ikpoba Creek, that any white man seeking to come to the City would be killed, presenting a problem for this strategy.[32] Phillips pressed on regardless, doubtless aware of the potential risks. In his final letter, to Captain Child on the *Ivy*, after landing at Gwato on 3 January, Phillips explained how he had decided to send the military band back to base: 'we have been threatened and solemnly warned at every step that the soldiers of the King of Benin are waiting to fire on us if we dare to land at Gwato. So much so that in a panic I sent back the [Brass] Band for which I am sorry now. However here we are.'[33]

Initial press reports stated that all nine white men had been killed, along with all 250 carriers. What is reasonably certain is that on 4 January at least four of the nine whites were killed at the village of Ugbine, near Ughoton: Phillips himself, Vice Consul Major Peter Wade Grant Copland-Crawford (Vice Consul of Benin and Warri Districts), Dr Robert Elliott (Medical Officer of Sapele and Benin District), and Captain Arthur Maling of the Niger Coast Protectorate Constabulary.[34] Described variously as an 'ambush' and a 'massacre', the circumstances of their deaths are unclear. Alan Boisragon (Commander of the Niger Coast Protectorate Forces) and Ralph Frederick Locke (District Commissioner of Warri District) emerged from the bush a few days later. The eyewitness accounts of Boisragon and Locke do not describe the deaths of the other three whites, who were Mr Kenneth C. Campbell[35] (District Commissioner of Sapele) and two traders' agents, Harry S. Powis of the Glaswegian Miller, Brother and Company (based at Sapele) and Thomas Gordon[36] of the Liverpool-Hamburg company the African Association (based at Old Calabar) – although the official report to the Foreign Office on 23 February claimed that Powis and Gordon were shot dead.[37] In his

reassessment of the incident, Robert Home concluded that these other three whites may have been taken to Benin City as hostages, and perhaps lost their lives before or during the British attack of the subsequent month.[38] Subsequent claims that 'more than 200 carriers were killed' are not clearly substantiated by the documentary record.[39] Indeed perhaps the only published eyewitness account apart from Alan Boisragon's book was the testimony of Chief Ojo Ibadan, written up two years later by Boisragon (and so hardly an impartial record of what he said) and published in a local newspaper piece titled 'The Romance of Adventure', which stated that 80 black men had been killed and 120 prisoners taken to Benin City.[40]

The *Daily Mail*, reporting on 16 January on a private telegram received in London with news of Boisragon and Locke's survival, stated that 'it is also rumoured that Mr Powis escaped', and another source stated that Powis 'was made a prisoner'.[41] Various reports suggested that the expedition 'offered a stout resistance'.[42] This description might call into question the unarmed status of the expedition, not least when considered alongside Galway's published recollection of discovering the site of the 'massacre' after the sacking of Benin City: this description of the road strewn with bodies might relate to a slaughter of the peaceful expedition carriers, or to a more sustained two-way exchange:

> As soon as the Naval Brigade had left Benin City, I was deputed, with a company of Hausas and a Maxim gun, to open up the road from the city to Gwato, and to allow the Naval Force at the latter place to re-join their ships. I was therefore the first to visit the scene of the massacre. About a mile of the road was strewn with bodies, all in the skeleton stage. I had the remains collected and buried, and read a short service over them.[43]

Whatever the reality of the Phillips incident, the technique of the fabrication of a slight won through: that skill in the exchange of agency for the creation of victimhood, refined in earlier punitive expeditions. The technique was to be seen to want to speak, to be refused

a meeting, and so to sign one's own carte blanche for a retributive attack. The deaths were quickly spun as a 'massacre'. On 13 January, the *Daily Mail* reported that 'in addition to the murder and capture of nine British officers there is reason to fear that the 270 Kroomies who went up with the expedition were killed ... on the West Coast "Ju Ju" as a religious sacrificial cult is said to be paramount, and this accounts for the wholesale putting to death of victims by the monarch.'[44]

The Phillips incident was first reported on 12 January in *The Times*, following a Reuter's dispatch from Bonny on 11 January.[45] On the same day, the *Daily Mail* added that the city 'lies within the sphere of the Niger Coast Protectorate' and was 'the seat of a powerful theocracy of fetish priests, and used to be famous for its human sacrifices'.[46] The following day, 13 January, the *Daily Mail* reported that a meeting of Cabinet from 3.30 to 6 pm on the previous day discussed 'the feared massacre of the British expedition to Benin. The Government, it is understood, had determined to replace its officers without delay, and punitive measures will be undertaken at the earliest possible period.'[47]

It is telling that no record appears to be extant of a reply from Lord Salisbury to James Phillips until the telegram sent on 9 January, supposedly cancelling the expedition because of the difficulty in raising 400 troops, until 54 days after his letter had been written.[48] This was two days after news of the incident of Monday 4 January had reached Sapele, on Thursday 7 January, and just one day before the telegram from Henry Child for the Crown Agents for the Colonies with the news was sent from Bonny and received at the Foreign Office, on Sunday 10 January[49] – a telegram with which the official paper trail presented to both Houses of Parliament on the *Massacre of British Officials Near Benin and the Consequent Punitive Expedition* began.[50]

The Prime Minister's reply to Phillips, in his capacity as Foreign Secretary, after that 53-day pause, on Saturday 9 January – when the Acting Consul General had been dead for five days – represents extremely odd timing, to say the least. Indeed it recalls a Christmas season incident of time-juggling over the sequence of events through which authority for another iconic military action was given, almost precisely twelve months previously: the advance of the Jameson Raid

carried out by Cecil Rhodes' South Africa Company against the South African Republic on 29 December 1895–2 January 1896. Then, the key figure had been Flora Shaw, the Correspondent for the Colonies at *The Times* and a close friend of both Rhodes and Goldie, as well as of the future first Governor of Nigeria, and her future husband, Frederick Lugard. Shaw later said of her professional life that she had 'never thought of my work exactly as journalism, but rather as active politics without the fame',[51] but her involvement in the politics around the Jameson Raid was sufficiently open for her to be required to give evidence to the Select Committee investigating the Raid. Just as in the Niger Delta, so in South Africa the Company–Protectorate distinction mapped in London onto the Foreign Office and the Colonial Office respectively. The Jameson Raid was a disastrous plot to seek to incite a revolution in the South African Republic to overthrow the Protectorate, to the benefit of the Company; it effectively ended Rhodes's political career. In late November, Dr Jameson had procured a letter signed by five key figures of authority calling for the Raid to take place, and showed it to Rhodes on 20 December. On 14 February 1896, Sir William Harcourt MP explained to the House of Commons that copies of this letter dated 20 December had been found on the battlefield – but when published in *The Times* on 1 January, the text 'was post-dated so as to make it appear that it was written on the 28th December, the day before the advance began'.[52] The Select Committee found that Cecil Rhodes had cabled the letter to Flora Shaw in advance, 'for insertion in *The Times* newspaper with a date filled in that made it appear that it had been sent as an urgent appeal from Johannesburg just before the Raid'.[53]

The possibility that over Christmas 1896–97, Flora Shaw was again involved in forging the propaganda for a major corporate colonial operation becomes significantly more probable when we consider the timing of the publication in *The Times* of her most famous and influential piece of colonial writing – in which she coined the name 'Nigeria'. Shaw's long article, clearly pre-prepared for publication at the right moment, appeared on page 6 of *The Times* on Friday 8 January, less than 24 hours after news of the Phillips incident had

reached Sapele, and the day before the Prime Minister's reply to the dead Phillips. Its importance for the vision of the events that were about to unfold were critical. 'Nearly two months have elapsed since the despatch of additional officers and war-like stores to the territories of the Royal Niger Company prepared the public mind for probable military operations in these districts,' she wrote. Shaw's noting that Sir George Goldie, Governor of the Company, had arrived at the Company's military headquarters at Lokoja on New Year's Day was significant, not least because it was unlikely that he would be away from telegraph contact, the 'air-line' infrastructure for which had been a priority investment for the West African Frontier Force under Frederick Lugard, to connect from Lagos to Fort Goldie and towards Lokoja.[54] Just as Shaw had been in daily telegraph contact with Rhodes across New Year 1895–96, it is very likely that she was engaged in similar exchanges with Goldie and Lugard during the first days of the year 1897, as plans for the Expedition were developing. Indeed in a letter to Alfred Lumley, Earl of Scarborough and Deputy Governor of the Royal Niger Company, on 12 January 1897, Shaw wrote that she 'trusted *The Times'* suggestion of the name "Nigeria" was acceptable' to him, and thanked him for the loan of his diary.[55] The most probable explanation of the timing of Shaw's *Times* article and the Prime Minister's telegram is that news of the Phillips incident had reached Shaw by private telegram, just as regular updates on the Jameson Raid had done.[56]

Shaw's article set out a vision for an immensely radical shift of policy – the unification of North and South, the territories of the Company and the Protectorate, and the formation of Nigeria. While it was widely expected that the Protectorate might see the revocation of the Company's charter in the wake of the damning *Kirk Report*, and the removal of Rhodes and Beit from their directorships of the British South Africa Company in June 1896 after the Jameson Raid, Shaw's rhetoric set the scene for a wholly unexpected corporate-colonialist military operation, at an unprecedented scale in the region. While Goldie's stated policy for the Company was 'to continue its system of pressing forward as rapidly as means will allow, and in the meantime

to say as little as it may about what it is doing' continued,[57] Shaw's tel-egraphic newsprint propaganda was a crucial weapon in the armoury.

It was in this context that James Phillips set out on his supposedly peaceful expedition to Benin City, while his superior Ralph Moor was in London. The rationale for Phillips's action has been unclear to many commentators over the years, but would fit logically with the pattern of earlier punitive expeditions if his intention was a purely cosmetic prelude to an attack: the performance of seeking an audience with the Oba to ask him to keep to the terms of the 1892 treaty, and being refused. By carefully timing this attempt at a 'parley' to coincide with the period of the Ague Festival, Phillips presumably expected to achieve his aim, because it was fully understood that during this cer-emonial season the Oba was in a period of ritual isolation and could not receive visitors. There may also have been an expectation on Phil-lips's part that guns would not be fired at this time, something that would also explain the claim that the action was unarmed – as both a safe course of action and an attempt to feign respect for Bini tradi-tion, and the sincerity of the attempt to negotiate.[58] Perhaps Phillips's recent experience on the Gold Coast, of the bloodless nature of the Ashantee Expedition of the previous year, shaped his thinking. An additional factor may have been the humiliation that whites making an incursion on the City during a sacred period concerned with 'the ownership, pollution and sanctification of the land', and the ancestral past, would have brought. Meanwhile, however, unrest was develop-ing across the region; rumours of a renewed attack from Brass on the Company territory[59] and the recent escape of King Bakisuku of Okrika, who had been imprisoned by the Protectorate at New Calabar since 1896, and was now on the run, were also causing anxiety.[60]

Phillips's prize of being seen to have been refused by the Oba can, then, be expected to be something desired by the Protectorate both to convince the Foreign Office of the need for war,[61] and to build the public case for this action against the King. It is also far from incon-ceivable that Phillips's action was encouraged by the Protectorate and Goldie's Company as, under ideal circumstances, a provocation leading to retaliation that would justify war. Certainly the arrival of

Goldie at the mouth of the Forcados River on 28 December 1896, en route to Lokoja, in advance of what the *Standard* reported on 2 January as 'a step in advance towards the beginning of a warlike Expedition ... to proceed against some unnamed Chief or Chiefs in an undefined part of the vast territories between the coast lands and the Western Soudan',[62] represented an important context in which Phillips took the journey to Gwato on the very same day on behalf of the Protectorate. 'Nothing has been divulged as to the direction in which the force will operate,' the *Pall Mall Gazette* reported on 4 January.[63]

8

The Benin-Niger-Soudan Expedition

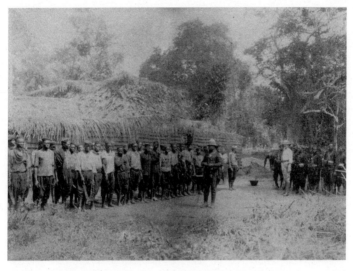

From a military point of view, the Benin Expedition constituted
a secondary theatre of war in comparison with other British cam-
paigns in Africa.

<div align="right">

Barbara Plankensteiner, Director of the
Museum für Völkerkunde, Hamburg, 2007[1]

</div>

Barbara Plankensteiner is a leading expert on the material culture
looted from Benin City in 1897, but in her assessment of the military
importance of the Benin Expedition, she could not be further from the
truth. In reality, the events of spring 1897 represented a 'momentous'
event in human and cultural loss, and an iconic moment, a water-
shed, in the ongoing shifting, accelerating processes of the propaganda
of domination – a lasting image of the reduction of the 'liberty and

equality' of colonial subjects, in which 'for the imperial idea to succeed, the European powers depended on exercising their military power over African peoples.'[2] The geographical extent of this event reached across both Company territories in the north and Protectorate territories in the south, bringing not so much a decisive military conquest as a new scale in democide, in which so many – how many? ten thousand? fifty? seventy thousand? – soldiers and civilians were killed in what is today Nigeria, scores of towns and villages were razed to the ground, and many more were wounded, displaced and terrorized, and two immensely powerful royal leaders were violently deposed.

Far from a secondary campaign, the joint action of the Company and the Protectorate represents the foundational moment in the creation of Nigeria as a British colony. Historians have emphasised the personal and political differences between the Company and the Government in this period, and it is certainly the case that decision making operated differently for the Company as compared with the Protectorate. But the Government had a common direction of travel, involving the gradual alignment of the interests of the Foreign Office and the Colonial Office. The historical narratives that we inherit have been shaped by the active playing-down by the Colonial Office of the significance of the Company's actions,[3] but in the longer term, and with an awareness of the significant resulting profit for the Company, the collaborative aspects should not be neglected, as well as ongoing discussions between Moor and Goldie over the future of the Company[4] and the earliest phases of Frederick Lugard's building-up of the West African Frontier Force after he was recalled from South Africa in 1895.[5]

On 8 January, Flora Shaw's article in *The Times* presumed to give the name 'Nigeria' to this conquered region as if it were already a British possession, and as if territories had 'been brought through the exertions of the RNC within the confines of a British Protectorate and thus need for the first time in history to be described as an entity by some general name'.[6] Even then, as the Company forces were beginning their action, the eventual form of the military operations was not finalised.[7] It was clearly planned that a major focus of the Company

would be within their territories, and on 6 January this had begun. But the nature of how the collaboration between the combined forces of the Company, the Protectorate, the West Africa Frontier Force, the Admiralty, and the dozens of 'special service' officers that had been and were still being recruited for the action by the Foreign Office, was only finalised in the coming days – indeed on 14 January 1897, the *Daily Mail* reported that 'More applications were sent in on behalf of officers who are desirous of taking part in the expedition against Benin City than could possibly be imagined.'[8] The Company's own desire to be involved in an action against the Oba of Benin – as they had been alongside the Protectorate in the case of Brass – continued into February, although in the end they were kept out of this part of the operations of this concerted military campaign.

The two simultaneous actions described as the 'Niger-Soudan Expedition' and the 'Benin Expedition' – which were firmly detached from each other through the propaganda machines of Company and Protectorate – should be understood as a single action. It was a double-headed attack undertaken following sustained exchanges between Goldie and Moor, that took place after the Kirk Report recommended that the Company would be rolled into the Protectorate in some form or another. It was clear to many that in the north the focus should be, as the *Glasgow Herald* reported on 5 January, either Ilorin or Bida 'to punish the power of the Emir of Nupé for frequent breaches of his agreement with the Company and for conduct which the Company cannot tolerate in territory within its sphere of influence' since 'sooner or later a trial of strength with one or other of the Fula States of the Western Soudan was bound to come.'[9] These cities of Bida and Ilorin were part of the Sunni Caliphate of Sokoto – which was founded by Shaihu Usman dan Fodio during the jihad of the Fulani War in 1804, and would be crushed by a violent 'pacification' by the British in 1903, as a result of which they removed the Grand Vizier Muhammadu al-Bukhari as head of the Fulani Empire, and installed Muhammadu Attahiru II as Sultan, forming the Sokoto Sultanate Council. 'Our Hausa troops have proved themselves excellent soldiers against the pagans, but they are now called on for the first

time to meet the Foulahs,' wrote George Goldie in his 'Order of the Day' just before the Expedition was launched.[10]

In the event, in January–February, the Company's military forces were directed at both targets in the north, at the same time as the Benin Expedition took place in Protectorate territory to the south. Taken together, these operations – the 'Benin-Niger-Soudan Expedition', as one might call them – were driven by a common justification: as with the Protectorate with the Oba of Benin at Benin City, so with the Company with the Emir of Bida: a treaty made in 1892 was now to be enforced with military action. Together, they represented a coherent double-pronged campaign sanctioned by the Prime Minister. Around 18 February 1897, after his forces were returning down the Niger River, Goldie even offered the services of his soldiers to the Protectorate's part of the campaign.[11] This may have been something previously discussed with Ralph Moor, who on 16 January had stated that Benin City might be attacked from the north (which would have meant actions at all four cardinal points, including that in which the military camp was located).[12] As the Intelligence Officer for the Benin Expedition put it: 'The capture of the ancient city, at nearly the same time as the destruction of the power of Beda, farther inland, will greatly increase the prestige of the white man.'[13]

Understood as a single operation, the 'Benin-Niger-Soudan Expedition' was an iconic consolidation of British power in Africa during the Diamond Jubilee year. The Company and Protectorate elements were of comparable size, and Hausa troops joined both in similar numbers – as did 'special service' officers brought out from Britain especially. The attacks took place simultaneously, with ongoing press coverage – to the extent that at some points the two campaigns were mixed up in public consciousness, and clarifications had to be given by newspapers.[14] But there were also significant differences in the nature of the warfare against what contemporary newspaper reports described as the double target of 'the heathen Mohammedan ruling caste of the interior and the heathen Chiefs, of which the King of Benin is a type, on the coast'.[15] The Benin Expedition was a naval operation based on the tried and tested Protectorate model of a punitive expedi-

tion undertaken with the Admiralty, ascribed by Callwell in his book, *Small Wars*, to the French, and involving 'a forced march followed by intrepid attack when the enemy turned out to be present in force',[16] and operating through the bush. The actions against Bida to the north of the Niger River and then Ilorin, 150 miles to the west, below the Niger River were also marches leading to an attack, but essentially an army operation in open country, involving cavalry. This difference in the landscape led in particular to very different situations for assessing the casualties.

Before moving on to describe the Protectorate's sacking of Benin City, it is necessary to take stock of the parallel action of the Company, some 250 miles to the north of Benin City: the Benin expedition of the Company – known variously as the Niger-Sudan Campaign and the Bida and Ilorin Expeditions – plans for which had been reported widely in the British newspapers throughout autumn 1896. In May 1896, a Foulah army – according to some contemporary reports, 20,000 infantry and 2,000 cavalry in strength – was led across the Niger to the town of Kabba, and formed a war camp. This action, and supposed massacres of enslaved people, in defiance of treaty arrangements, was the official pretext for the punitive Expedition.

With control of coastal areas along West Africa, the suppression of slavery moved from sea to land, giving an ideal mechanism for justifying commercial gains: as Lugard later recalled 'Cardinal Laverie began his crusade in Europe, preaching a "Holy War" against Moslem domination in African and the slave-trade.'[17]

Reports of the dispute with the Emirate of Bida, followed a similar story – repeated warnings, a visit in 1892, concerns over tribute paid to the Sultan of Gandu and the power of the Sultan of Sokoto, accusations of massacres of enslaved people, and a raid of Company-protected territory for which a punitive expedition was sent to Bida.[18]

Led by Major Arnold, there were three phases to the Expedition, over the months of January and February 1897: Kappa, and the Fulani emirates of Bida and Ilorin. A total of 32 special service officers, eight executive Company personnel 1,072 Hausa soldiers, and 1,878 carriers (including 300 Fante carriers recruited from the Gold Coast, the rest

Yoruba and Hausa carriers recruited at Lokoja) with 15 Maxims, each with 18,000 rounds, nine 7-pounder RML mountain guns and both a 9- and a 12-pounder Whitworth BL gun.[19] The force assembled at the Company headquarters at Lokoja, the confluence of the Rivers Niger and Benue, and marched on 6 January 1897.

Leaving Lokoja, the first objective was the town of Kappa, which was entered unopposed on 13 January. The Foulah army had left their camp to head north to assist with the defence of Bida, but appears to have been prevented from doing so by the Expedition's river fleet, and so remained on the southern side of the Niger.

Having marched to the river, and being carried by the Company ships closer to their next target, on 26 January the force marched on Bida, with the aim of deposing Abu Bakr dan Masaba, Emir of Bida. Here they met a large army estimated to be 15,000 strong,[20] although recorded by Goldie as twice that number: 'I expected 15,000 – they were fully 30,000 and brave to the last', he reported to the Deputy Governor and Council of the Company on 6 February.[21] The force was made up of cavalry supported by foot soldiers with muskets. Forming into a square according to plan as a key tactic against the cavalry,[22] and advancing towards the city, the force was continually charged by horsemen who were slaughtered in enormous numbers by the Maxim machine-gun teams positioned at the corners of the square. In his memoir of the attack, geographer-soldier Seymour Vandeleur recorded the destruction of 'the great capital, of 60,000 to 100,000 inhabitants, a mass of lofty thatched houses and high clay walls',[23] with the cavalry 'Like knights of old days, every horseman seemed to be followed by two or three squires carrying his gun and some spears',[24] coming within a hundred yards before being shot down:

It was the ideal battlefield. The Nupé army could be seen in their thousands … It was a strange sight to see the Fula horsemen firmly fixed in their high peaked saddles, with enormous brass and iron stirrups, as they galloped along on their long-tailed ponies covered

with gay trappings, waving their swords or spears in the air, with their white robes flying in the wind.[25]

Attacks on infantry and cavalry continued with the 7- and 9-pounder guns:

> At this time, there must have been fully from 20,000 to 30,000 of the enemy to the front and the flanks, and this gun opening with great precision at a long range did tremendous execution. Beautifully aimed, the first shell landed in a crowd of the enemy's horse near a village, scattering them in all directions … The enemy's losses must have been very large.[26]

The city of Bida was bombarded throughout the night, and further Maxim slaughter continued the following day as the square advanced. Then, once within range, the 12- and 7-pounder guns of the force bombarded the palace and all other buildings, and systematically set the whole city on fire. 'It is impossible to estimate the losses of the enemy, but they must have been enormous,' Vandeleur stated[27] – and these deaths and woundings included several of the princes. In the aftermath, a treaty was signed with Muhammadu dan Umaru Majigi on 5 February, made Emir by Goldie, stating that 'the new Emir recognises that all Nupé is under the power of the company; all previous treaties are abrogated', with the Emir governing those areas which the Company chose not to.[28]

On 15–16 February, the same tactics were used as the force fought their way towards Ilorin. Some 800 cavalry and 5,000 infantry were mown down on the first day.[29] A surrender was ignored, and the city was bombarded with shells and then sacked; Vandeleur recalled that 'The destruction of the palace – rather a misnomer for this collection of rude stone buildings – was indeed complete, and the market-place, where we pitched our tents, was still filled with the smoke and smell of burning.'[30] The Emir of Ilorin was reinstated after this major destruction of the palace and town and, again no estimate of casualties was given.

Goldie's plan was to attack forces that 'have never yet faced the Maxim or Mountain Gun'.[31] To some, the Company's campaign was hailed as a great victory. The Church Missionary Society noted that 'proofs of the depredations of Nupé princes were seen by Bishops Tugwell and Phillips in the winter of 1894–5', and welcomed 'the dispersion of the long-dreaded Nupé cavalry'.[32] 'Twelve hundred slaves rescued' from riverside stores reported the *Weekly Irish Times*, as the attack on the Bida capital was getting under way.[33] In the pages of *The Times*, Flora Shaw compared the importance of the Battle of Bida to the Battle of Plassey of 1757, in which Robert Clive had brought the East India Company to a decisive victory over the Nawab of Bengal and his French allies, slaughtering hundreds – an event celebrated in the Victorian imagination as marking the beginning of British rule in India.[34] But here, the casualties were very much higher. 'We were compelled to inflict heavy losses on the enemy,' Goldie wrote two days after the destruction of Bida.[35]

There was a very different tone in other responses. The casualties, including the 15,000 soldiers at Bida, the 20,000 displaced from the camp at Kappa, and the thousands of civilians, women and children in the city, were not recorded – but the Company's destruction of an army with the medieval military technologies of cavalry, muskets and castles by rockets and machine guns outraged many in London. The *Scotsman* criticised how 'many hundreds ... were literally mown down by the Maxims'.[36] Among the loudest voices of criticism came, unexpectedly perhaps, from the imperialist politician Sir Charles Dilke and from the *Spectator* which, on 13 February, stated 'The square defied the charges which the enemy, though mowed down by the Maxims, repeatedly made, apparently with all the daring of Zulus or Matabeles ... For God's sake do not let us mow down black men in swathes and waste the heroic energy of our own people in order to get more oil.'[37]

Goldie swiftly defended the Company and the militarist nature of its palm oil operations, in his introduction to Vandeleur's account of the Bida attack:

When the application of force becomes absolutely necessary, it ought surely to be thorough and rapid. Yet last spring, after the completion of the operations, one of the most able and respected organs of public opinion in this country questioned the morality of 'mowing down natives with artillery and Maxim guns'. Now, these 'natives' were the fighting organisation of great regions which they – though in a comparatively small minority – held down with a hand of iron, treating the less warlike inhabitants as cattle to be raided when wanted. The death of each Fula killed at Bida secured the lives and liberty of scores of peaceful and defenceless natives. If Europe had no material interests to protect and develop in Africa, it would still have the same right, the same duty to extirpate slave-raiding that a man has to knock down a ruffian whom he sees maltreating a woman or child in the street.[38]

Vandeleur's account, *Campaigning on the Upper Nile and the Niger*, described the routine nature of looting of ivory tusks, arms, cowries and textiles,[39] and at Bida he described the looting of manuscripts:

All loot, as it was found, was supposed to be handed over and placed in the square, where lay heaped up a great pile of different coloured cloths, silks, and an innumerable quantity of brass basins; but of course soldiers and carriers kept whatever they could conceal about them. Captured in the town, besides, were some cannon, 350 rifles of all imaginable sizes and patterns, 550 barrels of gunpowder, 25,000 cartridges of all sorts, and numerous loads of brass and heterogeneous articles. A great many books and boards with Arabic writing, also a very tattered old lion skin with a plan and some Arabic characters on it, were found. The latter was just rescued in time, having been appropriated already by the soldiers to sweep the rubbish off the market place.[40]

All along, in working for the Royal Niger Company, Vandeleur combined geographical knowledge with military action: 'I never saw him disabled for one moment from taking his sights through his

sextant or his equally important sights over the barrel of his Maxim gun,' observed the Company Governor,[41] at a discussion at the Royal Geographical Society, to the presidency of which Goldie was elected in 1905.

The revocation of the RNC's charter had been under consideration since 1896.[42] It is in the context of proposals to unify Nigeria – which led to the signing of the Niger Convention with France in June 1898 and the eventual revocation of the charter in January 1900 and the buying-out of the RNC by the British Government – that we need to understand the dual action of the RNC against Emirs in the north ('Sudanese' areas) and of the NCP against the Oba in the south ('coastal' areas). By November 1897, the decision to revoke the charter was being made. As will be discussed below, the treaties signed after the Company's attacks on Bida and Ilorin dramatically strengthened the hand of the Company in negotiating compensation in this process of revocation. Before addressing that, however, the sacking of Benin City needs to be considered.

9

The Sacking of Benin City

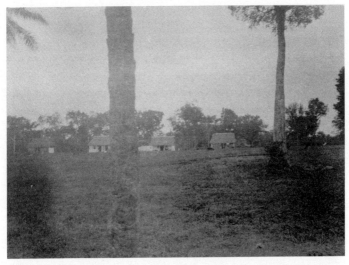

Benin, the capital of a kingdom of the same name, is the residence of their kings, and is seated pretty far in the country: it stands on a plain, and is about four miles in compass. The streets are long and broad: and there are markets twice a day where they sell cows, cotton, elephants' teeth, European merchandises, and whatever the country produces. The houses are large with clay walls, and at a distance from each other; they are covered with reeds, straw, and leaves ... The king's palace makes [a] great part of the town; and its great extent excepted, there is nothing worth taken note of, it being only a confused heap of buildings, made with boards and clay, without regularity or neatness. In the middle, there is a wooden tower, about 70 feet high, made like a chimney; and on the top is a brazen serpent, hanging with his head downwards; this is

pretty well made and is the most curious thing in the town: there is a gallery of statues, although so wretchedly carved, that there is no knowing what they represent without being told: behind a curtain there are eleven brazen heads, with an elephant's tooth on each; these are the king's idols: his throne is made of ivory, on which he sits in a pavilion of India stuff. The king shows himself but once a year, on the day of a certain festival.

Encyclopaedia Britannica, 1797[1]

'The King of Benin can bring 100,000 fighting men into the field', continued the third edition of the *Encyclopaedia Britannica* in 1797 in its entry for Benin City. This sacred urban landscape and the royal artworks will be introduced below, as will the ruined buildings described in this account of the city 100 years before it was sacked – but first that sacking needs to be introduced.

The Benin Punitive Expedition took place over three weeks between 9 and 27 February 1897, and involved the mobilisation of around 5,000 men, including European and African soldiers and supporting roles such as carriers (from Sierra Leone, Lagos and Benin) and scouts and guides.[2] The attack was organised as a naval operation, led by Vice Admiral Sir Harry Rawson, Commander-in-Chief at the Cape of Good Hope, with the Niger Coast Protectorate – as some earlier expeditions had been. It involved an immense force of some 1,400 soldiers, drawn variously from the Protectorate's Constabulary, Admiralty seamen, and more than 100 marines and officers brought on 'special service' from Malta, South Africa and Britain. These troops were supported by an estimated 2,500 carriers, most of whom carried water, plus scouts, and there were also dozens of medics and Protectorate staff. Ten Royal Navy ships took part, and the P&O cruiser SS *Malacca*, which had brought a battalion of 310 marines, was fitted as a hospital ship.[3]

The Expedition operated in three simultaneous column advances, across an area of some 5,000 square kilometres. A main column marched north-west from Warrigi to Benin City – avoiding the march from Gwato which previous visitors had learned would be easily defended by Bini soldiers,[4] and instead coming through the jungle

on the so-called 'King's Road'. (A route from Benin City to Gwato was cleared by troops in reverse, so to speak, in the days following the sacking of the city, arriving on 25 February.) This main column comprised 250 Hausa troops from the Protectorate Force, with five Maxims and two 7-pounders, alongside 120 bluejackets from HMS *St George* and HMS *Theseus* with two rocket tubes, 120 marines, light artillery and marine artillery, and around 1,200 carriers.

Meanwhile, Captain Michael Pelham O'Callaghan led a flying column from a flotilla of warships and gunboats, including HMS *Philomel, Barrosa* and *Widgeon*, along Gwato Creek to the west of Benin City, and Captain McGill led another flying column, with HMS *Phoebe, Alecto* and *Magpie*, along the Jamieson River at Sapobar, to the east of Benin City. As a military method, the flying column was pure destruction and democide. The stated aim of the Gwato and Sapobar 'flying columns' was 'to harass and destroy towns and villages while the main operations lasted, and so increase the punishment inflicted on the nation',[5] 'drawing away the enemy's attention from the main attack and also stopping any fugitives escaping from Benin City'.[6] Their instructions were 'to destroy all towns' on their routes along the river, bombarding them from the ships and burning them to the ground, including the 'wholesale destruction' of the Jakri town of Ologbo and trading settlements as well as scores of other towns and villages including Egoru, Sapoba, Gill-Gilli; there were three days of intense bombardment and fighting before the eventual sacking of Gwato, with houses blown up with gun cotton and huts burned to the ground.[7]

The towns and villages were clearly entirely unprepared, as was the intention with a flying column. One account recorded how 'up to the day before the taking of Ologbo, women were seen bathing at the beach, which showed that they anticipated no immediate attack.'[8] Official reports documented how all three columns recorded encountered 'determined resistance at all three points of attack'.[9]

The main column involved a five-day advance from Warrigi through the settlements of Ciri, Ologbo, Agagi and Awoko, and several other villages, along what was known as 'the King's Road'. The City was

taken on 18 February. As at Bida, so at Benin City, the differences in military technology between the African and European soldiers were stark. The 1893 Brussels Act had prohibited the sale of 'arms of precision' – including rifles and percussion cap guns – in certain zones, including the Niger Coast Protectorate. There is some evidence that flintlock guns were rifled by hand, and converted into percussion locks, by the Bini soldiers,[10] but in general the Bini fought with what they had to hand: Dane guns (muzzle-loading smooth-bore flintlock muskets), pistols, machetes, cutlasses, spears, bows and arrows, knives, and a few ancient cannon that fired broken iron pieces ('pot leg').

The British firepower was carefully documented by the colonial administrators and military quartermasters involved in this action,[11] and are detailed in the manuscript diary of Captain George Le Clerk Egerton, Chief of Staff for the Benin Expedition, held at the Pitt Rivers Museum.[12] There were a dozen 7-pounder RML mountain guns, each carried with more than 300 charges and projectiles. Six rocket-tubes and 'a ready supply of war rockets' were carried by each division, along with many hundredweights of gun cotton (nitrocellulose) with specialist demolition parties, which were used to destroy defensive stockades, palace walls, and even sacred trees. There were 14 Maxim guns adapted to be carried across land, each with 126 belts and boxes of 334 rounds – plus 24 more Maxims on the warships, with HMS *St George* and *Theseus* having seven each. That makes a total of 38 Maxim guns, with perhaps 2 million machine-gun cartridges in total that could be shot at the rate of 380 bullets per second if all Maxims were firing at once. This fire power was doubled by 1,200 Martini-Enfield and Lee Metford bolt-action rifles for which each man carried a hundred rounds of ammunition, with more than twice that number held by the carrier columns. A simple count-up is chilling. We can calculate more than 1½ million rounds for the rifles, plus a pistol for each man, with 36 rounds, and six times that number in the supply column: more than 3 million brass bullets.

* * *

The cost of the Niger-Soudan Expedition was estimated at £25,000,[13] and that of the Benin Expedition at £30,000[14] – celebrated in some quarters as vastly less than the outlay for the army operation of the Ashanti Expedition of 1896 had been. But the human costs mounted up in different ways.

The sacking of Benin City in February 1897 was an attack on human life, on culture, on belief, on art, and on sovereignty. It developed in the forced march of mounting indiscriminate violence and democide on the Niger Delta wrought by the energies of the Company and Protectorate feeding off each other: removing chiefs and killing, terrorising and displacing civilians, as part of a new period of large-scale, high-profile military operations concerned with regime change and the removal of royal power. In the run-up to the Diamond Jubilee, and with the pressure of new territorial regimes from French and German colonial enterprises, a new geopolitics of sovereignty emerged. Central here was what, in the sections below, I want to call 'chronopolitics' – the use of time, rather than just territory, as an arena for control.

Reports of the British atrocity at Benin City were doubtless on the desk of those who – within two years of the sacking of the city – drafted the treaties and declarations of the 1899 Hague Convention. The Circular of 11 January 1899 confirmed that the aim of the meeting was 'to revise the Declaration concerning the laws and customs of war elaborated in 1874 by the Conference of Brussels, which has remained unratified to the present day', informed also by the American 'Lieber Code' that had been published during the Civil War in 1863.[15] The 1874 Brussels Declaration had never been ratified but it had set out principles for a 'humanization of war',[16] explicitly forbidding 'the employment of arms, projectiles or material calculated to cause unnecessary suffering', the bombardment of towns and villages, attacks on defended settlements without warning, any failure in 'sparing of buildings dedicated to art', 'any destruction or seizure of the enemy's property that is not imperatively demanded by the necessity of war', and 'the giving over of a town taken by assault to pillage by the victorious troops'.

The British atrocity at Benin City was a crime against humanity that mapped directly onto the three principal elements of the 1899 Hague Convention: the indiscriminate attack on human life in which tens of thousands died; the purposeful and proactive destruction of an ancient cultural, religious and royal site; and the looting of sacred artworks. The Hague Convention banned the bombardment of 'undefended settlements, villages or towns', while also banning bullets, like the 'soft-point' .303 full metal jackets, that were designed to expand when they hit humans, along with all other 'arms, projectiles, or material of a nature to cause superfluous injury'.[17] The Convention undertook to 'spare as far as possible edifices devoted to religion, art, science, and charity', and the destruction or seizure of property. Further, it repeatedly stated that 'the pillage of a town or place, even when taken by assault is prohibited' (Article 28), 'private property cannot be confiscated' (Article 46), and 'pillage is formally prohibited' (Article 47). By the time the Convention came into effect, on 4 September 1900, the Royal Niger Company had been sold to the British Crown.

The next three chapters will take stock of how the sacking of Benin City destroyed human life at an industrial scale, erased a unique cultural site of global significance, and effected an informal campaign of looting and sale that continues, through the agency of western museums, to this day.

10

Democide

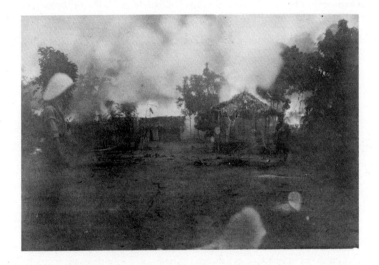

Unassailable naval powers such as the United States and Britain were seduced by their military victories against primitive opponents into mistaken ideas about the value of destroying homes and attacking peaceful citizens.

<div align="right">Eberhard Spetzler, a German legal expert, 1956[1]</div>

Some attempt at counting up the deaths must come first. On the Protectorate side, eight were killed in action: one officer, three soldiers, one marine, a doctor, a Protectorate soldier and a guide, plus 40 slightly or severely injured.[2] On the Bini side, the military and civilian casualties were never estimated. We can count up the 3 or 4 million bullets, the 38 Maxims, the twelve mountain guns, the six or more rocket tubes, but not the bodies – the few casualties among the British are listed by

name, and there are even a few memorials in the form of brass plaques in provincial English churches. But what of the Bini and iJekri deaths during the three-column assault across the Benin Kingdom?

The nature of jungle fighting meant that soldiers' corpses were dispersed across a wide area and hard to see. Alan Boisragon wrote that much of the 22-mile route of the main column was overgrown with thick bush on alluvial swamp-land, and teams of cutters with Maxim machine-gun teams 'searching' the bush, cleared the way, unceasing firing against an 'unseen' enemy.[3] Charles Callwell described how ammunition was used incredibly freely on the Benin Expedition, through the technique of 'searching the bush with volleys', so 'the enemy was scarcely ever actually seen'; there was 'a liberal expenditure of ammunition but it was probably well expended ammunition, considering the results achieved by the system':

> It is only in very thick jungle and when fighting an enemy who will not stand, that precautionary volleys would be used. The Benis were very ill-supplied with bullets and depended largely upon slugs. It was therefore very important to get them to discharge their muskets at some little distance from the troops, because the slugs were then prevented from doing any harm by the luxuriant foliage ; they were well aware that their arms were of little use firing through zones of thicket, and they only assembled in force at clearings, where they could be satisfactorily tackled. The precautionary volleys really aimed rather at keeping the snipers at a distance than at driving off hostile bodies of appreciable strength.[4]

So too, the bush was continually raked by the Maxims as the two other columns advanced. Rockets and shells razed to the ground dozens of towns and villages across this vast swathe of countryside. William Heneker used his experience on the 1897 Benin Expedition, and expeditions against Nana and other Niger Coast Protectorate expeditions, to write his military guidebook *Bush Warfare*, published in 1906. There, he underlined the importance of continual volley firing and raking the bush with machine-gun fire:

We cannot hope to bring matters to a satisfactory conclusion until the enemy's forces in the field have suffered severe defeat. The capture and burning of towns is, of course, a concomitant to savage fighting; but if, in the taking of these places, the enemy has not been made to suffer severely, difficulties and dangers are at once added to the commander's responsibilities.[5]

Interviewed in advance of the Expedition, and based on his experience of the 1894 Benin River Expedition, Felix Roth concurred: 'The nature of the country lends itself so readily to ambuscades that every precaution in the way of clearing the bush on either side of an advancing column, by means of Maxim guns and continual volley firing, has to be resorted to, though no enemy may be in sight.'[6]

'They must have sustained very heavy losses while endeavouring to drive back the invaders,' Heneker underlined: 'they must have stood up in great numbers, simply relying on their guns, and so have sustained heavy losses.' The taking of Benin City was an example of how 'savage nations have, as a rule, to be cowed, by having their warriors severely beaten in action and made to suffer heavy losses,' Heneker repeated.[7] 'Neither was it a "walk-over",' chimed Major Mockler-Ferryman in his account, *Imperial Africa*, 'for the Binis resisted stoutly and the bush-fighting was most trying work, though in the end the natives found it quite impossible to resist shells, rockets and Maxim guns.'[8] There were running fights along the way,[9] and thousands of people appear to have fled away into the bush from the city[10] before Benin City was sacked on 18 February. There are indications that the action went further afield, for example even as far as 50 kilometres to the south at Wari. At the annual meeting of the British Association for the Advancement of Science in Bristol in September 1898, the Report of the Committee on the Climatology of Africa explained that there was missing data from one of its 26 research stations in tropical Africa: 'no returns have been received from Wari since the hostile operations against Benin, and there is reason to believe that the instruments at that station have been destroyed' – despite it lying 100 kilometres to the south of Benin City.[11]

In the House of Commons two years after the action, in April 1899, when further military action was taking place in the region under the same pretext, this time against Chiefs Abohun, Ologbosheri and Oviaware, the Irish Republican MP Michael Davitt asked Joseph Chamberlain whether

> considering that punitive measures, including the burning of towns and villages and the killing of many people, have already been carried out in retaliation for the killing of Mr. Phillips and his party, there is any necessity to continue action of that character; and, if he can state the number of natives who have been killed and the number of villages that have been burned by British troops since the first march on Benin took place?

'I have no information which would enable me to answer,' came the reply.[12] Official reports on punitive missions always stated it was impossible to estimate casualties, of course. Even away from the constant attacks, colonial administrators tried not to assess population numbers in the Company and Protectorate territories in the 1890s. George Goldie was keen to underline, in a lecture to the Royal Geographical Society in 1901, that

> a result of the neogenesis of British Empire in Africa is that, for much of the territory acquired ... exact statistics of population do not exist, and mere estimates are very untrustworthy. For instance, in one province, Nigeria, some experienced travellers and geographers have estimated the population as high as 40 millions, and others as low as 20 millions.[13]

Such vagueness suited 'men on the spot' like the Company's George Goldie and the Protectorate's Ralph Moor, who could not be held to account for killings. It is clear that the population of the Niger Coast Protectorate and the Royal Niger Company was very high compared with other regions of Africa at the time, estimated in 1890 at 12 million people;[14] in 1895, Ravenstein gave the figure of 24.4 million

people – from a total of 43.2 million in the whole of British Africa: Cape Colony standing at 1.8 million, Lagos and Yoruba at 3 million, Gold Coast at 1.8 million, Sierra Leone at 480,000, and Zanzibar and Pemba at just 210,000.[15] Population estimates for Benin City were as high as 50,000 in some newspaper reports of the attack,[16] while the 1875 edition of *Encyclopaedia Britannica* recorded that the City 'covers a large extent of ground, but is so broken up into separate portions by intervening spaces of jungle that no proper estimate can be formed of its population. The King's Quarter (*Obwe*), alone is supposed to have upwards of 15,000 inhabitants.'

Let us focus first on the human death toll wrought by the two 'flying columns' and the subsequent attacks on displaced people and villagers in the wider landscape. Expanding and intensifying the pattern of the punitive expeditions developed since the late 1880s, hundreds of buildings were torched in February 1897, many dozens of villages were razed, towns rocketed, jungle areas machine-gunned, any hint of resistance burnt to the ground. Even before the expedition, on 30 January 1897, the *Standard*, when reporting that work at the Royal Arsenal, Woolwich and the Royal Victualling Yard in Deptford had continued till midnight to get war stores for the expedition prepared, underlined the potential damage to civilians:

One hundred boxes of war rockets and supplies of the electric search light have been sent, the latter for discovering the operations of the enemy at night and inspiring awe into the semi-savages to be attacked, and the former for driving the enemy from the bush and setting fire to any towns or villages where the British forces may be opposed, or where the enemy is likely to fall back. Before bombarding any place with incendiary missiles, the women and children will have an opportunity of leaving the place.[17]

There is no evidence that such opportunities or warnings were given. Some indications of the methods used in such 'flying' attacks can be seen in the description of the aims of the latest action, the three-week 'Benin Territories Expedition', to which the MP was referring. Com-

missioner Moor, who had overseen the 1897 attack, set out its aim in a *Memorandum of Instructions for the Expedition* issued from Benin City on 19 April 1899:

> The object of this expedition is to break up the camps of the rebel chiefs Abohun, Ologbosheri, and Oviaware, in or about the town of Okemue, to capture the chiefs themselves and as many of their followers bearing arms against the Government as possible, allowing, of course, that in the operations which resistance of the Government will entail the chiefs themselves and many of their followers may be killed. After breaking up the actual camps, the chiefs and their followers should be pursued as far as possible. Those not actually captured must be as widely scattered as possible, and an extended march should be made through the Benin territories, with a view to demonstrating the effectiveness of the Government established in the territories. The operations being from their initiation of a purely military nature, no political question can arise until they have been to a great extent carried through but should any overtures for peace be made by the rebels the only terms on which they should be entertained are absolute surrender of the two rebel chiefs, Abohun and Ologbosheri, together with 20 of their minor chiefs and headmen, and giving up of all arms and ammunition in the hands of the rebels.[18]

With a force of 270 British soldiers, including many who had been involved in 1897, and with two Maxim guns, a rocket tube and a 7-pounder, over twelve days Moor's official report, presented to both Houses of Parliament in October 1899, details the destruction of the towns, villages and farms, and giving the official figures of having fired 20,000 rounds from the rifles, 2,000 rounds from the Maxims, and five rockets:

> 20 April. I brought the rocket tube into action, and sent five 24-lb. war rockets into Okemue, setting the houses on fire. Under the covering fire of the 7-pr. and 2 Maxim machine guns, I sent one

and a half companies of Hausas down the steep ravine, and, ceasing fire with the guns, charged up the steep incline, and rushed the stockade successfully, driving the enemy back through the town of Okemue. I thoroughly destroyed the town of Okemue, levelling all houses to the ground.

28 April. I made a reconnaissance in force to a village one hour's march from Ekpon, owned by Abohun, encountered a few of the enemy, burnt and destroyed the village.

1 May. Sent Captain Heneker and company to destroy town of Udo; burnt and completely destroyed the large town of Ugiami, including the king's house. At 6.45 a.m. marched through bush by compass to Ovearwuri's camp. On arrival there at 11.15 a.m. was fired on by about 25 of the enemy. Captain Heneker and half company pursued them for 2 and a half miles, and came upon the bush encampment of this chief. They had a sharp engagement there, burning the camp and destroying two adjoining farms.[19]

When it comes to the main column, attacking the city itself, we begin again with vagueness from written accounts: 'It is always difficult when fighting in thick bush to calculate with any degree of accuracy what the actual losses are. The natives are always very clever in carrying away their killed and wounded, and actual casualties can therefore only be guesswork.'[20] George Egerton's diary recorded 'quantities of dead natives killed during the fight' in the city. In his revisionist history of the sacking of Benin, Robert Home suggested no more dead than 'probably several hundred' in the city.[21] But how to quantify the jungle deaths of an army of tens of thousands, the urban population, the ravaging of the countryside over weeks, and then in military actions that continued beyond February 1897 for two years and more?

Before going any further, an additional element to the human destruction wrought by the British at Benin needs to be mentioned. The Benin-Niger-Soudan Expedition involved new technologies of canned food, coils of barbed wire and trip wire, electric searchlights, shells specially made to set fire to thatched roofs, and composite large

guns that could be transported over land in new ways, including dismantlable Maxims 'made under the supervision of the inventor himself'.[22] As well as thorn zareba defences around overnight camps, lines of wire were fastened at a distance of 40 yards, and the 'surprise light' flares for night operations, operated by a pull-cord and burning with a bright blue light for seven minutes, were accompanied by '[M]axims distributed round the perimeter, kept loaded and ready for action'.[23] Among these new technological innovations, the most surprising discovery is evidence for a very early use of the 'expanding' bullet. A remarkable news report from the *Portsmouth Evening News* on 20 March 1897 reported unfiltered evidence of marines just arriving back to Gosport on the SS *Malacca* from Benin, interviewed after a celebratory dinner:

One of our party had a chat with Sergeant Ellison, who was in the advance party in the attack at Benin City. This force said the Sergeant was composed of a number of Houssas, the A Company from the *St George* and the first section of marines under Captain Byrne. The serious part of the fighting commenced about a mile and a half from the city proper, the fire being very severe. Some of the enemy used repeating rifles, and kept so well under cover that the troops had nothing to aim at but the puffs of smoke. The natives also had a heavy gun from which they discharged an extraordinary admixture of projectiles, including a number of knives ... The slaughter was enormous. Asked how it was that the official reports made no mention of the loss inflicted on the enemy another man said it was impossible to count the number of men killed owing to the thickness of the bush. A great quantity, however, had fallen, and where the savages made their most determined stand the slaughter was enormous. Some Houssa soldiers, who penetrated the bush, reported that they had seen hundreds of dead bodies, some of which were simply cut in two by the Maxim fire ... After dinner the toast of 'The Queen' was drunk with enthusiasm, and the rest of the evening was devoted to 'yarning' ... Early in the expedition it became evident that the fighting would be at close quarters and

to make the Lee-Metford rifle fire effective the tips of all the bullets were filed off.[24]

The purpose of this practice of filing down bullets was to convert them into expanding bullets, which cause a more extensive wound when hitting a human target – such as the so-called 'Dum-Dum' bullets later used by the British in India, and other such bullets made at Woolwich for use by the South Africa Company. The earliest use of Dum-Dum bullets (Mark III) is often thought to be the Tirah Expedition of November 1897–April 1898 in India.[25] But this account describes the manual modification of .303 Mark II non-expanding full metal jackets in the field to turn them into expanding bullets – apparently with official sanction.[26] The ultra-modernity of this improvisation is underscored when we consider that the experiments at Dum Dum and Woolwich were not even completed by January 1897.[27] This is further evidence of the brutal experimentation with mass violence, pushing at and over-stepping the boundaries of what was legal under the St Petersburg Declaration of 1868 and other normal standards of war, that was used in the Benin-Niger-Soudan Expedition.[28]

What is clear is that the attack on the city was indiscriminate. This was a democidal campaign, involving massacres of civilians through the bombardment of towns and villages from the air and thus women and children across the whole of the Benin Kingdom, scorching the earth with rockets, fire and mines. Primary among the war crimes was the scale of the killing and bombings of civilian targets.

Comparisons with the South Africa Company, where mass killings were widely protested against among the British establishment, might form some yardstick. There we know that an estimated 60,000 people were killed in South Zambezia/Rhodesia (modern Zimbabwe) in the Matabele Wars of October 1893–January 1894 and March 1896– October 1897,[29] which were 'waged with great cruelty'.[30] Many more were killed in the April 1896 attack on Lobengula Khumalo, King of the Northern Ndebele people, described at the time by James Caldwell, MP for Mid Lanark, as 'not in the interest of civilisation as was often hypocritically said, but to get possession of their land':

In rising against the invaders and endeavouring to drive them out of the country the Matabeles were only doing what they themselves or any other patriotic people would do if they considered themselves able. The only result of civilisation which the natives saw in the new rule was in Maxim guns which killed its hundreds and left its thousands of wounded to suffer torture worse than death, whilst the civilised barbarians possessed themselves of the riches of the land.[31]

Against the Maxims, warships, rockets, and shells of Chartered Companies 'in the pursuit of gold, of diamonds, and of dividends', 'most of the black men [*sic*] killed were practically unarmed', Liberal MP William Byles asked in 1894 after the first Matabele War, 'protesting in the name of many Englishmen and Englishwomen against such barbarous proceedings': 'What chance had they with their poor arms against the Maxim guns and other weapons used against them?'[32]

There was a significant degree of technological determinism in this process. The histories of South Africa and Sudan in the 1890s bear a bloody witness to the vast differences in military power that had opened up between European and African societies. This imperial march, this colonial vector of accelerationist ultraviolence, this mounting degeneration of western morality wrought through new forms of racist thinking, dehumanisation and dispossession, on which the event of Benin 1897 came about, reaches back to Kumasi 1874, Maqdala 1868 and beyond, but was also already reaching a new speed with the massacre of 8,000 Zulu warriors in the Anglo–Zulu War of 1879, and 1,500 Ndebele warriors in a single incident, known as the Battle of the Shangani on 25 October 1893, by the British South Africa Company. These events foreshadowed the slaughter of some 12,000 soldiers and further uncounted civilians, plus a further 16,000 soldiers wounded, at the Battle of Omdurman in Sudan under General Sir Herbert Kitchener on 2 September 1898, an act of supposed vengeance for the British loss of the Battle of Abu Klea to a Mahdist army led by Mohammed Ahmed in January 1885 when an earlier design of machine gun, the Gardiner, jammed. Where is the Benin-Niger-Soudan Expedition in this growing tally of killings?

What constitutes that degenerative vector, that ongoing event on which these horrors arranged themselves? It is a negative: loss, death, sovereignty over an absence of sovereignty. If the vision of settler colonialism imagined nature as a blank canvas, a *terra nullius* empty of people, then the action of militarist colonialism, from Cecil Rhodes to George Goldie, sought to blank out African culture. One part of this was the falsehood that 'the senseless massacre of native tribes on the Dark Continent was quite in keeping with the traditions of these tribes themselves.'[33] But there was more to it: Benin 1897 was a foundational moment in this process, a foreshadowing of 20th-century horror. This violent line is the beginning of the colour line, and of the borderwork of the modern nation state. As will be seen in later chapters, the borderwork of empire took place in the museum, transformed through the ethnological project into a temporal technology for the classification of humans in cultural forms, always an intervention and a redaction before it was a representation. At the heart of all this is 'race science'. This necrology represents a forgotten history of Europeans in Africa, a prefiguration of the industrialized destructions of the First World War, and a prehistory of 20th-century militarist racism.

* * *

For Benin 1897, perhaps most telling is the sustained silence in both official and informal documentation of any prisoners of war, or any injured African casualties, or of the spread and effect of disease, or of any hospital operations for Africans of any kind, or of hunger or starvation after environmental destruction, or any camps for displaced people other than those bombed and burnt by the British. For example, in his journal entry for 8 March, four weeks after the sacking of Benin City and while the pursuit of the Oba continued, Captain Herbert S. Walker of 'The Cameronians' (Scottish Rifles) – Special Service Officer, aged 32, later Chief Constable of Worcestershire – described the destruction of a new settlement being built in the bush some 60 miles away from the town, and further villages burned, by an expedition party led by Consul Moor and Colonel Bruce Hamilton, with 80 Hausa soldiers, two Maxims, a rocket party and 140 carriers:

'Burned all the king's preparations. Several large clearings, filled with huts and the framework of new houses. He must have 2–3000 follow- ers with him. At 2.30 p.m. marched back to Amofia's village. [Next morning] burned A's village.'[34]

'The natives were not unfriendly but were in great fear … no further resistance is anticipated', it was reported.[35] What then became of the tens of thousands of Bini soldiers? Of the Oba's harem and servants? The metalworkers, farmers, priests? What of the women and children of the city and the towns and villages which were razed to the ground? In descriptions of the 'city of blood', it is continually left vague how many deaths represented human sacrifices and how many were casualties of the British attack: 'The heat was terrible in the place, the sights ghastly, and the odour awful. Human sacrifices and corpses were strewn in all directions,' recalled Harry Rawson.[36] Or to take another example, how should we read the testimony of Dr Felix Roth:

After dispersing the natives with Maxims and volley firing, Benin City was ours. As we neared the city, sacrificed human beings were lying in the path and bush – even in the king's compound the sight and stench of them was awful. Dead and mutilated bodies seemed to be everywhere – by God ! may I never see such sights again! A party have gone out this afternoon to find and see the king's place; they went down the main thoroughfare, and have just returned. The whole road is strewn with dead, crucified and beheaded bodies in all states of decomposition. It was a charnel house. All about the houses and streets are dead natives. Treacherous though they are, it is unlikely they will try and recapture the place after the lessons received from the Maxims and breech-loaders of our troops. Their Juju is broken, their fetich places burned.

'*Their fetich places burned.*' We have seen how this Expedition marked an escalation of a longer-term pattern of ongoing violence against iJekri and Bini people, and beyond. Let us hold back on fixing any number on the African casualties of the Benin atrocity at this point.

A key connection made by Kim Wagner, in his discussion of British colonial 'small wars' of this period can help us here, however. Wagner describes the different standards and rules for such operations in terms of Partha Chatterjee's account of 'the rule of difference', in which 'the conceptualization of non-white enemies within the Empire' operated across multiple fields, including those of violence and medicine as well as racial difference.[37] Here, a further connection can be made with the museum, as a device, as a weapon, as a machine for the generation of difference:

> Since the modern age the museum has been a powerful device of separation. The exhibiting of subjugated or humiliated humanities has always adhered to certain elementary rules of injury and violation. And, for starters, these humanities have never had the right in the museum to the same treatment, status or dignity as the conquering humanities. They have always been subjected to other rules of classification and other logics of presentation.[38]

The 'rule of difference' operated also, I want to suggest in this necrography of Benin 1897, across time – in order to defeat a human culture. Central to that chronopolitics, subsequent to the primary task of this corporate-militarist colonial operation, the killing and scattering of people, was the destruction and scattering of royal and sacred cultural heritage. It is to that theme that we now turn, as it began outdoors at Benin, and then came indoors to the European museums.

11

Iconoclasm

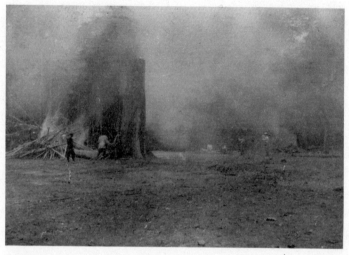

For years the cruelties known to be enacted in the city of Benin have been such that it was only a question of ways and means that deterred the Protectorate officials smashing the place up years ago.

Mary Kingsley, *West African Studies*, 1899[1]

Mary Kingsley – Victorian 'explorer', writer, colonialist ethnographer of West Africa – was not understating what the British did at Benin City when she talked about 'smashing the place up'. Systematically destroyed by fire, gun cotton and sledgehammers, alongside the surely vast but undocumented loss of life, the vandalistic nature of this act of extreme iconoclasm demands our consideration. The attack upon Benin was an attack on the urban landscape, the historic built environment itself – obliterating it. The British attacks on Bida and Ibadan burned sacred and royal manuscripts. Why?

This ancient urban physical landscape first emerged during the 11th century CE,[2] during a precolonial period of urbanisation that took place along the rainforest belt around 1,000 years ago, across modern Ghana, the Republic of Benin, and southern Nigeria during the period of the West African past that archaeologists call the 'Late Iron Age' – although Benin City is also close to the older late Stone Age site of Iwo Eleru.[3] An immense ancient monumental network of sacred earthworks (*iya*), comprising ditches, banks, and causeways or entrances, was built. Developing over centuries, this ancient monument was assumed by 19th-century Europeans to be defensive in nature, and more recently some have suggested a practical historic function of defence against the African forest elephant, or a wider function in the housing of enslaved people in the context of slave-trading. However, it clearly held great symbolic, spiritual and religious significance. Graham Connah's programme of archaeological survey and fieldwork undertaken between December 1961 and May 1964,[4] and earlier excavations by Astley Goodwin,[5] led to an appreciation of the nature and extent of this monument, and radiocarbon dates showed that the innermost enclosure dated from the 12th century CE.[6] Estimates of the size of this main enclosure range from 11 to 16 km in length, and it has been claimed that the wider landscape of forest ditches and banks may extend across 6,500 hectares, to a total length of perhaps 16,000 km. Such figures have passed to some extent into myth. They led Patrick Darling[7] to suggest that the pre-mechanical construction of the network was 'four to five times longer than the Great Wall of China and moved over a hundred times more earth than the Great Pyramid of Cheops in Egypt'.[8] The 1976 edition of the *Guinness Book of Records* even claimed that

the largest earthworks in the world carried out prior to the mechanical era were the Linear Earth Boundaries of the Benin Empire in the Mid-Western state of Nigeria. These were first reported in 1903 and partially surveyed in 1967. In April 1973 it was estimated that the total length of the earthworks was probably between 5,000

and 8,000 miles with a total of almost 600,000,000 cubic yards of earth moved.[9]

In less hyperbolic language, Graham Connah described the monument as 'a massive earthen ditch and bank, with a total vertical height, from the excavated bottom of the ditch to the top of the surviving bank, of as much as 17.4 metres, and a circumference of 11.6 kilometres', and concluded that the wider network of enclosures may have measured 145 km in length.[10] Comparable urban earthwork enclosures exist at sites including Oyo-Ile ('Old Oyo'), Ip-apo-Ile and Koso, Ile-Ife, Ijebu-Ode and Sungbo's Eredo.[11] The historical anthropology of both Benin City[12] and comparable earthworks at Saví in the Republic of Benin to the west,[13] have shown the complex political and cosmological significance of such enclosures as public works – over and above previous functional interpretations of labour calculations and defence concerns. As ongoing building projects across the centuries, they were part of the religious administration of slave and corvée labour and chiefly power, but also separated out sacred and natural spaces in a physical enacting of cosmology, and represented a focus for offerings[14] – creating zones within the chiefly palace landscape, and representing a powerful artefact, which could be activated through sacrifice and offerings, and was built and maintained in different sections by different parts of the Royal Court.

In the sacking of Benin, a unique urban landscape of royal palaces, mudbrick residential houses, mausoleums, ancestral shrines or altars, courtyards, artisan workshops, administrative and religious buildings, compounds, pavements, and sacred trees was destroyed with rockets and gun cotton. Two days after the city was taken, George Le Clerc Egerton wrote out his to-do list for the day:

> Work to be done Saturday 20th February
> Cots and stretchers to be prepared for sick.
> Ju-Ju houses to blow down.
> Walls + houses to be knocked down.
> Queen Mother's house to be burnt.[15]

Egerton's list reveals the systematic nature of the destructions of this ancient site for days after the city was initially taken – the transformation of a living sacred and royal place into an archaeological site. The following day, on Sunday, 21 February 1897, the Palace was burned to the ground – in an event later claimed as accidental, but in fact probably just one that got out of control and so damaged stored goods in a mounting frenzy of demolition. This fire and perhaps others appear to have had the parallel function of burning dead bodies, with Ralph Moor describing how 'a fire destroyed the king's and all surrounding quarters, leaving us only open camp, but the cleansing effect of it compensated fully for the destruction of shelter and loss of baggage and provisions.'[16] Intelligence Officer Reginald Bacon added:

> It seemed as if the ground itself had caught fire and was burning. There was a dim grandeur about it all, and also there seemed to be a fate. Here was this head-centre of iniquity, spared by us from its suitable end of burning for the sake of holding the new seat of justice where barbarism had held sway, given into our hands with the brand of blood soaked into every corner and relic; fire only could purge it, and here on our last day we were to see its legitimate fate overtake it, and see this, the centre of bloodshed, burn before our eyes in retribution for the millions of lives that had been wilfully sacrificed.[17]

The primary intention of this physical destruction of the city was to 'break the power of the fetish priests'.[18] Just within Benin City, the compounds, hundreds of houses, ceremonial buildings and palaces – including those of Chiefs Ojumo, Ochudi and Ezomo, and the Queen Mother's House – were demolished, and the sacred tree was exploded with gun cotton.[19] A fort, prison and hospital were built in the former palace grounds, and, within their first month the British had constructed a golf course, the ninth hole of which was 'on the spot where the main crucifixion tree had stood'.[20] The '"Overami" Handicap' was reported from the Residency, Benin City, in the pages

of the magazine *Golf* on 5 November 1897 by Captain Charles Carter of the Scots Guard.[21]

A British Resident was appointed (Alfred Turner, who died after a few months, and then the 26-year-old Ernest Percy Stuart Roupell). As the expeditions, destructions and violent counterinsurgency operations continued across the Kingdom in partnership with the Royal Niger Company,[22] the show trial of the Oba and his exile to Calabar (where he died in 1914) took place; six chiefs were executed in the market place.[23] The rationale for the active use of erasure and replacement with a new monumental regime was clearly explained by Galway:

> The Benin people on that execution morning had much to think about. Their King removed, their fetish Chiefs executed, their Ju-ju broken, and their fetish places destroyed. Of their crucifixion trees not a trace left; and all around evident signs of the white man's rule – equity, justice, peace and security. Further, at the spot where the tragedy of the previous year was enacted stood an Aberdeen granite cross recording the names of the brave men who were treacherously shot down in their tracks. The natives of the country for years afterwards always hurried past that recording monument, as something to be dreaded and respected.[24]

On 26 February, the diary of Herbert Walker recorded how the systematic destruction was still ongoing: 'Have started clearing jungle round site of future residency, 3/4 mile distant, nearer the river. Strong defensive post, with stockade to be constructed. King's house & all surrounding will eventually be destroyed & no building allowed on same site.'[25] A week beforehand, on 19 February, the same diary recorded one example of the destruction of the royal compound and shrines: 'In the afternoon ordered to proceed with two Companys and a Maxim to destroy Ojumo's house & compound. Thought possible that the enemy might have rallied there, but we found the place deserted, destroyed the "Ju-Ju" shrines & set the whole on fire.'[26]

As the destruction of the city's royal precincts continued in these first days and weeks after the fall of Benin City, the ruined nature of many of the buildings was commented on. For many observers, this was a sign of a city having 'degenerated' – a key word for anthropology at this time – from former greatness. In a visitor's account from around 1860, W.F. Bray described the houses as follows:

> The houses in Benin are built of red clay, and have many rooms. One curious feature was that most of the houses had from one to half a dozen ruined rooms, roofless, and with crumbling walls. Whether this meant that the city was falling into decay, or whether for some reason whenever a room becomes untenable they build another one, I could not satisfactorily ascertain.[27]

When he visited in 1892, Galway suggested that 'the number of ruins testify to the fact that it was once very much larger.'[28] However, as Read and Dalton observed a few years later:

> We may safely infer, from the parallel practice at Dahomey, and indeed in many distant parts of the world, that when a king died his house was shut up and never used again. This is almost necessitated by the West African practice of burying the dead man beneath the floor of his house, in which are also placed objects which he used and valued during his life.[29]

Buildings falling into ruin, containing artworks and human remains, were clearly part of a form of royal and sacred memory and memorialisation in the city. The burning and looting of these places therefore represented without doubt a deliberate desecration and pillaging of sacred royal mortuary monuments.

The sustained and almost total erasure of Benin City's built environment within the *iya* earthworks constituted the destruction of a monument of immense importance for the African past, but also crucially a key part of Benin's living present and future. As this necrography of Benin 1897 proceeds, the chronopolitics of this attack

comes closer to the function and complicity of museums, as brutal weapons in this militarist, corporate, extractivist disaster-capitalist colonialism. With this image of an ancient living city of monuments and royal power destroyed in an attempt to switch one form of sovereignty for another, the accelerating impulse that ran from Jaja and Nana to the Oba of Benin and the Emir of Bida in an ongoing, coherent military campaign, dressed up in the rhetoric of civilisation versus barbarity, and national pride and colonial anxiety in the run-up to the Diamond Jubilee in 1897, let us consider the third of the unholy trinity of British crimes at Benin – as well as the slaughter of human lives and the demolition of cultural heritage, there was of course the looting of art.

12

Looting

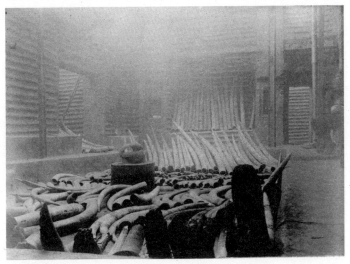

In planning a war against an uncivilised nation ...' says Lord Wolseley, 'your first object should be the capture of whatever they prize most, and the destruction or deprivation of which will probably bring the war most rapidly to a conclusion. This goes to the root of the matter. If the enemy cannot be touched in his patriotism or his honour, he can be touched in his pocket. The destruction of the crops and stores of grain of the enemy is another way of carrying on hostilities. This method of warfare is more exasperating to the adversary than carrying off live stock; for while they appreciate the principle that the victor is entitled to the spoils, wanton damage tends to embitter their feeling of enmity. The same applies to the destruction of villages so often resorted to in punitive expedition, but it hardly does so to the same extent,

since the dwellings of these races can be reconstructed easily. The most satisfactory way of bringing such foes to reason is by the rifle and sword, for they understand this mode of warfare and respect it. Sometimes, however, the circumstances do not admit of it, and then their villages must be demolished.

Major-General Charles Callwell,
Small Wars: Their Principles and Practice, 1896[1]

'Honour', 'patriotism', now 'the pocket'. At times, the introduction to Charles Callwell's *Small Wars* advised, 'regular troops are forced to resort to cattle lifting and village burning, and war assumes an aspect which may shock the humanitarian.' In such operations, troops should target whatever is 'prized most'.[2]

Like the African casualties, the number of royal and sacred objects that were taken is unknown, but previous estimates have been far too conservative (Plate IIb). In 1919, the curator Felix von Luschan was the first to attempt a *catalogue raisonné*. 'I have followed up all the reports about scattered pieces from Benin in England, and I believe that not a single significant piece has escaped inclusion on my register,' he proclaimed, estimating that 'the entire inventory of Benin antiquities presently accessible for scientific research can be estimated at around 2,400 in number.'[3] Von Luschan certainly highlighted the international spread – to St Petersburg, Basel, Scandinavian museums, Chicago and New York – but he had hardly counted every item of loot. In 1982, Philip Dark observed that 'The extent of the loot brought back is hard to estimate; it is not a matter of several hundred objects, but of some four thousand or so, or perhaps more.'[4] Today, as we consider the looting of Benin City, I want to suggest that any attempt to create a fixed list of what was stolen is a hopeless task, given the enormity of the loss and the nature of what was taken, and what is still hidden – something on which Kathryn Gunsch, following her ground-breaking attempt to identify the extant Benin plaques,[5] and I are in agreement.[6] We need another approach, that works with the uncertainty of numbers and forms that comes about with every re-discovery, as we begin to excavate, to sift and to document the long-neglected hoards of looted museum collections.

Today we must acknowledge that the total figure of what was looted may quite possibly be 10,000 bronzes, ivories and other objects – but also that any hope for a definitive or final number is futile, since there is so much hidden in private and family collections. There is an inherent lack of fixity in number here, an intrinsic instability to quantify what was taken as our excavations proceed. As with any archaeological process, it would be a mistake to seek, to quantify in advance of a sustained enquiry these dispossessions. In the wake of the sheer destruction exacted by the British upon Benin culture – rather than counting up, however, we can begin to *count back*, so to speak: this is the method that I am calling 'necrography' here, unpicking each layer of these looting events, in reverse, as the digging proceeds, to match up circumstances with well-provenanced objects, and to begin to share and compare data so collections' stratigraphies can be read across from one to another, like indexes to loss. This counting-back, like all archaeological excavation, is not some attempt to undo, nor simply to move on: but more precisely to re-trace and to make visible. Western curatorial attempts to pin down everything that was lost *in advance*, so to speak, to reconstruct in order to undo without needing to excavate, are not just misguided: they misdirect whatever work the western curator might do that is not entirely self-serving. They extend the work of destruction. Let us be clear on this point: the arrival of loot into the hands of western curators, its continued display in our museums and its hiding-away in private collections, is not some art-historical incident of 'reception', but an enduring brutality that is refreshed every day that an anthropology museum like the Pitt Rivers opens its doors.

* * *

Although a few pieces had strayed our way before, the spoils of war [*Kriegsbeute*] made during the conquest of Benin on 18 February 1897 were the biggest surprise that the field of ethnology [*Völkerkunde*] had ever received. Felix von Luschan *Altertümer von Benin*.[7]

Benin royal artwork and material culture was virtually unknown to Europeans before spring 1897. Some written reports had come back from visitors, including Richard Burton's visit in 1862[8] and trader Cyril Punch's unpublished diary during his 1889 visit[9] and photographs taken in an 1891 visit. Gifts from the Royal Court had also circulated in small numbers, including two ivory tusks given to Cyril Punch during his 1889 visit, a bronze figure of a horseman given by the Oba to the trader John Swainson on the 1892 treaty-signing visit,[10] and an ivory tusk given to Galway on the same occasion, which he had inscribed with the words 'Presented to Captain H. L. Galway by King Overami, Benin City, 1892'. In this last case, Galway recorded the question of private versus state property being raised, which would take on some further significance in 1897: 'On showing the tusk to my chief, Sir Claude MacDonald, he informed me that the tusk was the property of the Government. I told him I would not do it again, and so was permitted to retain the ivory.'[11]

Today, by contrast, the Kingdom of Benin is famous for its tradition of artworks, especially in the medium of brass, which represent one of the oldest living traditions of art on the African continent, developing in the early, precolonial years of the city's growth, before the arrival of the Portuguese. In the military attack, thousands of brass artworks, carved ivory tusks, coral beads, and other objects of royal, religious and political power were looted by the marines and Protectorate forces. Eyewitness accounts suggest that there were about 300 white men at the final attack on Benin City[12] – and perhaps up to a further 50 whites found their way to the city or the loot in the subsequent weeks and months, including traders as well as soldiers and Protectorate staff, and looting was also done by Protectorate troops.

An introduction to the range and scale of the Benin court art and material culture is beyond the scope of this book,[13] but a brief outline is necessary. The rectangular cast brass relief plaques are the most famous (Plates III and IV). More than 1,000 such plaques had adorned the hardwood pillars of the Royal Palace for centuries, depicting the ceremonial and political history of the ancient African Kingdom of Benin, with figures ranging from Obas with their attendants to Portuguese

traders with sticks, swords and pikes, bearing brass manillas, messengers with pendant crosses and 'cat-whisker' scarification on each brass cheek, warriors in battle, court officials with rattles and fly switches. In these images, helmeted hunters stand with antelopes and muzzled leopards; acrobats leap from tree ropes with rattles and bells while fish eagles watch from above; a priest with beard, a kilt, three feathers in his hair and a cowrie shell armband strikes a gong; a hunter carefully aims his bow and arrow at a bird in the tree branches that spread out above him. This is an iconography in which chickens can predict the future, their cry declaring good or bad fortune: an art of sovereignty that documents events through images and storytelling in a non-literate society; memory and prophecy cast in material form.[14] Soon after seeing them, Ormonde Maddock Dalton of the British Museum described them as 'a valuable manuscript' – 'a new "Codex Africanus" not written on fragile papyrus but in ivory and imperishable brass'.[15]

In the Edo language, the verb *sa-e-y-ama* means 'to remember', but its literal translation is 'to cast a motif in bronze', the act of casting constituting a form of recollection.[16]

There are also the well-known brass commemorative heads, some more than 500 years old (Plate V). They were made to be placed on shrines (Plates VIa and VIb) to physically embody the ongoing presence of royal ancestors – Kings and Queen Mothers in coral regalia of crowns and tightly bound neck collars of wound strings of coral beads that reach the bottom lip, and a single bead hung in the centre of the forehead. Scores of carved ivory tusks were made from at least the early 18th century (Plate VII), designed to be placed in the hollow tops of the heads, and carved in each case as a form of unique historical record of sovereignty, of politics and of culture. It is possible that the tusks replaced the plaques as the means of documenting and memorialising court history.[17] Some had intricate relief carvings of royals, priests, palace officials, warriors, Europeans, leopards, snakes, mudfish (air-breathing catfish), divine artefacts and others. The heads and ivories were arranged on 35 royal ancestral shrines: one for each of the unbroken line of Obas that began with Ewuare I who reigned from 1440 CE, more than four and a half centuries before the attack

on Benin City in 1897. There was also previously an immense brass snake on the side of a tower, descending from the sky.

Visiting in December 1889, Cyril Punch recorded how the tusks were placed in the brass heads arranged on chiefly and royal altars (Plate VIb):[18]

> There are eight, nine or ten heads of cast brass, each supporting a tooth of ivory some ten feet high and completely covered with carvings of men, horses and crocodiles, etc, in high relief. Between the teeth of ivory are more of the square shaped bells of brass and also iron castings of men on horseback, men in armour, and other things of a most minute and, I think, artistic workmanship. In the centre is one larger head surrounded by carved sticks like sceptres, in the top of which is a loose piece of wood which rattles when the stick is struck on the ground and this noise, the king told us that evening, causes the juju to approach quickly.[19]

Also from these shrines came dozens of brass figurative 'tableaux' showing monarchs and Queen Mothers with their attendants (Plate VIII), wooden rattle-staffs, four-sided pyramid-shaped brass bells and ivory 'double bells' (Plate IX), brass altar-rings, prehistoric stone axes or 'thunderbolts', and a host of brass figures: soldiers, horsemen in chain mail, Europeans, drummers, craftsmen, court officials, divine messengers and horn-blowers (Plate X). There were brass cockerel and leopard figures (Plate XIa and XIb), brass heads of close-mouthed horses and open-mouthed snakes, a cast brass sculpture of a leopard skull, a brass container in the shape of a palace building, brass gaming boards, carved wooden heads placed on the ancestral shrines of chiefs, and terracotta heads that commemorated past members of the royal brass-makers guild.

There were hundreds more brass, copper, iron, wood, coconut and coral-bead body ornaments with intricate designs, worn as part of palace ceremonies: pectoral- and hip-masks of elephant, human, ram and crocodile heads (Plate XII), including the famous ivory Queen Mother masks of which six examples are known (Plate XII), bracelets,

finger-rings, hair pins. Necklaces are strung with coral, agate, jasper and glass beads; there were amulet chains, cotton waist pendants, needlework tapestries, ritual costumes of pangolin scales, beaded shirts and aprons, hats made of cowrie shells, and helmets made of crocodile hide; artworks in which human eyes were represented by an iron nail in a flat bronze surface.

There were staffs of office made from ivory, iron, wood and brass, and beaded fly-whisks used in rituals, objects for healing and objects for divination, ceremonial swords and axes that were hung on the palace walls, hand-held clappers, ivory side-blown horns, drums, gongs and strikers (Plate XIV).

There were ceremonial flasks, cups, bowls, basins, buckets and aquamaniles (jugs in the form of animals). Small wooden 'altars to the hand', honouring personal achievements in life. Ivory spoons, boxes and saltcellars. Brass fans. A wooden-framed mirror. Brass manillas. Brass keys and padlocks. Ivory door bolts. A carved wooden door. Powder flasks, copies of European-style helmets, brass helmet masks, leather tunics, bronze cannon, crossbows, arrows, a flag. Ancient European firearms kept for centuries, the carved wooden paddles of iJekri chiefs. Carved wooden ceremonial chests and stools, brass royal stools, royal chairs and arm-rests, head-rests, coral hats and ceremonial costumes, a brass imperial orb, brass crucifix, beaded crown.

* * *

The diary of Captain Herbert Walker for 20 February documented the gathering of the loot:

All the stuff of any value found in the King's palace and surrounding houses has been collected in the *Palave* house, which at present is occupied by the hospital and Headquarters Staff. A large quantity of brass castings & carved tusks have been found. Two tusks & two ivory leopards have been reserved for the Queen. The Admiral & his staff have been very busy 'safeguarding' the remainder, so I doubt if there will be much left for smaller fry, even if we had any carriers to take it down. The whole camp is strewn with loot, chiefly

cloths, beads etc, and all the carriers are decked out in the most extraordinary garments. They have assumed a most warlike & truculent aspect, & are at present engaged in celebrating the occasion with a war dance, chanting their deeds of valour.[20]

A month later, Walker's entry for his day of departure from the city simply read: 'Start for Gwato tomorrow, en route for England. Busy packing loot!'[21]

*　*　*

There is a general misconception, which misinforms many dialogues about cultural restitution, that the looting of Benin City was a coherent exercise of collecting and safeguarding. Nothing could be further from the truth: this act of vandalism and cultural destruction possessed no logic of salvage, or of saving culture for the world. It is not even clear whether, in the small number of sales by Protectorate officials, proceeds passed to the state, or simply enriched the individual officers and civil servants. Nick Thomas, for example, repeats the claim: 'the Benin Bronzes were auctioned to cover the costs of the mission.'[22] Let us examine the evidence.

Philip Dark's claim that 'a portion of the loot was sold by the Foreign Office'[23] is closer to the mark. More accurate still is the British Museum's Bill Fagg's frank admission that officers took the loot for themselves – although even here the idea that some sales took place 'to defray the cost of pensions for the killed and wounded' is euphemistic:

The bronze plaques, between 900 and 1000, were reported by cable to the Lords Commissioners of the Admiralty by Admiral Rawson and became the official booty of the Expedition to be sold to defray the cost of the pensions of the killed and wounded. The remainder – bronzes, ivories, wood carvings and iron work, were not reported but shared out carefully among the officers. This was an unofficial loot which was still the custom of war in the 19th century, however reprehensible we may now think of it.[24]

The idea of the sale funding pensions 'for the killed and wounded' appears, Staffan Lundén has argued, to be a pure fabrication on the part of Fagg, thought up during a period of increasing pressure towards restitution in the 1980s.[25] Certainly, in February 1898, Charles Hercules Read – Keeper of British and Mediaeval Antiquities and Ethnography at the British Museum – had suggested that the objects would be 'sold for the benefit of the Protectorate'.[26] But what did this mean, and how accurate was it? To understand the looting, a primary task is to distinguish the range of what was taken, which can be broken down into three main categories: uncarved ivory, brass plaques, and the rest of the brass, carved ivory and other artistic, royal and sacred material culture.

Firstly, the fate of the large reserves of uncarved ivory is unrecorded – however it had long been of interest to Protectorate forces, and it is probable that this was the source of direct profit for the Protectorate. Previous visitors to the City of Benin had remarked on the large quantities of ivory, one estimating 'there must be hundreds of tusks, weighing up to 60 or 70 lbs.'.[27] In 1892, Galway had complained that

Ivory is seldom offered for trade; this is accounted for owing to that article being used by the Benin people almost entirely for the purchase of slaves in the Sobo and surrounding countries, as they consider they get better value by so doing, the Sobos appreciating the article highly. Besides this, the King of Benin claims half the ivory obtained in his dominion; when an elephant is killed, one tusk always goes to the King. The King stores his ivory in very large quantities, and appears very loath to get rid of it even for trade purposes.[28]

As seen above, in his telegram of 17 November 1896 to the Foreign Office proposing the Expedition, Phillips had suggested that 'sufficient ivory may be found in the King's house to pay the expenses incurred in removing the King from his Stool.'[29] The selling-off of the considerable ivory stocks clearly did take place, and Philip Igbafe indicates that £800 had been made for the Protectorate by mid-March

1897.[30] There is some circumstantial evidence that Hamburg-based ivory traders were involved here, including that Max and Carl Westendarp, the owners of the Heinrich Adolph Meyer Ivory Products Company, were the source of a carved ivory tusk from Benin in the collections of the Linden Museum in Stuttgart in 1903. Ralph Moor later recalled that 'from memory about £1200 or £1500 was realised locally and credited to Protectorate funds.'[31] No formal record of such income has yet come to light, and if such a payment did take place, given the relatively low monetary value of Benin artworks at this time, these funds must have come from ivory – although potentially also from other raw materials that could be salvaged from royal material culture, such as any precious metals or perhaps coral. But like the gold from the attack on the palace at Kumasi in 1896, some of which was melted down and sold by its weight, so with the ivory from Benin City it is impossible to tell how many billiard balls, combs, or piano keys may have come from this loot.

Second, how might the fate of the thousand or so brass plaques be traced? Three hundred and four of these plaques were shipped by Ralph Moor, Commissioner for the Niger Coast Protectorate, along with other objects to London, arriving in July 1897. By September, his assemblage – which Read optimistically described as a 'series',[32] rather than a random sample acquired from among the loot – was on loan to the British Museum and temporarily arranged on screens in the Assyrian Saloon;[33] a large central case in the African section of the Ethnographical Gallery was also devoted to the carved tusks and some of the bronzes.[34] Then in 1899, the African section was 'entirely re-arranged' and 'the large series of bronze plaques from Benin was removed from the Assyrian basement and placed in the middle of the African section.'[35]

Of the 300 plaques loaned to the British Museum, some 200 were selected for retention, the other 104 or so returning to the Foreign Office and – according to a hand-list headed 'Fate of the Benin Bronze Plaques' prepared by Charles Hercules Read – then either purchased by various dealers, collectors and museums, including General Pitt-Rivers, Eva Cutter, the Horniman Museum, and Dresden, or

apparently circulated as gifts on an ad hoc basis by Ralph Moor to civil servants, politicians and royalty – while Moor clearly retained some for himself.[36] In the summer of 1898, 11 more plaques arrived at the Foreign Office, and the British Museum took three of these: again, the fate of the other eight is not clear. As with all of the Benin loot, sales were piecemeal and informal – and the vast majority was handled by private individuals, for their own personal profit.

What can be said of the provenance histories of the other 700 or more plaques? The history of their looting involved a diversity of routes: some were taken directly to Bremen and Berlin by German traders, some sold by Protectorate staff in Lagos and in Britain, many brought back to Britain by the officers, colonial administrators and traders. Several accounts describe the ongoing collection of plaques which had been buried to safeguard them, or for other reasons during the functioning of the Palace, for some time after February 1897. For example, Richard Dennett, writing in 1906, commented: 'I never saw the palace and cannot therefore describe it, but while wandering about its ruins I have come across holes in the ground some 15 feet deep … The people still dig amongst the ruins of the palace for the bronzes the Oba and his followers valued so much.'[37]

In her book *The Benin Plaques: A 16th-Century Imperial Monument*, Kathryn Wysocki Gunsch (2018) has counted up 868 plaques that can be located in 95 extant collections: 330 in Germany, 223 in the UK, 120 in the USA, 78 in Nigeria, and the remainder in Austria, Russia, Sweden, Holland, Belgium, Switzerland and Canada, which I have summarised in Appendix 1 at the end of this book. Immediately, however, the problems of creating a comprehensive list are clear: 54 are classed as 'fragments' rather than whole plaques. Some images covered two plaques, and now the two parts are dispersed across two institutions, as for example with a relief plaque of a Portuguese man, his head and torso, shown with two mudfish and his left hand on the hilt of his sword, are in the British Museum,[38] while from the waist down, his legs, the sword blade, shown with two crocodile heads, are 900 miles away in the Weltmuseum in Vienna.[39] Meanwhile, the sum of items on Gunsch's gazetteer[40] comprises 868 entries rather than 854

as she states, and 18 of these are from a museum that no longer exists: the 'second Pitt Rivers Museum' – of which more below.

Third, the haphazard nature of this story is even more extreme for what is by far the largest category of loot: the other objects taken apart from the brass plaques – brass, ivory, wood, coral and other art and material culture. Here the sheer chaos and haphazard contempt shown for royal and sacred objects in the dispersal of the loot reveals itself. Indeed, as James Johnson Sweeney clearly stated in 1935, in his introduction to the Museum of Modern Art catalogue *African Negro Art*, the process operated mainly through 'the liquidation of estates of old soldiers who had taken part in punitive expeditions against the natives (particularly in England whose African forces had reaped a harvest of Benin bronzes)'.[41]

* * *

The Benin loot was on display in London within six months of the sacking of Benin City. There was an exhibition of the Benin collections of George William Neville at the Royal Colonial Institute in June–July 1897.[42] The Lords Commissioners of the Admiralty and Captain Charles Campbell exhibited 'Benin curios' at the Royal United Service Institute in August 1897, including brass plaques, statues and heads, 'ivory idols, brass and wooden bowls, a dagger', and many other objects.[43] In October 1897, Captain Henry Galway exhibited a number of 'most interesting and valuable objects' at the Royal Geographical Society.[44]

Looted Benin objects were swiftly put on display at the Horniman Free Museum at Forest Hill, London,[45] in Liverpool,[46] and at the Pitt-Rivers Museum in Farnham and the Pitt Rivers Museum in Oxford (see Chapter 13 below), among other places – including, of course, the British Museum. By June 1898, the Edinboro Castle public house on Mornington Crescent, owned by T.G. Middlebrook, was reported to have a Benin head on display.[47] A plaited grass ceremonial costume covering the whole body and head, reportedly purchased by Harry Lyall from two enslaved people who had escaped from Benin City before it was sacked, described and illustrated as 'worn at one

time by executioners', was brought into the London office of the *Daily Mail* where attempts were made to put on the outfit.[48] In August 1898, Benin bronzes were included in the Art Metal Exhibition at the Royal Aquarium and Winter Garden opposite Westminster Abbey (demolished 1903, now the site of the Methodist Central Hall); one visitor recorded that 'the singular bronzes from Benin city, of which the nation has fortunately acquired a series' were exhibited by 'Colonel Talbot', which may be a reference to Sir Reginald Arthur James Talbot.[49]

Benin loot appeared in many other places. In 1919, the first major attempt at a *catalogue raisonné* of all the Benin collections was made by von Luschan, who suggested a total of 2,400 objects, including plaques. By the 1950s, William Fagg referred to 'several thousand cult objects' taken as loot.[50] The crucial work of unpicking the provenance history of this scattering of objects is the subject of emerging research, in which Felicity Bodenstein's ongoing work at the Sorbonne is pioneering.[51] A key part of this is to understand the roles of officers and administrators – but also the dealers and auctioneers. Von Luschan listed the following auction houses and dealers as particularly significant during the first two decades of Benin loot sales: Christie's, Manson and Woods, Eva Cutter, Fenton and Sons, William Ockleford Oldman, H.E. Rogers and J.C. Stevens.[52] The dealer William Downing Webster, based at Bicester near Oxford, played a key role in the sale of loot from returning servicemen:[53] indeed, an estimated 562 Benin objects were sold by Webster alone between 1897 and 1901.[54] In reality, the total number of looted objects probably numbered more than 10,000 'relics' and 'curios' brought to Britain by officers and soldiers and kept in private collections or sold on the open market. And the diversity of the loot in circulation from Benin was immense. Among this material there is also an unknown quantity of human remains. It is even currently unclear how many skulls and other human remains taken from Benin survive in museums and private collections – although at least five human teeth found their way from Benin City in 1897 to London, and are now lying at the British Museum in a divination kit, strung on a necklace, and contained within a brass mask.[55]

For example, on 16 March, the *Standard* reported the arrival in Lagos of George William Neville – who had been an agent for Liverpool traders including the African Steamship Company in Niger Coast and Lagos since the mid-1870s, and by 1896 was a partner of the Bank of British West Africa Limited – after spending six weeks with the Benin Expedition in a civilian capacity. Neville had with him a quantity of Benin loot.[56] The next day, Charles Hercules Read wrote to his Director, Sir Edward Maunde Thompson:

> I saw in the papers yesterday a telegram from Lagos announcing the return of the Hon. G.W. Neville from Benin, and stating that Mr Neville brought to Lagos specimens of antique ivory, bronze and other native ornaments. I think it would be desirable to ascertain from the proper quarter whether these articles, and perhaps many other similar things, that have been discovered by our officers in Benin, could not be secured for the British Museum. So far as my department of the Museum is concerned, I should be quite prepared to recommend the Trustees to pay a fair price for any such objects … I wish it could be made known to our officers and men who go on such expeditions as this so fortunately ended, that the national Museum is anxious to acquire the native 'curiosities' that so often fall into their hands.[57]

On 7 May 1897, the British Museum also sought to persuade Lord Curzon, as Under-Secretary of State for Foreign Affairs, to direct a separate body of 'curios' sent by Moor to the Palace to be 'secured for the British Museum … if the Queen does not herself want them'[58] – and Read expressed a particular interest in 'the two wonderful leopards and ivory tusks'.[59]

As Read's attempts to collect Benin 'relics' gathered pace during 1898, the active and extensive buying-up of Benin material by German museums was documented by his colleague Dalton.[60] Soon after news of the looting, von Luschan sent a telegram to the German consulate in Lagos asking to acquire bronzes and other loot circulating there 'regardless of the price',[61] an approach which

led to the acquisition of some 263 objects.[62] In a visit to Hamburg, Berlin, Dresden and Leipzig in July 1899, Dalton noted how Berlin's Museum für Völkerkunde alone through 'liberal gifts, consular assistance, and important pecuniary support from non-official sources' had acquired 'Benin collections in many ways superior to those in the British Museum', including 12 carved ivory tusks and 30–40 bronze heads.[63] As the first Director of the Museum für Kunst und Gewerbe Hamburg put it in May 1899:

> The spoils [*Ausbeute*], insofar as they did not reach the British Museum, were quickly scattered across the continent's museums. Much reached Germany via Hamburg, a large number to Berlin, important pieces, including some of the most beautiful ironwork, have remained in Hamburg. For the Bavarian Ethnographic Museum Dr Büchner acquired a number of good examples, mainly carvings.[64]

* * *

Why are the facts so vague? It was the sheer force with which Benin City was destroyed, the ultraviolence with which the town and its wider landscape were decimated, a culture attacked with the intention of the erasure of one form of sovereignty and its replacement with colonial governance, that led to this scattering, this fragmentation. But the role of the market was and is also a central driver. The annihilation of the Royal Court's material culture was a new but coherent next step in the growing momentum of corporate-militarist colonialism – of destruction for extraction in the name of profit. A sense of *necrography* – of the knowledge of human and cultural loss – informs our understanding of how every day that our museums open their doors to re-tell the story of the punitive expedition with the loot that was taken, this loss is re-enacted, and thus re-doubled and extended across time and space.

But this violence of western anthropology museums, the continuing loss, the sheer hypocrisy, begins with the fact that in these supposed safety deposits for universal heritage, today's curators'

understanding of what is even *in* collections is so minimal. We don't know what there is. We're not sure where it is. We can't say for sure how it got there. Mostly, curators are encouraged not to share what they *do* know – never mind what they don't. This is generally not what curators themselves want, of course, but is rather the product of a set of circumstances, from institutional inertia to directorial caution, the wrong people on trustee bodies, and ill-informed governmental interference, which combine to make time, resources and freedom to speak out scarce commodities at the coalface of day-to-day curatorial life. Most curators want this to change – but then in the UK there are so many important 'orphaned' collections where there isn't even a curator to do this crucial work. This shameful situation has to change, and at the end of this book I'll set out some steps for action.

For now, let us underscore how the power of the nation state has been consistently over-estimated in discussions of the Benin looting – as if the taking of objects were an explicit colonial policy that we need to justify today, as if all the looted objects were in national museums like the British Museum, as if the sole terrain of critique should be that of the nation state in isolation from the corporate-militarist-colonial enterprise. A previous generation of western scholars used the Benin looting to critique the role of colonial heritage in the support of the nation state, based on the idea that imperialism was mobilised towards 'promoting' national unity.[65]

Instead, I want to be guided by the motto: *as the border is to the nation state so the museum is to empire.* The agency lay not with Whitehall alone, but in some far more dangerous zone: that of corporate colonialism, extractive militarism, a harbinger of the disaster capitalism, the ultraviolence, and the racist dispossessions and even exhibitionary regimes that the 20th century would bring not just to West African culture and sovereignty but to the soils of Europe. West Africa lived through a foundational moment for a new kind of race science during the 1890s, one that was driven by what Max Weber called 'booty capitalism' – a concept that connected Britain's early modern slave-trading and piracy with late Victorian militarist

colonialism[66] – and what Marx called 'primitive accumulation', where profit was extracted at all costs. As Achille Mbembe puts it:

> It is necessary to consider the generally conventional distinction between commercial colonialism – or even trading-post colonialism – and settler colonialism properly speaking. Certainly, in both cases, the colony's – every colony's – enrichment made sense only if it contributed to enriching the metropole. The difference in between them, however, resides in the fact that settler colonies were conceived as an extension of the nation, whereas trading post or exploitation colonies were only a way to grow the metropole's wealth by means of asymmetrical inequitable trade relations almost entirely lacking in heavy local investment.[67]

To date, western museums have mapped their approaches to cultural restitution onto the geography of settler colonialism, developing connections and relationships with Indigenous 'source communities' in North America, Australia, and across the Pacific. The risk for Africa is the indigenisation of colonial loot on a North American model. How, then, to begin to think through what cultural restitution means in the ongoing circumstances of extractive colonialism in West Africa? One first step is to understand not the 'life-history' but the loss; to slice open the museum and to see what cancer is inside. Here the necrography begins.

13
Necrology

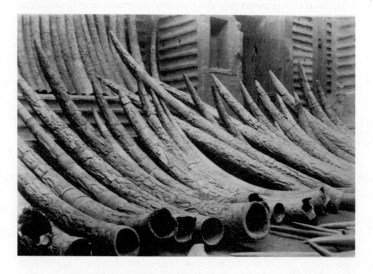

Guns paved the way of the explorers. Much of the collection is the plunder of punitive military expeditions. The relics of the Benin tribe in the section on Divine Kingship in Africa are here as a result of war with the British.

The Treasures of the British Museum, 1971[1]

The museums know so little about what they hold, and they share just a fraction of what they could know. The sheer haphazard nature of the supposed western curation of universal heritage is shocking. In the UK, where most of the Benin loot is still located, more is held in the regional and university museums than in the national museums such as the British Museum, the Royal Collections, or the Victoria and Albert Museum. Even the British Museum remains unable to

publish any comprehensive account of what is in their collections, and unwilling to publish what it knows for now. In the regions, the situation is often much worse, with some large urban collections not even having a 'world cultures' – not to mention an African – curator, and so accurate knowledge is hard to come by. In 1972, a group of four brass and ivory Benin figures were discovered in a broom cupboard at the McLean Museum and Art Gallery, Greenock, after having been given in 1925 by Sir William Northrup Macmillan.[2] Many remain in private hands, as with a bronze figure of a Portuguese soldier used as a door stop until acquired by National Museums Scotland.[3] And here at the Pitt Rivers Museum, a brass head of a staff in the form of an animal, which may or may not have come from the 1897 expedition, was 'found unentered' in 1980.[4]

As some institutions begin to open up their archives, and while others batten down the hatches concerned that too much would be revealed about how poorly loot is cared for, how much might be mislaid, for now at least – even how much access one part of a museum might grant to another! – the urgent task is to reverse-engineer what we know; to turn those tired tropes of 'object biographies' and 'relational entanglements' inside-out by exposing what was taken, what was lost, working outwards from what we know and what we can find out.

Studies of iconography have proliferated, from Philip Dark's use of a visual sorting punch card of his own invention to analyse 'Benin formal traits', examining some 7,000 objects from 224 collections,[5] to Kathryn Gunsch's 'thought process of suppositional analysis' to reconstruct the arrangement of plaques in the Royal Palace in the sixteenth century as a single moment.[6] But in the context of loot from punitive expeditions, any understanding that western curators might create adds up to very little if it does not take the ongoing event of loss and dispossession as its primary focus. Let us call the knowledge made through death and loss in the anthropology museum *necrology*, and the writing of such loss *necrography*.

The necrology of Benin 1897 – knowledge of the loss and death involved – requires us to decentre militarist-colonial knowledge in

the form developed by General Pitt-Rivers and museum anthropology ever since, and by the nation state in the form of the British Museum, by excavating cultural loss, to start to remove the imprint of looting from each object as it emerges through the process. In this process, each stolen thing is not a fixed entity to be pinned, mounted on a display, typed into a database – but an unfinished event – as 'all the King's corals and bronzes and ivories passed into the hands of the British force'.[7] We need to understand these unhistories, these processes of taking life rather than adding new biographical layers, in order to make visible how much is unfinished.

To study loss at this scale, performed across hundreds of museum displays, requires some conceptual and practical framework, requires of us something beyond the conventional art-historical definition of 'provenance'. Rather than trying to short-circuit the history, to foreground some past context might be reasserted or thought back into, the necrographer must reverse the current to understand their task as future-oriented, not some backward-looking or nostalgic exercise. This is not so much a question of the study of Warburgian *Nachleben* (afterlives) or the Tylorian image of *survivals*,[8] as if looted artworks were readymades, in the form of fragments, but more about the close reading of some Gothic *Boys' Own* myth, some immersive captivity narrative about the undead, where the roles of survivor and victim are cleverly switched.

We need to find the tools, in the form of picks and shovels rather than merely paintbrushes and teaspoons, to excavate how the actions of the soldiers, traders and administrators – that holy trinity of corporate colonial labour – have given way to the mutual gestures of the anthropology museums on the one hand, and the tribal art market on the other. The twin concerns of sovereignty and profit have run through this process from start to finish. The focus of the necrographer must therefore be unashamedly on the white men who took these things and inflicted such loss, so that we can understand and locate what was taken, and can inform and catalyse the task of restitution. This knowledge presently lies with Euro-American museum curators, and it needs to be shared. The dangers are of new hagiographies of dead white men

I. Sketch of a second (final) design for the Ashantee War Medal, Edward J. Poynter, July 1874, British Museum (accession number 1919.1216.19).

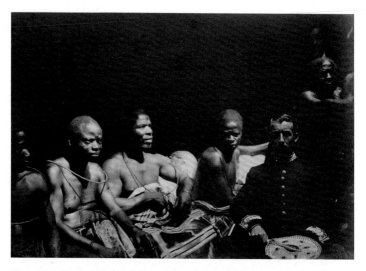

IIa. Vice-Consul Henry Galway (Gallwey) with Benin chiefs during his visit to Benin City in March 1892. Photograph by John H. Swainson, Liverpool trader. Macdonald Niger Coast Protectorate Album, A1996-190143. Eliot Elisofon Photographic Archives, National Museum of African Art, Smithsonian Institution.

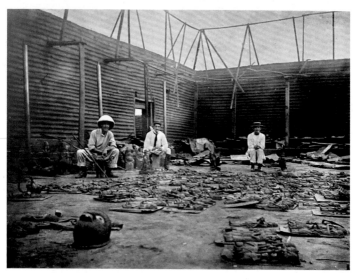

IIb. Interior of the Royal Palace during looting, showing Captain Charles Herbert Philip Carter (1864–1943), 'E.P. Hill' and an unnamed man, February 1897. Pitt Rivers Museum (accession number 1998.208.15.11).

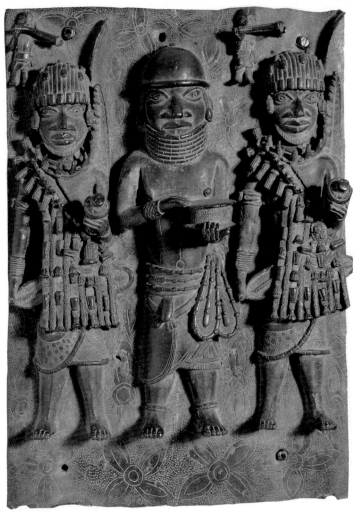

III. Brass plaque looted by Captain George Le Clerc Egerton from
Benin City. Pitt Rivers Museum/Dumas–Egerton Trust (accession number
1991.13.8).

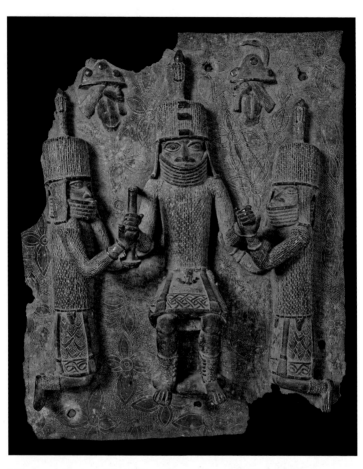

IV. Brass plaque purchased from Thomas Francis Embury, recorded as having been bought by him in Lagos after it had been 'hidden away from our soldiers after the capture of Benin on the punitive expedition of 1897, and was brought to Lagos by a native trading woman from whom it was obtained'. Pitt Rivers Museum (accession number 1907.66.1).

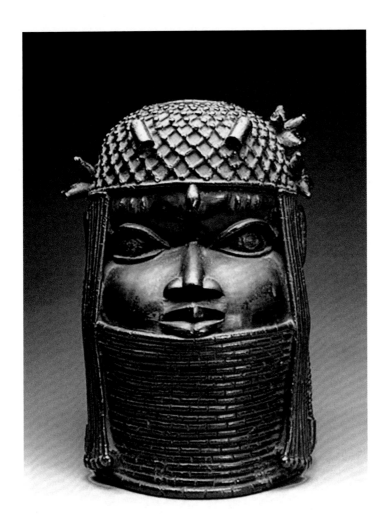

V. Bronze Benin head, mid-17th century, given to Queen Elizabeth II from the collections of the National Museum, Lagos by General Yakubu Gowon in June 1973. Royal Collection Trust (accession number RCIN 72544).

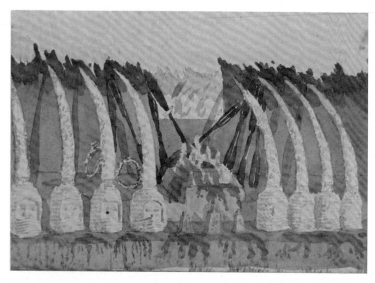

VIa. Watercolour of an ancestral shrine by Captain George LeClerc Egerton, 1897. Pitt Rivers Museum/Dumas-Egerton Trust (accession number 1991.13.3).

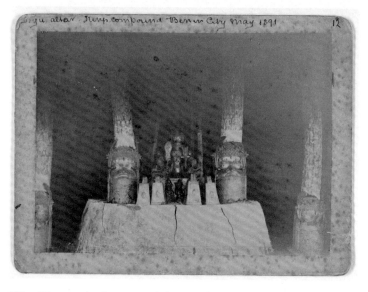

VIb. Photograph of an ancestral shrine at the Royal Palace, Benin City taken during the visit of Cyril Punch in 1891. Eliot Elisofon Photographic Archives, National Museum of African Art, Smithsonian Institution. EEPA.1993-014.

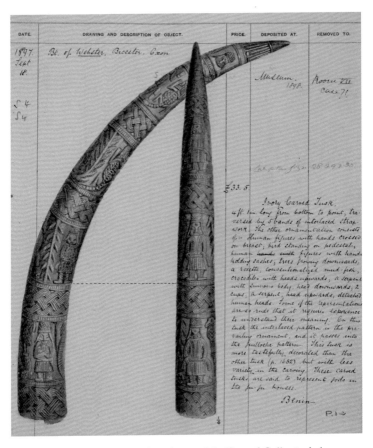

VII. Page from the illustrated catalogue of the 'Second Collection', the Pitt-Rivers Museum at Farnham, showing a carved ivory tusk bought from Webster for £35.0.0 on 18 September 1897. The tusk was probably sold at Sotheby's on 30 March 1981 (University of Cambridge Libraries Add. 9455, Volume 5, p. 1600).

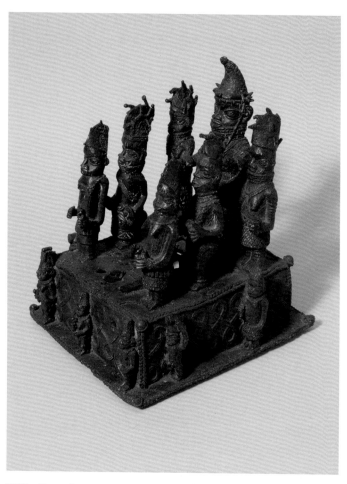

VIII. Brass Queen Mother altarpiece with the figures of six attendants, looted from Benin City by George LeClerc Egerton. Pitt Rivers Museum/ Dumas-Egerton Trust (accession number 1991.13.25).

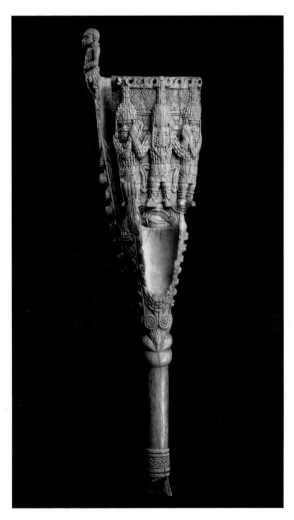

IX. Ivory double bell (*egogo*), early 16th century. Bought from Henry Ling Roth for £6.0.0 for Pitt-Rivers Museum, 2 October 1898 (Catalogue volume 5, p. 1746), bought by Mathias Korner by 1958, purchased by the Brooklyn Museum 1958 (accession number 58.160).

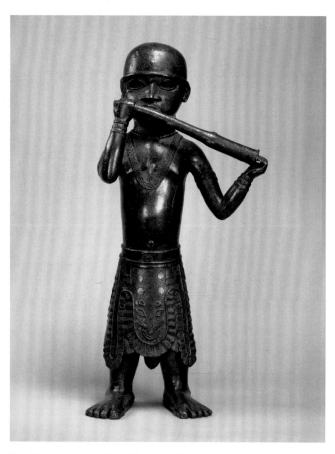

X. Brass figure of a horn-blower, 16th century. Bought from Webster for Pitt-Rivers Museum, 7 August 1899 (Catalogue volume 6, p. 1989), sold to K. John Hewitt before 1957, bought by Nelson A. Rockefeller 1957, donated to the Museum of Primitive Art 1972, transferred to the Metropolitan Museum of Art 1978 (accession number 1978.412.310).

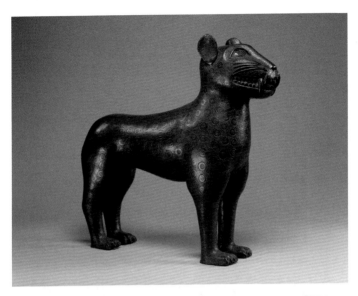

XIa.　Brass figure of a leopard, 16th or 17th century. Bought from Webster for £20.0.0 for Pitt-Rivers Museum, 17 March 1899 (Catalogue volume 6, p. 1929), sold to K. John Hewitt before 1957, bought by Matthias Komor 1957, bought by Nelson A. Rockefeller 1958, donated to the Museum of Primitive Art 1972, transferred to the Metropolitan Museum of Art 1978 (accession number 1978.412.321).

XIb.　Page from the illustrated catalogue of the 'Second Collection', the Pitt-Rivers Museum at Farnham, showing a the brass figure of a leopard illustrated in Plate XIa. (University of Cambridge Libraries Add. 9455, Volume 6, p. 1929).

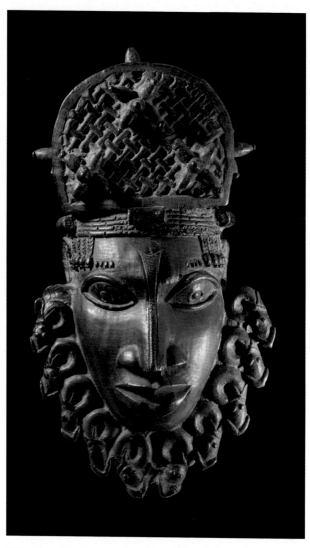

XII. Brass hip pendant mask, Ashmolean Museum, University of Oxford, on long-term loan to the Pitt Rivers Museum (accession number 1983.25.1).

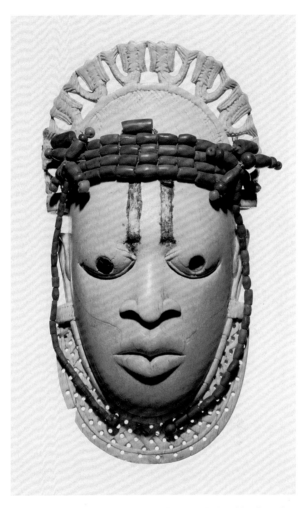

XIII. Ivory hip pendant mask of Queen Mother Idia. Bought at Stevens Auction Rooms for £25 for Pitt-Rivers Museum, 14 April 1898 (Catalogue volume 5, p. 1623), and acquired by the Linden Museum, Stuttgart 1964 (accession number F 50565).

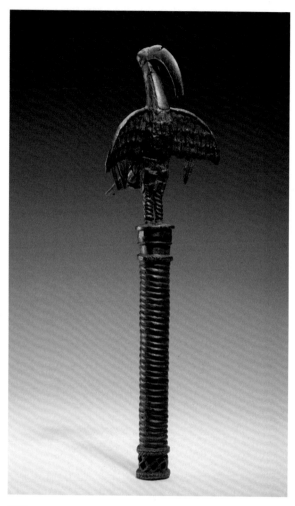

XIV. Brass gong in the form of a bird on a hollow brass staff, 18th century. Bought for £4.1.0 from Webster for Pitt-Rivers Museum 8 June 1899 (Catalogue volume 6, p. 1954), sold 1966 to Olga Hirshhorn 1966–2015, National Museum of African Art, Smithsonian Institution 2016–present (accession number 2016-1-1).

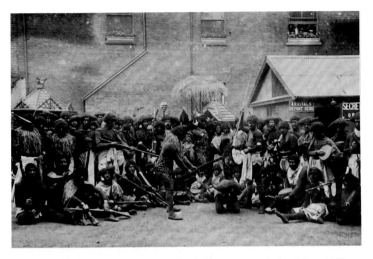

XVa. Performance of a human sacrifice by Benin troops in blackface, 1897, possibly in Portsmouth or London. National Army Museum (negative 18804); see Nevadomsky 2006.

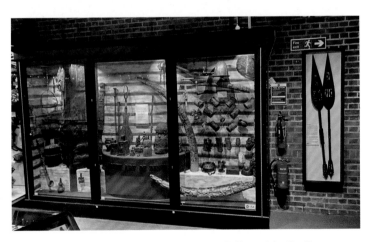

XVb. 'Benin Court Art' display on the Lower Gallery of the Pitt Rivers Museum, University of Oxford in February 2020. To the right, a temporary display of the wooden ceremonial paddles inherited by Mark Walker can be seen, next to the fire escape, during the restitution process.

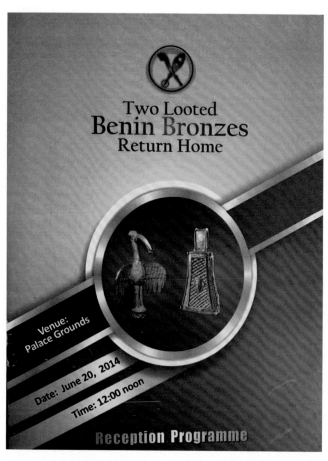

XVI. 'Two looted Benin Bronzes return home'—programme for the ceremony for Mark Walker's cultural restitution, Royal Palace Grounds, June 2014 (courtesy of Mark Walker).

on the one side, and of simply retelling stories of war as a kind of 'dark heritage' or 'ruin porn' on the other. The task of necrography therefore requires the curator to learn from and adapt what the forensic scientist understands about ethics, about evidence, about responsibility, about debts to those who live with the ongoing effects of killing and destruction. In 1919, Felix von Luschan recalled how:

> A large part of the pieces had come into the possession of officers and marines as war booty [*Kriegsbeute*] and was sold off to dealers in Lagos after just a few days. I know of three series, including some exceptionally beautiful pieces, that were held in an English private collection for several years, but were eventually sold off.[9]

Apart from what was brought back to London for the Foreign Office and for himself by Ralph Moor, the three most significant collections made by officers identified by von Luschan a century ago were those of Admiral Harry Rawson (1843–1910), Captain George Le Clerc Egerton (1852–1940) and Captain Charles Campbell (1847–1911).[10] We can identify further possible collections, and point to others that von Luschan did not know of.

So here comes an A to Z of 17 dead white men. This necrography begins with a partial muster roll of the looters, just a few cases where names might be connected to objects they stole, calling up their ghosts so we can start better to understand what spoils they left behind, and where.

* * *

Allman. Robert Allman (1854–1917), Principal Medical Officer of the Oil Rivers/Niger Coast Protectorate in 1891, came home with a wide range of loot, which was gradually dispersed after his death. A helmet mask that had been sold to Harry Beasley's Cranmore Museum, a collection which was itself broken up after his death in 1939, was given to the British Museum in 1944 by Beasley's widow.[11] Other objects may have been sold along the way, and then on 7 December 1953, Allman's son, R.B. Allman, sold some or all of the collection through

Sotheby's, including a bronze Queen Mother head, a bronze horseman figure, two bronze leopards, a bronze bird, as well as bronze stand or seat in the form of two mudfish, a bronze jug, a round carved ivory box, two brass 'dance wands', and three ceremonial swords; almost all were purchased for the Nigerian Government for the new National Museum in Lagos.[12]

* * *

Bacon. There are no known collections of Benin loot brought back by Commander Reginald Hugh Spencer Bacon (1863–1947) from Wiggonholt, Sussex, who was Chief of the Intelligence Department during the Benin Expedition (and later Captain of HMS *Dreadnought* during her first commission) as well as the author of *Benin, City of Blood* (1897); he died in Romsey, Hampshire in 1947.

* * *

Campbell. The fate of loot brought back by Charles Campbell – later Admiral Sir Charles Campbell – who commanded HMS *Theseus*, after its initial display, described above, at the Royal United Service Institute in the summer of 1897 is unclear, although after his death in 1911 four carved ivory armlets, a drum and a bowl were purchased by the British Museum from Lady Campbell.[13]

* * *

Cockburn. William Alexander Crawford Cockburn (b. 1863), of the Niger Coast Protectorate Force, sold 69 looted Benin objects to the British Museum in 1897, paid for through the Christy Fund – including wooden arrows, embossed brass discs, a ceremonial war jacket of wool and hide, bracelets, hip-masks, armlets, a carved wooden box and lid mounted in brass, a dagger, a sword, a key, and an 'altar of the hand' (*ikegobo*).[14]

* * *

Egerton. More is known in the case of George Le Clerc Egerton, Chief of Staff for the Benin Expedition, who was from Ringwood,

Hampshire. Egerton had served alongside Rawson in Mombasa in 1895 and at the bombardment of the Sultan of Zanzibar's Palace in 1896; he was later Commander-in-Chief at the Cape of Good Hope (1908–10), Second Sea Lord of the Admiralty (1911–12), and Commander-in-Chief at Plymouth (1913–16). The fate of his loot is more complex: an ivory double gong from his collection was donated to the British Museum in 1962, presumably after being purchased at auction.[15] At least one other Egerton object has reached North America having been sold: an ivory bracelet in New York's Metropolitan Museum of Art.[16] As discussed in Chapter 13 below, a significant part of the Egerton loot is currently curated by the Pitt Rivers Museum in Oxford.

* * *

Heneker. William Charles Giffard Heneker (1867–1939), a Canadian, later the author of the handbook of colonial ultraviolence that was *Bush Warfare* (1906), sold a Benin side-blown horn soon after returning to Britain, which was then purchased from the dealers Rollin and Feuardent in 1900 by the British Museum.[17]

* * *

Galway. Turning to the wider cast of administrators and officers involved, we know little of the loot taken by Henry Lionel Galway/ Gallwey (1859–1949, Deputy Commissioner and Consul Niger Coast Protectorate), who had been attached to Henry Rawlinson's Intelligence Staff, and was also in command of a Hausa Company during the operations in the Benin country, including the sacking of Benin City, 1897. Had he developed earlier collections apart from the tusk he was given, as mentioned in the last chapter, by the Oba in 1892 when as Vice Consul of the Protectorate he had signed the treaty? What did Moor and Galway divide between themselves? Certainly Galway took a carved ivory Queen Idia mask, which he displayed in December 1947 at the Berkeley Galleries in Davies Street in London.[18] Did Galway take Benin loot with him when he went on to be Governor of St Helena (1902–11), Governor of the Gambia

(1911–14) and Governor of South Australia (1914)? Did he sell his share along the way, or pass to descendants?

* * *

Kennedy. Francis William Kennedy (1862–1939), First Lieutenant of HMS *Phoebe*, who had served in the bombardment of Alexandria in July 1882, the Mweli and other Expeditions in East Africa in 1895, and had been in Niger Coast Protectorate for two years, later donated a painted linen flag looted during the expedition, possibly from Benin City itself, to the Royal Museums Greenwich – a collection which also received the personal flag of Chief Nana Olomu.[19] We don't know what else he might have looted from Benin City.

* * *

Locke. Ralph Frederick Locke (1865–1933), with Boisragon he was one of the two survivors of the Phillips incident, and fought in the Benin Expedition, and was later a Divisional Commissioner in Southern Nigeria Protectorate. He went on to give a Benin head to the Royal Albert Memorial Museum after moving to Exeter to be the city's Prison Governor. He sold off his Benin collection at Stevens's on 3 January 1928, the catalogue for which listed the lots as follows:

A finely carved ivory mask; an ivory spoon supposed to have been used by the King of Benin; a very large ivory armlet worn by a Sobo Chieftainess, a pair of bronze supports with raised decoration, two bronze 'JuJu' bird surmounts for the staff of a chief, a bronze pipe bowl, a bronze figure of an executioner, a bronze figure of a native, a bronze figure of man in armour holding a gun, a pair of bronze anklets in the form of slugs, two bronze wands carried on cere-monial occasions behind a chief, bronze bird and armlet, a bronze plaque with three full-length figures, a conical shaped bronze, a bronze mask, a brass 'demon's head mask' with a collar in the shape of a serpent's head, a pair of heavy bronze armlets, a bronze armlet used by a medicine man with small containers for holding drugs etc, a large bronze ring, a bronze plaque with the figure of a warrior,

an executioner's sword, a cowrie shell waistbelt, two pairs of ivory tusks, a reed case containing pieces of broken cannon shot found during the trouble in 1894.[20]

* * *

Moor. What of Consul General Sir Ralph Denham Rayment Moor (1860–1909), who oversaw the transfer of loot to the Foreign Office and to the Queen, a part of which found its way to the British Museum? We know he sent the two famous carved ivory leopards, with spots of inlaid bronze, to the Queen, who put them on display at the Museum at Windsor Castle in 1900.[21] We know that in 1899 he donated one of four 16th-century Portuguese breech-loading swivel guns taken from Benin City to the British Museum.[22] We also know that after Moor's suicide back in England in 1909, by taking cyanide, aged 49,[23] two of the famous ivory mask-shaped hip-pendants of Queen Idia, mother of Oba Esigie, which Moor had kept for himself, was bought by the anthropologist Charles Seligman – who sold one to the British Museum in 1910, the second being sold by Brenda Seligman for £20,000 to Nelson A. Rockefeller in 1958, and now in the Metropolitan Museum of Art in New York.[24] The sale of the latter provided an endowment to the Royal Anthropological Institute. 'The ethnographer is delighted at the feasibility thus demonstrated of translating the worth of his inert stock-in-trade into so much clinking coin,' wrote one commentator.[25] There is clearly much more to understand in the case of Ralph Moor, not least since Charles Hercules Read wrote very shortly after his death that 'The late Sir Ralph Moor, who was directly instrumental in securing the bulk of the Government share of the loot, was fortunate enough to obtain for himself some pieces of exceptional merit, and the whole of these were dispersed after his death.'[26]

* * *

Neville. The major collection made by Liverpool trader and Lagos banker George William Neville, exhibited as described in the previous chapter at the Royal Colonial Institute in June–July 1897, was displayed in his house in Weybridge during his lifetime, including a

bronze cockerel donated to Jesus College, Cambridge,[27] and then largely dispersed after his death through a major sale at the Foster auction rooms in London on 1 May 1930.[28]

* * *

O'Shee. We know nothing at present about any collections brought back by Lieutenant Riebard Alfred Poer O'Shee (1867–1942) of Royal Engineers, who was a Special Service Officer on the Benin Expedition.

* * *

Rawson. In the case of Rear Admiral Harry Holdsworth Rawson – Lancastrian, freemason, recipient of the Queen Victoria Diamond Jubilee Medal for his role as Commander-in-Chief of the Benin Expedition – we know very little about his loot. Rawson had served through the Second Opium War, serving at the taking of the Taku forts and of Beijing in 1860, aged 17. He later wrote writing after the burning of the Summer Palace to the ground that 'The Emperor's palace was looted, but I was not there, so did not get any of the valuables, of which there were a tremendous lot taken, one officer getting £1,000 worth in the shape of a gold picture-frame.'[29]

Appointed commander of British naval forces at the Cape of Good Hope and West Coast of Africa Station, his squadron captured Mweli, the stronghold of Mbarak bin Rachid, a Mazaria chief, in August 1895, and in August 1896 he oversaw the bombardment of the Palace at Zanzibar, as outlined in Chapter 6 above. Rawson seems to have joined with Moor in ordering the looting. In 1953, William Fagg reported that a brass horseman figure from Rawson's loot had found its way to the national collection at Lagos.[30] What other Rawson loot was there? What did he take back to South Africa, or with him when he became Governor of New South Wales in 1902, or give away, pass to descendants, or sell on?

* * *

The Roth Brothers. Felix Norman Roth (1857–1921) who had worked at Warri trading station since 1892 as a self-styled 'doctor-engineer'.[31]

He fought alongside his brother Henry Ling Roth (1855–1925) in the Benin Expedition. Henry Ling Roth was Curator of the Bankfield Museum in Halifax, Yorkshire, who in 1903 published the influential study of *Great Benin: Its Customs, Art and Horrors*, as well as a 1911 article on 'the use and display of anthropological collections in museums'[32] – and in 1897 sold three Benin heads and three pendant ornaments to the British Museum.[33] Felix Ling Roth is listed as the source for one Benin object in the Pitt Rivers Museum in Oxford, and Henry Ling Roth as the source for eight Benin objects in the Pitt-Rivers Museum at Farnham (of which more below).

* * *

Roupell. Ernest Percy Stuart Roupell (1870–1936) of the Royal Welsh Fusiliers and the Milford Haven Division Royal Engineers Militia – 26 years old at the time of the Benin Expedition, from Richmond Hill, London, educated at Marlborough College – had previously taken part in the expedition against Nana, and had been Assistant Commissioner of the Anglo-German Boundary Commission, Niger Coast Protectorate since 1896. After the Benin City Expedition, he was appointed British Resident and Political Officer, 1897–98. In 1898, he sold the royal wooden stool (*agba*) of the Oba to the British Museum.[34]

Among loot that he sold off in London, including a sale through dealers Spink and Son in 1948, the British Museum bought the coral bead fly-whisk of the Oba of Benin, formed of strings of coral beads with a handle of four large beads of red jasper, an apron made from a mesh of coral beads on vegetable fibre, a coral cap, a royal stool, and an ivory staff or rattle in the form of bamboo[35] – and in 1948 the Barber Institute of the University of Birmingham acquired a brass Queen Mother altarpiece from Roupell's collection.[36]

* * *

Seppings Wright. Henry Charles Seppings Wright (1850–1937) – special war correspondent to *Illustrated London News* to Ashanti, Soudan, Benin, Greek, Spanish-American and Balkan wars, and

amateur painter – arrived at Benin City on Sunday, 21 February 1897. His donkey is pictured in a photograph in the collections of the British Museum, with a haul of loot on the ground before it was ready to be packed up.[37] We can, however, trace some objects in the British Museum to this collection with some certainty, including the famous bronze head of Queen Idia,[38] and four ivories, a staff, an altar ornament, two further brass figures, and an altarpiece; these were acquired from Sir William James Ingram (1847–1924), former Liberal politician and Managing Director of the *Illustrated London News*, for whom Seppings Wright worked.

* * *

Walker. Of the loot of Lieutenant-Colonel Herbert Sutherland Walker (1864–1932) of the Cameronians (Scottish Rifles), Special Service Officer in the Benin Expedition, Chief Constable of Worcestershire from 1903, more is known. Some of Walker's collection was sold at the Foster auction rooms in London on 16 July 1931, and in 1957, Josephine Walker, who had married Herbert Walker in 1909, donated an ivory tusk from the collection to the Jos museum in Nigeria.[39] Then, after he inherited them in 2013, one of the four grandsons of Herbert Sutherland Walker, Mark Walker, personally returned a brass 'bird of prophecy' and a brass bell to the Royal Court of Benin in June 2014 (Plate XVI).[40] A further restitution, of two iJekri wooden ceremonial paddles, from the Walker family collection, is at the time of writing being supported through the Pitt Rivers Museum.[41]

* * *

And what loot might all the other soldiers who served on the Benin Expedition of which we know so little have taken? Midshipman Charles Rodney Blane, Fourth Baronet, aged 17? The impossibly named Edward Leonard Booty, 26 years old, who had previously served in the Brass River and Mweli Expeditions in 1895? The 16-year-old Midshipman Percival van Straubenzie from Spennithorne, North Yorkshire, Aide-de-Camp to Chief Commissariat Officer Stokes-Rees, later lost in action in HMS *Good Hope* at Coronel on 1 November

1914? Tufton Percy Hamilton Beamish, aged 22 – later a Rear-Admiral commanding HMS *Invincible* and HMS *Cordelia* in the First World War, and the Tory MP for Lewes in the 1920s and '30s, who recalled the Benin Expedition in a long and intolerant speech in the House of Commons on 21 May 1940 – what did these men take? And this is not to mention what might have been retained by ministers and civil servants – museum curators too – as these objects passed from hand to hand.

There are so many unexplored death-histories of Benin objects here. To take just a few from the British Museum: how did Percy Tarbutt, the British Museum source in 1941 of a Benin staff and a bird figure, come by these items?[42] What of Philip Smith, from the executors of whom the British Museum purchased some 29 Benin objects – including a leopard figure, gunpowder flask, masks and more – in 1947?[43] The looted bronze figure of an elephant cut from a staff given to the British Museum by Mrs Spottiswode in 1947.[44] An ivory armlet purchased from the estate of Lord Rosmead in 1898.[45] An ivory handle of a ceremonial fly-whisk given by J. Edge Partington.[46] What stories lie behind the purchase by the British Museum from the Church Missionary Society of a ceramic head-rest recorded as 'a pillow which belonged to one of the 100 wives of the King of Benin'?[47]

Let any enduring sense that the old fake justifying myth that loot was taken to pay for the Expedition, or to punish a crime, stop here. Perhaps this personal gain on the art markets is what the British Museum's William Fagg was referring to when he wrote of indemnity and pensions for the officers? The practice of looting was passed across generations of naval officers. Many of the older soldiers brought experience of looting from Wolseley's 1882 campaign against Arabi Pasha in Egypt, and more recently from Zanzibar and from the Gold Coast. Many of the younger soldiers went on to serve in future looting episodes in China during the Boxer Rebellion – such as the so-called 'Carnival of Loot' that took place during the sacking of Beijing in aftermath of the Boxer Rebellion.[48] We should not perhaps underestimate the influence of Admiral Rawson's direct teenage experiences in the earlier episode of looting in China in 1860.

Let us also stop here, in its tracks, the old plea about the technical legality of the looting.[49] Part of the context was a shift from naval to land armies, before the birth of military air force – normal practices of the navy versus those of the army – as if Africa were one great floating culture, from which salvage was acceptable before it sank. Foreshadowing the horrors of 20th-century practices of defining a group as racially inferior, seizing their loot in circumstances of mass killing, and putting it on public display to show the victory of civilization over savagery, extending the strategy of white projection back to the metropolis, and the museum. Each of the three principal corporate-militarist colonial ultraviolences of the Benin-Niger-Soudan Expedition of 1897 – the slaughter of human life (by attacking villages and towns, using improvised expanding bullets, firing indiscriminately into the jungle or mowing down cavalry, seemingly taking no prisoners and shooting the wounded), destroying cultural sites, and looting royal material culture – were banned by the Hague Convention of 1899. Even at the end of the 19th century, the world was aware that these acts were wrong. Moreover, judging, in a contemplative and abstract fashion, by the standards of the day is not an option open to us for as long as these trophies remain on display in museums across the Northern Hemisphere. The violence is an endurance, not some past relic to be revisited on the curator's own terms.

But let's also stop pretending that even with the personal enrichments of soldiers and administrators, and the unjustifiable nature of the violence and the taking, that somehow the outcome is okay. For example, in the Preface to the major 2007 touring exhibition *Benin: Kings and Rituals*, Christian Feest, Jean-Pierre Mohen, Viola König and James Cuno, at the time the directors of the four Euro-American hosting institutions – Museum für Völkerkunde Vienna (since renamed the Weltmuseum), the musée du quai Branly in Paris, the Ethnologisches Museum, Berlin, and the Art Institute of Chicago – felt able to make the following claim: 'From our 21st-century perspective the military action seems unjustifiable; however, we must recognise the role it played in bringing these works of art to far broader attention.'[50]

This necrography has begun to excavate the circumstances of some of this loss. Excavation must always begin with the most recent layer, and *archaeology is not the study of fragments of the past, but the science of human duration*. So, let's excavate that claim of 'bringing to attention'. The old lie of caring for world cultures through destruction and violent theft, that notion of cultural *Schutzhaft*, is beginning to fall away as the sheer disregard for African cultures with which looting began is seen to extend into museums' sustained disregard for their world culture collections and for the diverse communities they serve, and still fail to represent among their staff. The fate of the Benin collections of the Pitt-Rivers's two Museums, to which we now turn, shows that in stark terms; it is a lens through which we can see how European museums, in acquiring military loot from Africa, became weapons in their own right.

14

'The Museum of Weapons, etc.'

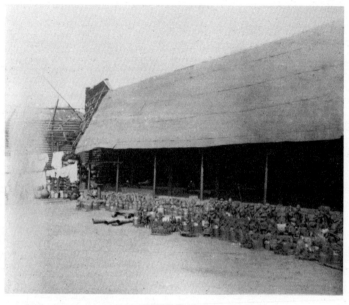

Edo Wood Altar Head of a Chief, Benin Kingdom, Nigeria.
THE COLLECTION OF ALLAN STONE: AFRICAN,
OCEANIC, AND INDONESIAN ART – VOLUME ONE
15 November 2013, 2:00 pm EST, Sotheby's New York
ESTIMATE: 7,000-10,000 USD
LOT SOLD. 20,000 USD
HEIGHT: 24 1/2 in (62.2 cm)
EXHIBITED: Pitt-Rivers Museum, Farnham, Dorset,
 1934–1960s
PROVENANCE:

Augustus H. Lane Fox Pitt-Rivers, Farnham

Alexander Lane Fox Pitt-Rivers, Farnham, by descent from the above

George H. Lane Fox Pitt-Rivers, Farnham, by descent from the above

Stella Pitt-Rivers, Farnham, acquired from the above

K. John Hewett, Bog Farm, and James Economos, Santa Fe, acquired from the above

William Stark, Denver, acquired from the above

S. Thomas Alexander III, Saint Louis, acquired from the above

Merton D. Simpson, New York, acquired from the above in May 1976 (inv. no. "1785")

Allan Stone, New York, acquired from the above in May 1977

LITERATURE: Augustus Henry Lane-Fox Pitt-Rivers, *Antique Works of Art from Benin*, London, 1900, p. 73, pl. 36, figs. 277 & 278 (two views)[1]

If the looting of Benin City led to the careful curation and conservation by Euro-American museums as places where African cultural heritage can be safely kept for the world to visit, to appreciate, and to preserve, then how did this wooden Benin head, which we know was bought for £30 from William Downing Webster for the Pitt-Rivers Museum at Farnham on 12 January 1899, come to be passed between nine different owners, plus Webster and the unnamed original looter, and then offered on the open market to a twelfth in just twelve decades, sold in 2013 for $20,000?[2]

The case of the Benin collections of 'the Pitt Rivers Museum' shows how misguided any faith in the rhetoric of cultural *Schutzhaft* (protection of artworks) must be, where a key part of the dispossession of Africa was and continues to throw its cultural heritage to the market. As so often with the enduring shattering effects of the sheer scale of the violence of 1897, a kind of double-vision develops; reversals occur, the order of time is shuffled, things blur into each other: museums and the market, past and present. Even the Pitt Rivers itself, it turns out, reproduced itself into two.

There were two Pitt Rivers Museums, of which only one survives as a collection today. The first began as a private collection of arms displayed in the owner's various houses in London – expanding later from a museum of weapons into public displays of skulls, European prehistory, and 'ethnology' – ending up in Oxford. The second was a totally new collection built up on his private estate.

It is perhaps no mere coincidence that both museums were founded in 1884, the same year of the Berlin Conference. Both were made by the same man, Augustus Henry Lane Fox Pitt-Rivers, born 4 April 1827 , who was 10 years old when Queen Victoria came to the throne on 20 June 1837, and died on 4 May 1900, just eight months before she did on 22 January 1901, and three years after the sacking of Benin City. Both were major centres for the acquisition of Benin loot. For convenience, a hyphen distinguishes one from the other. The first was a collection made between 1851 and 1882, and exhibited by General Augustus Henry Lane Fox in Bethnal Green and South Kensington before he inherited the title Pitt-Rivers and used the fortune that came with it to fund the costs of donating his collection to the University of Oxford for display in new specially built galleries, which opened in 1884. The 30,000 objects of the founding collection grew, under the curatorships of Edward Burnett Tylor and Henry Balfour to a quarter of a million objects by the outbreak of the Second World War. Today it holds 300,000 objects from around the world, and a similar number of colonial photographs. Then, as soon as his first collection was handed over, and with the financial resources now at his disposal, the newly re-named Augustus Henry Lane Fox Pitt-Rivers began to create a second collection, ultimately of a similar size to his first, and to put this on display on his estate at Farnham, on the Wiltshire-Dorset borders in southern England.

Both Pitt Rivers collections were described by their founder as 'typological museums', where objects from times and places around the globe were taken from their different life-worlds and mixed together, reduced to form, juxtaposed in a kind of social evolutionary *bricolage*, to tell the story of the progress of gradual material form and western technological superiority.[3] Before exploring what that means in the

next chapter, let us introduce the creation, and the reduction, of the collections of Benin loot in the Pitt Rivers Museum/s. In the strange time sequences of Benin, it is the 1897 loot in the 'second collection' that began to form first.

* * *

In 1919, Felix von Luschan described the importance of the Benin objects in the so-called 'second collection' made by General Pitt-Rivers – that is, the Pitt-Rivers Museum at Farnham:

> I counted 280 exquisitely beautiful pieces in the British Museum. But General Pitt-Rivers, that outstanding genius of collecting, used his great resources to buy Benin antiquities among other things even during the final years of his life, and left behind a collection of 227 pieces which, according by his specific instruction, will not go to the museum that bears his name in Oxford, but must remain far off the beaten track at his estate at Rushmore near Salisbury.[4]

To take the 'second Pitt Rivers collection' first, since in this case it was formed first, the sources of 283 objects can be outlined, as summarised in Appendix 3 at the end of this book. The collection was formed in the final three years of Pitt-Rivers's life. The first objects looted from Benin City to enter the collection appear to have been two bronze figures bought at Stevens Auction House on 25 May 1897.[5] Pitt-Rivers acquired Benin loot at six further separate Stevens Auction Rooms' sales between 4 April 1897 and 7 November 1899.[6] But by far the most significant source, from which two-thirds (188 objects) were acquired, was the ethnological dealer William Downing Webster,[7] as well as other dealers, including Webster's partner Eva Cutter, George Fabian Lawrence, George R. Harding of the Charing Cross Road, and James Tregaskis of High Holborn. Pitt-Rivers also acquired seven plaques purchased from 'Crown Agent of the Niger Coast Protectorate, Downing Street' on 24 March 1898, and a further two from 'the Crown Agents' on 12 November 1898 for between £5 and £8, to a

total of £58. He also purchased nine objects directly from an officer who served in the expedition: Major Norman Burrows (South Wales Borderers) of Mellor Hall (now in Greater Manchester), who was a District Commissioner with Niger Coast Protectorate between 1895 and 1899.[8]

Pitt-Rivers's growing collection of Benin art was clearly a major focus of his interest and activity, despite ill health, in the final three years of his life. His catalogue *Antique Works of Art from Benin Collected by Lieutenant-General Pitt Rivers*[9] went to print in the same month as his death, and was published posthumously, and a hand-written catalogue with detailed watercolours was produced as well (Plate VII).[10]

* * *

The Pitt Rivers Museum in Oxford, meanwhile, currently holds at least 145 objects that were taken in the Benin Punitive Expedition of 1897, a collection formed between the receipt of a brass cylinder or powder flask from Henry Ling Roth in 1898 to the accession in 2012 of three reproduction casts of Benin bronzes (not included in the count-up here). These casts were made in the 1960s for Bernard Fagg – the younger brother of William Fagg (from 1938 Assistant Keeper and then (1969–74) Keeper in the Department of Ethnography at the British Museum) – the first Director of the Nigerian Department of Antiquities, a key figure in the 20th-century history of Nigerian museums, and later Curator of the Pitt Rivers Museum from 1963 to 1975.

Of these 145 objects (see Appendix 2), around 43 are on loan rather than owned by the museum, in addition to significant photographic, watercolour and manuscript materials. Ten of these are brass relief plaques, and the rest are a variety of brass, gilded brass, ivory, iron, wooden and coral objects. Further objects in the collections may have been looted in the Benin Expedition, but the supporting evidence is currently insufficient for these to be included in this number.

The largest body of material is 43 objects on long-term loan from the Dumas-Egerton Trust, collected by George Le Clerc Egerton. This material includes two carved ivory tusks, a ceremonial sword

(*eban*), three more ceremonial swords (*ada*), one in a sheath of coral beadwork, a carved ivory ladle inlaid with brass, a carved ivory head with eyes inlaid with brass, a lidded ivory pedestal bowl, a brass relief plaque, a lidded brass vessel, the brass base of an altarpiece, eleven cast brass, gilded brass and carved ivory armlets, a cast brass altarpiece with figures of a Queen Mother with six female attendants, a wooden painted mask, a carved ivory fly-whisk handle, a side-blown ivory trumpet and a fragment of a second side-blown trumpet, four cone-shaped brass hip ornaments, a wooden bowl or lid, a carved wooden staff, a wooden weaving sword, and five perforated agate beads.[11]

Next largest is a body of 28 objects donated from the estate of Mary Kingsley through her brother (named after their uncle, the children's author Charles Kingsley), in September 1900, after her death, in June 1900 aged 37, in Simon's Town, during the Second Boer War. This donation comprised two brass plaques, an ivory leopard's-head mask, an ivory door-bolt with an iron hinge, a brass fan with repoussé designs, a wooden casket in the shape of an animal head, a brass figure of a horse-rider broken from a staff, two carved cups of coconut-shell, a ceremonial brass helmet, two brass bells, nine brass, ivory and iron armlets, a small unidentified brass object, a brass casket embossed with animal heads and a human head with a suspending chain, a brass staff with the figure of a bird, and four brass masks depicting human, ram's and crocodile's heads.[12]

Of the remaining objects, 19 were purchased at Stevens Auction Rooms – ranging from brass plaques to seven brass miniatures of stone axes – and another 55 were built up through ad hoc purchases and donations between 1898 and 1988. A brass plaque, purchased by Thomas Francis Embury in 1907, was recorded as 'hidden away from our soldiers after the capture of Benin on the punitive expedition of 1897 and brought to Lagos by a native trading woman from whom it was obtained by Mr Embury'.[13] Six objects – four further brass plaques, an ivory staff mount in the form of an *iyase* (war captain) on horseback, and a brass staff of office – were donated in December 1908 by Henry Nilus Thompson, Conservator of Forests in Southern Nigeria.[14]

A carved wooden box looted by Special Service Officer Captain (later Lieutenant Colonel) Fred William Bainbridge Landon, then aged 36 years old – who had been educated at Magdalen College School, Oxford before going to Sandhurst, and served in the Benin expedition as Second in Command and Commissariat and Transport Officer of the Niger Coast Protectorate Force – was donated to the Museum in 1909.[15] In 1917, George Chardin Denton – who had been Colonial Secretary of the Colony of Lagos from 1889 to 1900, and then Administrator (renamed in 1901 Governor) of the Gambia from 1900 to 1911 – gave a brass mask.[16] Also in 1917, the novelist and diarist Beatrice Braithwaite Batty (1833–1933), donated two brass bells.[17] In 1922, Percy Amaury Talbot (1877–1945), author of *In the Shadow of the Bush*, donated a Benin crossbow and a 16th-century Portuguese rapier, both possibly looted from Benin City.[18] A carved wooden stool looted by Reginald Kerr Granville was donated by John Granville, grandson of the officer, in 1979.[19] A carved wooden head was bought at Sotheby's in 1970.[20] The Pitt Rivers also has on long-term loan from the Ashmolean Museum three masks that formed part of a larger bequest of Gerald Roberts Reitlinger to the University of Oxford, recorded as 'originally in the possession of Harold Moseley Douglas, appointed Governor of Benin City after the punitive expedition of 1897' – which is a reference to Harold Mordley Douglas, a colonial officer.[21] With the death of Harry Beasley and the dispersal of the contents of his Cranmore Ethnographical Museum, in 1941 the Pitt Rivers Museum received as donations three Benin bells.[22]

The Pitt Rivers also holds three watercolours made by George Le Clerc Egerton during the Benin Expedition, papers of Walker and Egerton, and a significant collection of photographs of the attack, some collected by Nevins.

* * *

The 'second collection' in Farnham was not added to after Pitt-Rivers's death and any possibility of his second collection joining the first was ruled out by the General himself, in the context of various differences and disputes between him and the University of Oxford.

In a strange, but typical, gesture, connecting the two institutions, passing objects backwards from the 'second' to the 'first' collection, Pitt-Rivers arranged for the presentation of four objects from the Pitt-Rivers Museum to the Pitt Rivers Museum in Oxford by his assistant Harold St. George Gray: one of the bronze 'medalets' used by General Pitt-Rivers for placing at the bottom of his excavations to record the date of its opening, a Romano-British bronze ear-cleaner found in the City of London, an old penknife ploughed up at Motcombe, North Dorset, in 1900 – and a string of coral beads looted from Benin City.[23]

This small act of de-accessioning and dispersal of the major collection of Benin loot made by Pitt-Rivers, with his immense resources and deep knowledge of the antiquarian and ethnographic markets, was by no means the last. The museum remained open during the 20th century, until the 1970s, as responsibility for it passed between family members. However, through the agency of the General's fascist grandson – George Lane-Fox Pitt-Rivers (1890–1966), who had written his eugenicist book *Clash of Cultures and the Contact of Races* while a student at Worcester College, Oxford,[24] and then especially that of his partner Stella Lonsdale – a Nazi double agent during the War who had also been imprisoned by the British as a Nazi sympathiser under Defence Regulation 18B – the collection was gradually broken up and sold off. Our limited current understanding of the whereabouts of this lost collection of Benin loot is summarised in Appendix 4 below.

It has been suggested, although not to my knowledge in print, that it was George's and Stella's fascism which drove them actively to break up, scatter and enrich themselves through the sale of one of the most significant collections of tens of thousands of items of 'non-western' art, including the 283 looted objects. The damage done is hard to assess. Later owners who purchased the re-sold loot include the Smithsonian, the Met, the Hood Museum of Art at Dartmouth College, the Linden Museum in Stuttgart, and many private collections – although the current locations of most of the objects dispersed from Farnham is not known, or at least not accessible (see Appendix 4). Between 1965 and 1988, six of the 283 objects sold off from the

'second' Pitt-Rivers Museum were acquired by the Pitt Rivers in Oxford: a brass leopard-head mask, brass head, a brass figure, a brass vessel, and two wooden combs.[25]

* * *

The General Handbook to the Pitt-Rivers Museum – the one in the countryside, with the hyphen between the 'Pitt' and the 'Rivers' for convenience – was published in 1929. In the preface, George Pitt-Rivers – grandson of the collection's founder, anthropologist, and a fascist later imprisoned by the British state during the Second World War – reflected on 'the crude and primitive arts of modern savages ... those barbarian cultures to which we are in many ways closer in savagery than we are apt to suspect'.[26] In 1898, a new gallery – Room IX – was added, designed to a large extent to allow proper space for the display of these objects from Benin.[27] They were introduced by the sometime curator of the museum, Leonard Dudley Buxton, on the final pages of the *Handbook* as follows:

> The antique works of art from Benin form one of the most interest-ing parts of the Museum and are exhibited just inside Room IX on either side of the doorway. The city of Benin lies near the mouth of the Niger on the Guinea Coast. It was first discovered by the Portu-guese about the beginning of the fifteenth century or a little earlier. A Dutch writer at the beginning of the eighteenth century describes the city, and draws attention to the numerous works of art in brass, bronze and ivory, and also to the human sacrifices which took place there. In 1896 an expedition attempted to reach the ancient City of Benin, which by this time had fallen into ruins, owing, very largely, to the abolition of the slave trade. The expedition was ambushed and only two members escaped. Shortly after a punitive expedition was dispatched. The town was captured and found to be indeed the city of blood it was reputed to be. A large number of artworks were discovered and carried away. These are somewhat ghastly relics of a savage religion which recked little of human life. Savage art first seems uncouth to those of us who are accustomed to Western ideas,

but the visitor who is interested will find it well worth his while to look at these specimens. If any reader of this guide is able to draw, I can strongly recommend an attempt to draw these objects. The photographs reproduced in this guide cannot do more than give a rather crude representation. Better still, if you can, try and model them in Plasticine or some other plastic material. You will find it an interesting but very difficult occupation.[28]

Nine decades on, re-reading the words with which Dudley Buxton closed his book, as we try to understand the Pitt Rivers Museum/s, to recognise the implications of how uncertain and unstable the western homes for these stolen objects were (as Igor Kopytoff described the condition of slavery) 're-individualised by acquiring new statuses' in different situations while always remaining a 'potential commodity' with the ever-present potential to have an exchange-value realised by re-sale.[29] There is the nagging sense that these two museums somehow themselves took on some of the physical qualities of some such 'plastic material', as the necrology, the curator's knowledge formed through death, operates like the rubber and palm oil for which these things were taken, like memory slipping, multiplying, as if the museum were a device for the generation of double consciousness, making the act of taking the primary, originary moment, disruption of cultural pasts and presents, until the theft can be made visible, and action taken.

Time to ditch those predictable, linear 'object life-histories': seeing African art through the eyes of a Victorian imperial general was never going to be a one-way street. Time to give up chasing those spectral 'relational entanglements': this is not so much a contact zone as a shock zone, a space made not by giving but by taking, by subtraction not addition. We tilt our head to and squint at the page, at the illustrations, at the cabinets present and absent, as loss has doubled, multiplied; the colonial violence has been extended across time and space through the double agency of the institution and the market. The double-vision of the Pitt Rivers Museum/s – one still here gathered together piecemeal as circumstances made possible, one now totally dispersed to the market, around the world, and into unknown private

collections – is reproduced for all Benin collections, as the regimes of the art market and the exhibitionary complexes of museums combined to generate an image of alterity, of the 'primitive' or the 'tribal', at a global scale across the 20th century – a process through which the violence of 1897 did not dissipate but grew. A provisional attempt to list the museums and collections around the world in which the loot taken from Benin City in 1897 is presented in Appendix 5.

The objects that came to Britain as loot and were purchased by museums for the display of 'primitive' or 'tribal' art of the defeated enemy were far from safe. Whole museums, like the Pitt-Rivers and the Cranmore Ethnographical Museum, were closed and their collections sold off. Objects given to the regimental museums and other military museums are poorly understood. And some objects were mislaid or damaged – as for instance with the burnt brass fragments of the Queen Mother bronze head that had been exchanged with the Field Museum in Chicago in 1899, but was one of the thousands of objects tragically destroyed in the fire that swept through Liverpool Museum after it was hit by a German incendiary bomb during the Blitz on the night of 3 May 1941.[30] The following month, on 24 June, Hull Municipal Museum was also destroyed by fire during a bombing raid, a Benin plaque looted in 1897 was one of the objects salvaged from the wreckage.

As Max Sebald noted in his account of the Allied aerial bombing campaign against 131 German towns and cities, during which 600,000 civilians died, cultural memory in the context of extreme violence and loss requires a kind of 'natural history', a descriptive mode, an account of ruins that is something other than flâneuristic.[31] Sebald learned some of this from Walter Benjamin's account of memory as 'not an instrument for the investigation of the past, but rather the medium; the medium of experience, just as the soil is the medium in which ancient cities lie buried'.[32]

Standing in the Lower Gallery of the Pitt Rivers Museum, this most melancholic of mediums forged through recollection, one vast archive of colonial destructions hand-written in microscopic museum labels that are indexed by the most brutish commemorations of military vic-

tories that forged new kinds of 'race' science through the propaganda of cultural superiority in the form of stolen objects, standing here, in front of the triple vitrine that bears the title *Benin Court Art*, that continuing loss lands heavy and hard and shattering, as if the brass shells from Alan Boisragon's 7-pounder, the gun that shoots twice, impossibly transformed into brass heads and plaques and armbands, are now, 12 decades on, 4,500 miles away from Benin City, beginning, one by one, to explode, to shatter the glass, to splinter the wood of the cabinet, and to transform this place, like a thousand kinds of plastic material, into something new: a place to revisit the politics of time.

15

Chronopolitics

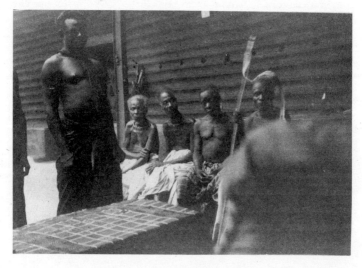

One of the museum's functions has also been the production of statues, mummies, and fetishes – indeed objects deprived of their breadth and returned to the inertia of matter. Mummification, statuefication, and fetishization all correspond perfectly to the logic of separation. The point is generally not, it so happens, to offer the sign that has long accommodated the form some peace and rest. It was first necessary to chase out the spirit behind the form, as occurred with the skulls gathered during the wars of conquest and classification. In order to acquire a right to the city in the museum as it exists today, the slave necessarily had to be emptied – as did all the primitive objects that had gone before – of all force and primary energy.

Achille Mbembe, *Necropolitics*, 2019[1]

Achille Mbembe's crucial account of 'mummification, statuefication and fetishization' above, the theorisation of how objects are drained of force and energy, has at least two genealogies. First, it recalls what Frantz Fanon, in *The Wretched of the Earth*, called the Europeans' 'compartmentalized world', an 'immobile world of statues': where African culture and African thought and action is reduced to nothing but 'the statue of the general who led the conquest', reduced to immobility, instructed to learn to stay in its place, not to overstep boundaries. As Fanon puts it, 'apartheid is just one modality of the division of the compartmentalization of the colonial world.'[2]

Fanon's words in turn recalled Aimé Césaire's account of the process of *chosification* ('thingification') in which the false equation of 'Christianity = Civilization, Paganism = Savagery' brought 'abominable colonialist and racist consequences':

I have spoken about 'contact'. Between colonizer and colonized there is only the space for forced labour, intimidation, coercion, the police, levies, theft, rape, enforced cultivation, contempt, mistrust, arrogance, self-importance, self-indulgence, decaying elites and degraded masses. No human contact, but relationships of domination and submission which turn the colonizer into a supervisor, a warrant officer, a prison guard, a slave driver [*chicote*], and that turn the Indigenous man into an implement of production. My turn to state an equation: colonization = *chosification*. I hear the storm. They talk to me about progress, about 'achievements,' diseases cured, improved standards of living. I speak of societies emptied of themselves, cultures trodden down, societies undermined, lands confiscated, religions slaughtered, artistic magnificence destroyed, extraordinary possibilities suppressed. They throw facts in my face, statistics, the kilometre lengths of roads, canals and railways ... I am talking about millions of men torn away from their gods, their land, their traditions, their life: torn from life, from dance, from knowledge.[3]

The transformation of sacred and royal material culture into not things, but objects, through the twin devices of the market and the museum, constitutes a further dimension to the processes of colonialism in its most modern and violent *fin-de-siècle* forms as seen in the Benin-Niger-Soudan Expedition.

The Euro-American anthropology museum constitutes a further space of *containment*, in Fanon's terms, of *chosification* in Césaire's terms, of *mummification, statuefication* and *fetishisation* in those of Mbembe. In this transformation of life and substance museums became a key regime of practice through which Africans were dehumanised. Here *brutish museums* like the Pitt Rivers where I work have compounded killings, cultural destructions and thefts with the propaganda of race science, with the normalisation of the display of human cultures in material form. An act of dehumanisation in the face of dispossession lies at the heart of the operation of the brutish museums. A major part of what is involved here, I want to suggest, can be described as *chronopolitics*. This involved more than being denied a place in the contemporary world, as was the thesis of Johannes Fabian in his crucial book *Time and the Other*, although the early modern practice of the nascent anthropological gaze, which collapsed space into time so that it appeared that the further from the metropolis the European travelled, the further back in time they went, until reaching the Stone Age in Tasmania, or Tierra del Fuego, etc.,[4] is certainly one element. But more than just the denial of what Fabian called 'coevalness' – a verbal assertion that two living human groups were living in incommensurable time periods – there was a double process of material change that was effected through which whole cultures really were stripped of their technologies, had their living landscapes transformed into ruins – and had these moments of violence extended across time, memorialised, through the technology of the anthropology museum.

* * *

The origins of Pitt-Rivers's idea of the typological museum were militarist.[5] It is not just that his first collection began in the 1850s as a museum of arms: more than that, it was 'his classification of the

museum of weapons, etc.', wrote Edward Burnett Tylor after seeing its first public display in Bethnal Green, that led Augustus Pitt-Rivers 'to form his theories'.[6] Pitt-Rivers's account of how to extend a Darwinian conception of the evolution of nature into the much messier, more complex, world of material culture, began with three lectures he gave on 'Primitive Warfare' at the Royal United Service Institution in 1866 and 1867.[7] Pitt-Rivers's interest in arranging weapons by 'type', and then each 'type' into hypothetical 'series', was to demonstrate – through public displays in Bethnal Green from 1873, in South Kensington from 1878, and in Oxford from 1884 – how small innovations in design have incrementally significant effects when taking place at scale. Central to Pitt-Rivers's vision of what he called 'the evolution of culture' was what he called 'the degenerate descendants of people in a higher phase of culture', where a tradition of culture can degrade itself making poor copies of an earlier phase, so that decay can take the same form as the effect of a quick sketch – where 'a degeneration of form is the result of haste.'[8] This came to be an important theme in the racist presentation of Bini culture in the 1890s.

Building on this approach, 'primitive' art and technology came to rub shoulders with human skulls, photographs of racial types, prehistoric stone tools, and colonial trophies of victory – a unique regime of display that was increasingly developed across Germany and Britain in the last third of the 19th century – from Amsterdam's Tropenmuseum (founded 1864), to the Museen für Völkerkunde in Munich (1868), Leipzig (1869), Berlin (1873), Dresden (1875), Hamburg (1879), and Frankfurt (1904), beyond Germany to Stockholm's Skandinavisk-etnografiska samlingen (1873), the Musée du Trocadéro (1878), the Pitt Rivers Museum at Oxford University, the Museum of Archaeology and Anthropology at Cambridge, and the second Pitt-Rivers Museum at Farnham (1884), Ethnographic Collection of Zürich (1889), the Powell Cotton Museum (1896), Musée d'ethnographie de Genève (1901), Stuttgart's Linden Museum (1911), and beyond. Whereas slavery had been a tool for domination through capture and possession, so too archaeology and anthropology came to

be tools for subjugation, through the seizure and display of material culture.

By the 1890s, long after Pitt-Rivers had retired from active service, his theory of military technology was witness not just to gradual shifts, but the enormous chasm that had opened up between the Maxims and rockets and the cavalry and Dane guns of the supposed 'enemy' in the Benin-Niger-Soudan Expedition – European 'history advancing at the speed of its weapons systems',[9] dislocating time, and regimes of time, as fields of conflict.

The museum *of* weapons gradually transformed the museum *as* weapon, a device for the production of alterity, and to see this we need to appreciate a shift in the scope of 'race science' as it developed in the 1890s. Benin 1897 appears to be a watershed for this process in both Pitt Rivers Museums, and is, I want to suggest, a key lens for understanding a wider process across British museums, anthropology as a discipline, and Victorian and Edwardian society – not to mention their German counterparts, with whom dialogue both in museums and in trade was so close. Through the medium of loot, museums became a device to make the remembrance of colonial violence and cultural destruction, as it circulated in private homes and public collections, endure – and to do the work of creating difference between the Global North and the Global South, 'civilisation' and 'barbarism' – which in the hands of the anthropology curator became a temporal rather than a simply geographical difference. The colour line of corporate extractive colonialism came, back in Europe, to be mapped out in objects using the dimension not of space but of time displayed, as a proxy for the visuality of anti-black racism. Quite apart from the two Pitt Rivers Museums, within the University of Oxford, the founding of two museums of archaeology in 1884 – the Pitt Rivers and the re-founded Ashmolean – a distinction between the Classical and the Non-Classical was enacted, in which the boundaries were drawn firmly in some surprising places[10] – Stone Age Egypt and Turkey in the Pitt Rivers, Bronze Age Egypt and Turkey in the Ashmolean; Bronze Age, Iron Age and Roman Britain in the Ashmolean, but the European Stone Ages and European folkloric collections in

the Pitt Rivers, and so on. What was at stake here at the Ashmolean was the physical display of civilisation under the curatorship of Arthur Evans. At the Pitt Rivers, meanwhile, the parallel project was focused on what the first curator, E.B. Tylor, called 'object lessons':

> In our time there has come to the front a special study of human life through *such object-lessons as are furnished by the specimens in museums*. These things used to be little more than curiosities belonging to the life of barbarous tribes, itself beginning to be recognised as curious and never suspected as being instructive. Nowadays it is better understood that they are material for the student 'looking before and after'.[11]

At the same time, the concept of 'object lessons' was also being directly used by Ralph Moor in justifying the Benin atrocity when he wrote: 'The punishment of the individuals responsible for the massacre will be *an object-lesson in civilization* for the poor and weak to see the rich and strong punished for misdeeds perpetrated by their orders. Civilization with protection to life and property has then to be introduced – this must be the work of years.'[12]

How did these object lessons work? Ethnology has often been praised for its opposition to an alternative kind of 'anthropology' in the 1860s, when the metropolitan intellectual debate in the face of growing numbers of 'small wars' was about the basis for western technological superiority: biological and cognitive difference between so-called 'races', or different histories of material things between different 'cultures'.[13] At this stage, figures like Pitt-Rivers and his ethnological contemporaries have been understood, wrongly, to be absolved of involvement in 'race science', since their interest was in objects not bodies. Of course Pitt-Rivers's account of object 'types' was intimately bound up with ideas of racial types[14] – but our focus here must be on how within the shift from evolutionary anthropology of the mid-to-late Victorian period to the more modern, sometimes even actively anti-racist Boasian anthropologies of culture, a space opened up in which material culture was used as a tool, or more precisely a

weapon, for the creation of difference. Where the craniometer had been used to capture the dimensions of skulls for phrenology, now in the 1890s, anthropologists like Everard im Thurn called for photography to be used 'for the accurate record not of the mere bodies of primitive folk – which might indeed be more accurately measured and photographed for such purpose dead than alive, could they be conveniently obtained in that state – but of these folk as living beings'.[15] This visual knowledge of the life and death of 'others', part photology part necrology, captured through the camera lens, emerged alongside a new kind of racial thinking through the whole collections of the ethnological museum that came, through acts of taking, to be used to measure out the distance of 'non-western' cultures from the West, one object at a time.

We see this twist in the history of social Darwinism in the fact that in both Pitt Rivers Museums, the Benin 1897 material was treated very differently – not spread out across the collections, broken up and abstracted from cultural context but presented as a coherent body of material from one place and time.[16] Walking upstairs from the 'Court' of the Pitt Rivers in Oxford to the 'Court Art of Benin' case, material culture is put to work alongside a text panel that talks of 'ambush' and 'retaliation' – an object lesson indeed (Plate XVb). The provision of a dedicated Benin case at Farnham is interpreted by Jeremy Coote as 'another instance of Pitt-Rivers' sometimes surprising open-mindedness that he recognized that dispersing the objects in his Benin collection amongst the other displays in his museum would not do them justice'.[17]

A less generous interpretation of General Pitt-Rivers's thinking might be countenanced. There is a connection between the genre of horror with which the Benin 1897 story was told (Chapter 3 above), the kind of adventure fiction of the Rider Haggard variety – *King Solomon's Mines* having been published in 1885, and the trader Cyril Punch describing in 1889 the Royal Court as 'a scene weird and bizarre enough to be described by Rider Haggard: a land of blood and poison, of slavery, superstition and tyranny'[18] – and the darkening atmosphere curated at both Pitt Rivers, in which the Benin cases were a turning point.

The effect was to show an ancient living culture, freshly destroyed, as if it were nothing but archaeological remains. If geography was a primary arena for the racial ideologies and violence of settler colonialism – attacking people on the basis of their indigeneity, their 'Indian-ness', their land rights – then time was the equivalent arena under extractive, corporate militarism. The Kingdom of Benin was destroyed, then, in order to put it into the past, and it was exhibited alongside non-European antiquities in order to reinforce the image of a future-oriented European victory over 'primitive', archaeological African cultures. The propaganda had been for years that there was no 'civilisation' in West Africa. In 1889, Lord Aberdare, the Governor of the Royal Niger Company argued, in a speech written for the Company's ninth ordinary general meeting at their offices at Surrey House on London's Victoria Embankment, against any comparison with India: 'The East India Company planted itself in countries already occupied by old civilisations. On the Niger there was no pagoda-tree to be shaken with the accompanying showers of rupees.'[19]

The problem posed by the Benin Bronzes was turned into a new regime within the infrastructure of white supremacy – in which museums volunteered, or were put to work and co-opted. The duration of violence was achieved through the propaganda of 'archaism': destruction of a living tradition and the slaughter of human lives sought to transform a centre of sovereignty and religious power into an archaeological site. In this process, the acts of theft in looting were less effective than their ongoing display since the sacking of Benin City in galleries and museums across Europe and North America. The brutalism of the museum here extended the time-warp atrocities wrought by British military technology and disaster-extractivist colonialism in the Benin-Niger-Soudan Expedition, where modern industrial militarism attacked ancient sacred and royal landscapes – the Iron Age sacred earthworks of Benin, and the medieval strongholds of the Caliphate.

Looking back from 1930, Galway described the Benin materials as having been 'buried in the dust and dirt of centuries':

In some of the houses were hundreds of bronze plaques of unique design; castings of wonderful detail, and a very large number of carved elephants' tusks of considerable age. The art of carving, I learnt later, had been lost some years before. There was, too, a large quantity of ivory in the shape of uncarved tusks. About fifty tusks were found in one well. In addition to the tusks and plaques there was a wonderful collection of ivory and bronze bracelets, splendid ivory leopards, bronze heads, beautifully carved wooden stools and boxes, and many more articles too numerous to mention. A regular harvest of loot![20]

In the hands of the curator, what Césaire calls *chosification* and Mbembe calls *mummification* took on a new dimension. William Fagg sought to justify the looting on the grounds that 'the great heap of bronze wall plaques was apparently discarded by an eighteenth-century Oba.'[21] So too, one reviewer of Pitt-Rivers's *Antique Works of Art from Benin* wondered at how 'these extraordinary relics of an advanced civilisation, of which no other traces are left, were found buried beneath the king's compound, or hidden in native houses, and were most of them still covered with blood, probably from the human sacrifices in which they had been used.'[22]

The plaques even came to be compared to a kind of 'card index'.[23] There were sustained attempts to dissociate the artworks from the people. The tone was set by *Scientific American*'s first coverage of Benin art, which reflected on 'whether they are the work of negroes or of some wandering tribe of alien craftsmen, with whom casting was an hereditary occupation, they are certainly the most interesting works of art which have ever left the western shores of the Dark Continent.'[24]

In the same year, Read and Dalton observed that 'It need scarcely be said that at the first sight of these remarkable works of art we were at once astounded at such an unexpected find, and puzzled to account for so highly developed an art among a race so entirely barbarous as were the Bini, and it must be confessed that the latter problem has not yet been solved.'[25]

In his paper about the Benin Bronzes given at the British Association for the Advancement of Science at Bristol in September 1898, Charles Hercules Read underlined Benin's influence 'from the north by means of the great trade routes which diverge towards the north from such trading centres as, e.g., Timbuktu', suggested the city might hold 'some relics of the ancient civilisations of the Mediterranean' and underlined how 'relations with Abyssinia are founded on the journey of a Franciscan friar from the neighbourhood of Benin to Christian Ethiopia in the fourteenth century.'[26]

Mary Kingsley repeated the idea of external influence:

It is a very curious fact that the people of Benin have been, from the earliest accounts we have of them, great workers in brass. Might not the ancestors of this people have brought the art of working in brass with them from the far distant land of Canaan? Moses, when speaking on the land of Canaan, says 'out of those hills thou mayest dig brass' (Deut. Viii: 9).[27]

And the elderly Pitt-Rivers too considered that 'no doubt we cannot be far wrong in attributing it to European influence, probably that of the Portuguese sometime in the sixteenth century.'[28] A decade later Frobenius went further, famously identifying precolonial Nigerian cities such as Ife and Benin with the Lost City of Atlantis described by Plato as 'beyond the Pillars of Heracles', as if this were directly comparable with the ancient remains of Classical antiquity – the product of white Europeans.[29] Many others, von Luschan among them, suggested Egyptian, Arab, or even Etruscan connections.

Hand-in-hand with this archaeologising of Benin City, a distinctive kind of ethnographic thought also emerged, coming out in part from long-standing traditions of 'merchant ethnography' in West Africa since the 17th and 18th centuries. Mary Kingsley and her circle, including Henry Ling Roth, were key players here. As a close associate of Goldie and Liverpool traders including John Holt, and others like 'Count' de Cardi who gathered together in the African Society of London, Mary Kingsley's particular form of white supremacy was

summarised in a line delivered to the Fellows of the Royal Colonial Institute, approvingly recorded by Roth in his book on Benin City, in a discussion of 'the wide physical and mental differences that exist between the white and black man': 'an African is no more an under-developed European than a rabbit is an undeveloped hare.'[30] In her *Travels*, Kingsley stated that 'I own that I regard not only the African, but all coloured races, as inferior – inferior in kind not in degree – to the white races.'[31]

This kind of white supremacist thinking, based on cultural rather than purely biological difference, was reflected in the 1910 *Handbook of Ethnological Collections of the British Museum*, which explained how

The mind of primitive man is wayward, and seldom capable of con-tinuous attention. His thoughts are not quickly collected, so that he is bewildered in an emergency; and he is so much the creature of habit that unfamiliar influences such as those which white men introduce into his country disturb his mental balance. His powers of discrimination and analysis are undeveloped, so that distinctions which to us are fundamental need not be obvious to him ... The simple methods of primitive reasoning have one pleasing result, for to them is due the imaginative, half-poetical language common to uncivilized men and civilized children.[32]

Crucially, Kingsley's active resistance of the Christian dogma that would 'make them equals of the white man',[33] was grounded in a model not of biological difference, but cultural incommensurability – a form of racism in which ethnological knowledge was fore-grounded to forge the image of inferiority. Using this philosophy, Kingsley became 'the intellectual and philosophical spokeswoman for the British traders to West Africa'.[34] As Kenneth Dike Nworah has observed, a distinctive Liverpool-based 'sect' of ethnological-colo-nial thinking about British West Africa emerged from around 1895, inspired by the thinking of Mary Kingsley. Calling itself 'The Third Party', and combining aspects of Christianity, humanitarianism and paternalism with support for the nascent project of global capitalism,

its key ideas concerned understanding cultural context, as applied to a form of informal empire based on the creation of difference, a respect for African cultures, the purpose of which was 'to support the traders' position, and to undermine that of the missionary'. Inspired by Kingsley's aim 'to win sympathy for the black man and honour and appreciation for the white trader',[35] the group's interest was 'the administration of the negroid races of Africa as a challenging problem of world importance, demanding justice and wisdom but above all an appreciation of ethnological facts'.[36]

This corporate, militarist, vernacular kind of ethnography represented a new kind of white supremacy – where ideas of 'civilisation' and difference were addressed as well as simple biology, where a strange and pernicious kind of empathy was deployed to create otherness. This was an ideology not of biological alterity, but cultural degeneracy; as John Flint argued in his 1963 'reassessment' of Kingsley:

> [Mary Kingsley] would not accept current concepts of biological inferiority. To do so would have destroyed her purpose, for if Africans had an inherent biological inferiority then Colonial Office rule was surely the moral system of rule, the disinterested father knowing what was best for his children.[37]

There was plenty of direct racism among the officers and colonial administrators. Of the Protectorate's own Hausa troops Bacon wrote, 'Their mental capacity and traditions are so inferior to those of the English',[38] moving on to describe Africans' brains as 'slow', their minds as 'chaotic' and child-like.[39] In his 1897 book The Benin Massacre, Alan Boisragon freely described himself as part of 'the ruling race'.[40] But anthropological museums introduced a new kind of materialism, evidence, display, performance to transform these prejudices into a new kind of hatred and violence. The display of material culture came to stand in for the skin as a device for race 'science', in a new kind of objectification, of not just decontextualisation but also 'desubjectification'.[41] As Chinua Achebe described in his discussion of Joseph

Conrad's *Heart of Darkness*, so African art was set up as 'a foil to Europe', presented as 'the antithesis of Europe'.[42]

In this regard, as after the abolition of slavery and the emancipation of enslaved people in the British Caribbean, new modalities and vocabularies of 'race' were produced by Europeans wishing to maintain and to justify their dominance over Africans. Physical anthropology's destructive relationship with 'race' thinking in the mid- to late 19th century, and the ongoing influence of eugenicist and fascist thought in the first third of the 20th century, is a familiar topic. The stories of how ethnological museums in Britain and Germany came to be co-opted for the display of loot taken violently from Africa, put to work for the propaganda that justified these horrors, remains little understood. But Benin 1897 was, I want to suggest, a watershed in this process – through which virtually every ethnographic museum or 'world culture' museum worldwide now repeats the story of the Phillips incident, and the 'punitive expedition', illustrated by the royal art of Benin. To slaughter populations, and to destroy cultural sites, and to throw royal treasures to the market, is to turn time itself into a war zone – and here archaeology and anthropology became one of the 'imperial applied sciences' that were central to Chamberlain's policy of 'constructive imperialism'. In the emerging chronopolitics of the 1890s, the temporal juggling of the punitive expedition – pre-emptive, white-projectionist, anticipatory, and thus timeless – became intertwined with new strategies for performing geographical distance as if it were temporal distance – to reduce a powerful kingdom to an ancient culture, a lost world, an unwelcome archaism, and thus a dangerous intrusion of a dangerous past into the present, and into the metropolis itself, through the device of the museum. Benin culture was, through its material culture, reduced to 'relics' and *Altertümer* (antiquities),[43] while the invention of 'primitive art' and 'ethnographica' as categories also removed objects from the present, making them timeless masterpieces,[44] where boundaries between 'genuine' and 'fake' (i.e. post-1897) had to be policed rigorously.[45]

Benin material culture thus came to be presented as part prehistoric, and part what Hannah Arendt called '"posthistoric" survivors of some

unknown disaster which ended a civilisation we do not know ... the survivors of one great catastrophe which might have been followed by smaller disasters until catastrophic monotony seemed to be a natural condition of human life.'[46]

This was far more than mere primitivist prejudice, or casual 'othering' – through museum displays it was more performative.[47] 'The main task of an ethnographic museum is to serve as an instrument of cultural and colonial propaganda', observed Paul Rivet in December 1931, during the visit of the Mission Dakar-Djibouti to Dahomey.[48] And as David Graeber has argued, 'It was not the "Otherness" of the West Africans that ultimately drove Europeans to extreme carica-tures but rather, the threat of similarity – which required the most radical rejection.'[49] In this context, the performativity of ethnographic museums extended a broader enacting of racial difference through military action, most infamously through the installation during 1897 of the 'human zoo' in the royal park around King Leopold's new Royal Africa Museum at Tervuren for the World Fair in Brussels, a 'Univer-sal Exposition' in which 267 Congolese men, women and children, brought by steamship and railway to live in grass huts in three themed villages – river, forest, civilised – were displayed to hundreds of thou-sands of visitors. These much-criticised actions of the self-appointed 'King-Sovereign of the Congo' have usually been considered quite separately from Victoria's simultaneous Diamond Jubilee year, with the assumption that public displays were limited to, for example, the grand pageant on Saturday, 26 June 1897 in which

at the head of the fifth company appeared the Gold Coast and Royal Niger Hausas in their blue serge jackets, zouave knickers, and small low-crowned red fezzes with heavy blue tassels. These men had never before been seen in Europe; and, remembering their recent service in the Benin, Ashanti and Niger expeditions, the people cheered them on heartily.[50]

Such march-pasts and reviews for the African troops were certainly important parts of the celebratory atmosphere of that summer in

London, but there were other displays to come. 'Benin Besiegers Repeat Their West African Deeds', announced the *Daily Mail* in May 1898, reporting on the 19th annual Military Tournament, which ran from 19 May to 2 June. These performances were attended, like pantomimes, by public audiences – 7,000 people reportedly saw the dress rehearsal alone, of whom 6,000 were schoolchildren from north London. After the 3rd Dragoon Guards had completed 'a thrilling and workmanlike version of South African warfare … making prisoners of all the Zulus', and various other pageants, the finale of the tournament was 'The Capture of Benin' in which

> A force of Hausas and bluejackets accomplishes in miniature what their comrades, and in individual cases what some of them, actually did in February 1897. The Maxim-tripod used at the Agricultural Hall was actually used at Benin, and Lieutenant Burrows, of the Hausa Constabulary, merely enacts over and over again the part he played in Africa. This portion of the show is most realistic, and the horrors of a battlefield under the conditions of savage warfare are brought vividly before the onlookers. No details appear to have been omitted, from the working of the ambulances to the blowing up of the gates of the king's compound and the final hoisting of the Union Jack on the city wall.[51]

Such theatre began months before. A photograph in an album in the National Army Museum, perhaps taken at Portsmouth or in London shortly after the return of some of the Benin soldiers, shows 45 soldiers and officers in blackface (Plate XVa).[52] They have raffia capes, wigs, clubs, staffs, spears, bows and arrows and drums, and one holds a skull aloft on a stick. In the foreground, the group look on while one of the ceremonial swords looted from Benin City is held to the back of the neck of a kneeling man, in a parody of human sacrifice.[53] This shocking image of blacking-up is a further modality of the switching of places by Europeans, which has been discussed above under the theme of 'white projection', here in a visual display, both photographic and performative, that contains the same prejudices and

triumphalism as the Benin displays with their texts about the punitive expedition.

Benin was presented as 'degenerate'.[54] And the exhibition of 'degenerate art', and the industrial slaughter of its people, defined as inferior, and the demolition of its religious and cultural sites, was a forewarning of the horrors of the 20th century. Here the ethnological museum must take its place alongside the fortified trench, barbed wire, the Maxim machine gun, and the tank, as part of the coming techno-brutality of the 20th century. As we learn from Hannah Arendt, 'race was a substitute for the nation', and as a device for imperial rule.[55] Anthropology museums became, and remain, part of the physical and ideological landscape of imperial borderwork through the display of loot. In their enduring qualities, let us underline how the processes outlined here form part of what Ann Laura Stoler calls not the 'ruins' of empire, but ongoing structures of 'ruination'. For this period, in this context, and up to the present, the museum vitrines were used as the shopfront for a corporate-militarist project of racism, slaughter, and the destruction of cultural heritage which museum curators, directors, trustees, Friends associations, donors and others have no business in excusing, justifying, or facilitating today. It's time to start to bring this episode to a conclusion, by understanding, rejecting and dismantling this white infrastructure.

16

A Declaration of War

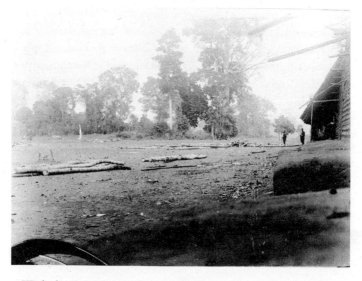

With the Benin bronzes, the rape proved to be a rescue.
Professor John Boardman, University of Oxford, 2016

On a bleak December morning in 2002, 15 months after the 9/11 attacks in New York City and Washington, DC, and three months before the invasion of Iraq, a press officer uploaded a new page to the British Museum website. It heralded a new declaration – *The Declaration of the Importance and Value of Universal Museums* – issued by the self-styled 'Bizot Group', founded in 1992, which by 2002 comprised 'eighteen of the world's great museums and galleries ... supporting the idea of the universal museum'. The text on the web page read:

The statement was drafted at their last meeting in Munich last October, and presented to the British Museum for publication. Their directors are all members of an informal group of museums worldwide which meets regularly to discuss issues of common interest. One of the most pressing of these is the threat to the integrity of universal collections posed by demands for the restitution of objects to their countries of origin. Museums and galleries such as these are cultural achievements in their own right. They bring together the different cultural traditions of humanity under one roof. Through their special exhibitions and their permanent displays they endow the great individual pieces in their collections with a worldwide context within which their full significance is graspable as nowhere else. Neil MacGregor, Director of the British Museum, said 'This declaration is an unprecedented statement of common value and purpose issued by the directors of some of the world's leading museums and galleries. The diminishing of collections such as these would be a great loss to the world's cultural heritage.'[1]

Drawing solely from institutions in the Northern Hemisphere,[2] half of the signatories were from the United States of America.[3] The remainder represented each of the other G8 nations, except for Canada, whose place was taken by Holland.[4] Just four of the 18 signatories – in London, Paris and Madrid – were national museums, and yet the declaration made various claims about national and multi-national heritage. The declaration distinguished between 'the conviction that illegal traffic in archaeological, artistic, and ethnic objects must be firmly discouraged' on the one hand, and the conceptualisation of 'objects acquired in earlier times' on the other. In the case of artefacts taken 'decades and even centuries ago', such acts 'must be viewed in the light of different sensitivities and values, reflective of that earlier era', 'acquired under conditions that are not comparable with current ones', 'whether by purchase, gift, or partage', becoming 'part of the museums that have cared for them, and by extension part of the heritage of the nations which house them', since 'museums too provide a valid and valuable context'. The statement continued:

Universal admiration for ancient civilizations would not be so deeply established today were it not for the influence exercised by the artifacts of these cultures, widely available to an international public in major museums ... Museums serve not just the citizens of one nation but the people of every nation. Museums are agents in the development of culture, whose mission is to foster knowledge by a continuous process of reinterpretation. Each object contributes to that process. To narrow the focus of museums whose collections are diverse and multifaceted would therefore be a disservice to all visitors.

Claims for restitution were not new. They had been growing for decades. The first claims for restitution to Benin had begun in 1936 through the agency of Omo n'Oba n'Edo Uku Akpolokpolo, Akenzua II, the Oba of Benin from 1933 to 1978. Oba Ovonramwen had died in Calabar in 1914, and after his son Aiguobasinwin Ovonramwe, Eweka II was enthroned as Oba, he began the process of rebuilding the Royal Palace under Lugard's evolving policy of 'indirect rule'.[5] In 1936, Akenzua II made the first formal claim for restitution of the objects looted in 1897. Within two years, two coral crowns and a coral bead garment, which had been on loan to the British Museum, were returned to him on the instruction of their owner G.M. Miller – apparently the son of a member of the Benin Expedition – who had previously loaned the pieces to the British Museum in 1935.[6]

Questions of restitution continued after the Second World War, and after Nigerian independence, and restitutions included Josephine Walker's return of part of the Herbert Walker loot in 1957 (see Chapter 12 above). The looting of Benin City and the importance of Benin art for Nigerian, African and African diasporic culture grew in the public imaginary and in popular culture: the Benin Bronzes featured on Nigerian stamps in 1971, and in 1979 Nigerian film-maker Eddie Ugbomah made a movie called *The Mask*, in which a Nigerian action hero steals the Queen Idia mask back from the British Museum.

A key moment came when Nigeria hosted the Second World Black and African Festival of Art and Culture FESTAC festival in 1977,

80 years after the sacking of Benin City. The symbol chosen for the festival was the Queen Idia ivory mask in the British Museum, and the loan of this object from London was requested in 1974 and again in 1976, but refused on the grounds of its fragility. The attitude of a dominant part of the British establishment of the time was captured by the comments of Lord Donaldson of Lymington (just a few months after he had been the judge that delivered the famous miscarriages of justice to the Guildford Four and the Maguire Seven, famously reminding the unjustly convicted men that they would have been executed in earlier times) to the House of Lords on 8 March 1977:

> There is a new and strident school of thought that argues that because these objects came originally from abroad, they should now be sent back because they 'belong' there. I should like to make it emphatically clear that any such objects which are in the national collections were legally acquired and properly paid for at the time. The public collections and this Government respect the export control of other countries on works of art and will have nothing to do with objects which are alleged to be illegally imported into this country ... But we must distinguish illicit trade from objects which have been properly acquired. If we had not lawfully made these collections in the past, the probability is that many of the objects concerned would have perished, and that the great collections which were established could never have been put together for the benefit of scholars and the public all over the world. In presenting them properly conserved and catalogued, and in a way which facilitates their appreciation and study, the trustees of our national institutions perform a service for the world.[7]

The Nigerian government continued to purchase looted objects when they appeared on the open market, paying £800,000 for objects bought at a Sotheby's auction in 1980 for an exhibition called 'Lost Treasures of Ancient Benin' at the National Museum in Lagos the following year, which aimed 'to reach those countries that have refused to return our art treasures'. 'We believe that it is our right to demand that

all our art treasures illegally removed must be returned to Nigeria,' the exhibit's booklet stated.[8] In reply, Jean Rankine, Deputy Director of the British Museum, told the British press that 'nothing in the British Museum was obtained illegally': 'In the case of the Benin Bronzes the British were the legitimate authority in the land at the time and therefore anything they did was in accordance with that legitimacy.'[9]

Three new forms of the ideology of white projection emerged around this time. First was the claim not just that loot was taken legitimately, but that restitution would itself be illegal, making the whole question of returns impossible due to the rules over de-accessioning of museum collections. Second was the claim not just that the destructions wrought in Nigeria had led to safety in Britain, but the returning objects would place these objects in danger, due to security reasons. Third, claims for the return of objects taken as part of the denial of African sovereignty were themselves dismissed as 'political'.

A decade later, the centenary of 1897 represented a further focus for restitution, especially through the campaign led by Bernie Grant MP from 1994. Grant's pioneering work revealed how many of the looted Benin objects were in regional, non-national museums across the UK, and led to new pressure on the British government.[10] Old and new arguments were generated in response: that any return would set a precedent leading to an emptying of western museums, that returns would limit the access of a global audience to a heritage that belongs to the whole world, that returned objects would not be adequately cared for; and so on.

Then in 2002, the debate reached a new tipping point. In January 2002, the Nigerian Parliament unanimously passed a motion calling on President Obasanjo to demand the return of the Benin Bronzes from the British Museum. 'Envoy Recalled over Bronzes' read the headline on the front page of *The Times* earlier that year, as 'Britain braced itself for a showdown with Nigeria.'[11] 'These objects of art are the relics of our history,' said Omotoso Eluyemi, Head of Nigeria's National Commission for Museums and Monuments: 'Why must we lose them to Europe?'[12]

The following March, following investigative work done by Martin Bailey at *Art Newspaper*, it was revealed that the British Museum had restituted 24 Benin Bronzes, and sold off eight, between 1950 and 1972. It emerged that in the 1950s, through the agency of Bernard Fagg in Nigeria and his brother William at the British Museum, ten of the museum's Benin Bronzes were sold at what William Fagg described as a 'nominal' price to Nigeria to support the establishment of the new national museums, in which Bernard Fagg was closely involved. Eight more may have been sold off on the open market by the British Museum, supposedly to confirm the market value, before a further 14 or 20 were sold in Nigeria in 1972 – using a loophole in the 1963 British Museum Act which allowed for de-accessioning where objects are 'duplicates'.[13] Questions were asked in the House of Lords, and the British Museum – with no hint of irony – 'expressed sorrow at the loss'.[14] The testimony in the Lords at the time does not reveal the detail of any sales to parties other than the Nigerian Government – although two plaques in the collection of Robert Lehman Jr, currently on loan to the Museum of Fine Arts in Boston as a promised gift, are recorded as having been acquired from the British Museum in 1972, presumably in an exchange or a purchase.[15]

Then in September 2002, news broke, again through an *Art Newspaper* investigation, of a 17th-century Benin bronze head[16] with an even more complex death-history – looted in 1897 (Plate VII), bought for the state of Nigeria in the 1940s or 1950s, and then removed from the National Museum in Lagos by General Yakubu Gowon, Head of the Federal Military Government of Nigeria, and given to Queen Elizabeth II during his State Visit to the United Kingdom, 12–15 June 1973. The General had reportedly ordered a replica but, dissatisfied with its quality, took the head from the museum. It was assumed to be a replica until the news story broke 29 years later.

In this increasingly politically heated context, the Declaration of Universal Value in December 2002 introduced a new series of assertions to refute the growing momentum of claims for restitution from Nigeria for the Benin Bronzes, from Greece for the Elgin/Parthenon Marbles, and beyond. First, the incommensurability of past and

present when it comes to looting. Second, that the acquisition of objects by museums represents a positive recontextualisation. Third, that western museums are tasked with caring for a universal, and thus supranational, material heritage – for the people of every nation.

* * *

Today there is no place for the logic of *Kunstschutz* (the fascist idea of seizing art to keep it safe) in our anthropology museums any more – not least in the language used by Professor John Boardman – Oxford University art historian, professor of classical archaeology, and former assistant museum keeper – in the opening quotation for this chapter,[17] nor for the allied idea that African societies are unable to care for and make decisions about their own cultural heritage.

For two decades now, this rhetoric of 'the universal museum' has been increasingly adopted not only by art museums like the Met, the Getty, MOMA and the Louvre, but across 'world culture' museums – driven from the only two signatory institutions with significant ethnological collections, the British Museum and Berlin State Museums. These two institutions, in London and Berlin, also currently house the largest collections of Benin loot taken in 1897, which is today in modern Nigeria. Almost every one of the 18 signatory museums holds in its collections or has at some point exhibited material from the sacking of Benin City. The claim was made that the idea of the universal museum was a tradition that needed to be defended. But in reality, it was a 21st-century charter myth.

The sequence for the invention of the myth of the universal museum appears to run as follows. The term came to be used in debates about the Elgin/Parthenon marbles in the 1980s, specifically in the context of a private member's bill which would have amended the British Museum Act of 1963 by granting the Trustee Board the additional power to de-accession an object if 'in the opinion of the Trustees it is desirable that, in fulfilment of international obligations, an object shall be returned to its country of origin'. In his contribution to the debate about the bill in October 1983 in the House of Lords, the

Chair of the Trustees of the British Museum, Baron Trend, summarised the position of the Trustees as follows:

> It is of course that they oppose [the bill] and they oppose it because they regard it as potentially damaging, perhaps irreparably damaging, to their main function as they see it, the function of maintaining and enhancing *a great universal museum* – one of the greatest, if not the greatest, of the universal museums of the world. I emphasise the word 'universal' because, although I think that there is no dispute about the excellence and the international reputation of the various individual collections in the museum – the Egyptian antiquities, the Classical antiquities, the mediaeval and modern collections, and so forth – and although they have to be administered for obvious practical reasons as largely separate or self-contained collections, nevertheless the museum is more than the sum of those individual collections. It aims to present an integrated picture of the stages in the development of various civilisations of the world and their indebtedness one to another, and it has the kind of physical integrity which comes from that kind of concept of human history.[18]

I want to suggest that although the vocabulary of the universal museum may have come about in the (post)colonial heritage-nationalism of the first term of Margaret Thatcher's administration (1979–83),[19] and presumably used informally around the Department for National Heritage ever since, it became codified as something far more coherent and powerful during the second term of Tony Blair's administration, as the British Museum was organised under the newly renamed Department for Culture, Media and Sport, and as the geopolitical landscape changed after 9/11.

As plans for the 2012 London Olympics were announced and museums and heritage were seen as a key to expanding global tourism and the brand of 'Cool Britannia', Greece's claim for the return of the Elgin/Parthenon marbles in time for the 2004 Athens Olympics presented a communications challenge, coming so soon after the Benin centenary. In this atmosphere, on 29 October 2003 Culture

Minister Estelle Morris spelled out to Parliament the aims of a universal museum:

> The Director of the British Museum has said that he sees the aim of the museum to 'hold for the benefit of humanity a collection representative of world cultures and ensure that the collection is housed in safety, conserved, curated, researched, exhibited and made available to the widest possible public.' In that sense, it is a *universal museum*.[20]

The myth of the 'Universal-Encyclopaedic' Museum emerged in part from the specific context of three main institutional re-arrangements and consolidations under Neil MacGregor's directorship around the 250th anniversary of founding of the British Museum (1753–2003): the closure of the Museum of Mankind and the relocation of the Department of Ethnography from Burlington Gardens back to the British Museum's main Bloomsbury site, the closure of the British Library Reading Room and the incorporation of the Department of Ethnography back into the Bloomsbury site, and the opening of the new 'Enlightenment Gallery' in what was formerly known as the King's Library – a room built between 1823 and 1827.

As part of how the reinvention of the British Museum was spun, anthropological narratives were actively diminished in favour of the false suggestion that the British Museum had been in any meaningful way established on 18th-century 'universal' ideals of the *Encyclopédistes*, and that it was now working to defend these ideals during times of cultural uncertainty. In reality, this latent vocabulary was reinvented for the moment of 2002, rather than representing some long-standing tradition. The terms 'universal museum' or 'encyclopaedic museum' were virtually never employed until the later 20th century. Where these terms were occasionally coined, universality referred either to the inclusion of multiple disciplines (natural history, archaeology, geology, art, etc.), or of multiple forms of art. So, for example, in 1962 Albert Eide Parr, Director of the American Museum of Natural History, explained that his was a 'universal museum' in that it is multi-

disciplinary, ranging from nature to culture.[21] Even earlier, Paul Vitry's 1922 *Guide to the Louvre* described it as an encyclopaedic museum because it included 'industrial, applied and decorative arts' as well as painting and sculpture.

At Macgregor's British Museum, the opening section of the book *Enlightenment*, published to coincide with the opening of the new Enlightenment gallery, was on the theme of 'The "Universal Museum"', and deftly misrepresented the provenance and antiquity of this idea through the title of Kim Sloan's introductory chapter '"*Aimed at universality and belonging to the nation*": the Enlightenment and the British Museum'. In reality, this quotation was a description of the legacy of Newton by Alexander Pope, rather than any reference to the British Museum at all.[22] Moreover, when it came to Bloomsbury in 1753, Hans Sloane's Tradescant-style collection of 1,000 rarities was always a sideshow to the library of 50,000 books, the 32,000 medals and coins, and the herbarium – the bric-a-brac of the New World plantocracy rather than anything like the modern universal vision of global heritage; it is an exercise in sheer mythography and spin to claim otherwise.

In anthropological terms, at times, the idea of the universal museum could be said to have functioned like Bronislaw Malinowski's account of 'mythical charters' among the Trobriand Islanders in the 1920s, where the past is 'one vast storehouse of events' where 'the line of demarcation between myth and history does not coincide with any division into definite periods of time.'[23] At other times, it has come closer to what Radcliffe-Brown called purely 'theoretical or conjectural history',[24] concerned more often with succession – that is to say, with power – than with descent.

The comparative global vision for 'world culture' collections certainly did come about, but that was very clearly a product of the museum's Department of Ethnology in the late 19th century, and of social evolutionary thinking as it combined with imperial 'collecting' and race science – in which the display of the Benin loot was a watershed moment. And as many anthropologists over the course of the 20th century sought to fight such globalising, decontextualising civilisa-

tional tendencies, to operate, in fact, in precisely the opposite direction from the classical-focused art history that came to be so bound up with ideas of European cultural supremacy, to operate, that is, towards context and ethnographic detail and the deep appreciation and cele-bration of different ways of living, making, seeing and knowing that came to characterise much of the ethos of the Museum of Mankind in the 1970s and 1980s, so in the same moment as the Declaration of the Importance and Value of Universal Museums was aired, this very part of the British Museum's operation was closed down.

Meanwhile across the Atlantic, Neil MacGregor's efforts were matched by those of James Cuno, whose declaration of war – what he has framed as 'Culture War: the case against repatriating museum artefacts'[25] – began with further myth-making, in this case the improb-able pretence that the 'encyclopaedic museum' forms part of a western inheritance that emerged hand-in-hand with the values of the Declara-tion of Independence.[26] George Abungu has eloquently deconstructed the Declaration of the Importance and Value of Universal Museums as a self-appointed 'group of privileged museums ... promoting the Western world's dominance and monopoly of interpretation over other peoples' cultures and colonization'.[27] Indeed, more than that, the Declaration emerged as part of a wider instrumentalisation of 'heritage' and culture as soft power in the rhetoric of multicultural and global exchanges, including international loans as a kind of cultural diplomacy, during the so-called 'war on terror' launched by the Blair and Bush administrations, using the universalist storyline to opera-tionalise museums as global spaces in the era of what George W. Bush described as 'a new world order'. In this new epoch of time-juggling, corporate-militarist colonialism and the rule of colonial difference, according different legal status to the enemy, came back into view in Africa and the Middle East, the 1890s echoing through the Wars in Afghanistan (2001–present), Syria (2011–present) and Iraq (1991, 1998, 2003–09, 2014–present) – and, above all, in Palestine.[28]

In an article written for the *Guardian* in July 2004, Neil MacGre-gor made a direct analogy between the sacking of Benin City and the recent invasion of Iraq:

The Benin bronzes [are] some of the greatest achievements of sculpture from any period. The brass plaques were made to be fixed to the palace of the Oba, the king of Benin, one above the other, a display of technological virtuosity and sheer wealth guaranteed to daunt any visitor. At the end of the 19th century, the plaques were removed and put in storage while the palace was rebuilt. A British legation, travelling to Benin at a sacred season of the year when such visits were forbidden, was killed, though not on the orders of the Oba himself. In retaliation, the British mounted a punitive expedition against Benin. Civil order collapsed (Baghdad comes to mind), the plaques and other objects were seized and sold, ultimately winding up in the museums of London, Berlin, Paris and New York. There they caused a sensation. It was a revelation to western artists and scholars, and above all to the public, that metal work of this refinement had been made in 16th-century Africa. Out of the terrible circumstances of the 1897 dispersal, a new, more securely grounded view of Africa and of African culture could be formed.[29]

'*Baghdad comes to mind*': the moment of the *Declaration of Value and Importance* held within it many troubling continuities with, and re-ignitions of, the corporate extractive colonialism that had driven the sacking and looting of Benin City. On 9 April 2003, American marines pulled down a statue of Saddam Hussein, in a mission set on overthrowing a regime as punishment for supposed breaches of international law on arms proliferation, the fabricated pretext of weapons of mass destruction, in a war that many knew to be illegal, and that spilt the blood of an unknown number of people – perhaps hundreds of thousands, perhaps more – for the combined agenda of corporate interests in extractive colonialism on the one hand (now for Iraq's oil fields rather than the rubber and palm oil of the Kingdom of Benin), and regime change on the other – removing a 'non-western' leader accused of interfering with free trade. Just as it had in Benin in the 1890s,[30] now in Baghdad the idea that violence could represent a kind of disarmament sought to justify acts of dispossession as some

kind of self-defence. The humanitarian pretexts of removing slavery or stopping cannibalism or human sacrifice were now replaced with the moral case against claimed human rights abuses and the cause of western democracy. The handwritten treaty signed with the mark of the Oba of Benin in 1892 echoed across the void of the 20th century in UN Security Resolutions 678 and 687, which approved the use of all necessary means to compel Iraq to comply with its international obligations. Normal human rights laws were suspended when, from early 2002, the status of 'unlawful combatant' was used to conduct 'extraordinary rendition'.

Meanwhile, the Taliban's dynamiting of the Buddhas of Bamyan in Afghanistan in 2001 was condemned by western museums, while the direct and indirect cultural destructions that led from the US invasion of Iraq's unique archaeological and cultural landscape, including allowing the looting of museums and cultural heritage sites, the burning of the National Library of Baghdad on two occasions, and the construction of a military base on the site of ancient Babylon, were blamed on Iraqis rather than on the coalition's failure in its duties under the Geneva and Hague Conventions to prevent looting. And yet universalism simply extended the late Victorian ideology of projection, as if the museum were a weapon reloaded after 9/11 with the world-view set out, for example, in Tony Blair's speech to the US Congress on 17 July 2003, where he claimed that 'our ultimate weapon is not guns, but beliefs':

There is a myth. That though we love freedom, others don't, that our attachment to freedom is a product of our culture. That freedom, democracy, human rights, the rule of law are American values or Western values. Ours are not Western values. They are the universal values of the human spirit and anywhere, anytime, ordinary people are given the chance to choose, the choice is the same. The spread of freedom is the best security for the free. It is our last line of defence and our first line of attack. Just as the terrorist seeks to divide humanity in hate, so we have to unify it around an idea, and

that idea is liberty. We must find the strength to fight for this idea; and the compassion to make it universal.[31]

Meanwhile tens, perhaps hundreds, of thousands of artefacts entered the illicit antiquities market. Meanwhile the sheer staginess of the deposition of Saddam Hussein, from the toppled statues to the manhunt to his capture on 13 December 2003 in Operation Red Dawn (named after a Patrick Swayze movie) led to what Nick Mirzoeff has described as a 'weaponization' of the image in 'global visual culture', as the CNN broadcasts of the deposed leader's medical examinations humiliated him in a manner that uncannily recalled the triumphalist taking of photographs and of objects,[32] and the display of loot with the story of the punitive expedition in museums from London to Washington, DC.

In the clearest re-playing of the militarist-corporate-colonialist model of the 1890s, the oil giant BP plc was first described as a 'corporate partner' in the Annual Report of the British Museum for 2001–02.[33] The sum of £1.5 million named the BP Lecture Theatre in the newly constructed Great Court. Since 1996, John Browne, later Lord Browne, Chief Executive of BP and a private collector of pre-Columbian art, had been a trustee of the British Museum. In the new atmosphere after 9/11, BP – which had previously supported the re-hang of the Tate and other smaller ventures – now seriously stepped up their support of 'world culture' at the British Museum.

It is, as we know, the victors who write the history, especially when only the victors know how to write. Those who are on the losing side, those whose societies are conquered or destroyed, often have only their things to tell their story. The Caribbean Taino, the Australian Aboriginals, the African people of Benin and the Incas can speak to us now of their past achievements most powerfully through the objects they made: a history told through objects gives them back a voice.[34]

So wrote Neil MacGregor in the preface of his handbook for the ideology of the universal museum, *A History of the World in 100 Objects*. Two decades on, as the lies of the Bush-Blair War on Terror and the Weapons of Mass Destruction are just as visible as the pretences of the punitive expeditions a century before, it is clear that the 'values' at stake in both the Declaration of War and the Declaration of Importance were about corporate finance and geopolitical power rather than about some western civilising mission. As the ideology of white projection re-emerged in its 21st-century form, it mapped itself straight back onto those items of loot that had been such effective ambassadors for destruction in the propaganda of Victoria's Jubilee Year of 1897, three years before the new century and all the horrors it would bring; it was just that now, three years after the century was over, it was tourist revenue and imperial nostalgia that concerned the museum directors, as the new front line in cultural warfare.

Just as everyone understood that both military attacks were for commerce and sovereignty not for civilisation conquering barbarism, so too we can see the idea of the universal museum as nothing but a weapon of its time, a 21st-century charter myth. The *Declaration of Importance and Value* of objects looted for rubber and palm oil was made hand-in-glove with the Declaration of War for oil. The great anthropologist of myth, Claude Lévi-Strauss, cautioned in 2005, 'the Louvre Museum is not at all a universal museum', because it simply 'brings together all that has formed the traditions of France and the Western world'.[35] The failure of the major 2007–08 *Benin Kings and Rituals* exhibition – which went to Vienna, Paris, Berlin and Chicago – to travel to Nigeria showed where the lines were drawn, and how firmly, as the regime of universal values became a time-geography of every place and era, as seen from London's Bloomsbury, or Berlin's Museumsinsel, or Chicago's Grant Park. This was a harsh mythography in the making: behind the façade of Enlightenment values the violent legacies of European imperialism were reloaded. But such efforts could not stop history from taking place around the museum, not least in Africa, where a transformative moment came about in the mid-2010s: what Achille Mbembe has called 'a negative moment'.

17

A Negative Moment

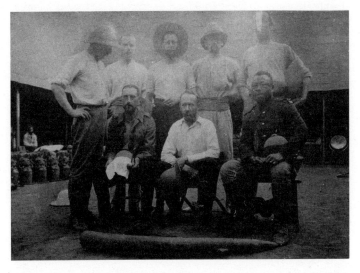

The Pitt Rivers Museum is one of the most violent spaces in Oxford.
Tweet from 'Rhodes Must Fall Oxford', 23 October 2015

When future archaeologists come to excavate the modern ruins of the western anthropological museum, they will puzzle over, as we do today, quite what was the event horizon that came about around 2015. It was not simply the rise of the populist right in the United States, nor the beginnings of Brexit in Britain, nor the advent of the refugee 'crisis'.[1] Perhaps it was the after-effects of the 2008 financial crisis to some degree. My own expectation is that it will appear, in retrospect, to have been a distinctively African moment. It was certainly African thinking that brought about an institutional watershed moment for the Pitt Rivers Museum (which is a department of the

University of Oxford) in October 2015, when the tweet above was sent from the account of the grassroots student movement Rhodes Must Fall Oxford.

The Oxford movement emerged from the successful Rhodes Must Fall campaign at the University of Cape Town that began during the spring of 2015, led by a collective of students and staff seeking to have the bronze statue of Cecil Rhodes, which had been erected in 1934, removed. The presence of the image of the British coloniser, racist, and founder and managing director of the chartered British South Africa Company during the 1890s, had been objected to for decades as oppressive to the university community. Then on 9 March 2015, Chumani Maxwele threw human excrement at the statue, in the first action of the Rhodes Must Fall movement that then led to a month of protests and occupations which culminated in the removal of the statue by university authorities on 9 April 2015.

As in Cape Town, so when Rhodes Must Fall Oxford launched in May 2015, the campaign was about the removal of the figure of Rhodes within the university – in this case, the statue on the High Street façade of Oriel College – as a way of addressing questions of institutional racism in the university.

Campaigning issues ranged from the 'colonial comeback' cocktail served at the Oxford Union, advertised with the symbol of chained hands, to incidents of racism experienced by black students and staff in colleges and departments, to the immense under-representation of Black and Minority Ethnic students and faculty at Oxford University, and to the decolonisation of the curriculum. But the physical built environment of the university was also a major focus, beyond the statue itself. As the founding statement of Rhodes Must Fall Oxford put it, on 28 May 2015:

The University of Oxford is an institution that has, for centuries, produced, profited from, and memorialised the violent conquests of Rhodes and other 'great' imperial men – including [Christopher] Codrington, [Benjamin] Jowett, Pitt-Rivers and many others. It is a

place choked with buildings, monuments, libraries and intellectual legacies raised from colonial pillage.[2]

The Rhodes Must Fall Oxford campaign shattered the complacency of the Pitt Rivers. The museum had mapped its approach to colonial collections directly and narrowly onto settler colonialism, making significant advances in work with 'source communities' in North America, Australia and the Pacific, both in terms of the return of human remains and in terms of cultural and artistic exchanges. Now black students were pointing out that the existence of 'permanent' gallery displays of material culture brutally looted from Africa meant that the very fabric of the institution was an extension of that brutalisation, refreshed each morning when the doors are opened to visitors again with the same displays on view – 'the open glorification of the racist and bloody project of British colonialism':[3]

> At Oxford survivors of imperialism find their own history held hostage, bequeathed to the archives by their oppressors. At Oxford, many find their histories excluded, or almost unidentifiable in Oxford's imperial iconographies of space. Here, people experience the pain of cognitive dissonance because there is no 'legitimate' language for their own experience and knowledge. Within the Pitt Rivers Museum, survivors find their families, their ancestors, their 'selves' unapologetically disciplined into objects of inquiry.[4]

The idea that removing images and objects erected in the name of white supremacy would be to silence or airbrush the past was eloquently rebutted by the campaign. 'A monument glorifying a mass murderer is itself an exercise in erasing the true history of colonialism', observed Kehinde Andrews.[5] The old habit of white projection, this time seeking to shift the blame for the work of erasure from the colonial institution to the survivors of colonialism, was called out by Amia Srinivasan:

> The suggestion that removing the statue would be an IS-level act of barbarism is odd. If all changes in public symbolism were equiva-

lent to the destruction of Palmyra, what would that mean for those who demanded the removal of the Confederate flag from the South Carolina State House after the murder of nine black churchgoers in Charleston; or the prohibition of Nazi iconography in post-war Germany?[6]

The geographical reach of the Fallism movement, from Rhodes in Cape Town and Oxford to Confederate statues in the southern United States, reminds us that what is shared between these figures and 'ethnological' objects, between Rhodes Must Fall Oxford and efforts to decolonise the Pitt Rivers Museum, is a parallel legacy of the memorialisation of wars of white supremacy.[7] As with each bronze Robert E. Lee and 'Stonewall' Jackson and Jefferson Davis, which multiplied across public spaces between the 1880s and 1910s, less as passive monuments than as rallying points for future violence, so with the Benin Bronzes in that same *fin-de-siècle* moment of a new form of cultural racism that made monuments to naturalise its military victories. And yet while it is uncontentious to state that the question of Confederate statues revolves around the enduring legacies of slavery in the form of structural racism, many museum curators fail to make the same connection between loot and colonial violence, imagining that somehow the anti-black violence is not ongoing.

In truth, the violence is far from over for as long as these processes of display and dispossession persist. At the time of writing, Oriel College's statue of Rhodes remains on display; but the landmark decision on 17 June 2020 by Oriel College Governing Body to remove the Rhodes monument reveals how the white infrastructure of Oxford's historic environment can be dismantled, as attention shifts to museum collections, as weapons of discrimination. As the border is to the nation state, so the museum is to empire – two devices for the classification of humans into types.

The Rhodes Must Fall movement brought this realisation to the Pitt Rivers a generation after the end of apartheid in 1994. These histories are not histories but presences. Achille Mbembe described this conjuncture as a 'negative moment':

A negative moment is a moment when new antagonisms emerge while old ones remain unresolved. It is a moment when contradictory forces – inchoate, fractured, fragmented – are at work but what might come out of their interaction is anything but certain. It is also a moment when multiple old and recent unresolved crises seem to be on the path towards a collision. Such a collision might happen – or maybe not. It might take the form of outbursts that end up petering out. Whether the collision actually happens or not, the age of innocence and complacency is over.[8]

* * *

The self-proclaimed universalist institutions have not ignored this negative moment, but have sought to fill the void. A new slippage in language, from universal values to global and postcolonial history, is taking place. This is happening at two of the signatory 'universal museums' which stand out as including major anthropological collections: Berlin and London. 'The role of encyclopaedic museums in complex times of social change must be redefined,' argued Neil MacGregor, now in Berlin as the founding director of the Humboldt Forum, in October 2017 writing in *Der Tagesspiegel* in answer to mounting criticism of the new 'world culture' museum in the rebuilt imperial palace on Museum Island as a neo-colonial project. 'Most of them are located in Europe and North America for historical reasons,' he continued. 'The key question is: to whom do the collections belong and why do they exist?' (my translation).[9]

'There are no foreigners here. This is a world country, this museum,' chimed the director of the British Museum Hartwig Fischer in an interview with Charlotte Higgins in the *Guardian* in April 2018, presenting the British Museum as 'a museum of the world for the world'.[10] Meanwhile, the Louvre Abu Dhabi opened in November 2017, billed as 'the first universal museum of the Arab world', complete with a bronze Oba head looted in 1897 as part of its founding collection.[11] In the United States, in 2012, the Museum of Fine Arts in Boston acquired 13 Benin objects formerly in the Pitt-Rivers Museum at Farnham on loan from the banker Robert Lehman, which were

immediately subject to a restitution request, while in 2014, the same museum returned eight Nigerian objects illegally trafficked after the UNESCO 1970 *Convention on the Means of Prohibiting and Preventing the Illicit Import, Export and Transport of Ownership of Cultural Property* came into effect on 24 April 1972, including a brass figure stolen from the Royal Court of Benin in 1976 and two Benin terracotta heads.[12]

As 'decolonisation', 'transparency' and a firm commitment to debating so-called 'difficult' or 'contentious' histories – all things on the face of it long striven for by others – become the preferred buzzwords of the press officers of the Bizot Group, as new galleries at the Victoria and Albert Museum and at Humboldt Forum promise to tell the history of European colonialism, an old violence emerges: that of the chronopolitical. At Vienna's Weltmuseum, an interpretation board titled 'Benin and Ethiopia: Art, Power, Resilience' claims that it 'reflects postcolonial changes in both the cultural contexts and the contemporary relational connections to Austria and to the Museum'.[13] And then from South Kensington, Tristram Hunt puts the argument for the telling of histories rather than decolonisation, in the name of a balanced sense of the past on its own terms:

> For a museum like the V&A, to decolonise is to decontextualize: the history of empire is embedded in its meaning and collections, and the question is how that is interpreted. A more nuanced understanding of empire is needed than the politically driven pathways of Good or Bad. For alongside colonial violence, empire was also a story of cosmopolitanism and hybridity: through trade, religion, war and force, peoples and cultures mixed and, in many cases, expressed that exchange and interaction through the type of material culture now found in museums.[14]

But we can't write colonial history on its own terms. We must not relativise our modern values in order to justify past acts, when those acts are unfinished. To pretend that the violence is over is the technique used, for example, by museums, galleries, salesrooms and private col-

lections in North America that hold looted Benin objects when they claim that they were acquired legally at the most recent transaction, and so no question of restitution should arise. It is equally a mistake that descendants of Benin soldiers who inherit loot might reasonably make, but in both cases this is a category error: these are no longer artworks but trophies of ultraviolence, until restitution begins.

Anthropology and archaeology are of some possible help here, since these disciplines, through which 'world culture' museums have been largely formed, are in some respects the very inverse of history. It is impossible for a researcher who thinks themselves back into some past epoch to tell the story adequately, since the whole point is that the things are still here; the museum is 600,000 events in material form. *Archaeology is not the study of past fragments, but the science of human duration.* And so, when it comes to one-sided mass violence, to the 'cultural rape' of Benin,[15] we need to start with the maxim of the ethnologist: 'The Tylorian method is to gather first and sift later.'[16] The sifting must start with Ariella Azoulay's awareness that the discipline of history will operate to disconnect the presence of looted objects in western museums on the one hand, and the ongoing situations of 'millions of people, stripped bare of most of their material world, including tools, ornaments, and other objects, [who] continue to seek a place where they can be at home again and rebuild a habitable world'.[17]

We must not allow 'world culture' museums to pretend that this violence and loss is in the past – it is here in front of us in debts that need to be paid for things that were taken. Let us listen to this story, told, untold, and re-told from Adelaide to New York, and from St Petersburg to Paris:

National Museums Scotland: *In February 1897 Britain undertook a punitive expedition against Benin, a kingdom located in what is now Nigeria. The invasion was retaliation for the killing of British colonial officials who had entered the kingdom uninvited earlier that year. British soldiers took around 4000 objects of immense cultural value from the royal city. On return to Britain some were sold to pay for the venture.*

Today most of these objects are in European and American museums, including a small proportion in National Museums Scotland. The location of these objects in museums outside of Nigeria has been contested ever since the mid-20th century and remains unresolved today.[18]

* * *

British Museum: *The Discovery of Benin Art by the West. The West discovered Benin art following the sack of Benin City by the British in 1897. In the 1890s Benin resisted British control over southern Nigeria. In March 1897, retaliating for the killing of British representatives, a punitive expedition conquered the capital. Thousands of treasures were taken as booty, including around 1000 brass plaques from the palace. The Foreign Office auctioned the official booty to cover the cost of the expedition. Large numbers of ivories, brass and wood works were retained and sold by the officers. Benin treasures caused an enormous sensation, fuelling an appreciation for African art which profoundly influenced 20th century Western art.*[19]

* * *

Kunstkamera Museum of Ethnology and Anthropology, St Petersburg: *In 1897 the English Army stormed the Oba's palace, putting an end to the greatness of Benin. The royal dynasty survived into the colonial period, but little remained of its former splendour. The bronze artworks are now scattered across European and American museums, while new ones are made in wood or clay.*[20]

* * *

Världskultur Museums, Stockholm: *The Invasion of 1897. The English colonial power saw Benin as an obstacle in its quest to expand its territory. So in 1897 Benin was taken and the king forced into exile. The English troops dismantled the palaces and brought the bronze and ivory artworks to London where they were sold to private collectors and museums.*[21]

* * *

Horniman Museum, London: *In February 1897 British troops led a violent campaign against the Kingdom. Benin City fell and the Kingdom lost its independence. Most of the objects you see here were removed by British officers as they burnt the city to the ground. The retention of these objects in museums across the world remains contentious. Curators at the National Museum, Lagos and the Benin City National Museum were consulted about our plans for this display.*[22]

* * *

Museum Volkenkunde, Leiden: *War Booty. To the irritation of the British the Oba monopolised trade. The killing of a British envoy in 1897 provided the excuse for a punitive expedition, which brought an end to the independent kingdom. The city was laid to waste and in order to recover the costs of the military expedition the British authorities sold off everything of value in the city as war booty.*[23]

* * *

The Field Museum, Chicago: *End of Independence, 1897. Geography led to Tragedy. At the Berlin Conference of 1884–5, European powers 'cut the cake' of Africa, dividing territory among themselves. But when England sought to expand its holdings in West Africa, Benin blocked access to the interior of Nigeria. Political tension came to a head in 1897. A British envoy disobeyed the Oba's orders and tried to enter Benin City during a religious ceremony. He and most of his entourage were ambushed and killed. Although it wasn't clear who ordered the ambush, the British used this incident as an excuse to invade Benin. When they reached Benin City a dreadful sight greeted British soldiers sent to punish the Oba. In a final effort to save his kingdom the Oba had ordered that countless human captives be sacrificed. In horror, the British burned Benin City and sent many of the Oba's treasures to London.*[24]

* * *

Musée du quai Branly, Paris: [*silence*]

* * *

Metropolitan Museum of Art, New York City: [*silence*]

* * *

In more than 150 museums across the western world, the story of the Benin punitive expedition is told in different versions, or told with silences, to tens of millions of visitors each year.

Why is this? Because the story told by Victorian militarist-corporate colonialism to justify mass killing and cultural destruction was exhibited with objects by museum curators, as anthropology museums were co-opted, put to work, to make sure this violence was not only not forgotten, but did not end. Each morning, this morning for instance, as these museums are unlocked, the alarms turned off, the lights switched on, the doors opened to the public, to tourists and to school groups, this loss and violence is repeated once again. The event density of each looted object increases fractionally. A tipping point is not far off. No amount of institutional self-consciousness or re-writing of the labels to make the story more direct, or less euphemistic will work – to tell the story of this colonial violence in the gallery space is itself to repeat it, to extend it, as long as a stolen object is present and no attempt is made to make a return. Reflexivity in this instance, as so often in anthropology and archaeology, becomes mere self-regard, mixed perhaps with virtue signalling, and always risking a kind of 'dark tourism', of 'ruin porn', of that kind of dereliction *flâneurie* that dehumanises by bringing just words and images to loss in material form, rather than actions. Museums must put an end to this through developing and investing in a new approach to restitution, where the duty of understanding and action begins with the curator.

It is clear that the old view that 'the Benin Bronzes were seized in the aftermath of violence'[25] must now be turned on its head, to acknowledge how their ongoing presence in a western museum continually instantiates that violence anew. Colonial violence and restitution are not two separate questions divided by time, one of the past, one of the present. This is one question, archaeological and anthropological before it is historical. The present book would have been impossible to write without the groundwork done on understanding the predic-

ament of displaced people in the colonial present.[26] Is it too hopeful to believe that archaeology and anthropology, as twin fields that work between people and things, might yet be repurposed to reconnect these intimately linked stories of displaced objects and displaced people?

* * *

Brass is a highly transformative material. The ability to amalgamate and to cast is one source of the power of the Benin bronzes. Most were cast from brass, melting down the manillas and wire that the copper producers of Bristol, London and Liverpool traded for enslaved people, transforming the very substance of a transaction between humanity and inhumanity, objecthood and subjecthood, and forming memory markers for significant events.[27] In the geographies of the triangular trade of the 17th- and 18th-century Atlantic world, this composite nature of Benin artworks in the 17th and 18th centuries had a European counterpart. Whereas the British Museum began in the 1750s with the collection of Hans Sloane, made during his life with an immense wealth derived from Jamaican sugar plantations, the source of Pitt-Rivers's fortune was composite in the same manner as a Benin brass, a sugar fortune inherited late in life from at least four separate Caribbean sources, including various Pitts and Beckfords, then boosted by a share of the £20 million in government payments that was given to absentee slave owners following emancipation in 1838 to compensate them for the supposed loss of property.

A kind of double-vision will be required of us if we are to trace how compensation paid for the white loss of African people freed from chattel slavery – paid to a quite distant relative when Augustus Henry Lane Fox (not yet Pitt-Rivers) was 11 years old – came, around the time of his 70th birthday in April 1897, to be used to buy back brass in the form of artwork, now taken through the massacre of further African lives. The complexity has defeated the UCL *Legacies of British Slave-ownership Database*, which misleadingly suggests that the first collection was not bought with this fortune, before going on to state that 'From 1880, General Pitt-Rivers acquired a second, separate collection, which was housed in a private museum in Farnham, Dorset,

and is now dispersed' – thereby obscuring how the violence of slavery continued through the purchase of 283 objects of Benin loot for Farnham during 1897–99, and the acquisition of a further 145 through the museum infrastructure at Oxford, all directly funded through this slavery fortune.[28] This is far from a question of 'legacies', even what the UCL project calls on its website 'legacies that we all still live with' – these are continuities, durations, which as Ann Laura Stoler shows involve not ruins but ongoing 'ruinations', and conditions of 'duress' that form part of what 'endurance' means in the context of 'imperial durabilities'.[29] Here those durabilities are composite, shifting in form, transformative, with all the questions of partibility and continued depredation that 'a theory of taking' requires of us.

On 26 January 2016, Sir Hilary Beckles, Vice Chancellor of the University of the West Indies, gave a lecture at Oxford University on the theme of 'Britain's Black Debt'.[30] Observing how the Blair government had, at the 2001 Conference on Race and Xenophobia at Durban, 'disgracefully postured' by claiming that transatlantic slavery had been legal under British law and so there was nothing to apologise for, Professor Beckles called for the repayment of debt in the form of returns – both financial investment to match the compensation that was not paid to formerly enslaved people but only to those who enslaved them, and also participation that would end 'the hostile post-colonialism that continues to emanate from the post-imperial centre'.[31]

It was widely discussed in the British newspapers that public borrowing for the £20 million compensation payments made in 1842 to white slave owners were finally paid off in 2015 – but there has been silence on the compensation paid to the Royal Niger Company in 1900. The endgame planned by Goldie after the Jameson Raid and the Kirk Report had been good financial terms for the revocation of the Company's charter – he even drafted Kirk onto the Council of the Niger Company to work towards this aim,[32] as well as carefully planning the co-ordinated Company-Protectorate actions of the Benin-Niger-Soudan Expedition with Ralph Moor. Following debates in Parliament during 1897, with the Company's hand greatly strengthened by their victories, in April 1899 the Foreign Office passed control

of the Niger Coast Protectorate to the Colonial Office, headed by Chamberlain.[33] The NCP charter revocation on 31 December 1899 has often been portrayed by historians as a 'downfall',[34] but Goldie and his Company profited massively from this arrangement. Parliament agreed to pay out £450,000 for rights and 'administrative losses' back-dated to 1886, £115,000 for buildings and stores, and the assumption of responsibility for a public debt of £250,000 – plus a 99-year royalties agreement for one-half of all receipts from minerals mined on the 500,000 square miles of their former territories including tin.[35] This amounted to a total of £865,000 plus mineral rights, the Royal Niger Company retaining all plant, assets, stations and wharves.

The creation of Southern Nigeria Protectorate on 1 January 1900, amalgamated with the north to form the Colony and Protectorate of Nigeria in 1914, was what the sacking of Benin City had been about all along. In this ultimate amalgamation – of Company and Protectorate in terms of governance, giving the Company enormous resources with which to consolidate its business, in rubber and oil plantations, timber, and much more – Goldie's profits grew. After his death in 1925, the Royal Niger Company became part of the United Africa Company, controlled by Unilever from the 1930s, and the RNC continued in existence until it was absorbed into Unilever in 1987.

* * *

How can the distinction between *legacies* and *durations*, which we see in the question of reparations for Caribbean slavery, inform our contemporary understanding of loot, debt, massacre, cultural destruction, display and racism in the case of the presence of Benin 1897 in western museums today, and the enduring absences in Benin City today? Because the work of displaying loot served to naturalise inequality, to institutionalise 'scientific' racism in the most direct possible way, to produce difference by making a new physical space, then we need to understand it in environmental terms. As an intervention in time, as an act of taking, like the taking of the photographs, so the visual regimes of Benin displays carried forward the violence in the event, to make the event itself endure, with the time-juggling effect

that the myth was forged that the image of the Benin Kingdom made through prejudice – primitivism, cultural inferiority, brutality – was somehow the *cause* of the event, its *precondition* rather than its post-operation as the ideology of white projection involved temporal as well as moral place-switching. The Benin displays are no mimetic by-product, no epiphenomenal simulacrum, no isolated after-effect, but a postmodifier, a necrology – knowledge formed through death and made to last through the deferrals and hesitations of the museum as a weapon.

As Friedrich Engels explained in *Anti-Dühring*, in his discussion of Robinson Crusoe's sword, with which he dominates Friday, violence is not a simple act of will, but has material preconditions, central among which are the implements of violence. 'Where did Crusoe get his sword?' Engels asks.[36] In the case of the looting of Benin, we understand quite well how and where these royal and sacred objects, weaponised in the museum for an ideology of white supremacy, used to illustrate a western origin myth for the modern world of the pun-ishment and subjugation of Africa, were acquired. The surprise must, surely, be that these stories are still here, retold each day. We must, then, attend to the *pace* of this violence, which operates at the same tempo, through the daily opening and closing of the museum like some vast military drum, as the violence of the mineral rights of the Royal Niger Company and Unilever that ran for 99 years from 1900.

This is, of course, part of a wider truth about extractive, corporate-militarist colonialism, from the blood spilled for palm oil to the blood spilled today for petroleum. The historicisation of questions of colonial violence is again what holds back restitution. The last of the British soldiers who sacked Benin City in 1897 died as recently as the 1970s. How will Britain face up to the democidal ultraviolence of its colonial past, still just two generations ago, wrought by the grandfathers of British people still alive today, like Mark Walker, grandson of Herbert, who has made personal restitutions of looted objects to the Royal Court of Benin, as outlined in Chapter 12 above? The problem, counterintuitively, is the defeat of fascism, a continued belief in a 'moral impulse' which masks the history of racism, and the machinery that

supports it.[37] Our ultra-comfortable national stories about the British Empire still begin with pirates and end with the abolition of the slave trade. When museums talk and think about empire they too often follow suit, and leave one big, Queen Victoria-shaped gap between emancipation in 1838 and the Second Boer War (1899–1902). And yet that's the very period in which most of the global material began to enter the vaults of Britain's museums, in which objects came to be gathered through a host of routes and processes, among which, hiding in plain sight, are two main co-dependent structures: looting and the ideology of 'race', through which the Benin atrocity endures, 'ravaging a civilisation's memory markers and visual imagery',[38] a physical enactment of Jodi Byrd's notion of 'colonial agnosia', which concerns 'how colonialism remains pervasive but not comprehended as an extensive and constitutive living formulation by those situated in its complicity with colonial occupation'.[39]

As the museum became the implement of colonial violence, a technology of war for the production of difference, this was perhaps most clearly seen in the Pitt Rivers Museum's case titled '*On the treatment of dead enemies*', which ranges from so-called 'shrunken heads' (*tsantsa* heads) from Ecuador to the treatment of skulls and scalps from Papua New Guinea, South Sudan, Nagaland, North America and Brazil. For Benin, there is some suggestion that an early shift from the memorialisation of trophy heads to that of ancestral memorial heads may have taken place[40] – but what is certain is that through the projection of violent looters, brass ancestral heads were described as 'trophy heads' – memorials to the beheading of enemies, positioning the act of looting in the hands of the Africans. In truth, these are British trophies of killing, and will remain so until the slow work of environmental clean-up that turns re-collection into action, that builds peace through remembering as transitional justice that operates at the pace of sustained trauma, enduring dispossession and human and cultural survival.

Let us compare the ongoing effects of its institutional racism, the brutish world-view of the military victory of civilisation over the primitive, drawn out into the present through the museum as an oblique

weapon, to the extraction of fossil fuels, to desertification, to mass extinctions, climate change, an oil spill, nuclear waste, deforestation, the erasure of traditional land-management practices, the environmental aftermath of war, terrains full of landmines – what Rob Nixon calls the 'slow violence'[41] silently enacted through environments upon the poor across the Global South through extractivism that runs from violent dispossession to environmental loss, the end of worlds decades before Europeans and Americans felt their worlds were ending, just as Aimé Césaire described racial warfare and mass destruction in West Africa – to which we might add the looting of artworks, its display as 'degenerate' – brutalities witnessed three decades before their arrival on the soils of Europe, tolerated by Euro-Americans, as its 'accomplice' before too becoming subjugated by it, having to go to war against it before it engulfed Europe as well:

> they tolerated it before they too were subjected to it, they absolved it, closed their eyes to it, legitimized it, because, until then, it had only been applied to non-European peoples; they cultivated it, they are accountable for how it built up, broke out, and dripped through every crack in western and Christian civilisation, before they too were engulfed in its reddened waters. (Aimé Césaire, *Discours sur le colonialisme*, 1955)[42]

* * *

Exposing for a moment the ultimate white projectionist fantasy of western museum directors, Tristram Hunt imagines that the celebrated scene in the 2018 Marvel Comics movie *Black Panther* where the Museum of the United Kingdom is robbed by Eric Killmonger for an axe made of Vibranium – a fictional metal which has the potential to absorb, store and release masses of kinetic energy – 'highlighted controversies over museum collections and colonial injustice'.[43] As Johanna Zetterstrom-Sharp of the Horniman Museum has observed, 'Killmonger is the favourite reference for awkward defences of retention by privileged museum professionals. Why? Because he epitomises the threat such defence imagines it stands against: an irrational, emotional & aggressive diasporic impulsiveness.'[44]

There should be no 'controversy' over the future of violently looted objects and artworks in our care. To demand their return is not iconoclasm, but the reversal of iconoclasm, exposing the ideology of universality as a peculiarly western concern, and beginning a national process of British engagement with colonial ultraviolence and its enduring reality in global disaster capitalism, visible not least in the ongoing sponsorship of British Museum exhibitions by BP. In announcing a new age, 'anthropocene', we risk removing western colonial agency from it, as if extractivist colonialism accidentally changed environments, rather than that being their principal purpose. In reality, this is the literal naturalisation of inequality, writing race not onto the body but into the physical environment itself – multiplying through what Donna Haraway labels 'Capitalocene, Plantationocene, Chthulucene' – to which let us add the new term '*Chronocene*' – an epoch of placing others into other epochs.

When Achille Mbembe adopted the idea of the 'postcolony',[45] he was describing a time-geography, not just an intellectual position, in order 'to create a distance from what is known in Anglo-Saxon academic circles as "postcolonial theory"'.[46] Could that sense of something physical and not adjectival, not opposed to method or to practice, inform how we might treat the anthropology museum as such a zone: a place to stand, a position from which to seek to cast a light, one of privilege. The western anthropology museum is white infrastructure. From this standpoint, what can be known? My answer here is twofold.

First, let us build understanding of the history of British colonial violence in Africa – the scale of the slaughter, its corporate nature, the degree of human and cultural destruction. Mark Terkessidis, in his book *Wessen Erinnerung zählt?* (Whose Memory Counts?) has traced the effects for Germany of the yielding with the Treaty of Versailles on 28 June 1919 of German overseas colonies – Namibia, Cameroon and Rwanda – to the victorious powers of the First World War. Terkessidis's study challenges German academic, political and public culture to interrogate the status of the 'post'-colonial for German culture today, exposing deeply buried structures of racism in the context of the

diversity of contemporary German culture.[47] The Herero and Nama genocide, conducted by the German Empire against San, Nama and Ovahereero people in German South-West Africa in 1904, in retaliation for the reported killing of 100 Germans, killed an estimated 50,000–100,000 people. After the First World War, the British Foreign Office catalogued the mistreatments in the German African colonies between 1890 and 1905: the expropriation of land, seizure of cattle, floggings, destruction of customs and rights, and forced labour – 'a ruthless barbarity that, if committed by a less powerful nation, would have roused a storm of indignation throughout the civilised world'. These were condemned alongside 'unnecessary wars' against supposed 'risings and rebellions' in which, a 1912 estimate suggested, 'by the barbarous method of warfare 200,000 people were shot down in a few years', including in the Herero genocide of 1904 and the slaughter during the Maji Maji 'rebellion' in German East Africa in 1905–07: the killing of those fleeing or surrendered, the hanging of prisoners, and the shooting of women and children.[48] This colonial violence was not new to German colonialism: in 1897, Carl Peters was removed from office in German East Africa for atrocities against Africans.

As Germany begins to face up to the Herero and Nama genocide and the killings of Maji Maji, and more, so Belgium continues to learn more about Leopold II's Congo Free State, where perhaps 10 million people – half the population over 30 years – lost their lives.[49] As David Van Reybrouck has shown,[50] on the pretext of anti-slavery and free trade, the western demand for rubber tyres was met through the deaths of millions in Leopold's Congo. What then of the British in East Africa, South Africa and West Africa during this key period between the Berlin Conference of 1884, and the outbreak of the First World War in 1914? I suggest that Britain must start adding up the losses of the scores of so-called 'small wars' that it waged against African communities and leaders during this period – in what I call, for want of a better term, 'World War Zero'. Victories in two World Wars has blinded Britain to the history of white supremacy, cultural destruction and democide that is celebrated in any display of looted objects, no

matter how self-critical, inward-looking, contrite, or self-regarding its descriptions of violence are.

The second point follows directly from the first. Understanding loot requires a kind of unhistorical approach, what I have called here a 'necrographic' method: the writing of loss. Displays of loot are an endurance in the same way as apartheid was an endurance, or how the poisoning today of the Niger River by oil companies[51] is an endurance, a residue: an instance of what Chinua Achebe called 'a residue of antipathy to black people'.[52] The knowledge contained in loot in museums are therefore never 'ethnological' or 'anthropological' – it is necrology, the knowledge of human death and cultural extirpation. Anthropology museums are complicit in making this colonial violence endure, through their continued display of the objects in their care that were taken in the ultraviolence of 'punitive expeditions' and other conflicts during this period, and especially through telling and re-telling the story of the Benin punitive expedition, no matter how enlightened the language. There is no more important question for western museums today than restitution – which must involve, but is by no means restricted to, the return of cultural property. By using the case of Benin 1897 to consider these questions, the book seeks to join dots between loot and human remains, race science and ethnographic displays, and to show that looting was not just some by-product of empire but came in this period to be a principal means of domination and a new cultural ideology of 'race'.

* * *

Let us imagine anthropology museums where nothing is stolen, where everything is present with the consent of all parties. Let us imagine an art market where loot violently taken by white soldiers seeking to extinguish a culture, does not change hands for millions of dollars but is given back to its rightful owners. Let us imagine museums where the curators' principal task is that of detailed necrological research – understanding what was taken, and from whom, and facilitating its return where this is demanded.

In this respect, this book is written in defence of the anthropological museum as a space – a defence of these institutions against the proto-fascism that co-opted them in the late 19th and early 20th centuries. Displays of loot have no more rightful place in these places any more than exhibits of racial types, removed *en masse* after the fascists were beaten in 1945. Insofar as anthropology as a discipline is important for western societies – and I believe we have never needed anthropology more than we do today with the rise of populism, of racism, of intolerance – so too are its public spaces. But these institutions have an immense task to change themselves, dismantle, repurpose, re-imagine, disaggregate. The crucial first task, I suggest, is to understand and take action on every object that was violently taken within the collection. Anthropology museums will only be able properly to fulfil their central, crucial function – to bring a sense of other ways of seeing, knowing, living and making into the Euro-American consciousness, including an awareness of the universal importance of material culture in human lives – when nothing in their collections is present against the will of others. A major programme of returns, in which every departure is marked by a new creative act by an artist or designer, is the essential next step, hand-in-hand with transforming anthropology museums into sites of remembrance and conscience for the human lives, environments and cultures destroyed by European colonialism, past, present and future. This is how to dispel the illusion that the taking of photographs and the taking of objects was some past instant flash, like the split-second firing of the Maxim gun or the flash of a camera bulb – when in fact the museum was built to slow these moments of loss down to a near stand-still.

Museums are places where curators pretend that they can keep things the same. I prefer to see that stasis as a state of hesitation. The Pitt Rivers Museum has been hesitating for years, and maybe there is a new role for it to play. Facing up to inhumanity, just as in the urgent case of restitution to Africa, we can't pretend that the violence of the past, or the present, can be undone in a space like this, 'decolonised' out of existence . But it can nevertheless be made to be seen

by all, just as it is already felt by so many. Anthropology museums can be sites of conscience, for the present as well as the past, not frozen end-points but ongoing processes. But without acts of return this means nothing.

18

Ten Thousand Unfinished Events

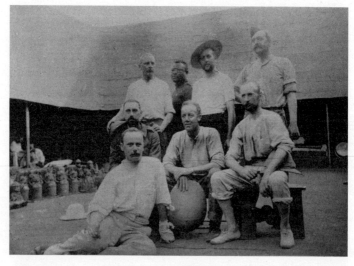

It crossed my mind that one could set up a museum here. As a warning.

Olga Tokarczuk, *Drive Your Plow Over the Bones of the Dead*[1]

The power of a museum begins with the skill of the conservator. Slowing decay to a near stand-still creates the familiar illusion, that most seductive of myths, that the passage of time itself might be halted, that things can be kept the same. We have all felt the wonder of going back to see a much-loved museum artefact, sculpture, or painting. Such returns are less about material stasis than human change. Bringing our bodies and biographies back to a mute object, they become yardsticks and flashlights: revealing how we have grown and aged, what has changed. Does some small trace of such visits

even remain for future visitors, building up in the gallery space? For museums to be more than mere reliquaries, to realise their potential as unique kinds of contemporary public space, this layered, recursive human dimension is central. Museums can't really bring time to a halt, of course. But they do throw change into relief; sometimes they may even bring change about. Each return to a gallery is a reminder that each museum object is an unfinished event. What then of material returns?

It is folly of the highest order for any museum director to imagine they could extend the act of conservation beyond the walls of the museum – mistaking it for something more than a method or metaphor. Nothing can stop the tide of history as it is being made and remade around our institutions at this global juncture for the colonial past. Nonetheless, the rhetoric is hardening. In Bloomsbury, an old prejudice is reworded: '*the taking of the Parthenon Marbles was "a creative act"*', as we saw in Chapter 3. From South Kensington, as we saw in the last chapter, a more extreme position emerges. The accusation is iconoclasm: that the return of cultural heritage is inherently destructive, '*an act of "decontextualisation"*'. But what exactly is the Victoria and Albert Museum contesting when it describes the sacred objects violently looted from Maqdala in 1868 as 'contested heritage'? And what, precisely, is the British Museum finding difficult when it 'acknowledges the difficult histories' of military colonial royal booty from Benin City in 1897?

The BBC-British Museum radio series *A History of the World in 100 Objects* first aired in January 2010, and a relic survives in the form of a website with short descriptions of each featured artefact followed by the words 'Comments are closed for this object'.[2] But comments are far from closed, and nor are actions. One of the entries is a Benin brass head from the collections of the Royal Albert Museum Exeter, and it opens with the line: 'This object is as controversial as it is magnificent.'[3]

This is the framing not of curators or activists, but of ill-informed spindoctors from Britain's national museums. Their chosen language is not just euphemistic; it is divisive – designed to cultivate the wide-

spread misunderstanding that questions of restitution are about some false choice between empty galleries or keeping everything. Of course, no one holds either position. In reality, it's routine for UK museums to return loot. Britain's National Museum Directors Council 'recognises and deplores the wrongful taking of works of art that constituted one of the many horrors of the Holocaust and World War II',[4] and adopted the 1998 Washington principles on Nazi-confiscated art, whereby the onus of responsibility for understanding provenance shifts to institutions not potential claimants. British museums have been returning colonial human remains to Indigenous communities for even longer. The urgent question now is: what about colonial spoliation of cultural property?

This issue affects the whole of the Global South, but the *Sarr-Savoy Report*, commissioned in 2017 by Emmanuel Macron, President of the Republic of France, responded to the particular contemporary African moment, which is changing how this question can be answered. In November 2017, in a speech at the University of Ouagadougou in Burkina Faso, Macron stated:

> I cannot accept that a large share of several African countries' cultural heritage be kept in France. There are historical explanations for it, but there is no valid, lasting and unconditional justification. African heritage cannot solely exist in private collections and European museums. African heritage must be showcased in Paris but also in Dakar, Lagos and Cotonou; this will be one of my priorities. Within five years I want the conditions to exist for temporary or permanent returns of African heritage to Africa.[5]

The suffering of the Continent of Africa at the hands of extractive, militarist-corporate colonialism throws up different circumstances from those of settler colonialism in the Pacific or the Americas. Felwine Sarr and Bénédicte Savoy's *Rapport* reminded us that the myth of the universal museum – in truth a concept antithetical to any ideal of universal human values – serves to obscure something on which we must be transparent and precise: the different modes of

colonial acquisition. Trophies of war are doubtless a human universal. But as we have seen, Victorian and Edwardian museums played a central role in 'race science' and colonial violence during the wanton destruction in Africa, where looting skulls and weapons and royal and sacred objects was not some side effect of empire, but a technology for performing white supremacy used to try to justify ultraviolence, democide, the destruction of cultural property, and the casting of sacred and royal objects to the open market.

Looting became something new during the three decades between the Berlin Conference of 1884 and the outbreak of World War in 1914, through the actions of anthropology museums. This is the brutish museum: a prolongation of violence in the name of sovereignty. These colonial museums became the infrastructure for a new kind of white supremacy. Violent military operations involving the theft and public display of art classified as 'primitive' or 'degenerate' were a key part of the ideology of white supremacy, foreshadowing the horrors of the 20th century. It is shameful for our national institutions to 'contest' this brutish complicity. The message of these chilling dispossessions was designed to live on through what visitors and curators alike today increasingly recognise as violent and racist museum displays.

For these reasons, the restitution of colonial loot is not a question of balance or taking sides. It's about addressing blind spots and ongoing institutional racism. The idea that Africans are incapable of caring for their own cultural heritage, for example, is still, incredibly, heard from senior British museum professionals and politicians – just like the disbelief at the British Museum when a cast bronze English jug, dating from around 1400 CE, carefully kept for half a millennium, was 'discovered' amid the violence of the Ashanti War of 1896.[6] '*Give it back and it'll only be stolen*' is the universal motto of the thief. Britain's national museums reduce 'decolonisation' to 'artwashing' by offering long-term loans rather than giving back what was stolen, while indulging in disingenuous special pleading about legal restraints (straightforwardly overcome for Holocaust spoliation and human remains). Our national museums' irrelevance grows as Britain's non-national museums, from universities to local authorities, adopt more

open-minded case-by-case approaches to restitution claims, start to take responsibility for understanding provenance histories of colonial spoliation, and begin to support African voices. This global shift is unstoppable: from the museum as end-point to the museum as process.

Restitution is not subtraction; it is refusing any longer to defend the indefensible; it is supporting African institutions, colleagues and communities; addressing western museums' roles as sites of conscience and remembrance, tackling the ongoing effects of racial violence, paying a debt, rebuilding a relationship. No museum can stop the world from changing around it. Dialogue is giving way to action. We don't know how this ends for the ten thousand objects looted from Benin.

Ten thousand unfinished events.

Afterword: A Decade of Returns

The looting of objects into a Western art museum is a dual process. It expropriates from people what was theirs, and supposedly enriches 'us' – scholars, students, artists, curators, photographers, museumgoers and museum's neighbors – with privileges that work against these people's rights and desires. Hence, a dual process is due in response: the restitution of the objects to claimant communities from whom they were directly or indirectly expropriated, and the disowning of the looted objects by institutions and communities that benefit from the looted objects. We are not demanding merely a physical transaction that displaces the object from our ownership to someone else's ownership, elsewhere. We are demanding public recognition of the symbolic and epistemic violence that our intellectual community helps perpetuate ... This is an opportunity to actualize repair.

Protest leaflet at Rhode Island School of Design, 30 November 2018[1]

This is the kind of book where the reader has to write the conclusion by taking action, but here is an afterword on some of the practical dimensions of making African restitution happen.

In November 2018, protests at Rhode Island School of Design called on the college's museum to return the Benin sculpture in its collections to the Royal Court of Benin. Letterpress posters read: 'Heads Up RISD. Decolonization, or Complicity? RISD, you have a decision to make'. On the same day, the grassroots group Decolonize This Place called on the Brooklyn Museum – another North American institution that currently holds a looted Benin collection – to create a 'Decolonization Commission', under the banner 'Reparations/Repatriation NOW!'[2] The Brooklyn action came a few months after protests at Brooklyn Museum for the 'tone deaf'

appointment of a white woman, Kristen Windmuller-Luna, as Consulting Curator for its African Art collection. Grass-roots movements are beginning to connect questions of reparations and fallism with those of restitution, questions of institutional racism with those of the use of museums as mouthpieces for outdated ideas of social evolution, cultural difference and white supremacy, and the challenge of decolonising knowledge in universities and in society with anthropology museums as public spaces. Where next?

It is clear that the enduring colonial violence of displaying loot is not just collateral damage, but an endurance of anthropology's period of being put to work for an ideology of white supremacy. The museum will not be decolonised,[3] but it can nonetheless be a place for thinking and doing. Anthropology museums are the public spaces in which Britain can begin to acknowledge the scale of the hundreds of thousands killed in Africa and beyond, and the role of 'race science' in justifying this. Just as skulls were removed from anthropology displays after the Second World War, as one form of 'race science', so today museums must face up to how cultural objects continue to play a role in justifying colonial violence based on cultural difference, and to put a stop to this.

Necrography reveals facts that are not just about museum 'transparency', but the excavation of the foundations – this is concrete, as talked about by Lindqvist at the start of this book, for which an archaeologist's trowel may be needed, but so too at some points a jackhammer to dismantle what has set in, hardened over time. Just as the 1998 Washington Principles placed the responsibility for understanding looted Holocaust art, taken by the Nazis between 1933 and 1945, with the museum rather than the claimant, so museums and their research communities need to collaborate on the major task of locating some 10,000+ objects looted from Benin City in 1897. This requires museums to publish their data, not just in raw form but with detailed 'necrographies' of loss, through which provenance can be understood. I have tried in this book to begin this process for the 422+ looted objects that fall under my immediate purview: the 145 loaned or acquired objects here in Oxford, and the 283 that were

documented in the dispersed 'second collection' (six of which are now within the 145 in Oxford). But there is so much more to be done. In Germany, an important campaign is under way to make public museums publish their accessions registers. In the UK, meanwhile, basic details of object collections are very hard to get hold of for most of the museums on the list. Even the well-funded British Museum claims that it continues to be unable to publish a definitive list of its Benin collections, while many non-national museums, after more than a decade of austerity and cuts, have very limited curatorial capacity to engage with these questions. Public funding is desperately needed to start to make these facts available, and to start to understand the necrology of each looted object, so restitution can begin.

Beyond the white projections of blame onto Africans through the ideology of the punitive expedition and so much more, and beyond the case of Benin City, there is an urgent need for museums to work together to build a much larger body of knowledge and understanding around colonial looting and the development of global capitalism throughout the 19th and early 20th centuries, and the earlier examples in the 17th and 18th centuries. Rather than further hagiographies of Captain Cook, or balanced and passive histories of British looting of libraries, monasteries and palaces, or displays of pillaged objects where provenance is not mentioned, but the sharing of knowledge of museum collections as unique indexes of imperial theft in order to begin to build a new infrastructure to fulfil museums' ethical responsibilities to dispossessed individuals, communities and nations – and also to visitors.

In this urgent, enduring 'negative moment', clear formal processes still need to be developed and evolved for the restitution of cultural remains by museums in the UK and globally. Human remains and Holocaust spoliation are generally well covered by national policy and guidance, but colonial spoliation is a major gap.[4] In the UK, there is some specific provision that limits de-accessioning for national museums under the National Heritage Act, but also many opportunities for immediate action in university and local authority museums.[5] Some of the factors that vary between claims include the legal basis

of ownership by the museum, the circumstances of acquisition, the relationship of the claimant to what is being claimed, the existence of any counter-claim by other parties.

The legality of unlicensed exports of Benin cultural objects from Nigeria to the United Kingdom after 1924, and especially after the 1970 UNESCO *Convention on the Means of Prohibiting and Preventing the Illicit Import, Export and Transfer of Ownership of Cultural Property*, is also a factor. A few instances exist where urgent questions need to be asked about the international movements of Benin bronzes into British collections. These include the Benin head taken from Lagos National Museum in June 1973 by General Yakubu Gowon, head of the military junta in Nigeria, and given to Queen Elizabeth. It would also be helpful if the precise circumstances that led to two British Museum plaques being given or sold to Robert Lehman from the collections of the British Museum at some point during 1972, and any object received from Lehman by the British Museum in exchange, were made clear. Other factors that may be taken into account in such processes include whether an object was acquired from someone not authorised to give or sell it, and the nature of the importance of an object for communities, as for example with sacred religious and royal objects. Above all, provision for genuine and equitable dialogue with claimants is crucial, and a commitment to take no interest in the use of an object after a return is made – as with human remains, where return often means destruction through burial.

Action is urgently needed on one principal lesson of the *Sarr-Savoy Report*: the need for a new kind of typological work, based not on imagined types of object or culture, but on the different forms that 'acquisition' through which colonial material culture came to western museums has taken. In this typology of taking – a key exercise in the task of 'necrography', to make knowledge of loss and death – the first category must be loot taken with violence, the trophies and spoils of 'small wars' from Maqdala in Ethiopia in 1868 to the Asante Kingdom in Ghana in 1874 and 1896, and far beyond – iconic and foundational among which, of course, is the sacking of Benin City. Felwine Sarr and Bénédicte Savoy challenge curators to extend their view of

restitution to include other circumstances. Let me suggest a preliminary series of seven types of taking: from (i) looting with violence in all its forms, including dispossessions of royal objects and other items of forms of sovereignty and power; (ii) physical anthropology collecting of human remains; (iii) missionary and other confiscations of objects of religion and belief taken during colonialism; (iv) archaeological collections and tomb-raiding; (v) 'scientific' collecting of natural history specimens; (vi) 'ethnographic' collecting; (vii) instances of barter, purchase and commissioning. This is not intended as a list of diminishing violence, since in all these cases, as Felwine Sarr and Bénédicte Savoy have observed,[6] various conditions of duress existed and continue to exist. Rather, this typology sketches out a new framework for new necrographies of colonial taking.

The world needs anthropology museums where nothing has been stolen. Museum 'dialogue', so often takes the form of filibuster, of stonewall, of obstruction, and even of silencing and redaction – not least through the idea of 'entanglement' or complexity. But many of these histories are not so complex, or so difficult, or so entangled – they are straightforward. Where an object has been looted, and a community asks for it back, western museums have a duty actively to make a return, both of the physical object and additionally of other sharing of knowledge, resource, connections and platform. Every return offers an opportunity to fulfil the curator's principal job: to understand their collections better. This extends to human remains as well, where the old reactive codes of practice need to shift to a new proactive process of sharing knowledge and being open to returns. It can also take place without sponsorship by disaster capitalist corporations like oil companies, whose extractivist project has wrought so much damage across the Global South, and continues to decimate landscapes and environments today.

The existence of museums of world culture in Euro-American towns and cities, where other ways of living, seeing, thinking and relating can be understood, has never been more vital. These museums need new commissioning programmes, through which each gap made by returns is filled by new work made by artists, designers, writers and

others from the dispossessed community paid for by the museum, to help museums remember and to bear witness to colonialism today.

Let us re-imagine and reinstate the anthropological, archaeological and world culture museum as a site of conscience, of transitional and restorative justice, and of cultural memory. The museum as process, not an end-point.

Britain has reached a crucial juncture in how it understands its imperial past at just the moment when international pressure around African restitution is at a tipping point. The objects looted under colonialism's cultural destructions are becoming new zones of intense action.

This may be a time for hope and for optimism; it is certainly a time for action. Twenty years ago, my future colleagues at the Pitt Rivers felt able to joke that 'leaving Benin plaques to gather dust in a museum store could be regarded as a culturally appropriate way for museums to keep them.'[7] Today, as plans for the new Royal Museum in Benin City, to be designed by Sir David Adjaye, move ahead, the world is changing around collections like Oxford's.

The question of restitution to Benin is often framed, as so often across the continent of Africa, as solely about relationships between nation state and nation state: the African country and the former colonial power. But of course restitution in this case is not 'repatriation' to a nation, but returns to the Royal Court. And even within the UK, more Benin loot is held in non-national museums – that is, outside the British Museum and the Victoria and Albert Museum – than is held in the nationals. Each of more than 40 museums and universities could choose to restitute Benin objects from their collections – as Jesus College, Cambridge is in the process of doing for a brass cockerel figure currently in its possession.[8]

Appendix 5 at the end of this book is one place to start if we are to move the question of the Benin Bronzes from colonial violence towards restitution. A total of 165 potential collections of Benin 1897 loot worldwide is identified. Of these, around half are in either the UK (43) or the US (45). There are also collections in an estimated 24 German museums and nine Nigerian collections, including that

of the Royal Court of Benin. Beyond these four main countries, a further 44 collections can be provisionally identified, from Angola and Senegal to Australia, Austria, Belgium, Canada, Denmark, France, Ireland, Italy, Japan, the Netherlands, Norway, Portugal, Russia, Spain, Sweden, Switzerland and the United Arab Emirates. This list is provisional, and in some cases speculative and potentially historic – for example, the Wellcome Collection may have given away or sold its Benin collections, or it may retain some or have some on long-term loan. Other museums have definitely sold Benin collections, most famously when the highest recorded price for a looted Benin object was set in 2007 when Sotheby's New York sold a 17th-century bronze head of an Oba de-accessioned from the Albright-Knox Art Gallery in Buffalo, New York, for $4,740,000. The list also does not include private collections made through purchase or inheritance. One example of this category came to public attention when the attempted sale at Sotheby's of one of the six known ivory Queen Idia hip-masks alongside other looted items including bronzes and ivories by some of the descendants of Sir Henry Galway, who died in 1949, was prevented by a Nigerian-led campaign in 2010.[9] Information about private sales is often poorly understood, as for example with the sale of another bronze head by Woolley and Wallis/Entwhistle in 2016 for an undisclosed 'substantial seven-figure sum', which the salesroom believed to be 'a record for any Benin work of art'.[10] I hope, in a second edition of this book, to be able significantly to expand the detail here, and to be able to update the picture of scale, location, and the progress of restitution to the Royal Court of Benin. Please tweet your contributions and corrections to @BrutishMuseum.

* * *

The clasps of the Royal Niger Company medals bore the Company motto: *Pax, Jus, Ars* – peace, justice, art. Is it possible to repurpose that phrase today from its bleak history? Could it be that, like the *cire perdue* (lost wax) process through which Benin's brass heads were cast, so the negative framework of the brutish museums can be melted away, to leave something new – not a return to form, but something

multiplied, recast from diverse materials? The answers lie in the hands of those who, after reading this book, will put it down, stand up from their chair, walk out of the door, and take action to make the 2020s a decade of restitution.

Appendix 1: Provisional List of the Worldwide Locations of Benin Plaques Looted in 1897[†]

Museum	Number of Plaques*
Private Collections	Unknown**
Ethnologisches Museum of Berlin State Museums	255
British Museum, London	192
National Museum, Lagos	64
Weltmuseum, Vienna	46
Staatliche Museum für Völkerkunde, Dresden	36
The Field Museum, Chicago, Illinois	35
Metropolitan Museum of Art, New York City	26
Grassi Völkerkundemuseum zu Leipzig	20
'ex-Pitt-Rivers, Farnham'	18***
Kunstkamera Museum of Ethnology and Anthropology, Saint Petersburg	18
Museum of Fine Arts, Boston, Massachusetts	15
Världskultur Museum, Stockholm	14
Horniman Museum, London	13
Museum Volkenkunde, Leiden	13
National Museum, Benin City	12
National Museum of African Art, Washington, DC	11
Pitt Rivers Museum, University of Oxford	10
Museum of Archaeology and Anthropology, University of Cambridge	7
Museum of Archaeology and Anthropology, University of Pennsylvania	7
Museum der Weltkulturen, Frankfurt am Main	6
Hirschhorn Museum and Sculpture Garden, Washington, DC	5

[†] This is a provisional list of the 868 identified brass relief plaques of probably more than 1,000 that were looted, and of the more than 10,000 objects in total looted during the 1897 Benin Expedition.

Linden Museum, Stuttgart	5
American Museum of Natural History, New York City	3
Bremen Ethnologisches Museum	3
Brooklyn Museum, New York City	3
Peabody Museum of Archaeology and Ethnology, Harvard University	3
Museum Fünf Kontinente, Munich	3
Cleveland Museum of Art, Ohio	2
Jos Museum, Nigeria	2
MARKK Museum am Rothenbaum – Kulturen und Künste der Welt, Hamburg	2
Seattle Art Museum, Washington State	2
Völkerkundemuseum, University of Zürich	2
Art Institute of Chicago, Illinois	1
Baltimore Museum of Art, Maryland	1
Dallas Museum of Art, Texas	1
de Young Museum, San Francisco, California	1
Indianapolis Museum of Art, Indiana	1
Los Angeles County Museum of Art, California	1
New Orleans Museum of Art, Louisiana	1
"Private Collection (ex-Tropenmuseum, Amsterdam)"	1
Rautenstrauch-Joest Museum, Cologne	1
Reiss Engelhorn Museum, Mannheim	1
Royal Ontario Museum, Toronto	1
Tropenmuseum, Amsterdam	1
Ibadan University	1
University of Iowa, Iowa City	1
World Museum, Liverpool	1
TOTAL	**868**

* After Gunsch 2017: Annex 4

** Developing understanding of what is in private collections presents two separate challenges: tracing what has been sold on the art market, and looking for where loot has been passed down generations within families, whether in cases where families never sold inherited material, or where some was sold and some retained.

*** Since the Pitt-Rivers Museum at Farnham no longer exists, these 18 plaques must be elsewhere, and some or all may well already be counted under other collections here.

Appendix 2: Provenance of Benin Objects in the Pitt Rivers Museum, Oxford (the 'First Collection')

Provenance	Number of Objects
Admiral Sir George Le Clerc Egerton	43
Mary Henrietta Kingsley	28
Stevens Auction Rooms	19
William Downing Webster	9
William John Ansorge	7
Pitt-Rivers Museum	7
Henry Nilus Thompson	6
Cranmore Ethnographical Museum	4
Felix Norman Ling Roth	4
Harold Mordley Douglas	3
Lieutenant Colonel Frederick William Bainbridge Landon	2
George Fabian Lawrence	2
Beatrice Braithwaite Batty	2
Henry Balfour	1
G.F. Martin	1
Thomas Francis Embury	1
Sir George Chardin Denton	1
Thomas William Taphouse	1
Sotheby and Company	1
Mervyn David Waldegrave Jeffreys	1
Lieutenant Reginald Kerr Granville	1
Unknown	1
TOTAL	**145**

Appendix 3: Sources of Benin Objects in the Former Pitt-Rivers Museum, Farnham (the 'Second Collection')

William Downing Webster	188
Stevens Auction Rooms, 38 King Street, Covent Garden, London	26
George Fabian Lawrence	25
Crown Agent of the Niger Coast Protectorate, Downing Street	9
Norman Burrows, Mellor Hall	9
Henry Ling Roth	8
Eva Cutter	5
William Cross, Liverpool	4
Unknown	3
James Tregaskis, 232 High Holborn	2
Charles Hercules Read	1
Liverpool Museums	1
George R. Harding, St James' Square, London	1
J. Young, Glasgow	1
TOTAL	**283**

Appendix 4: Current Location of Benin Objects Previously in the Pitt-Rivers Museum at Farnham (the 'Second Collection')[2]

Unknown	227
Metropolitan Museum of Art, New York City	27
Museum of Fine Arts, Boston, Massachusetts	14
Smithsonian Institution, Washington, DC	8
Sainsbury Centre, University of East Anglia	1
Yale University Art Gallery, New Haven, Connecticut	1
Hunt Museum, Limerick, Ireland	1
Brooklyn Museum, New York City	1
Seattle Art Museum, Washington State	1
Linden Museum, Stuttgart, Germany	1
Hood Museum of Art, Dartmouth College, Hannover, New Hampshire	1
TOTAL	**283**

Appendix 5: A Provisional List of Museums, Galleries and Collections that May Currently Hold Objects Looted from Benin City in 1897

UNITED KINGDOM (43)

University Museums, University of Aberdeen
Ulster Museum, Belfast
Barber Institute, University of Birmingham
Brighton Museum and Art Gallery
Bristol City Museum
Museum of Archaeology and Anthropology, University of Cambridge
Jesus College, Cambridge
Dumas-Egerton Trust, Cambridge
National Museums Scotland, Edinburgh
St Mungo's Museum of Religious Life, Glasgow
Kelvingrove Art Gallery and Museum, Glasgow
Bankfield Museum, Halifax
East Yorkshire Regimental Collection, Hull
The Royal Albert Museum, Exeter
Hull Museums
Ipswich Museum
Maidstone Museum, Kent
Powell Cotton Museum, Birchington-on-Sea, Kent
Leeds City Museum
Royal Armouries, Leeds
World Museum, National Museums Liverpool
Museum of Liverpool, Liverpool
British Museum, London
Horniman Museum, London
Lambeth Palace, London
Natural History Museum, London
Royal Museums Greenwich, London
Victoria and Albert Museum, London
Wellcome Collection, London
Manchester Museum, University of Manchester
Great North Museum, Newcastle
National Museum of the Royal Navy, Portsmouth
Cumberland House Museum, Portsmouth

Lancashire Infantry Museum, Fulwood Barracks, Preston
Norfolk Museums, Norwich
Sainsbury Centre, University of East Anglia, Norwich
Ashmolean Museum, University of Oxford
Pitt Rivers Museum, University of Oxford
City Art Gallery, Salford
Sheffield Museums
Warrington Museum and Art Gallery
Myers Museum, Eton College, Windsor
Royal Collection, Windsor

UNITED STATES OF AMERICA (45)

Baltimore Museum of Art, Maryland
Phoebe A. Hearst Museum of Anthropology, University of California, Berkeley
de Young Museum, San Francisco, California
Los Angeles County Museum of Art, California
Fowler Museum, University of California, Los Angeles
Albright Knox Art Gallery, Buffalo, New York
Buffalo Museum of Science, Buffalo, New York
Peabody Museum, Harvard University, Cambridge, Massachusetts
Art Institute of Chicago, Illinois
Field Museum of Natural History, Chicago, Illinois
Hood Museum of Art, Dartmouth College, New Hampshire
Denver Art Museum, Colorado
Detroit Institute of Arts, Michigan
Indianapolis Museum of Art, Indiana
Sidney and Lois Eskenazi Museum of Art at Indiana University, Bloomington,
 Indiana
University of Iowa, Iowa City
Milwaukee Public Museum, Wisconsin
Davis Museum, Wellesley College, Massachusetts
Museum of Fine Arts, Boston, Massachusetts
Minneapolis Institute of Arts, Minnesota
Newark Museum, New Jersey
Yale University Art Gallery, New Haven, Connecticut
New Orleans Museum of Art, Louisiana
American Museum of Natural History, New York City
Brooklyn Museum, New York City
Metropolitan Museum, New York City
Sam Noble Museum of Natural History, Norman, Oklahoma
Cleveland Art Museum, Ohio
Allen Memorial Art Museum, Oberlin, Ohio
Philadelphia Museum of Art, Pennsylvania
Museum and Archaeology and Anthropology, University of Pennsylvania,
 Philadelphia
Carnegie Institute, Pittsburgh, Pennsylvania

University of Pennsylvania Museum of Archaeology and Anthropology,
Philadelphia
Museum of Art, Rhode Island School of Design (RISD), Providence, Rhode
Island
Haffenreffer Museum of Anthropology, Brown University, Providence, Rhode
Island
Kimbell Art Museum, Fort Worth, Texas
Dallas Art Museum, Texas
Seattle Art Museum, Seattle, Washington State
City Art Museum, St Louis, Missouri
Middlebury College, Vermont
Fleming Museum of Art, University of Vermont
Jamestown Settlement and American Revolution Museum at Yorktown, Virginia
Virginia Museum of Fine Arts, Richmond, Virginia
The Barnes Foundation, Washington DC
National Museum of African Art, Smithsonian Institution, Washington DC

GERMANY (24)
Ethnologisches Museum, Berlin
Bode Museum, Berlin
Übersee-Museum, Bremen
Städtisches Museum, Brunswick
Rautenstrauch-Joest Museum, Cologne
Hessisches Landesmuseum, Darmstadt
Dresden Museum für Völkerkunde
Folkwang Museum, Essen
Museum der Weltkulturen, Frankfurt am Main
Museum Natur und Mensch, Freiburg
Göttinger Institut für Ethnologie und Ethnologische Sammlung, University of
Göttingen
MKG Museum fur Kunst und Gewerbe, Hamburg
MARKK Museum am Rothenbaum – Kulturen und Künste der Welt, Hamburg
Landesmuseum, Hannover
Völkerkundemuseum der J. und E. von Portheim Stiftung, Heidelberg
Roemer-Pelizaeus-Museum, Hildesheim
Museum für Völkerkunde zu Leipzig
Völkerkundesammlung, Gesellschaft für Geographie und Völkerkunde zu
Lübeck
Johannes Gutenberg University, Mainz
Landesmuseum Mainz
Reiss Engelhorn Museum, Mannheim
Museum Fünf Kontinente, Munich
Lindenmuseum, Stuttgart
Museum der Stadt Ulm

NIGERIA (9)
Royal Court of Benin
Collection of the High Priest Osemwegie Ebohon, Benin
National Museum, Benin City
National Museum Calabar
National Museum, Ife
Jos Museum
National Museum, Lagos
Ibadan University, Nigeria
Nigeria National Commission for Museums and Monuments, Abuja

ANGOLA (1)
Museu do Dundo

AUSTRALIA (2)
South Australian Museum, Adelaide, South Australia,
Australian Museum, Sydney

AUSTRIA (2)
Weltmuseum, Vienna
Ostereichische Akademie der Wissenschaften, Vienna

BELGIUM (3)
Etnografisch Museum, Antwerp
Art and History Museum, Musées royaux d'art et d'histoire, Brussels
Royal Africa Museum, Tervuren

CANADA (4)
Musée canadien de l'histoire, Gatineau, Quebec
Musée des beaux-arts, Montréal
Royal Ontario Museum, Toronto
Museum of Anthropology at the University of British Columbia, Vancouver

DENMARK (2)
Moesgaard Museum, Aarhus University
National Museum, Copenhagen

FRANCE (2)
Musée du quai Branly, Paris
Cluny Museum, Paris

IRELAND (2)
National Museum of Ireland, Dublin
Hunt Museum, Limerick

JAPAN (1)
National Museum of Ethnology, Osaka

NETHERLANDS (4)
Tropenmuseum, Amsterdam
Afrika Museum, Berg en Dal
Museum Volkenkunde, Leiden
Wereldmuseum, Rotterdam

NORWAY (1)
Museum of Cultural History, University of Oslo

PORTUGAL (2)
Sociedade de Geografia, Lisbon
Museo de Grao Vasco, Videu

RUSSIA (2)
Anthropological Museum of Moscow State University
Kunstkamera Museum of Ethnology and Anthropology, Saint Petersburg

SENEGAL (1)
Musée des civilisations noires, Dakar

SPAIN (2)
Museu de Cultures del Món, Barcelona
Museo Nacional de Antropología, Madrid

SWEDEN (4)
National Museums of World Culture, Museum of World Culture, Gothenburg
Kulturen in Lund, Lund
The Nobel Foundation, Stockholm
National Museums of World Culture, Museum of Ethnography, Stockholm

SWITZERLAND (7)
Museum der Kulturen, Basel
Bernisches Historisches Museum, Bern
Musée d'Ethnographie, Geneva
Musee d'Ethnographie, Neuchatel
Historisches und Völkerkundemuseum, St Gallen
Museum Rietberg, Zurich
Sammlungen fur Volkerkunde, University of Zurich

UNITED ARAB EMIRATES (1)
Louvre, Abu Dhabi

VATICAN CITY (1)
Vatican Collections

TOTAL: 165

Notes

Preface (pp. xii–xvii)

1. Linqvist 1979: 25–26.
2. Erediauwa and Akpolokpolo 1997: 32.
3. Osadolor and Otoide 2008.

Preface to the Paperback Edition (pp. xviii–xxii)

1. Melanie Phillips, Challenging the falsehoods about white supremacism, 6 April 2021 https://melaniephillips.substack.com/p/challenging-the-falsehoods-about; Michael Mosbacher, Who really owns the Benin Bronzes?, *The Spectator*, 1 August 2021. https://www.spectator.co.uk/article/who-really-owns-the-benin-bronzes-; David Aaronovitch, We can't allow radicals to strip our museums, *The Times*, 3 June 2021, https://www.thetimes.co.uk/article/we-cant-allow-radicals-to-strip-our-museums-5kzlkdv8w.
2. Tristram Hunt, Enough with the imperial nostalgia and identity politics. Let museums live, *Observer*, 25 April 2021, https://www.theguardian.com/commentisfree/2021/apr/25/enough-with-the-imperial-nostalgia-and-identity-politics-let-museums-live.
3. Nick Thomas, Don't trash talk museums at this perilous time: we must adapt – not throw away – our cultural heritage, *The Art Newspaper*, 2 June 2021, https://www.theartnewspaper.com/comment/nicholas-thomas-the-trashing-of-cultural-institutions-comes-at-a-perilous-time.
4. Ethics and empire: an open letter from Oxford scholars, *The Conversation*, 17 December 2017, https://theconversation.com/ethics-and-empire-an-open-letter-from-oxford-scholars-89333.
5. The Times view on returning Benin bronzes: Home Territory, *The Times*, 25 March 2021, https://www.thetimes.co.uk/article/the-times-view-on-returning-benin-bronzes-home-territory-gjcrb6n5j.
6. Nigeria welcomes Germany's decision to return looted Benin Bronzes, *DW*, 30 April 2021, https://www.dw.com/en/nigeria-welcomes-germanys-decision-to-return-looted-benin-bronzes/a-57382591.

Chapter 1. The Gun That Shoots Twice (pp. 1–17)

1. Boisragon 1897: 26.
2. For a discussion of the history of the name of Ubini/Benin City, see Osadolor 2001: 51–3.

3. Boisragon 1897: 63, 189; cf. Bacon 1897.

4. 'Ein ausgeraubtes Schaufenster, das Haus, aus dem man einen Toten getragen hatte, die Stelle auf dem Fahrdamm, wo ein Pferd gestürzt war – ich faßte vor ihnen Fuß, um an dem flüchtigen Hauch, den dies Geschehn zurückgelassen hatte, mich zu sättigen' (Benjamin 1938: 422; my translation).

5. Read 1899: n.p.

6. Read and Dalton 1899: 4.

7. Hicks 2015: 12.

8. Weisband 2017.

9. Olivier 2008.

10. Hawkes 1951: 26.

11. Latour 1991.

12. Haraway 1991; Hacking 1999.

13. Hicks 2010.

14. Cowan 1985.

15. Hollenback and Schiffer 2010.

16. Hicks 2019a, 2019b.

17. Sven Lindqvist, recalling a 20th-century childhood brought up on aerial warfare, recalled this phallocentric nature of modern warfare: 'I cannot recall taking a single piss during my childhood, whether outside or at home in the outhouse, when I didn't choose a target and bomb it. At five years of age I was already a seasoned bombardier. "If everyone plays at war," my mother said, "there will be war"' (Lindqvist 2001:1).

18. Geary 1997: 47.

19. Karpinski 1984.

20. Boisragon 1898: 77.

21. Dennett (1906: 188) described the photographs of the palace and bronzes taken by German trader Mr Erdmann, in the immediate aftermath of the sacking.

22. Roth 1903: vii; University of Oxford, Pitt Rivers Museum manuscript archives, Egerton diary, p. 28. Granville's widow went on in 9 October 1920 to marry the Governor of Falkland Islands, John Middleton. Cf. *The Times*, 6 August 1943, p. 1.

23. 'Presque partout, en particulier, l'appareil photographique paraît spécialement dangereux. Les indigènes ignorants, dit M. Junod, ont une répulsion instinctive quand on veut les photographier. Ils disent : « Ces blancs vont nous voler et nous emporter au loin, dans des pays que nous ne connaissons pas, et nous resterons des êtres privés d'une partie de nous-mêmes. » Quand on leur montre la lanterne magique, on les entend qui plaignent les personnages représentés sur les images, et qui ajoutent : « Voilà ce qu'ils font de nous quand ils ont nos photographies ! » Avant que la guerre de 1894 éclatat, j'étais allé montrer la lanterne magique dans des villages païens éloignés. Les gens m'accusèrent d'avoir causé ce malheur, en faisant ressusciter des hommes morts depuis longtemps' (Lévy-Bruhl 1922: 440; my translation).

24. Papers of Captain George Howard Fanshawe Abadie, 1897–1904: Letters from Nigeria. Oxford University Bodleian Library Special Collections MSS Afr s 1337: 7–8.

25. James 1995: 303.

26. Mbembe 2003, 2019; cf. Hicks and Mallet 2019: 29, 41, 88.

Chapter 2. A Theory of Taking (pp. 18–24)

1. Kassim 2017; original emphasis.

2. Hicks 2010: 63; Hicks and Beaudry 2010: 8–9.

3. Guyer 2016.

4. Mauss 1925: 74; Guyer 2012: 494.

5. 'Die Entdeckung der Gold- und Silberländer in Amerika, die Ausrottung, Versklavung, und Vergrabung der eingebornen Bevölkerung in die Berg-werke, die Eroberung und Ausplünderung von Ostindien, die Verwandlung von Afrika in ein Geheg zur Handelsjagd auf Schwarzhäute, bezeichnen die Morgenröthe der kapitalistischen Produktionsära. Diese idyllischen Prozesse sind Hauptmomente der ursprünglichen Accumulation. Auf dem Fuss folgt der Handelskrieg der europäischen Nationen, mit dem Erdrund als Schauplatz' (Marx 1867: 734; my translation).

6. Luxemburg 1951 [1913]: 364–5; emphasis added.

7. Harvey 2003.

8. Luxemburg 1951 [1913].

9. Stoler 2016: 6–7.

10. 'Refuser de donner, négliger d'inviter, comme refuser de prendre, équivaut à déclarer la guerre; c'est refuser l'alliance et la communion' (Mauss 1925: 51; my translation).

11. Sahlins 1972: 1–2.

Chapter 3. Necrography (pp. 25–36)

1. Interview with Hartwig Fischer, Ta Nea, 26 January 2019, www.tanea.gr/print/2019/01/26/greece/h-ellada-lfden-einai-o-nomimos-lfidioktitis-lfton-glypton-lftou-parthenona/.

2. For example, Gosden and Marshall 1999; Hoskins 1998.

3. Appadurai 1986.

4. For example, Henare 2008.

5. Whyte 2011.

6. Hicks 2010.

7. Thomas 1991: 207.

8. Ibid.: 83.

9. Ibid.: 207.

10. Thomas 1998: ix.

11. Thomas 2010: 7.
12. Ibid.
13. Hicks 2010.
14. Hicks 2013: 12.
15. Ingold 2014: 383–5.
16. Hicks 2013.
17. Gosden and Larsen 2007: 7, 32, 68.
18. Friedman 2002.
19. Plankensteiner 2007c.
20. Gosden and Larsen 2007: 15, 241.
21. Coote and Morton 2000: 39.
22. Coote 2014: 131.
23. O'Hanlon and Harris 2013: 8–12.
24. For example, Krmpotich and Peers 2011; Peers 2013.
25. For example, Morton 2015; Derbyshire 2019.
26. Clifford 1997: 192.
27. Hicks and Mallet 2019: 29.
28. Foucault 1997: 243.
29. Agamben 1998.
30. Hicks and Mallet 2019.
31. Mbembe 2003; cf. Mbembe 2019.
32. Hicks and Mallet 2019: 29.
33. Kopytoff 1986: 65.
34. Hicks 2010.
35. Patterson 1982: 39.
36. Cf. Kopytoff 1982: 220.
37. Gilroy 2003: 263.
38. Mbembe 2019: 171.
39. Thomas 2016.
40. Arendt 1958a: 199–212; see Hicks and Mallet 2019: 79.

Chapter 4. Projection (pp. 37–48)

1. 'Überhaupt ist es schwer, einen Gegenstand zu erhalten, ohne zum mindesten etwas Gewalt anzuwenden. Ich glaube, daß die Hälfte Ihres Museums gestohlen ist' (quoted by Essner 1986: 77; my translation).
2. Peckham 2015: 131.
3. September 1896 was the very time during which Sir James Reid, personal physician to Victoria, prescribed a 1% solution of cocaine as eyedrops to aid her failing eyesight (King 2007: 76). Lady Lytton, the Queen's lady-in-waiting, recorded the belladonna component in her diary of 29 September 1896 (Lutyens 1961: 81).
4. Goldie 1901: 238.

5. Curtin 1973: 300–2.
6. Eyo 2007: 34; *Sunday Guardian*, Lagos, 16 February 1997.
7. Burton 1870.
8. Bacon 1897: 13; cf. Bacon 1925; Boisragon 1897; Burton 1863a, 1863b; Roth 1903: 49, 79; cf. Galway 1893: 8–9; Pinnock 1897.
9. Menke 2008; Peckham 2015.
10. Arata 1990: 622.
11. Fagg 1981; cf. Eyo 1997.
12. Plankensteiner 2007c: 25.
13. Anene 1966; Ryder 1969; Home 1982: 32; see Ratté 1972: 8.
14. Lämmert 1975: 112–37.
15. 'Die Projektion der eigenen bösen Regungen in die Dämonen ist nur ein Stück eines Systems, welches die "Weltanschauung" der Primitiven geworden ist' (Freud 1913: 60; my translation).
16. Desbordes 2008.
17. Callwell 1906: 27.
18. Boisragon 1897: 189.
19. Bacon 1897.
20. Forbes 1898: 70.
21. Roth 1897: 508.
22. Igbafe 1975: 417.
23. Bray 1882: 362.
24. Geary 1965 [1927]: 119.
25. The Royal Niger Company, *The Times*, 22 August 1887, p. 14.
26. Lugard 1922: 76.
27. Ayandele 1968: 408.
28. Boisragon 1897: 189.
29. Bacon 1897: 30; my redaction.
30. House of Commons, 2 April 1897, *Hansard* 48: column 445.
31. Trevor-Roper 1965: 9.
32. DiAngelo 2018.
33. Roth 1903: xv.

Chapter 5. World War Zero (pp. 49–56)

1. Callwell 1906: 22.
2. *Western Gazette*, 25 September 1896, p. 8.
3. Poynter's first (unused) Classical design, dated May 1874 depicted British soldiers with leather armour, helmets, swords and round shields, and partially clothed Africans in grass loincloths with spears and hatchets. Ink on paper. British Museum accession number 1919,1216.17. A further revision is also held by the British Museum, but Poynter's final 1874 design is held by the Royal Mint Museum.

4. Wroth 1894: 269; see Kear 1999: 90–92.
5. Wesseling 2005: 101.
6. Ibid.: 102.
7. Johnston 1923: 183.
8. Home 1982: 2, 10.
9. Lugard 1902: 5.
10. House of Commons, 21 March 1887, *Hansard* 312: 831. See also FO 84/1880/411.
11. Gallagher and Robinson 1953: 15.
12. Cain and Hopkins 1987, 1993: 8–10.
13. Darwin 1997.
14. Stoler 2006: 136.
15. Hicks and Mallet 2019; cf. Wolfe 2016.
16. Klein 2007.
17. Galway 1930: 238.
18. Lugard 1922: 304.
19. Galway 1930: 245.
20. Ibid.: 246–7.
21. Nigeria, *The Times*, 8 January 1897, p. 6.
22. Stern 2015: 36.
23. Koch 1969.

Chapter 6. Corporate-Militarist Colonialism (pp. 57–78)

1. University of Oxford Bodleian Libraries Special Collections Mss Afr. s. 88, f. ff.44a–b. Goldie to Salisbury, 14 August 1896.
2. Carlos and Nicholas 1988.
3. Darwin 1935: 139.
4. Hall 1894: 213.
5. FO 84/1880/7 'The Lower Niger', G.D. Goldie Taubman/National African Company 18 June 1885.
6. FO 84/1880/131. The Humble Petition of the National African Company, Limited, to the Queen's Most Excellent Majesty in Council, 20 February 1885.
7. Pearson 1971: 72; Notification of the British Protectorate of the Niger Districts, *London Gazette*, 18 October 1887.
8. Lugard 1895: 973.
9. Galway 1937: 550.
10. Dutt 1953: 32.
11. Galway 1937: 551; FO 84/1880/1.
12. Hall 1894: 204–5.
13. Ibid.: 206.
14. Mintz 1985.

15. Pearson 1971: 70.
16. Pinnock 1897: 44.
17. Shield 1997: 68.
18. Pearson 1971: 70.
19. von Hellermann 2013: 51; Thompson 1911: 12.
20. Pearson 1971: 73.
21. FO 84/1880./397, 15 December 1886.
22. The Royal Niger Company, *The Times*, 27 July 1889, p. 12.
23. Pearson 1971: 74.
24. MacDonald 1895: 12.
25. Lugard 1922: 361.
26. FO 84/2194/218-226, Regulation to carry out the General Act of the Brussels Conference 1890, Her Majesty's Protectorate of the Oil Rivers, 1 January 1893.
27. Goldie 1888.
28. Galway 1937: 548.
29. Galway 1930: 226.
30. British and Foreign State Papers, 1894–95, LXXXVII, 929.
31. FO 84/2194 275–280. Typescript report by R. Moor, Commandant of the O.R. Irregulars, 9 August 1892.
32. *Scotsman*, 13 January 1897, p. 6.
33. Boisragon 1894; Macdonald 1896: 5.
34. E.g. FO 84/2194 269–270. MacDonald to Curzon, 8 December 1892.
35. House of Commons 1899: 17–22; cf. Galway 1937: 548.
36. Johnston 1923: 178.
37. Johnston 1899: 26.
38. *Liverpool Mercury*, 1 August 1885.
39. Galway 1930: 222. Or perhaps not, since newspaper reports indicated he had been at Tenerife for twelve months (e.g., *New York Times*, 9 August 1891).
40. Burton 1863a, 1863b.
41. *Edinburgh Evening News*, 18 June 1885, p. 4.
42. A visit to the King of Benin by Cyril Punch, 1889. Manuscript journal held at Bodleian Libraries, University of Oxford, GB 0162 MSS.Afr.s.1913.
43. Blackmun 1997.
44. Auchterlonie and Pinnock 1898.
45. FO 84/2194 54–60. 'Report on the journey from Benin to Lagos by way of the interior creeks by H. Galway, Vice Consul'.
46. *Scotsman*, September 24, 1894, p. 7.
47. Galway 1893a: 128–30.
48. Treaty Between HM the Queen of England and the King of Benin. Oil Rivers Protectorate, 26 March 1892. FO 84/2194/114–116.

49. FO 84/2194 120–121. Report on visit to Ubini (Benin City) the capital of Benin Country. H. Galway, 30 March 1892.

50. Anene 1966: 189.

51. FO 84/2194 111–113, MacDonald to Salisbury 16 May 1892.

52. Galway 1893b: 8.

53. Ibid.: 9; emphasis added.

54. Sir Claude MacDonald on West African affairs, *The Times*, 4 November 1892, p. 3; emphasis added.

55. *London Gazette*, 16 May 1893, p. 2835.

56. Johnston 1923: 200.

57. *Hansard*, 14 December 1888, Volume 332: 227–8.

58. Gordon 2018: 159.

59. Henderson 1892.

60. Ebrohimie was located near modern Koko in Warri North, Delta State, today the location of the Nana Living History Museum.

61. Johnston 1923: 197–8; Galway 1893a: 125; *Scotsman*, September 24, 1894, p. 7.

62. *The Times*, 22 November 1894, p. 8.

63. Geary 1965 [1927]: 109.

64. *The Times*, 4 November 1892, p. 3.

65. MacDonald 1895: 12.

66. Anene 1966: 178; Home 1982: 19.

67. *Yorkshire Herald*, 4 September 1894, p. 6.

68. Moor: 1895: 4.

69. MacDonald 1895: 11.

70. While serving with the coastguard at Hull, Heugh was court-martialled for 'drinking intoxicating liquors to such an excess as to produce illness', in the form of hallucinations of "naked women" and "Satan coming alongside in a steam-pinnace" – although he returned to active service, receiving a medal and three clasps in South Africa in 1901. *Daily Mail*, 2 January 1897, p. 3.

71. Home 1982: 10; *Scotsman*, 22 December 1894, p. 10.

72. Hickley 1895: 191, 198.

73. House of Commons 1895: 13.

74. Hickley 1895.

75. House of Commons 1895: 38; *Scotsman*, 22 December 1894, p. 10.

76. *The Times*, 22 November 1894, p. 8.

77. Hickley 1895: 198.

78. *Edinburgh Evening News*, 15 January 1895, p. 4.

79. House of Commons 1895: 25, 32.

80. *Glasgow Herald*, 7 January 1895, p. 6.

81. MacDonald 1896: 5.

82. Salubi 1958: 199.

83. Johnston 1923: 185; Kirk 1896: 21.

84. Galway 1937: 553.
85. Ibid.: 556.
86. Kirk 1896: 22.
87. Moor 1898: 3.
88. *Irish Times*, 12 April 1895.
89. Galway 1937: 555.
90. AFRICA: Report. Enquiry into Outrage Committed on Brass People by Royal Niger Company, 25 August 1895. National Archives. FO 881/7754X.
91. *Irish Times*, 12 April 1895.
92. *Pall Mall Gazette*, 2 April 1896.
93. Fox Bourne 1898: 288.
94. Kirk 1896: 2, 8, 17–20.
95. Ibid.: 6.
96. Ibid.: 13
97. Roupell 1897: 85.
98. Koe 1896.
99. Anon. 1896: 379.
100. House of Commons 1895: 11.

Chapter 7. War on Terror (pp. 79–98)

1. Mr Chamberlain and the Colonies, *Glasgow Herald*, 12 November 1895.
2. Harvey 2003: 126.
3. Goldie to Hill, 24 August 1896. Bodleian Libraries special collections MSS Afr s 88, f 44d.
4. The idea of absenteeism was of course, among other things, a tried and tested colonialist trope favoured by the white gentry of the Caribbean plantocracy of the Georgian Atlantic world (Hicks 2008: 219).
5. *Hansard*, 22 August 1895, Volume 36, column 641.
6. Home 1982: 54.
7. Rawson 1914: 90–96.
8. *Manchester Guardian*, 2 October 1896, p. 5.
9. Igbafe 1970.
10. Anon. 1896: 379.
11. *Scotsman*, 13 January 1897, p. 7.
12. Home 1982: 26.
13. Ibid.: 25; Egharevba, 1968: 46.
14. *Scotsman*, 23 February 1897, p. 7.
15. Boisragon 1897: 56; Burns 1963: 176; Geary 1965 [1927]: 108; Home 1982: 22; Igbafe 1970: 396.
16. The Kumassi Expedition, *The Times*, 1 February 1896, p. 9.
17. *Edinburgh Evening News*, 15 February 1896, p. 2.
18. Reprinted in *Scotsman*, 13 January 1897, p. 7.

19. The African Trade, *Liverpool Mercury*, 9 March 1897.

20. West African News, *The Times*, 19 February 1896, p. 10.

21. Foreign News, *Liverpool Mercury*, 19 February 1896.

22. J.C. Anene (1966: 190) gives the date of the letter as 24 November rather than 16 November.

23. Partially reproduced by Newbury 1971: 147–8 from National Archives FO 2/102: Niger Coast/Commissioners and Consuls General/Mr Moor, Capt. Galway, Mr Phillips/West Coast/Despatches, 83–119. Vol. 3; see also National Archives of Nigeria (Enugu): Catalogue of the Correspondence and Papers of the Niger Coast Protectorate 268 3/3/3, p. 240; National Archives of Nigeria (Ibadan): CSO 1/13, 6, Phillips to FO, Number 105, 16 November 1896.

24. Anene 1966: 190–91; cf. Nevadomsky 1997: 20; Layiwola 2007: 83; War Office to Colonial Office, 24 December 1896 (Newbury 1971: 147, footnote 2).

25. West African Affairs, *Daily Mail*, 6 January 1897.

26. *Liverpool Mercury*, 7 January 1897, p. 4.

27. *Pall Mall Gazette*, 7 January 1897, p. 7.

28. West Coast of Africa, *The Times*, 7 January 1897, p. 8.

29. Houses of Parliament 1897: 7, 15.

30. Anene 1966: 191.

31. Auchterlonie and Pinnock 1898: 6.

32. Benin Disaster, *Daily Mail*, 13 January 1897.

33. Home 1982: 42.

34. Boisragon 1897: 111.

35. Kenneth C. Campbell is not to be confused with Captain Kenneth Rankin Campbell, who also served in the Benin Expedition of February 1897, and lived until 1931. Vice-Admiral Sir Charles Campbell (1847–1911) also served in the February 1897 sacking of Benin City.

36. Gordon's name is given as Jordan at one point in the official report on the 'massacre' (Houses of Parliament 1897: 18).

37. Houses of Parliament 1897: 21.

38. Home 1982: 45–6.

39. *pace* Plankensteiner 2007d: 86.

40. The Romance of Adventure, *Northampton Mercury*, 13 January 1899, p. 2.

41. *Standard*, 16 January 1897, p. 4.

42. *Daily Mail*, 16 January 1897.

43. Galway 1930: 244.

44. Benin Disaster, *Daily Mail*, 13 January 1897.

45. *The Times*, 12 January 1897, p. 3.

46. *Daily Mail*, 12 January 1897.

47. Benin Disaster, *Daily Mail*, 13 January 1897.

48. Foreign Office to Phillips, 9 January 1897. National Archives FO 403/248. (Niger Territories Further Correspondence, Part VII).

49. Ibid.; cf. Geary 1965 [1927]: 114.

50. Houses of Parliament 1897: 1.

51. Helly and Callaway 2000: 51.

52. House of Commons, 14 February 1896, *Hansard*, volume 37: column 372.

53. House of Commons 1897: viii.

54. Lugard 1899: 5.

55. Shaw to Scarborough, 12 January 1897. Bodleian Libraries Special Collections MSS Afr s 101: f. 99.

56. House of Commons 1897.

57. The Niger Expedition, *Standard*, 31 December 1896, p. 3.

58. Cf. Curnow 1997: 46.

59. Scarborough to Hill, 12 January 1897. Bodleian Libraries Special Collections, Lumley Papers: MSS Afr s. 101 f. 101.

60. British officers killed, *North American* (Philadelphia), 12 January 1897, p. 2.

61. Home 1982: 35.

62. The Niger Expedition, *Standard*, 31 December 1896, p. 3.

63. *Pall Mall Gazette*, 4 January 1897.

Chapter 8. The Benin-Niger-Soudan Expedition (pp. 99–108)

1. Plankensteiner 2007b: 201.

2. Osadolor and Otoide 2008: 408.

3. Flint 1960: 247.

4. Ibid.: 245.

5. Cook 1943: 149.

6. Nigeria, *The Times*, 8 January 1897, p. 6.

7. Flora Louise Shaw (1852–1929) was a journalist who had been required to testify before the House of Commons Select Committee on British South Africa around the Jameson Raid. In 1902, she married Lugard, who became the first Governor-General of Nigeria in 1914.

8. *Daily Mail*, 14 January 1897.

9. *Glasgow Herald*, 5 January 1897.

10. Goldie, 'confidential' circular: Order of the Day. 1 January 1897. Bodleian Libraries Special Collections MSS Afr s 88: f. 44.

11. Bodleian Libraries Special Collections, Lumley Papers. Scarborough to Foreign Office MSS Afr 101 f. 127; Vandeleur 1898: 97.

12. 'For the King' a speedy avenging, *Daily Mail*, 16 January 1897.

13. Bacon 1897: 128–9.

14. For example: 'the scene of the disaster is far removed from the headquarters at Lokoja of the Niger Company. The Company's expedition has already

started. It has nothing whatever to do with the Niger Coast Protectorate operations', *Scotsman*, 13 January 1897, p. 7.

15. *Standard*, 16 January 1897.

16. Callwell 1896: 246.

17. Lugard 1922: 359.

18. British occupy Bida, *Washington Post*, 11 February 1897, p. 10.

19. Kirk-Greene 1968: 52; Vandeleur 1898: 202.

20. Orr 1911: 37.

21. Goldie, Despatch from Egnon to Council, 6 February 1897. Bodleian Libraries Special Collections MSS Afr s 88: f. 45.

22. Goldie, 'confidential' circular: Order of the Day. 1 January 1897. Bodleian Libraries Special Collections MSS Afr s 88: f. 44.

23. Vandeleur 1898: 205.

24. Ibid.: 206.

25. Vandeleur 1898: 209–11.

26. Ibid.: 212.

27. Ibid.: 202.

28. The Colonies, *The Times*, 30 March 1897, p. 13.

29. The Wars of 1897, Number 1, *Glasgow Herald*, 24 January 1898.

30. Vandeleur 1897: 366.

31. Goldie, 'confidential' circular: Order of the Day. 1 January 1897. Bodleian Libraries Special Collections MSS Afr s 88: f. 44.

32. *The Times*, 17 July 1897, p. 20.

33. Nigeria Expedition: further successful operations. Southern Foulah Capital Destroyed, *Weekly Irish Times*, 6 February 1897, p. 5.

34. The Colonies, *The Times*, 30 March 1897, p. 13.

35. Newbury 1971: 148; Goldie to Denton, 18 February 1897. National Archives CO 879/45.

36. The Niger Expedition, *Scotsman*, 29 March 1897, p. 7.

37. The Battle of Bida, *Spectator*, 13 February 1897, p. 78–9.

38. Goldie 1898: xviii.

39. Vandeleur 1898: 58, 89, 93, 114, 218, 233.

40. Ibid.: 223.

41. Goldie 1897.

42. Uzoigwe 1968: 472.

Chapter 9. The Sacking of Benin City (pp. 109–114)

1. *Encyclopaedia Britannica* (1797: 172).

2. University of Oxford, Pitt Rivers Museum manuscript archives, Egerton Papers.

3. HMS *St George*, HMS *Theseus*, HMS *Phoebe*, HMS *Forte*, HMS *Philomel*, HMS *Barrosa*, HMS *Widgeon*, HMS *Magpie*, HMS *Alecto* and Admiral Rawson's yacht *The Ivy*.
4. Auchterlonie and Pinnock 1898: 6.
5. Bacon 1897: 115.
6. Boisragon 1897: 171.
7. Ibid.: 173.
8. Bacon 1897: 115.
9. Ibid.: 42.
10. Ihekwaba 2016.
11. Bacon 1897.
12. University of Oxford, Pitt Rivers Museum manuscript archives, Egerton Papers.
13. Kirk-Greene 1968: 51, fn. 12.
14. Home 1982: 98.
15. Scott 1909: 4.
16. The Usages of War, *Pall Mall Gazette*, 3 September 1874; The Brussels Conference, *The Times*, 26 October 1874, p. 10.
17. These bullets were arguably already banned by the 1868 St Petersburg *Declaration Renouncing the Use, in Time of War, of Explosive Projectiles Under 400 Grammes Weight.*

Chapter 10. Democide (pp. 115–127)

1. Cited by Lindquist 2001: 50.
2. Houses of Parliament 1897: 42–4.
3. Boisragon 1897: 175.
4. Callwell 1906: 370–71.
5. Heneker 1907: 5.
6. Roth 1897: 508.
7. Ibid.: 26, 162.
8. Mockler-Ferryman 1898: 295–6.
9. *Manchester Guardian*, 25 March 1897.
10. Ibid.
11. Ravenstein 1898: 603.
12. House of Commons 20 April 1899. *Hansard* Volume 70: Column 35.
13. Goldie 1901: 237.
14. *The Times*, 7 February 1890, p. 4.
15. Scott Keltie 1895: 519–21.
16. Killed on the Niger, *Milwaukee Sentinel*, 12 January 1897.
17. *Standard*, 30 January 1897, p. 5.
18. Houses of Parliament 1899a: 6.
19. Ibid.: 9.
20. Galway 1937: 561.

21. Home 1982: 96.

22. Flint 1960: 247–8; Kirk-Greene 1968: 50.

23. Heneker 1907: 138.

24. *Portsmouth Evening News*, 20 March 1897.

25. Wagner 2019: 282.

26. I am grateful to Dr Kim Wagner for his expert input on this point.

27. Spiers 1897: 4.

28. In July 1899, an official submission from the War Office to the Foreign Office explained some of the history of these trials, in which Benin 1897 clearly played some part: 'When Her Majesty's Government … introduced the small-bore rifle, they adopted at the same time a bullet entirely covered by a hard envelope … Experience with this bullet in the Chitral Campaign of 1895 proved that it had not sufficient stopping power, that the bullet drilled through a bone and did not fracture it, that at close quarters the injury was insufficient to cause immediate shock, and that when soft tissues only were struck, the amount of damage was comparatively trivial. It was proved that the enemy expressed contempt for the weapon, as compared with that previously in use; and numerous cases were brought to light in which men struck by these bullets were not prevented from remaining in action. Under these circumstances, Her Majesty's Government ordered experiments to be undertaken with the object of obtaining a bullet which should possess equal stopping effect as that of the rifle of larger calibre. The Committee which investigated the question recommended two bullets, one of which was proved to make more severe wounds than the other; Her Majesty's Government however rejected the one making the more severe wounds, and decided to adopt the less destructive bullet now known as the Mark IV pattern, as giving the minimum of stopping effect necessary' (Houses of Parliament 1899b: 118).

29. 'To Butcher the Boers': letters and telegrams sent to Mr Van Deth, a citizen of Transvaal now in New York, *Daily Inter Ocean*, 3 March 1896.

30. House of Commons, 15 March 1894. *Hansard* Volume 22: Column 206.

31. *Glasgow Herald*, 8 April 1896.

32. House of Commons, 15 March 1894. *Hansard* Volume 22, column 428.

33. Arendt 1958b: 192.

34. University of Oxford, Pitt Rivers Museum manuscript archives, Diary of Herbert Walker, entry for 8 March 1897.

35. *Manchester Guardian*, 23 March 1897.

36. Rawson 1914: 138.

37. Wagner 2018: 224; Chatterjee 1994.

38. Mbembe 2019: 171.

Chapter 11. Iconoclasm (pp. 128–134)

1. Kingsley 1899: 465.

2. Connah 1975.
3. Es'andah 1976: 12.
4. Connah 1967.
5. Goodwin 1957, 1963.
6. Connah 1975.
7. Darling 1976, 1984, 1998, 2016.
8. Darling 1984: 6.
9. McWhirter and McWhirter 1976: 273.
10. See Connah 2015: 203; cf. Roese 1981, Roese et al. 2001; Maliphant et al. 1976; Kaplan 2009.
11. See Willet 1970; Soper and Darling 1980; Agbaje-Williams 1983; Ogundiran 2003; Usman 2004.
12. Rowlands 1993.
13. Norman and Kelly 2006; Monroe 2010.
14. Ben-Amos 1980: 78.
15. University of Oxford, Pitt Rivers Museum manuscript archives, Egerton Papers.
16. Moor 1897: 28.
17. Bacon 1897: 107–108
18. *Scotsman*, 23 February 1897.
19. Bacon 1897: 102–105; Rawson 1914: 152.
20. Galway 1930: 242.
21. Handicaps were given for Carter, Lieutenant R.E.P. Gabbett (Royal Welsh Fusiliers), Captain W. Heneker (Connaught Rangers), and Dr Howes, Captain L.C. Koe, Captain E.P.S. Roupell and Sir Ralph Moor all of the Niger Coast Protectorate. Correspondence, *Golf*, 5 November 1897, p. 149.
22. Osadolor 2001: 227–32; Home 1982: 109.
23. Ryder 1969: 291.
24. Galway 1930: 243.
25. University of Oxford, Pitt Rivers Museum manuscript archives, Diary of Herbert Walker, entry for 26 February 1897.
26. University of Oxford, Pitt Rivers Museum manuscript archives, Diary of Herbert Walker, entry for 19 February 1897.
27. Bray 1882: 367.
28. Galway 1893: 130.
29. Read and Dalton 1899: 9.

Chapter 12. Looting (pp. 135–151)

1. Callwell 1896: 34–5.
2. Callwell 1906: 34.
3. Von Luschan catalogued the numbers in the main Benin collections as follows: Berlin (580), Cologne (73), Dresden (182), Frankfurt am Main

(51), Hamburg (196), Leiden (98), London (280), Pitt Rivers (227), Stuttgart (80), Vienna (167), and 'rest' (379), to a total of 2,400 (von Luschan 1919: 12–13). As well as the British Museum and the Pitt-Rivers Museum at Farnham, in 1919, von Luschan stated that 'Halifax, Liverpool and Oxford have some very beautiful pieces' (von Luschan 1919: 10; cf. von Luschan 1898).

4. Dark 1982: xi.

5. Gunsch 2017.

6. Gunsch pers. comm.

7. Von Luschan 1919: 1, my translation.

8. Burton 1863a, 1863b.

9. A visit to the King of Benin by Cyril Punch, 1889. Manuscript journal held at Bodleian Libraries, University of Oxford, GB 0162 MSS.Afr.s.1913.

10. The horseman was later purchased by Liverpool Museum in 1978; see Karpinski 1984. A photograph of the horseman, taken in Niger Protectorate, survives in the Claude Macdonald photographic archive in the Eliot Elisofon Photographic Archives, National Museum of African Art, Smithsonian Institution (EEPA.1996-019).

11. Galway 1930: 236.

12. *Portsmouth Evening News*, 20 March 1897.

13. See Ben-Amos 1980; Plankensteiner 2007c.

14. Plankensteiner 2010.

15. Dalton 1898: 419.

16. Plankensteiner 2007b: 22; Ben-Amos Girshick 2003.

17. Plankensteiner 2007d: 78.

18. A visit to the King of Benin by Cyril Punch, 1889. Manuscript journal held at Bodleian Libraries, University of Oxford, GB 0162 MSS.Afr.s.1913, f. 31.

19. A visit to the King of Benin by Cyril Punch, 1889. Manuscript journal held at Bodleian Libraries, University of Oxford, GB 0162 MSS.Afr.s.1913, f. 40.

20. University of Oxford, Pitt Rivers Museum manuscript archives, Diary of Herbert Walker, entry for 20 February 1897.

21. University of Oxford, Pitt Rivers Museum manuscript archives, Diary of Herbert Walker, entry for 14 March 1897.

22. Thomas 2016: 74. The official British Museum label (as of March 2020) states that 'Thousands of treasures were taken as booty, including around 1000 brass plaques from the palace. The Foreign Office auctioned the official booty to cover the cost of the expedition.'

23. Dark 1973: 13.

24. Fagg 1981: 21.

25. Lundén 2016: 409, fn. 49.

26. Read and Dalton 1898: v.

27. Auchterlonie and Pinnock 1898: 9–10.
28. Galway 1893b: 8.
29. Omitted from Newbury 1971: 148; see National Archives of Nigeria (Enugu), Catalogue of the Correspondence and Papers of the Niger Coast Protectorate 268 3/3/3, p. 240; National Archives of Nigeria (Ibadan): CSO 1/13, 6, Phillips to FO, Number 105, 16 November 1896.
30. Igbafe 1970: 398.
31. Moor to Foreign Office, 9 June 1898. National Archives FO 83/1610.
32. Read 1899: n.p..
33. Benin Antiquities at the British Museum, *The Times*, 25 September 1897, p. 12.
34. British Museum 1898: 63.
35. British Museum 1899: 66.
36. Ratté 1972.
37. Dennett 1906: 188.
38. British Museum accession number Af1898,0115.2.
39. Eisenhofer 2007.
40. Gunsch 2018: 13n1, Annex 4.
41. Sweeney 1935: 12.
42. *The Times*, 1 July 1897, p. 10.
43. Interesting trophies from Benin, *Pall Mall Gazette*, 9 August 1897.
44. Goldie 1897: 373.
45. Coombes 1994: 150. The Horniman appears possibly to have acquired some objects smuggled out of Benin City before it fell, from a Mr Rider (Quick 1898). See Spoils from Benin, *Illustrated London News*, 10 April 1897.
46. Forbes 1898; Tythacott 2008.
47. *Daily Mail*, 21 June 1898. The pub contained an informal 'free museum', the contents of which were disposed of by auction by Messrs. Debenham, Store & Co in January 1908.
48. From Benin, *Daily Mail*, 10 February 1897. Given the date of this article, this object, if genuinely from Benin City, was clearly taken before the sacking.
49. Starkie Gardner 1898: 571.
50. Fagg 1953: 165..
51. Bodenstein 2018.
52. Von Luschan 1919: 9.
53. For example, Webster 1899; cf. Waterfield and King 2006.
54. Plankensteiner 2007b: 34.
55. British Museum 2010: 74; British Museum accession numbers Af1954,23.394.i, Af1954,23.396–398, Af1954,23.780.
56. The Benin Massacre, *Standard*, 16 March 1897, p. 3.
57. Read to Thompson, 17 March 1897. National Archives FO 800/148/11, ff. 47–8.

58. FO 800/30/1-2./ Letter from Walter Langley to Curzon, 7 May 1897.
59. FO 800/30/1-2./ Letter from Charles Hercules Read to Walter Langley, 7 May 1897.
60. Dalton 1898; cf. Carlsen 1897.
61. Von Luschan 1919: 8.
62. Plankensteiner 2007b: 34.
63. Chit-chat, *Yorkshire Telegraph and Star*, 10 August 1899, p. 3; *Standard*, 16 August 1899, p. 8.
64. Brinkmann 1899, my translation.
65. For example, Coombes 1994: 59–60; cf. Coombes 1988: 57; 1997.
66. Bendix 1960: 306.
67. Mbembe 2019: 11.

Chapter 13. Necrology (pp. 152–165)

1. Stafford-Clark 1971: 163–4.
2. Idiens 1986; Idiens 1991: 39.
3. Plankensteiner 2007b: 36.
4. Pitt Rivers Museum Accession Number 1980.19.1 – an object not included in the calculations on Pitt Rivers Benin 1897 collections here given the current paucity of provenance data.
5. Dark 2002: 15; see Dark 1967, 1982.
6. Gunsch 2017, 2018.
7. Galway 1930: 236.
8. Didi-Huberman 2002: 61.
9. Von Luschan 1919: 8, my translation.
10. Ibid.: 10.
11. British Museum accession number Af1944,04.12.
12. Fagg 1953: 169, fn. 25.
13. British Museum accession numbers Af1922,0313.1–6.
14. British Museum 1898: 70, 75.
15. British Museum accession number Af1963,04.
16. Metropolitan Museum accession number 1978.412.340.
17. British Museum collections, Af1900,0720.4.
18. Of arts and witchcraft, *Daily Mail*, 20 December 1947.
19. National Maritime Museum collections, West African flag (AAA0557), Itsekiri Flag (AAA0555).
20. Stevens 1928.
21. Royal Collection RCIN 69926.
22. British Museum collections, Af1899,0610.1.
23. Home 1982.
24. British Museum collections, Af1910,0513.1. Metropolitan Museum, 1978.412.323.

25. Linné 1958: 172.
26. Read 1910: 49.
27. Zetterstrom-Sharp and Wingfield 2019. See the photograph of the interior of Neville's house reproduced here: http://brunoclaessens.com/2014/09/benin-treasures-on-a-pre-1930-interior-photo/#.XiXB3lP7R24.
28. Foster 1930; Grim trophies for sale, *Daily Mail*, 29 April 1930.
29. Rawson 1914: 22.
30. Fagg 1953: 166.
31. Roth 1922; cf. Roth 1897; McDougall and Davidson 2008.
32. Roth 1903, 1911; cf. Roth 1898, 1900.
33. British Museum accession numbers Af1897,1217.2 Af1897,1217.3 Af1897,1217.6 Af1897,1217.5 Af1897,1217.4.
34. Plankensteiner 2007c: 487; British Museum accession number Af1898,0630.2.
35. British Museum accession numbers Af1898,0630.1–5. A carved ivory bell-striker, recorded as also acquired by Roupell, also came to the British Museum via Lady Kathleen Epstein in 1964 – Af1964,07.1.
36. University of Birmingham, Barber Institute. Accession number No.48.1. http://barber.org.uk/unknown-west-african-artist/.
37. 'The donkey belongs to Sepping Wright local correspondent of the Illustrated London News', British Museum accession number (Photographs) Af,A79.17.
38. Read and Dalton 1899: 41–3; British Museum accession number Af1897,1011.1.
39. Foster 1931; Fagg 1953: 169.
40. The man who returned his grandfather's looted art, *BBC News*, https://www.bbc.co.uk/news/magazine-31605284.
41. Soldier's grandson to return items he looted from Benin City. https://www.theguardian.com/uk-news/2019/dec/17/soldiers-grandson-to-return-items-looted-from-benin-city-nigeria.
42. British Museum collections, Af1941,02.2.
43. British Museum collections, Af1947,18.46.
44. British Museum collections, Af1947,14.1.
45. Read and Dalton 1899: 40.
46. Read and Dalton 1899: 40; British Museum 1899: 70.
47. British Museum collections, Af1952,07.123.
48. Hevia 2007.
49. For example, Fagg 1970: 9.
50. Feest et al. 2007: 17.

Chapter 14. 'The Museum of Weapons, etc.' (pp. 166–177)

1. http://www.sothebys.com/en/auctions/ecatalogue/2013/so-stone-n09040/lot.68.html.

2. Cambridge University Libraries Add.9455. *Catalogue of the archaeological and anthropological collections of Augustus Pitt-Rivers* Volume 6, f.1818.

3. Hicks 2013b.

4. Von Luschan 1919: 9–10; my translation.

5. Cambridge University Libraries Add.9455. *Catalogue of the archaeological and anthropological collections of Augustus Pitt-Rivers* Volume 4, f.1507/1 and /2.

6. See Waterfield 2006. Bought from Stevens at sales on 4 April 1897, 25 May 1897, 7 March 1898, 4 April 1898, 6 June 1898, 4 July 1899 and 7 November 1899.

7. Bought from Webster on 8 September 1897, 30 September 1897, 15 October 1897, 14 April 1898, 24 May 1898, 6 June 1898, 22 June 1898, 25 June 1898, 28 June 1898, 13 August 1898, 15 August 1898, 15 October 1898, 12 November 1898, 5 December 1898, 15 December 1898, 17 December 1898, 30 December 1898, 31 December 1898, 2 January 1898, 12 January 1899, 14 January 1898, 23 January 1899, 2 March 1898, 17 March 1899, 17 May 1899 and 8 June 1899.

8. The National Army Museum holds 23 photographs from an album by Burrows (accession number 1966-12-45), photograph of Norman Burrows with Benin ivories at Mellor Hall, Derbyshire is included in the plates section of Robert Home's *City of Blood Revisited* (1982).

9. Pitt-Rivers 1900a.

10. Cambridge University Libraries Add.9455. *Catalogue of the archaeological and anthropological collections of Augustus Pitt-Rivers* (Six manuscript volumes).

11. Pitt Rivers Museum accession numbers 1991.13.1–28, 32–44.

12. Pitt Rivers Museum accession numbers 1900.39.1–27.

13. Pitt Rivers Museum accession number 1907.66.1.

14. Cf. Thompson 1911. Pitt Rivers Museum accession numbers 1908.41.1–4, 1909.1.1–2.

15. Pitt Rivers Museum accession number 1909.11.1.

16. Pitt Rivers Museum accession number 1917.2.13.

17. Batty wrote under the name Beatrice Stebbing. Pitt Rivers Museum accession number 1917.38.1-2.

18. Pitt Rivers Museum accession numbers 1922.67.1, 1923.2.1.

19. Pitt Rivers Museum accession number 1979.8.1.

20. Pitt Rivers Museum accession number 1970.16.1.

21. Pitt Rivers Museum accession numbers 1983.25.1–3.

22. Pitt Rivers Museum accession numbers 1941.2.119.

23. Cambridge University Libraries Add.9455. *Catalogue of the archaeological and anthropological collections of Augustus Pitt-Rivers* Volume 5, f.1741/1; Pitt Rivers Museum accession number 1900.32.4.

24. Pitt-Rivers 1927; see Hart 2015.

25. Pitt Rivers Museum Accession Numbers 1965.9.1B, 1966.13.1, 1975.7.1–2, 1988.11.1–2.
26. Pitt-Rivers 1929: 3.
27. Coote 2014, 2015; Saunders 2014: 219–20.
28. Dudley Buxton 1929: 61–3.
29. Kopytoff 1986: 65.
30. Tythacott 1998: 25.
31. Sebald 1999.
32. 'Das Gedächtnis [ist] nicht ein Instrument für die Erkundung des Vergangnen, vielmehr das Medium. Es ist das Medium des Erlebten wie das Erdreich das Medium ist, in dem die alten Städte verschüttet liegen.' (Benjamin 1932: 400; my translation).

Chapter 15. Chronopolitics (pp. 178–193)

1. Mbembe 2019: 171.
2. 'Monde compartimenté, manichéiste, immobile, monde de statues: la statue du général qui a fait la conquête, la statue de l'ingénieur qui a construit le pont. Monde sûr de lui, écrasant de ses pierres les échines écorchées par le fouet. Voilà le monde colonial. L'indigène est un être parqué, l'apartheid n'est qu'une modalité de la compartimentation du monde colonial. La première chose que l'indigène apprend, c'est à rester à sa place, à ne pas dépasser les limites' (Fanon 2002 [1961]: 53; my translation).
3. 'J'ai parlé de contact. Entre colonisateur et colonisé, il n'y a de place que pour la corvée, l'intimidation, la pression, la police, l'impôt, le vol, le viol, les cultures obligatoires, le mépris, la méfiance, la morgue, la suffisance, la muflerie, des élites décérébrées, des masses avilies. Aucun contact humain, mais des rapports de domination et de soumission qui transforment l'homme colonisateur en pion, en adjudant, en garde-chiourme, en chicote et l'homme indigène en instrument de production. À mon tour de poser une équation : colonisation = chosification. J'entends la tempête. On me parle de progrès, de «réalisations», de maladies guéries, de niveaux de vie élevés au-dessus d'eux-mêmes. Moi, je parle de sociétés vidées d'elles-mêmes, de cultures piétinées, d'institutions minées, de terres confisquées, de religions assassinées, de magnificences artistiques anéanties, d'extraordinaires possibilités supprimées. On me lance à la tête des faits, des statistiques, des kilométrages de routes, de canaux, de chemins de fer … Je parle de millions d'hommes arrachés à leurs dieux, à leur terre, à leurs habitudes, à leur vie, à la vie, à la danse, à la sagesse' (Césaire 1955: 12–13).
4. Hicks and Mallet 2019: 62–4.
5. Evans 2014.
6. Tylor 1874: 129.
7. Cf. Hicks 2010, 2013b.

8. Lane Fox 1875: 519.

9. Virilio 1977: 74.

10. Evans 1884; Hicks 2013a.

11. Tylor 1896: vi; emphasis added; see Hicks 2010: 34.

12. Moor 1897: 29; emphasis added.

13. Hicks 2013a.

14. Morton 2015.

15. im Thurn 1893: 184.

16. The Cypriot case and North America may also be early examples of such non-typological treatment at the Pitt Rivers – a topic that is worthy of further enquiry.

17. Coote 2015: 9.

18. A visit to the King of Benin by Cyril Punch, 1889. Manuscript journal held at Bodleian Libraries, University of Oxford, GB 0162 MSS.Afr.s.1913, ff. 35, 46.

19. The Royal Niger Company, *The Times*, 27 July 1889, p. 12.

20. Galway 1930: 241.

21. Fagg 1953: 165.

22. Anon. 1903.

23. Ezra 1992: 118.

24. *Scientific American* 1898.

25. Read and Dalton 1898: 371.

26. Read 1898: 1020.

27. Kingsley 1899: 456.

28. Pitt-Rivers 1900b: iv.

29. Frobenius 1909; Ita 1972.

30. Roth 1903: xix.

31. Kingsley 1897: 500.

32. Joyce et al. 1910: 31–2; see Lundén 2016: 363.

33. Kingsley 1897: 489.

34. Flint 1963: 96.

35. Ibid.: 100.

36. Nworah 1971: 349.

37. Flint 1963: 99.

38. Bacon 1897: 132.

39. Ibid.: 30.

40. Boisragon 1897: 142.

41. Agamben 1999: 106.

42. Achebe 1978: 2–3.

43. Plankensteiner 2007a: 201.

44. Coombes 1996: 31; Gunsch 2014.

45. Nevadomsky 2012: 14.

46. Arendt 1958b: 192.

47. Cf. Taussig 1992: 33.
48. Edwards 2017.
49. Graeber 2005: 413.
50. *Lloyds Weekly Newspaper*, 27 June 1897.
51. *Daily Mail*, 19 May 1898, p. 3. See also The Military Tournament, *Graphic*, 28 May 1898.
52. Nevadomsky 2006.
53. The image is a strange foreshadowing of the 'Dreadnought Hoax' of 1910, where members of the Bloomsbury Group – led by Horace de Vere Cole (who had fought in the Second Boer War) and including Virginia Stephen (later Woolf) – blacked up to gain access as an Abyssinian delegation to HMS *Dreadnought* – captained by Reginald Bacon, former Intelligence Officer of the Benin Expedition.
54. Coombes 1994: 11–17, 28–9.
55. Arendt 1958b: 185.

Chapter 16. A Declaration of War (pp. 194–208)

1. https://web.archive.org/web/20031017051711/http://www.thebritish museum.ac.uk/newsroom/current2003/universalmuseums.html.
2. Schuster 2004.
3. From the West Coast, there was the Los Angeles County Museum of Art and the J. Paul Getty Museum in Los Angeles. From the East Coast, the Museum of Fine Arts, Boston, Philadelphia Museum of Art, and four of the museums of New York City: the Solomon R. Guggenheim Museum, the Metropolitan Museum of Art, the Museum of Modern Art and the Whitney Museum of American Art. Last but not least were the Cleveland Museum of Art, Ohio and the Art Institute of Chicago.
4. Ranging from the Berlin State Museums and Bavarian State Museum, Munich to the Prado Museum and the Thyssen-Bornemisza Museum in Madrid, the Paris Louvre, the Opificio delle Pietre Dure in Florence; the Rijksmuseum in Amsterdam; the State Hermitage Museum in St Petersburg, and London's British Museum.
5. Lugard 1922: 304.
6. Plankensteiner 2007c: 88, 501–2; Lundén 2016: 211.
7. House of Lords, 9 March 1977. *Hansard* Volume 380, column 1061.
8. Plea for the Return of Benin's Art Treasures, *Financial Times*, 2 November 1981, p. 20.
9. Should we give back these treasures?, *The Times*, 19 October 1981, p. 10.
10. The archives of Bernie Grant's restitution campaign, developed in advance of 1997 as the centenary year of the British sacking and looting of Benin City, are held at London's Bishopsgate Institute, Benin Bronzes Campaign Files BG/ARM/4. 1994–2000.

11. Envoy recalled over bronzes, *The Times*, 26 January 2002, p. 1.

12. Nigeria wants bronzes back, *The Times*, 25 January 2002, p. 17.

13. Reply by Baroness Blackstone to a written question by Lord Freybery, House of Lords, 10 April 2002. *Hansard* Volume 633, column 104.

14. Museum sold Benin Bronzes for £75 each, *The Times*, 27 March 2002, p. 13. No details were given in the House of Lords reply about the outcome of a proposed swap by the British Museum of a bronze horseman purchased by the New York banker and leading Benin 1897 collector Robert Owen Lehman for two of the brass plaques given by the Foreign Office in 1898, again on the pretext of their being supposed 'duplicates'.

15. Museum of Fine Arts Boston accession numbers L-G 7.21.2012 and L-G 7.27.2012.

16. Royal Collection accession number RCIN 72544.

17. Boardman 2016: 326.

18. House of Lords, 27 October 1983. *Hansard* Volume 444, columns 405–6; emphasis added.

19. On which see Wright 1985.

20. House of Commons, 29 October 2003. *Hansard* 412, column 412; emphasis added.

21. Parr 1962.

22. Sloan 2003.

23. Malinowski 1922: 300–301.

24. Radcliffe-Brown 1941: 1.

25. Cuno 2014.

26. Cuno 2011: 21.

27. Abungu 2008: 32.

28. Hicks and Mallet 2019: 59.

29. The whole world in our hands. www.theguardian.com/artanddesign/2004/jul/24/heritage.art.

30. For example, Galway 1937: 565.

31. Our ultimate weapon is not guns, but beliefs, *The Times*, 18 July 2003.

32. Mirzoeff 2005: 70.

33. British Museum 2002: 37.

34. MacGregor 2011: xvii.

35. Quoted in Price 2007: 35.

Chapter 17. A Negative Moment (pp. 209–229)

1. Hicks and Mallet 2019: 71. Please note that this book was written between July 2019 and January 2020, in ignorance of the coming effects of COVID-19.

2. Rhodes Must Fall Oxford 2018 [2015]: 3–4.

3. Qwabe 2018: 10.

4. Rhodes Must Fall Oxford 2018 [2015]: 4.

5. Andrews 2018: x.

6. Srinivasan 2016.

7. Cf. Upton 2015.

8. Mbembe 2015: 2.

9. Neil MacGregor zur Kolonialdebatte Welterbe und Besitz, *Der Tagesspiegel*, 16 October 2017. www.tagesspiegel.de/kultur/neil-macgregor-zur-kolonial debatte-welterbe-und-besitz/20457758.html.

10. www.theguardian.com/culture/2018/apr/13/british-museum-director-hartwig-fischer-there-are-no-foreigners-here-the-museum-is-a-world-country.

11. Louvre Abu Dhabi accession number 2015.036.

12. Museum of Fine Arts, Boston, transfers eight antiquities to Nigeria. www.mfa.org/news/nigeria-transfer.

13. https://twitter.com/artcrimeprof/status/1076586936691814401/photo/1.

14. Tristram Hunt, 2019, Should museums return their colonial artefacts? *Guardian*, 29 June 2019. www.theguardian.com/culture/2019/jun/29/should-museums-return-their-colonial-artefacts.

15. Layiwola 2007: 83.

16. Marett 1936: 69.

17. Azoulay 2019: 33.

18. https://twitter.com/johngiblin/status/1145974975763013632.

19. https://twitter.com/profdanhicks/status/1145683532209184768.

20. 'В 1897 году английская армия взяла штурмом дворец Обы, положив конец величию Бенина. Царская династия пережила колониальные времена, но от былого блеска осталось немногое. Бронзовые изображения рассеялись по европейским и американским музеям, а новые делают из дерева или глины.'

21. 'Invasionen 1897. Den engelska kolonialmakten såg Benin som ett hinder i sina strävanden att utvidga sitt territorium. År 1897 intog man därför Benin och tvingade kungen i exil. De engelska trupperna skövlade palatsen och förde konstverk av brons och elfenben till London där de såldes vidare till privatsamlare och museer.' https://twitter.com/mlawbarrett/status/1146065512738123776?s=20.

22. https://twitter.com/johnmcternan/status/1160142618082316288.

23. https://twitter.com/acediscovery/status/1185915391199055873.

24. https://twitter.com/KimTodzi/status/1146021850532765697.

25. Thomas 2016: 86.

26. Hicks and Mallet 2019.

27. But see Ben-Amos Girshick 2003: 106.

28. Legacies of British Slave-ownership, George Pitt-Rivers, 4th Baron Rivers (1810–66). www.ucl.ac.uk/lbs/person/view/23192.

29. Stoler 2008, 2016.

30. Beckles 2018; cf. Beckles 2013.
31. Beckles 2016: 72.
32. Flint 1960: 213.
33. Cook 1943: 75.
34. For example, Falola and Heaton 2008: 101.
35. Burns 1929: 175.
36. Engels 2010 [1878]: 153.
37. Cf. Gilroy 2003: 264.
38. Nevadomsky 2012: 15.
39. Vimulassery et al. 2016; cf. Byrd 2011.
40. Rowlands 1993: 296.
41. Nixon 2011.
42. '… que ce nazisme-là, on l'a supporté avant de le subir, on l'a absous, on a fermé l'œil là-dessus, on l'a légitimé, parce que, jusque-là, il ne s'était appliqué qu'à des peuples non européens; que ce nazisme-là, on l'a cultivé, on en est responsable, et qu'il sourd, qu'il perce, qu'il goutte, avant de l'engloutir dans ses eaux rougies, de toutes les fissures de la civilisation occidentale et chrétienne' (Césaire 1955: 6–7; my translation).
43. Hunt, 2019. Should museums return their colonial artefacts?
44. https://twitter.com/JohannaZS/status/1145985271118422016.
45. Mbembe 1992.
46. Mbembe and Dorlin 2007: 142; my translation.
47. Terkessidis 2019.
48. Foreign Office 1920: 45–6.
49. Vansina 2010: 58.
50. Van Reybrouck 2014.
51. Okonta and Douglas 2003; Wengraf 2018.
52. Achebe 1977: 789.

Chapter 18. Ten Thousand Unfinished Events (pp. 230–234)

1. Tokarczuk 2018.
2. https://twitter.com/profdanhicks/status/1212854436860702720.
3. www.bbc.co.uk/ahistoryoftheworld/objects/ZR_ouZoBTTeJOibUSdejDA.
4. National Museum Directors Council, Spoliation of works of art during the Holocaust and World War II period. www.nationalmuseums.org.uk/what-we-do/contributing-sector/spoliation/.
5. Emmanuel Macron's Speech at the University of Ouagadougou. www.elysee.fr/emmanuel-macron/2017/11/28/emmanuel-macrons-speech-at-the-university-of-ouagadougou.en.
6. Read and Dalton 1899: 2.

Afterword: A Decade of Returns (pp. 235–242)

1. Protesters request RISD Museum return bronze sculpture to Nigeria. https://hyperallergic.com/473864/protesters-request-risd-museum-return-bronze-sculpture-to-nigeria/.
2. www.artnews.com/art-news/news/year-protest-met-chapel-hill-kochi-beyond-11583/.
3. Kassim 2017.
4. There is some EU legislation that may guide restitution claims within the European Union: Directive 2014/60/EU of the European Parliament and of the Council of 15 May 2014 on the return of cultural objects unlawfully removed from the territory of a Member State and amending Regulation (EU) No 1024/2012 (Recast). https://eur-lex.europa.eu/eli/dir/2014/60/oj.
5. To focus on the UK here, clearly, the National Heritage Act has been altered in the past, not least in the case of the Holocaust (Return of Cultural Objects) Act 2009, the 'sunset clause' for which was removed by Parliament in 2019. As things stand at present, it may be some time before Britain's National Museum Directors Council supports a similar change for colonial loot. In the UK, this places 'non-national' museums – local authority and university museums – in a unique position to innovate and to find new ways of doing cultural restitution. See www.museumsassociation.org/museums-journal/news/28032018-nmdc-back-repeal-holocaust-claims-sunset-date.
6. Sarr and Savoy 2018.
7. Coote and Morton 2000: 54, n. 5.
8. Bronze cockerel to be returned to Nigeria by Cambridge college. www.theguardian.com/education/2019/nov/27/bronze-cockerel-to-be-returned-to-nigeria-by-cambridge-college.
9. Plankensteiner 2016: 139. Urgent appeal to stop Lieutenant-Colonel Henry Lionel Galway from selling stolen Benin mask for £5 million In London. http://saharareporters.com/2010/12/22/urgent-appeal-stop-lieutenant-colonel-henry-lionel-galway-selling-stolen-benin-mask-£5.
10. Benin bronze helps Woolley & Wallis retain lead in regional sales league. www.antiquestradegazette.com/news/2017/benin-bronze-helps-woolley-and-wallis-retain-lead-in-regional-sales-league/.

Appendices (pp. 243–252)

1. Stevens Auction Rooms, 4 December 1899 and 12 February 1901.
2. These estimated figures are based on a very cursory, initial assessment of online catalogues, cross-referenced with the Pitt Rivers Second Collection catalogue. The completion of this table, to reduce the number of unknown provenances, will be a major part of the future programme for my work.

References

Abungu, G.O. 2008. 'Universal Museums': New contestations, new controversies. In G. Mille and J. Dahl (eds) *Utimut: Past heritage – future partnerships, discussions on repatriation in the 21st century*. Copenhagen: International Work Group for Indigenous Affairs and Greenland National Museum & Archives, pp. 32–43.

Achebe, C. 1978. An Image of Africa. *Research in African Literatures* 9(1): 1–15.

Agamben, G. 1999. *Remnants of Auschwitz: The witness and the archive* (trans. D. Heller-Roazen). London: Zone.

Agbaje-Williams, B. 1983. A Contribution to the Archaeology of Old Oyo. Unpublished PhD, University of Ibadan.

Andrews, K. 2018. Preface. In R. Chantiluke, B. Kwoba and A. Nkopo (eds) *Rhodes Must Fall: The struggle to decolonise the racist heart of empire*. London: Zed, pp. ix–xiv.

Anene, J.C. 1966. *Southern Nigeria in Transition 1885–1906. Theory and practice in a colonial Protectorate*. Cambridge: Cambridge University Press.

Anon. 1896. West Africa. *The Annual Register: A review of public events at home and abroad. For the year 1896*. 138 (VI): 376–80.

Anon. 1903. Review of Antique Works of Art from Benin. Collected by Lieutenant-General Pitt-Rivers. *The Studio* 29(123), June 1903: 72.

Arata, D. 1990. The Occidental Tourist: 'Dracula' and the anxiety of reverse colonization. *Victorian Studies* 33(4): 621–45.

Appadurai, A. 1986. Introduction: Commodities and the politics of value. In A. Appadurai (ed.) *The Social Life of Things: Commodities in cultural perspective*. Cambridge: Cambridge University Press, pp. 3–63.

Arendt, H. 1958a. *The Origins of Totalitarianism* (second enlarged edition). Cleveland, OH: Meridian Books.

Arendt, H. 1958b. *The Human Condition* (second edition), Chicago, IL: University of Chicago Press.

Arnold, A.J. 1898. Campaigning on the Upper Niger (letter to the Editor). *The Spectator* 81(3660), 20 August: 243.

Auchterlonie, T.B. and J. Pinnock 1898. The City of Benin. *Transactions of the Liverpool Geographical Society* 6: 5–16.

Ayandele, E.A. 1968. The Relations between the Church Missionary Society and the Royal Niger Company, 1886–1900. *Journal of the Historical Society of Nigeria* 4(3): 397–419.

Azoulay, A. 2019. *Potential Histories: Unlearning imperialism*. London: Verso.

Bacon, R. 1897. *Benin: City of blood*. London: Edward Arnold.

Bacon, R. 1925. Benin Expedition. In *A Naval Scrap-Book, First Part, 1877–1900*. London: Hutchinson and Company, pp. 197–207.

Beckles, H.M. 2013. *Britain's Black Debt: Reparations for Caribbean slavery and native genocide*. Kingston: University of the West Indies Press.

Beckles, H.M. 2018. Britain's Black Debt: Reparations owed for the crimes of native genocide and chattel slavery in the Caribbean. In R. Chantiluke, B. Kwoba and A. Nkopo (eds) *Rhodes Must Fall: The struggle to decolonise the racist heart of empire*. London: Zed, pp. 62–73.

Ben-Amos, P. 1980. *The Art of Benin*. London: Thames and Hudson.

Ben-Amos Girshick, P. 2003. Brass Never Rusts, Lead Never Rots: Brass and brasscasting in the Edo Kingdom of Benin. In F. Herreman (ed.) *Material Differences: Art and identity in Africa*. New York: Museum of African Art, pp. 103–11.

Bendix, R. 1960. *Max Weber: An intellectual portrait*. Berkeley, CA: University of California Press.

Benjamin, W. 1932. Ausgraben und Erinnern. *Gesammelte Schriften* IV (ed. T. Rexroth). Frankfurt: Suhrkamp Verlag, pp. 400–1.

Benjamin, W. 1938. Berliner Kindheit um neunzehnhundert. *Gesammelte Schriften* VII (ed. T. Rexroth). Frankfurt: Suhrkamp Verlag, pp. 385–433.

Blackmun, B.W. 1997. Continuity and Change: The ivories of Ovonramwen and Eweka II. *African Arts* 30(3): 68–79, 94–6.

Blumberg, H.E. and C. Field 1934. *History of the Royal Marines 1837–1914*. Devonport: Swift and Company.

Boardman, J. 2016. Review of A. Swenson and P. Mandler (eds) 'Britain and the Heritage of Empire, c. 1800–1940'. *Common Knowledge* 22(2): 326.

Bodenstein, F. 2018. Notes for a Long-term Approach to the Price History of Brass and Ivory Objects Taken from the Kingdom of Benin in 1897. In B. Savoy, C. Guichard and C. Howald (eds) *Acquiring Cultures: Histories of world art on western markets*. Berlin: De Gruyter, pp. 268–87.

Boisragon, A. 1894. Inclosure 5: Niger Coast Protectorate Force. In C.M. Mac-Donald (ed.) *Report on the Administration of the Niger Coast Protectorate August 1891 to August 1894. Presented to both Houses of Parliament by Command of Her Majesty*. London: Harrison and Sons (Africa 1), p. 16.

Boisragon, A. 1897. *The Benin Massacre*. London: Methuen.

Borgatti, J. 1997. 'Recovering Benin': The conference at Wellesley. *African Arts* 30(4): 9–10.

Bradbury, R. 1973. *Benin Studies*. Oxford: Oxford University Press.

Bray, W.F. 1882. A Visit to a King. *Californian* 5(28): 362–71.

Brinckman, J. 1899. Bronzen und Schnitzereien aus Benin. *Dekorative Kunst* 4 (8 May 1899): 46.

British Museum 1898. *Account of the income and expenditure of the British Museum (special trust funds) for the year ending the 31st day of March 1898, and return of the number of persons admitted to visit the museum and the British*

Museum (Natural History) in each year from 1892 to 1897, both years inclusive; together with a statement of the progress made in the arrangement and description of the collections, and an account of objects added to them in the year 1897. London: Eyre and Spottiswoode (HMSO).

British Museum 1900. *Account of the income and expenditure of the British Museum (special trust funds) in each year from 1894 to 1899, both years inclusive, and. Return of the number of persons admitted to visit the museum and the British Museum (Natural History) in each year from 1894 to 1899, both years inclusive; together with a statement of the progress made in the arrangement and description of the collections, and an account of objects added to them in the year 1899.* London: Eyre and Spottiswoode (HMSO).

British Museum 2002. *Trustees' and Accounting Officer's Annual Report and Foreword for the for the year ended 31 March 2002.* London: British Museum.

British Museum 2010. List of human Remains in the Collection of the British Museum (version 3.0). https://enews.britishmuseum.org/pdf/British-Museum-Human-Remains_August-2010.pdf.

Burns, A. 1929. *History of Nigeria.* London: George Allen and Unwin.

Burns, A. 1963. *History of Nigeria* (sixth edition). London: George Allen and Unwin.

Burton, R. 1863a. *Wanderings in West Africa from Liverpool to Fernando Po* (volume 2). London: Tinsley Brothers.

Burton, R.F. 1863b. My Wanderings in West Africa: A visit to the renowned cities of Wari and Benin. *Fraser's Magazine* 67: 273–89, 407–21.

Burton, R.F. 1870. *Vikram and the Vampire.* London: Longmans.

Byrd, J.A. 2011. *Transit of Empire : Indigenous critiques of colonialism.* Minneapolis: University of Minnesota Press.

Cain, P. and A.G. Hopkins 1987. Gentlemanly Capitalism and British Expansion Overseas II: New imperialism, 1850–1945. *Economic History Review* 40(1): 1–26.

Cain, P. and A.G. Hopkins 1993. *British Imperialism: Innovation and expansion, 1688–1914.* London: Longman.

Callwell, C.E. 1896. *Small Wars: Their principles and practice.* London: Harrison and Sons (HMSO).

Callwell, C.E. 1906. *Small Wars: Their principles and practice* (third edition). London: Harrison and Sons (HMSO).

Carlos, A. and S. Nicholas 1988. Giants of an Earlier Capitalism: The chartered companies as modern multinationals. *Business History Review* 62: 398–419.

Carlsen, F. 1897. Benin in Guinea und seine rätselhaften Bronzen. *Globus* 72: 309–314.

Césaire, A. 1955. *Discours sur le colonialisme.* Paris: Éditions Présence Africaine.

Chatterjee, P. 1994. *The Nation and its Fragments: Colonial and postcolonial histories.* Princeton, NJ: Princeton University Press.

Clifford, J. 1997. *Routes: Travel and translation in the late twentieth century.* Cambridge, MA: Harvard University Press.

Connah, G. 1967. New Light on the Benin City Walls. *Journal of the Historical Society of Nigeria* 3(4): 593–609.

Connah G. 1975. *The Archaeology of Benin: Excavations and other researches in and Around Benin City, Nigeria.* Oxford: Clarendon.

Connah, G. 2015. *African Civilisations: An archaeological perspective* (third edition). Cambridge: Cambridge University Press.

Cook, A.N. 1943. *British Enterprise in Nigeria.* Philadelphia: University of Pennsylvania Press.

Coombes, A. 1988. Museums and the Formation of National and Cultural Identities. *Oxford Art Journal* 11: 57–68.

Coombes, A.E. 1991. Ethnography and the Formation of National and Cultural Identities. In S. Hiller (ed.) *The Myth of Primitivism.* London: Routledge, pp. 156–78.

Coombes, A.E. 1994. *Reinventing Africa: Museums, material culture and popular imagination in late Victorian and Edwardian England.* New Haven, CT: Yale University Press.

Coombes, A.E. 1996. Ethnography, Popular Culture, and Institutional Power: Narratives of Benin culture in the British Museum, 1897–1992. *Studies in the History of Art* 47: 142–57.

Coote, J.P.R.W. 2014. Archaeology, Anthropology, and Museums, 1851–2014: Rethinking Pitt-Rivers and his legacy – an introduction. *Museum History Journal* 7(2): 126–34.

Coote, J.P.R.W. 2015. General Pitt-Rivers and the Art of Benin. *African Arts* 48(2): 8–9.

Coote, J.P.R.W. and C. Morton 2000. A Glimpse of the Guinea Coast: An African expedition at the Pitt Rivers Museum. *Journal of Museum Ethnography* 12: 39–56.

Cowan, R.S. 1985. How the Refrigerator Got Its Hum. In D. MacKenzie and J. Wajcman (eds) *The Social Shaping of Technology: How the refrigerator got its hum.* Milton Keynes: Open University Press, pp. 202–18.

Cuno, J. 2011. *Museums Matter: In praise of the encyclopedic museum.* Chicago, IL: Chicago University Press.

Cuno, J. 2014. Culture War: The case against repatriating museum artifacts. *Foreign Affairs* 93(6): 119–24, 126–9.

Curnow, K. 1997. The Art of Fasting: Benin's Ague ceremony. *African Arts* 30: 46–53.

Curtin, P. 1973. *The Image of Africa: British ideas and action, 1780–1850 (Volume 2).* Madison: Wisconsin University Press.

Dalton, O. 1898. Booty from Benin. *English Illustrated Magazine* 18, 419–29.

Dark, P.J.C. 1980. Introduction. In *Catalogue of a Collection of Benin Works of Art.* London: Sotheby's, pp. 9–10.

Dark, P.J.C. 1982. *An Illustrated Catalogue of Benin Art.* Boston, MA: G.K. Hall and Co.

Dark, P.J.C. 2002. Persistence, Change and Meaning in Pacific Art: A retrospective view with an eye towards the future. In A. Herle, N. Stanley, K. Stevenson and R.L. Welsch (eds) *Pacific Art: Persistence, change, and meaning.* Honolulu: University of Hawai'i Press, pp. 13–39.

Darling, P.J. 1976. Notes on the Earthworks of the Benin Empire. *West African Journal of Archaeology* 6: 143–9.

Darling, P.J. 1984. *Archaeology and History in Southern Nigeria: The ancient linear earthworks of Benin and Ishan (two volumes).* Oxford: British Archaeological Reports (Cambridge Monographs in African Archaeology, BAR International Series, 215 i and ii).

Darling, P.J. 1998. A Legacy in Earth – Ancient Benin and Ishan, Southern Nigeria. In K.W. Wesler (ed.) *Historical Archaeology in Nigeria.* Trenton, NJ: African World Press, pp. 143–98.

Darling, P.J. 2016. Nigerian Walls and Earthworks. In G. Emeagwali and E. Shizha (eds) *African Indigenous Knowledge and the Sciences.* New York: Springer, pp. 137–44.

Darwin, J. 1997. Imperialism and the Victorians: The dynamics of territorial expansion. *English Historical Review* 112: 614–42.

Darwin, L. 1935. Sir George Goldie on Government in Africa. *Journal of the Royal African Society* 34(135): 138–43.

Dennett, R.E. 1906. *At the Back of the Black Man's Mind.* London: Macmillan and Co.

Derbyshire, S. 2019. Photography, Archaeology and Visual Repatriation in Turkana, Northern Kenya. In L. McFadyen and D. Hicks (eds) *Archaeology and Photography: Time, objectivity and the archive.* London: Bloomsbury, pp. 166–92.

Desbordes, R. 2008. Representing 'Informal Empire' in the Nineteenth Century. *Media History* 14(2): 121–39.

DiAngelo, R. 2018. *White Fragility.* Boston, MA: Beacon Press.

Didi-Huberman, G. 2002. The Surviving Image: Aby Warburg and Tylorian anthropology. *Oxford Art Journal* 25(1): 61–9.

Du Bois, W.E.B. 1915. The African Roots of War. *Atlantic*, May 1915: 360–71.

Dudley Buxton, L.H. 1929. The Antique Works of Art from Benin. In L.H. Dudley Buxton (ed.) *The Pitt-Rivers Museum Farnham.* Farnham: Farnham Museum, pp. 61–3.

Dutt, R.P. *The Crisis of Britain and the Empire.* New York: International Publishers.

Edwards, B.H. 2017. Introduction to the English edition. In M. Leiris *Phantom Africa* (trans. B.H. Edwards). Calcutta: Seagull, pp. 1–52.

Egharevba, J. 1968. *A Short History of Benin* (4th edition). Ibadan: Ibadan University Press.

Eisenhofer, S. 2007. Catalogue entries 234 and 235: Relief Plaques. In B. Plankensteiner (ed.) *Benin Kings and Rituals: Court Arts from Nigeria.* Ghent: Snoek, p. 454.

Encyclopaedia Britannica. 1797. Benin. In *Encyclopaedia Britannica* (third edition), Volume 3. Edinburgh: A. Bell and C. Macfarquar.

Engels, F. 2010 [1878]. Anti-Dühring. In *Collected Works of Karl Marx and Friedrich Engels Volume 25.* London: Lawrence and Wishart, pp. 3–309.

Es'andah, B.W. 1976. An Archaeological View of the Urbanization Process in the Earliest West African States. *Journal of the Historical Society of Nigeria* 8(3): 1–20.

Erediauwa, O. n'O. and U. Akpolokpolo 1997. Opening Ceremony Address. *African Arts* 30(3): 30–33.

Essner, C. 1986. Berlins Völkerkunde-Museum in der Kolonialära: Anmerken zum Verhältnis von Ethnologie und Kolonialismus in Deutschland. In H.J. Reichhardt (ed.) *Berlin in Geschichte und Gegenwart.* Berlin: Wolf Jobst Siedler Verlag (Jahrbuch des Landesarchivs Berlin), pp. 65–94.

Evans, A. 1884. *The Ashmolean Museum as a Home of Archaeology in Oxford: An inaugural lecture given in the Ashmolean Museum, November 20, 1884.* Oxford: Parker and Co.

Evans, C. 2014. Soldiering Archaeology: Pitt Rivers and 'militarism'. *Bulletin of the History of Archaeology* 24. http://doi.org/10.5334/bha.244.

Eyo, E. 1997. The Dialectics of Definitions: "Massacre" and "sack" in the history of the Punitive Expedition. *African Arts* 30(3): 34–5.

Fabian. J. 1983. *Time and the Other: how Anthropology makes its Object.* New York: Columbia University Press.

Fagg, W. 1953. The Allman Collection of Benin Antiquities. *Man* 53: 165–9.

Fagg, W. 1957. The Seligman Ivory Mask from Benin. *Man* 57: 113.

Fagg, W. 1970. *Divine Kingship in Africa.* London: Shenval Press.

Fagg, W. 1981. Benin. The Sack That Never Was. In F. Kaplan (ed.) *Images of Power. Art of the Royal Court of Benin.* New York: New York University, pp. 20–21.

Fanon, F. 2002 [1961]. *Les damnés de la terre.* Paris: La Découverte.

Feest, C., J.-P. Mohen, V. König and J. Cuno 2007. Preface. In B. Plankensteiner (ed.) *Benin Kings and Rituals: Court arts from Nigeria.* Ghent: Snoek, p. 17.

Flint, J.E. 1960. *Sir George Goldie and the Making of Nigeria.* Oxford: Oxford University Press.

Flint, J.E. 1963. Mary Kingsley: A reassessment. *Journal of African History* 4(1): 95–104.

Forbes, H.O. 1898. On a Collection of Cast-Metal Works of High Artistic Value, Lately Acquired for the Mayer Museum. *Bulletin of Liverpool Museum* 1: 49–70.

Foreign Office 1920. *Treatment of Natives in the German Colonies.* London: HMSO.

Foster 1930. *Highly Important Bronzes, Ivory & Wood Carvings from the Walled City of Benin, West Africa, 1 May 1930 (G.W. Neville Collection from Benin Punitive Expedition of 1897)*. London: Foster.

Foster 1931. *Bronzes, Ivory and Wood Carvings from Benin, West Africa. Also Chinese Bronzes, Iron Heads and Curios, 16 July 1931*. London: Foster.

Fox Bourne, H.R. 1898. Black and White 'Rights' in Africa. *The Living Age* 216(2795): 283–93.

Freud, S. 1913. *Totem und Tabu. Einige* Übereinstimmungen *im Seelenleben der Wilden und der Neurotiker*. Leipzig: Hugo Heller.

Friedman, J. 2002. From Roots to Routes: Tropes for trippers. *Anthropological Theory* 2(1): 21–36.

Frobenius, L. 1911. *Auf dem Wege nach Atlantis; Bericht über den Verlauf der zweiten Reiseperiode der DIAFE in den jahren 1908 bis 1910*. Berlin-Charlottenburg: Vita, deutches Verlaghaus (Deutsche Inner-Afrikanische Forschungs-Expedition. Reisebericht 2).

Gallagher, J. and R. Robinson 1953. The Imperialism of Free Trade. *Economic History Review* 6(1): 1–15.

Galway, H.L. 1893a. Journeys in the Benin Country, West Africa. *Geographical Journal* 1(2): 122–30.

Galway, H.L. 1893b. 'Report on the Benin District, Oil Rivers Protectorate, for the year ending July 31, 1892. In C.M. MacDonald (ed.) *Correspondence Respecting the Affairs of the West Coast of Africa*. London: Harrison and Sons (Africa 11), pp. 7–14.

Galway, H. 1899. *Annual Report of the Niger Coast Protectorate for the year 1897–98, Presented to both Houses of Parliament by Command of Her Majesty, April 1898*. London: Harrison and Sons (Africa 2).

Galway, H. 1900. *Colonial Reports: Annual (No. 315). Southern Nigeria, 1899–1900, Presented to both Houses of Parliament by Command of Her Majesty*. London: Darling and Son (HMSO).

Galway, H.L. 1930. Nigeria in the Nineties. *Journal of the African Society* 29(115): 221–47.

Galway, H.L. 1937. The Rising of the Brassmen. *English Review* 64(7): 546–65.

Gilroy, P. 2003. 'Where Ignorant Armies Clash by Night': Homogeneous community and the planetary aspect. *International Journal of Cultural Studies* 6(3): 261–76.

Geary, C.M. 1997. Early Images from Benin at the National Museum of African Art, Smithsonian Institution. *African Arts* 30(3): 44–53, 93.

Geary, W.N.M. 1965 [1927]. *Nigeria under British rule*. London: Frank Cass and Company.

Goldie, G.T. 1888. The Niger Territories. *The Times* 21 December, p. 14.

Goldie, G.T. 1897. Nupe and Ilorin: Discussion. *Geographical Journal* 10(4): 370–74.

Goldie, G.T. 1898. Introduction. In S. Vanderleur *Campaigning on the Upper Nile and Niger*. London: Methuen and Co, pp. ix–xxvii.

Goldie, G.T. 1901. Progress of Exploration and the Spread and Consolidation of the Empire in America, Australia, and Africa. *Geographical Journal* 17(3): 231–40.

Goodwin, A.J.H. 1957. Archaeology and Benin Architecture. *Journal of the Historical Society of Nigeria* 1(2): 65–85.

Gordon, M. 2018. The Dynamics of British Colonial Violence. In P. Dwyer and A. Nettelbeck (eds) *Violence, Colonialism and Empire in the Modern World*. London: Palgrave Macmillan, pp. 153–74.

Gosden, C. and F. Larson 2007. *Knowing Things: Exploring the collections at the Pitt Rivers Museum, 1884–1945*. Oxford: Oxford University Press.

Gosden, C. and Y. Marshall 1999. The Cultural Biography of Objects. *World Archaeology* 31(2): 169–78.

Graeber, D. 2005. Fetishism as Social Creativity or, Fetishes are Gods in the Process of Construction. *Anthropological Theory* 5(4): 407–38.

Gunsch, K.W. 2013. Art and/or Ethnographica? The reception of Benin works from 1897–1935. *African Arts* 46(4): 22–31.

Gunsch, K.W. 2017. *The Benin Plaques: A 16th-century imperial monument*. London: Routledge.

Gunsch, K.W. 2018. The Benin Plaques: A singular monument. *Tribal Art* 22–3(88): 84–97.

Hacking, I. 1999. *The Social Construction of What?* Cambridge, MA: Harvard University Press.

Haraway, D.J. 1991. *Simians, Cyborgs and Women: The reinvention of nature*. London: Free Association Books.

Hart, B. 2015. *George Pitt-Rivers and the Nazis*. London: Bloomsbury.

Harvey, D. 2003. *The New Imperialism*. Oxford: Oxford University Press.

Hawkes, J. 1951. *A Land*. London: Cresset Press.

Helly, D.O. and H. Callaway 2000. Journalism as Active Politics: Flora Shaw, *The Times* and South Africa. In D. Lowry (ed.) *The South African War Reappraised*. Manchester: Manchester University Press, pp. 50–66.

Herle, A. 2008. The Life-histories of Objects: Collections of the Cambridge Anthropological Expedition to the Torres Strait. In A. Herle and S. Rouse (eds) *Cambridge and the Torres Strait: Centenary essays on the 1898 Anthropological Expedition*. Cambridge: Cambridge University Press, pp. 77–105.

Henderson, A. 1892. Letter to the Editor: Royal Niger Company vs Oil Rivers Protectorate. *Glasgow Herald* 13 April.

Heneker, W.C.G. 1907. *Bush Warfare*. London: Hugh Rees.

Hevia, J.L. 2007. Looting and its discontents: moral discourse and the plunder of Beijing 1900–1901. In R. Bickers and G. Tiedemann (eds) *The Boxers, China and the World*. Lanham, MD: Rowman & Littlefield, pp. 93–114.

Hickley, J.D. 1895. An Account of the Operations on the Benin River in August and September, 1894. *Journal of the Royal United Service Institution* 39: 191–8.

Hicks, D. 2008. Material Improvements: The archaeology of estate landscapes in the British Leeward Islands, 1713–1838. In J. Finch and K. Giles (eds) *Estate Landscapes: Design, improvement, and power in the post-medieval landscape.* Woodbridge: Boydell and Brewer, pp. 205–27.

Hicks, D. 2010. The Material Cultural Turn: Event and effect. In D. Hicks and M.C. Beaudry (eds) *The Oxford Handbook of Material Culture Studies.* Oxford: Oxford University Press, pp. 21–99.

Hicks, D. 2013a. Characterizing the World Archaeology Collections of the Pitt Rivers Museum. In D. Hicks and A. Stevenson (eds) *World Archaeology at the Pitt Rivers Museum: A characterization.* Oxford: Archaeopress, pp. 1–15.

Hicks, D. 2013b. Four-field Anthropology: Charter myths and time warps from St Louis to Oxford. *Current Anthropology* 54(6): 753–63.

Hicks, D. 2016. 'The Temporality of the Landscape Revisited' and 'Meshwork Fatigue' (with responses by Tim Ingold, Matt Edgeworth and Laurent Olivier). *Norwegian Archaeological Review* 49(1): 5–39.

Hicks, D. 2019a. Event Density. In J. Meades, A. Boyd and D. Hicks *Isle of Rust.* Edinburgh: Luath Press.

Hicks, D. 2019b. The Transformation of Visual Archaeology, Part 1. In L. McFadyen and D. Hicks (eds) *Archaeology and Photography: Time, objectivity and archive.* London: Bloomsbury, pp. 21–54.

Hicks, D. 2019c. The Transformation of Visual Archaeology, Part 2. In L. McFadyen and D. Hicks (eds) *Archaeology and Photography: Time, objectivity and archive.* London: Bloomsbury, pp. 209–42.

Hicks, D. and M.C. Beaudry 2010. Material Culture Studies: A reactionary view. In D. Hicks and M.C. Beaudry (eds) *The Oxford Handbook of Material Culture Studies.* Oxford: Oxford University Press, pp. 1–21.

Hicks, D. and S. Mallet 2019. *Lande: the Calais "Jungle" and beyond.* Bristol: Bristol University Press.

Hollenback, K.L. and M.B. Schiffer 2010. Technology and Material Life. In D. Hicks and M.C. Beaudry (eds) *The Oxford Handbook of Material Culture Studies.* Oxford: Oxford University Press, pp. 303–32.

Home, R. 1982. *City of Blood Revisited.* London: Rex Collings.

Hoskins, J. 1998. *Biographical Objects: How things tell the stories of peoples' lives.* London: Routledge.

House of Commons 1895. *Sessional Papers: Correspondence respecting the Disturbances in Benin and the Operations against the Chief Nanna, 1894.* London: Harrison and Sons (HMSO).

House of Commons 1897. *Second Report from the Select Committee on British South Africa, together with the proceedings of the Committee and Minutes of Evidence.* London: Eyre and Spottiswoode (HMSO).

House of Commons 1899. *Sessional Papers: Royal Niger Company: presented to both Houses of Parliament by Command of Her Majesty.* London: Wyman and Sons (HMSO).

Houses of Parliament 1897. *Papers Relating to the Massacre of British Officials near Benin, and the Consequent Punitive Expedition, Presented to both Houses of Parliament by Command of Her Majesty, August 1897.* London: Harrison and Sons (HMSO) (Africa 6).

Houses of Parliament 1899a. *Nigeria: Correspondence relation to the Benin Rivers Expedition 1899, presented to both Houses of Parliament by Command of Her Majesty, October 1899.* London: Darling and Son (HMSO).

Houses of Parliament 1899b. *Correspondence Respecting the Peace Conference held at The Hague in 1899, presented to both Houses of Parliament by Command of Her Majesty, October 1899.* London: Harrison and Sons (HMSO).

Igbafe, P.A. 1970. The Fall of Benin: A reassessment. *Journal of African History* 11(3): 385–400.

Igbafe, P.A. 1975. Slavery and Emancipation in Benin, 1897–1945. *Journal of African History* 16(3): 409–29.

Idiens, D. 1986. New Benin Discoveries in Scotland. *African Arts* 19(4): 52–3.

Idiens, D. African Collections in Edinburgh and Perth. *Journal of Museum Ethnography* 3: 31–41.

Im Thurn, E.F. 1893. Anthropological Uses of the Camera. *Journal of the Anthropological Institute of Great Britain and Ireland* 22: 184–203.

Ingold, T, 2014. That's Enough About Ethnography! *Hau: Journal of Ethnographic Theory* 4(1): 383–95.

Ita, J.M. 1972. Frobenius in West African History. *Journal of African History* 13(4): 673–88.

James, L. 1995. *The Fall and Rise of the British Empire.* London: Abacus.

Johnston, H.H. 1923. *The Story of My Life.* Indianapolis, in: Bobbs Merrill Company.

Joyce, T.A., O.M. Dalton and C.H. Read 1910. *British Museum Handbook to the Ethnographical Collections.* Oxford: Horace Hart.

Karpinski, P. 1984. A Benin Bronze Horseman at the Merseyside County Museum. *African Arts* 17(2): 54–62, 88–9.

Kassim, S. 2017. The museum will not be decolonised. https://mediadiversified. org/2017/11/15/the-museum-will-not-be-decolonised/.

Kear, J.M. 1999. Victorian Classicism in Context: Sir E.J. Poynter (1836–1919) and the classical heritage (two volumes). Unpublished PhD thesis, University of Bristol.

Kiwara-Wilson, S. 2013. Restituting Colonial Plunder: The case for the Benin Bronzes and Ivories. *DePaul Journal of Art, Technology and Intellectual Property Law* 23(2): 375–425.

King, G, 2007. *Twilight of Splendor: the court of Queen Victoria during her Diamond Jubilee Year.* Hoboken, NJ: John Wiley.

Kingsley, M.H. 1897. *Travels in West Africa*. London: Macmillan and Co.

Kingsley, M.H. 1899. *West African Studies*. London: Macmillan and Co.

Kirk-Greene, A.H.M. 1968. The Niger Sudan Expeditionary Force, 1897: A note on the logistics of a forgotten campaign. *Journal of the Society for Army Historical Research* 46(185): 49–56.

Klein, N. 2007. *The Shock Doctrine*. New York: Henry Holt.

Koch, H.W. 1969. The Anglo-German Alliance Negotiations: Missed opportunity or myth? *History* 54(82): 378–92.

Koe, L.C. 1897. Report in Field, Cross River Expedition. In R. Moor (ed.) *Report for the Year of 1895–6 of the Administration of the Niger Coast Protectorate, Presented to both Houses of Parliament by Command of Her Majesty, January 1897*. London: Harrison and Sons (Foreign Office Annual Series No. 1834), pp. 77–8.

Kopytoff, I. 1982. Slavery. *Annual Review of Anthropology* 11: 207–30.

Kopytoff, I. 1986. The Cultural Biography of Things: Commoditization as process. In A. Appadurai and I. Kopytoff (eds) *The Social Life of Things: Commodities in cultural perspective*. Cambridge: Cambridge University Press, pp. 64–91.

Krmpotich, C. and L. Peers 2011. The Scholar–Practitioner Expanded: An indigenous and museum research network. *Museum Management and Curatorship* 26(5): 421–40.

Lämmert, E. 1975. *Bauformen des Erzählens*. Stuttgart: J.B. Metzlersche Verlagsbuchhandlung.

Latour, B. 1991. Technology is Society Made Durable. In J. Law (ed.) *A Sociology of Monsters? Essays on power, technology and domination*. London: Routledge (Sociological Review Monograph 38), pp. 103–31.

Layiwola, A. 2007. The Benin-Massacre: Memories and experiences. In B. Plankensteiner (ed.) *Benin Kings and Rituals: Court arts from Nigeria*. Ghent: Snoek, pp. 83–9.

Lévi-Strauss, C. 1966. Overture to *le Cru et le cuit*. *Yale French Studies* 36/37: 41–65.

Lindqvist, S. 1979. Dig Where You Stand. *Oral History* 7(2): 24–30.

Lindqvist, S. 2001. *A History of Bombing* (trans. L. Haverty Rugg). London: Granta.

Linné, S. 1958. Masterpiece of Primitive Art. *Ethnos* 23: 172–4.

Lowenthal, D. 2015. *The Past is a Foreign Country Revisited*. Cambridge: Cambridge University Press.

Lugard, F.D. 1895. British West African Possessions. *Blackwood's Edinburgh Magazine* 157 (June 1895): 970–79.

Lugard, F.D. 1899. *Colonial Reports: Annual, No. 280. Niger: West African Frontier Force, Reports for 1897–8. Presented to both Houses of Parliament by Command of Her Majesty, June 1899*. London: Darling and Son (HMSO).

Lundén, S. 2016. *Displaying Loot: The Benin Objects and the British Museum.* Gothenburg: Gothenburg University (GOTARC Series B. Gothenburg Archaeological PhD Theses 69).

Lutyens, M. (ed.) 1961. *Lady Lytton's Court Diary, 1895–1899.* London: Rupert Hart-Davis.

Luxemburg, R. 1951[1913]. *The Accumulation of Capital* (trans. A. Schwarzschild). London: Routledge Kegan Paul.

MacDonald, C.M. 1895. *Report on the Administration of the Niger Coast Protectorate August 1891 to August 1894. Presented to both Houses of Parliament by Command of Her Majesty.* London: Harrison and Sons (Africa 1).

MacDonald, C.M. 1896. Report of the Niger Coast Protectorate Force (Constabulary) 1894–95. In C.M. MacDonald (ed.) *Report on the Niger Coast Protectorate 1894–5, Presented to both Houses of Parliament by Command of Her Majesty, September 1895.* London: Harrison and Sons (Africa 9), pp. 4–5.

McDougall, R. and I. Davidson (eds) 2008. *The Roth Family, Anthropology, and Colonial Administration.* Walnut Creek, CA: Left Coast Press.

MacGregor, N. 2010. *A History of the World in 100 Objects.* London: Allen Lane.

Malinowski, B. 1922. *Argonauts of the Western Pacific.* London: Routledge and Sons.

McWhirter, N. and R. McWhirter 1976. *Guinness Book of World Records.* New York: Bantam Books.

Maliphant, G.K., A.R. Rees and P.M. Rose, 1976. Defense Systems of the Benin Empire Uwan. *West African Journal of Archaeology* 6: 121–30.

Marks, S. and A. Atmore 1971. Firearms in Southern Africa: A survey. *Journal of African History* 12(4): 517–30.

Marx, K. 1867. *Kritik der politischeen Oekonomie. Buch 1: Der Produktionsprocess des Kapitals.* Hamburg: Verlag con Otto Meissner.

Mbembe, A. 2003. Necropolitics. (trans. L. Meintjes) *Public Culture* 15(1): 11–40.

Mbembe, A. 2015. Decolonizing Knowledge and the Question of the Archive. https://wiser.wits.ac.za/system/files/Achille%20Mbembe%20-%20Decolonizing%20Knowledge%20and%20the%20Question%20of%20the%20Archive.pdf.

Mbembe, A. 2019. *Necropolitics* (trans. S. Corcoran). Durham, NC: Duke University Press.

Mbembe, A. and E. Dorlin, 2007. Décoloniser les structures psychiques du pouvoir: Érotisme raciste et postcolonie dans la pensée d'Achille Mbembe. *Dans Mouvements* 51: 142–51.

Menke, R. 2008. *Telegraphic Realism: Victorian fiction and other information systems.* Stanford, CA: Stanford University Press.

Mintz, S. 1985. *Sweetness and Power: The place of sugar in modern history.* New York: Viking.

Mirzoeff, N. 2005. *Watching Babylon: The war in Iraq and global visual culture.* London: Routledge.

Mockler-Ferryman, A.F. 1898. *Imperial Africa: The rise, progress and future of the British Possessions in Africa.* London: Imperial Press.

Monroe, J.C. 2010. Power by Design: Architecture and politics in precolonial Dahomey. *Journal of Social Archaeology* 10: 477–507.

Moor, R. 1895. Further Operations Against Nanna. *House of Commons Sessional Papers: Correspondence respecting the Disturbances in Benin and the Operations against the Chief Nanna, 1894.* London: Harrison and Sons (HMSO), pp. 3–5.

Moor, R. 1897. Consul-General Moor to the Marquess of Salisbury, Benin City 24 February 1897, received March 20. In *Papers relating to the Massacre of British Officials near Benin, and the consequent Punitive Expedition presented to both Houses of Parliament by Command of Her Majesty, August 1897.* London: Eyre and Spottiswode (HMSO, Africa 6), pp. 26–30.

Moor, R. 1898. *Annual Report of the Niger Coast Protectorate for the year 1896–97, Presented to both Houses of Parliament by Command of Her Majesty, April 1898.* London: Harrison and Sons (Africa 3).

Moor, R. 1899. *Colonial Reports: Annual (No. 289). Niger Coast Protectorate, 1898–1899, Presented to both Houses of Parliament by Command of Her Majesty.* London: Darling and Son (HMSO).

Morton, C. 2015a. Richard Buchta and the Visual Representation of Equatoria in the Later Nineteenth Century. In C. Morton and D. Newbury (eds) *The African Photographic Archive: Research and curatorial strategies.* London: Bloomsbury, pp. 19–38.

Morton, C. 2015b. Collecting Portraits, Exhibiting Race: Augustus Pitt-Rivers's cartes de visite at the South Kensington Museum. In E. Edwards and C. Morton (eds) *Photographs, Museums, Collections: Between art and information.* London: Bloomsbury, pp. 101–18.

Moreton-Robinson, A. 2015. *White Possessive: Property, power and Indigenous sovereignty.* Minneapolis: University of Minnesota Press.

Nevadomsky, J. 1997. Studies of Benin Art and Material Culture, 1897–1997. *African Arts* 30(3): 18–27, 91–2.

Nevadomsky, J. 2006. Punitive Expedition Photographs from the British Army Museum and the Parody of the Benin Kingdom in the Time of Empire. *Archiv für Völkerkunde* 56: 43–50.

Nevadomsky, J. 2012. Iconoclash or Iconoconstrain: Truth and consequence in contemporary Benin B®and brass castings. *African Arts* 45(3): 14–27.

Newbury, C.W. 1971. *British Policy Towards West Africa: Select documents 1875–1914 (Volume 2).* Oxford: Clarendon.

Nixon, R. 2011. *Slow Violence and the Environmentalism of the Poor.* Cambridge, MA: Harvard University Press.

Norman, N. and K.G. Kelly 2006. Landscape Politics: The serpent ditch and the rainbow in West Africa. *American Anthropologist* 104: 98–110.

Nworah, K.D. 1971. The Liverpool 'Sect' and British West African Policy 1895–1915. *African Affairs* 70: 349–64.

Ogundiran, A. 2003. Chronology, Material Culture and Pathways to the Cultural History of Yoruba–Edo Region, 500 BC to AD 1899. In T. Falola and C. Jennings (eds), *Sources and Methods in African History: Spoken, written and unearthed*. Rochester, NY: University of Rochester Press, pp. 33–79.

O'Hanlon, M. and C. Harris 2013. The Future of the Ethnographic Museum. *Anthropology Today* 29(1): 8–12.

Okonta, I. and O. Douglas 2003. *Where Vultures Feast: Shell, human rights, and oil in the Niger Delta*. London: Verso.

Olivier, L. 2008. *Le Sombre Abîme du temps*. Paris: Éditions de Seuil.

Orr, C.W.J. 1911. *The Making of Modern Nigeria*. London: Macmillan and Company.

Osadolor, O.B. 2001. The Military System of Benin Kingdom, c. 1440–1897. Unpublished PhD thesis, University of Hamburg.

Osadolor, O.B. and L.E. Otoide 2008. The Benin Kingdom in British Imperial Historiography. *History in Africa* 35: 401–18.

Parr, A.E. 1962. Museums and Museums of Natural History. *Curator: the Museum Journal* 5(2): 137–44.

Patterson, O. 1982. *Slavery and Social Death*. Cambridge, MA: Harvard University Press.

Pearson, S.R. 1971. The Economic Imperialism of the Royal Niger Company. *Food Research Institute Studies* 10(1): 69–88.

Peckham, R. 2015. Panic Encabled: Epidemics and the telegraphic world. In R. Peckham (ed.) *Empires of Panic: Epidemics and colonial anxieties*. Hong Kong: Hong King University Press, pp. 131–55.

Peers, L. 2013. Ceremonies of Renewal: Visits, relationships, and healing in the museum space. *Museum Worlds*: 136–52.

Pinnock, J. 1897. *Benin. The surrounding country, inhabitants, customs and trade*. Liverpool: Journal of Commerce.

Pitt-Rivers, A.H.L.F. 1900a. *Antique Works of Art from Benin*. London: Privately Printed (Harrison and Sons).

Pitt-Rivers, A.H.L.F. 1900b. Works of Art from West Africa Obtained by the Punitive Mission of 1897 and now in General Pitt-Rivers's Museum at Farnham, Dorset. In *Antique Works of Art from Benin*. London: Privately Printed (Harrison and Sons), pp. iii–iv.

Pitt-Rivers, G.H. 1927. *The Clash of Culture and the Contact of Races: An anthropological and psychological study of the laws of racial adaptability, with special reference to the depopulation of the Pacific and the government of subject races*. London: George Routledge and Sons.

Pitt-Rivers, G.H. 1929. Preface. In L.H. Dudley Buxton (ed.) *The Pitt-Rivers Museum Farnham.* Farnham: Farnham Museum.

Plankensteiner, B. 2007a. Introduction. In B. Plankensteiner (ed.) *Benin Kings and Rituals: Court arts from Nigeria.* Ghent: Snoek, pp. 21–39.

Plankensteiner, B. 2007b. The 'Benin Affair' and its Consequences. In B. Plankensteiner (ed.) *Benin Kings and Rituals: Court arts from Nigeria.* Ghent: Snoek, pp. 199–211.

Plankensteiner, B. (ed.) 2007c. *Benin. Kings and Rituals. Court arts from Nigeria.* Ghent: Snoeck.

Plankensteiner, B. 2007d. Benin: Kings and Rituals. *African Arts* 40(4): 74–87.

Plankensteiner, B. 2010. *Benin.* Milan: 5 Continents (Visions d'Afrique).

Price, S. 2007. *Paris Primitive: Jacques Chirac's Museum on the quai Branly.* Chicago: University of Chicago Press.

Quick, R. 1898. *Seventh Annual Report of The Horniman Free Museum, Forest Hill, London, S.E.* London: Horniman Free Museum, London.

Qwabe, N. 2018. Protesting the Rhodes Statue at Oriel College. In R. Chantiluke, B. Kwoba and A. Nkopo (eds) *Rhodes Must Fall: The struggle to decolonise the racist heart of empire.* London: Zed, pp. 6–16.

Radcliffe-Brown, A.R. 1941. The Study of Kinship Systems. *Journal of the Royal Anthropological Society of Great Britain and Ireland* 71(1–2):1–18.

Ratté, M.L. 1972. Imperial Looting and the Case of Benin. Unpublished Masters thesis, University of Massachusetts Amherst. https://scholarworks.umass.edu/theses/1898/.

Ravenstein, E.G. The Climatology of Africa. In Anon. (ed.) *Report of the British Association for the Advancement of Science held at Bristol in September 1898.* London: John Murray, pp. 603–10.

Rawson, G. 1914. *Life of Admiral Sir Harry Rawson.* London: Edward Arnold.

Read, C.H 1898. Ancient Works of Art from Benin City. In Anon. (ed.) *Report of the British Association for the Advancement of Science held at Bristol in September 1898.* London: John Murray, p. 1032.

Read, C.H. 1899. Preface. In C.H. Read and O.M. Dalton 1899. *Antiquities from the City of Benin and from Other Parts of West Africa.* London: British Museum.

Read, C.H. 1910. Note on Certain Ivory Carvings from Benin. *Man* 10: 49–51.

Read, C.H. and O.M. Dalton 1898. Works of Art from Benin City. *Journal of the Anthropological Institute of Great Britain and Ireland* 27: 362–82.

Read, C.H. and O.M. Dalton 1899. *Antiquities from the City of Benin and from Other Parts of West Africa.* London: British Museum.

Rhodes Must Fall Oxford 2018 [2015]. Rhodes Must Fall Oxford founding statement, Facebook 28 May 2015. In R. Chantiluke, B. Kwoba and A. Nkopo (eds) *Rhodes Must Fall: The struggle to decolonise the racist heart of empire.* London: Zed, pp. 3–5.

Roese, P.M. 1981. Erdwälle & Gräben im ehemaligen Königreich von Benin. *Anthropos* 76: 166–20.

Roese, P.M., A.R. Rees and D.M. Bondarenko 2001. Benin City before 1897: A town map and a map of the palace area with description. *Ethnographisch-Archäologische Zeitschrift* 42: 555–71.

Roth, F.N. 1897. The Disaster in the Niger Protectorate: A chat with Dr Felix Roth. *The Sketch* 16(208), 20 January 1897: 508–9.

Roth, F.N. 1922. Some Experiences of an Engineer Doctor: With an introduction on our schooldays by H.L. Roth. Edited by H.L. Roth and privately reprinted from *Halifax Courier and Guardian.*

Roth, H.L. 1898. Primitive Art from Benin. *The Studio* 15(69) (December 1898): 174–83.

Roth, H.L. 1900. Stray Articles from Benin. *Internationales Archiv für Ethnographie* 13: 194–7.

Roth, H.L. 1903. *Great Benin: Its customs, art and horrors.* Halifax: F. King and Sons.

Roth, H.L. 1911. On the Use and Display of Anthropological Collections in Museums. *Museums Journal* 10: 286–90.

Rowlands, M. 1993. The Good and Bad Death: Ritual killing and historical transformation in a West African kingdom. *Paideuma: Mitteilungen zur Kulturkunde* 39: 291–301.

Roupell, E.P.S. 1897. Narrative Report of Ediba Expedition—February, March, April, 1896. In R. Moor (ed.). *Report for the Year of 1895–6 of the Administration of the Niger Coast Protectorate, Presented to both Houses of Parliament by Command of Her Majesty, January 1897.* London: Harrison and Sons (Foreign Office Annual Series No. 1834), pp. 79–86.

Ryder, A. 1969. *Benin and the Europeans 1485–1897.* London: Longman.

Sahlins, M. 1972. *Stone Age Economics.* Chicago, IL: Aldine-Atherton.

Salubi, A. 1958. The Establishment of British Administration in the Urhobo Country (1891–1913). *Journal of the Historical Society of Nigeria.* 1(3)L: 184–209.

Sarr, F. and B. Savoy 2018. Rapport sur la restitution du patrimoine culturel africain. Vers une nouvelle éthique relationnelle. http://restitutionreport2018.com/.

Saunders, P. 2014. 'The Choicest, Best-Arranged Museums I Have Ever Seen': The Pitt-Rivers Museum, Farnham, Dorset, 1880s–1970s. *Museum History Journal* 7(2): 205–23.

Scientific American 1898. Curios from Benin. *Scientific American* 78(5): 73–4.

Scott, J.B. 1909. *The Hague Peace Conferences of 1899 and 1909. Volume 2: Documents.* Baltimore, MD: Johns Hopkins Press.

Scott Keltie, J. 1895. *The Partition of Africa* (second edition). London: Edward Stanford.

Schuster, P.-K. 2004. The Treasures of World Culture in the Public Museum. *ICOM News* 1: 4–5.

Sebald, W.G. 1999. *Luftkrieg und Literatur.* Munich: Cak Hanser Verlag.

Shelton, A. 1985. Introduction, In A. Shelton (ed.) *Fetishism: Visualising power and desire.* London: Lund Humphries, pp. 7–9.

Sloan, K. 2003. 'Aimed at Universality and Belonging to the Nation': The Enlightenment and the British Museum. In K. Sloan (ed.) *Enlightenment: Discovering the world in the 18th century.* London: British Museum Press, pp. 12–25.

Srinivasan, A. 2016. After Rhodes. *London Review of Books* 38(7): 32.

Smith, M. 1958. The Seligman Mask and the RAI. *Man* 58: 95.

Soper, R.C. and P. Darling 1980. The Walls of Oyo-Ile. *West African Journal of Archaeology* 10: 61–81.

Spiers, E.M. 1975. The Use of the Dum Dum Bullet in Colonial Warfare. *Journal of Imperial and Commonwealth History* 4(1): 3–14.

Stafford-Clark, D. 1971. Ethnography. In F.C. Francis (ed.) *Treasures of the British Museum.* London: Thames and Hudson, pp. 156–67.

Starkie Gardner, J. 1898. The Metal Workers' Exhibition. *Magazine of Art* 22(10), 10 August 1898: 569–72.

Stern, P. 2015. The Ideology of the Imperial Corporation: 'Informal' Empire Revisited. *Political Power and Social Theory* 29: 15–43.

Stevens 1928. *A Catalogue of Rare Benin Bronzes and Ivories to be Sold by Instructions of Ralph Locke, Esq. (Late Divisional Commissioner of S. Nigeria) January 3rd, 1928.* London: Stevens Auction Rooms.

Stoler, A.L. 2006. On Degrees of Imperial Sovereignty. *Public Culture* 18(1): 125–46.

Stoler, A.L. 2008. Imperial Debris: Reflection on ruins and ruination. *Cultural Anthropology* 23: 191–219.

Stoler, A.L. 2011. Colonial Aphasia. *Public Culture* 23(1): 121–56.

Stoler, A.L. 2016. *Duress: Imperial durabilities in our times.* Durham, NC: Duke University Press.

Sweeney, J.J. 1935. The Art of Negro Africa. In J.J. Sweeney (ed.) *African Negro Art.* New York: Museum of Modern Art, pp. 11–21.

Taussig, M.T. 1992. *Mimesis and Alterity: A particular history of the sense.* London: Routledge.

Terkessidis, M. 2019. *Wessen Erinnerung zählt?* Hamburg: Hoffmann und Campe Verlag.

Thomas, N. 1991. *Entangled Objects: Exchange, material culture, and colonialism in the Pacific.* Cambridge, MA: Harvard University Press.

Thomas, N. 1998. Preface. In A. Gell *Art and Agency: An anthropological theory.* Oxford: Clarendon Press, pp. vii–xiii.

Thomas, N. 2016. *The Return of Curiosity: What museums are good for in the 21st century.* London: Reaktion.

Thompson, H.N. 1911. *Annual Report on the Forestry Department for the Year 1910*. Benin: Forestry Department of Southern Nigeria.

Trevor-Roper, H. 1965. *The Rise of Christian Europe*. London: Thames and Hudson.

Tokarczuk, O. 2018 [2009]. *Drive Your Plow Over the Bones of the Dead* (trans. Antonia Lloyd-Jones). London: Fitzcarraldo Editions.

Tylor, E.B. 1874. Review of Catalogue of the Anthropological Collection Lent by Colonel Lane Fox for Exhibition in the Bethnal Green Branch of the South Kensington Museum: Lane Fox; London, 1874. *Academy* 6(460): 129.

Tylor, E.B. 1900. *Anthropology: An Introduction to the Study of Man and Civilization*. New York: Appleton.

Tythacott, L. 1998. The African Collection at Liverpool Museum. *African Arts* 31(3): 18–35, 93–9.

Upton, D. 2015. *What Can and Can't Be Said*. New Haven, CT: Yale University Press.

Usman, A. 2004. On the Frontier of Empire: Understanding the enclosed walls in Northern Yoruba, Nigeria. *Journal of Anthropological Archaeology* 23: 119–32.

Uzoigwe, G.N. 1968. The Niger Committee of 1898: Lord Selborne's Report. *Journal of the Historical Society of Nigeria* 4(3): 467–76.

Vandeleur, S. 1897. Nupe and Ilorin. *Geographical Journal* 10(4): 349–70.

Vandeleur, S. 1898. *Campaigning on the Upper Nile and Niger*. London: Methuen.

Van Reybrouck, D. 2014. *Congo: The epic history of a people*. London: Harper Collins.

Vansina, J. 2010. *Being Colonized: The Kuba experience in rural Congo, 1880–1960*. Madison: University of Wisconsin Press.

Virilio, P. 1977. *Vitesse et politique: essai de dromologie*. Paris: éditions galilée.

Von Hellermann, Pauline. 2013. *Things Fall Apart? The political ecology of forest governance in southern Nigeria*. Oxford: Berghahn.

von Luschan, F. 1898. Herr F.V. Luschan hält einen Vortrag über Alterthümer von Benin, *Zeitschrift für Ethnologie* 30: 146–64.

von Luschan, F. 1919. *Die Altertümer von Benin*. Berlin: Museum für Völkerkunde.

Wagner, K.A. 2018. Savage Warfare: Violence and the rule of colonial difference in early British counterinsurgency. *History Workshop Journal* 85: 217–37.

Wagner, K.A. 2019. Expanding Bullets and Savage Warfare. *History Workshop Journal* 88: 281–87.

Waterfield, H. and J.C.H. King 2006. *Provenance: Twelve collectors of ethnographic art in England 1760–1990*. Paris: Somogy éditions d'art.

Webster, W.D. 1999. *Catalogue 21: Illustrated catalogue of ethnographical specimens, in bronze, wrought iron, ivory and wood, from Benin City, West Africa. Taken at the fall of the City in February, 1897, by the British Punitive Expedition under the command of Admiral Rawson*. Bicester: W.D. Webster.

Weisband, E. 2017. *The Macabresque: Human violation and hate in genocide, mass atrocity, and enemy-making.* Oxford: Oxford University Press.

Wengraf, L. 2018 *Extracting Profit: Imperialism, neoliberalism and the new scramble for Africa.* Chicago, IL: Haymarket.

Wesseling, H. 2005. Imperialism and the Roots of the Great War. *Daedalus* 134(2): 100–7.

Whyte, W. 2011. Review of Dan Hicks and Mary C. Beaudry (eds) 'The Oxford Handbook of Material Culture Studies'. *English Historical Review* 125(519): 513–15.

Willet, F. 1970. Ife and its Archaeology. In J.D. Fage and R. Oliver (eds) *Papers in African Prehistory.* Cambridge: Cambridge University Press, pp. 303–26.

Wolfe, P. 2016. *Traces of History: Elementary structures of race,* London: Verso.

Wright, P. 2000. *Tank: The progress of a monstrous war machine.* London: Faber.

Wroth, W. 1894. Medals. In S. Lane-Poole (ed.) *Coins and Medals (their place in history and art).* London: Eliot Stock, pp. 236–69.

Zetterstrom-Sharp, J. and C. Wingfield 2019. A 'Safe Space' to Debate Colonial Legacy? The University of Cambridge Museum of Archaeology and Anthropology and the Campaign to Return a Looted Benin Altarpiece to Nigeria. *Museum Worlds* 7: 1–22.

Index